THE LOCATION OF EXPERIENCE

 Sara Guyer and Brian McGrath, series editors
Lit Z embraces models of criticism uncontained by conventional notions of history, periodicity, and culture, and committed to the work of reading. Books in the series may seem untimely, anachronistic, or out of touch with contemporary trends because they have arrived too early or too late. Lit Z creates a space for books that exceed and challenge the tendencies of our field and in doing so reflect on the concerns of literary studies here and abroad.

At least since Friedrich Schlegel, thinking that affirms literature's own untimeliness has been named romanticism. Recalling this history, Lit Z exemplifies the survival of romanticism as a mode of contemporary criticism, as well as forms of contemporary criticism that demonstrate the unfulfilled possibilities of romanticism. Whether or not they focus on the romantic period, books in this series epitomize romanticism as a way of thinking that compels another relation to the present. Lit Z is the first book series to take seriously this capacious sense of romanticism.

In 1977, Paul de Man and Geoffrey Hartman, two scholars of romanticism, team-taught a course called Literature Z that aimed to make an intervention into the fundamentals of literary study. Hartman and de Man invited students to read a series of increasingly difficult texts and through attention to language and rhetoric compelled them to encounter "the bewildering variety of ways such texts could be read." The series' conceptual resonances with that class register the importance of recollection, reinvention, and reading to contemporary criticism. Its books explore the creative potential of reading's untimeliness and history's enigmatic force.

THE LOCATION OF EXPERIENCE

Victorian Women Writers, the Novel, and the Feeling of Living

―—

Adela Pinch

Fordham University Press
New York 2025

Fordham University Press gratefully acknowledges the financial assistance and support provided for the publication of this book by the University of Michigan.

Copyright © 2025 Fordham University Press

All rights reserved. No part of this publication may be reproduced, stored in a retrieval system, or transmitted in any form or by any means—electronic, mechanical, photocopy, recording, or any other—except for brief quotations in printed reviews, without the prior permission of the publisher.

Fordham University Press has no responsibility for the persistence or accuracy of URLs for external or third-party Internet websites referred to in this publication and does not guarantee that any content on such websites is, or will remain, accurate or appropriate.

Fordham University Press also publishes its books in a variety of electronic formats. Some content that appears in print may not be available in electronic books.

Visit us online at www.fordhampress.com.

Library of Congress Cataloging-in-Publication Data available online at https://catalog.loc.gov.

Printed in the United States of America

27 26 25 5 4 3 2 1

First edition

Contents

Introduction 1

 Experience on the Move: Transitioning, Transferring, Containing, 3 • Narrative Relations, Novel Worlds, 7 • The Organization of This Book, 10 • Women Writers, Women Readers, Feminist Theory, 12 • Acknowledgments, 15

1 Transfers of Experience: Brontës, Gaskell, Meynell, Sinclair 18

 Introduction, 18 • Experience in Victorian Philosophy, 22 • The Brontës and Experience, 29 • May Sinclair, 33 • A Distributed-Brontë Theory of Experience, 37 • Images of Haworth, 40 • Coda: Little Brontës, 50

2 The Story of O: Margaret Oliphant and Anti-metalepsis 56

 Introduction, 56 • The Story of O, 60 • "No One to Interfere," 63 • "Let Me In!," 68 • The Story of "Oh!," 75 • The O of Experience and the World Stack, 81

3 George Eliot and Prolepsis: Prediction, Prevention, Protection 85

 Introduction: Rethinking Prolepsis, 85 • Beginnings and Endings, 93 • The Future in "The Lifted Veil," 95 • Predicting the End in *The Mill on the Floss*, 98 • Will, Determinism, Necessity, and Narration, 103 • Development, Education, and the Futures of *The Mill on the Floss*, 108 • Coda: *Silas Marner*, 111

4 Regret, Remorse, and Realism in Elizabeth Gaskell 117

 Introduction, 117 • Half-Mended Stockings, 123 • Lines and Angles, 126 • What Never Happened, 133 • Remorse, Narration, Description, 136

Coda	144
Notes	151
Bibliography	189
Index	209

THE LOCATION OF EXPERIENCE

Introduction

This book tracks the dynamic force of experience in Victorian fiction. Reading novels makes us feel that some kind of lived experience has happened or is happening: that experience may seem to be located in the world of the novel, or in the person who wrote it, or in us. I argue here that our impression of where experience is located is determined by a novelist's deployment of some of the signal features of fiction: features, I argue, that are simultaneously formal and psychological. Focusing on writings by and about the Brontës, Elizabeth Gaskell, George Eliot, and Margaret Oliphant, I discover that these writers took different—and often surprising—stances on the following set of questions: Can fiction effect transfers of experience between differentiated domains? Can experience travel from one person to another, one moment in time to another, and, above all, across the divide that seems to separate fiction and real life?

In *The Location of Experience*, I suggest that these writers' answers to these questions were intimately bound up with emotional and ethical orientations. Careful attention to writings by and about the Brontës, Eliot, Oliphant, and Gaskell can reveal, collectively in these writings, a philosophical account of experience—an account that rivaled and complemented those of their male philosophical contemporaries—crafted through their manipulation of the psychological dimensions of fiction's formal features. These writers contributed to a significant strain of nineteenth-century fiction that activates a sense of experience by manipulating a constellation of related moral, psychological states: a fear of missing out; a fear of harming others; a sense of responsibility; the imperatives of protection and care; the need for restraint, and occasions for remorse. In the writings that I study, these moral and psychological themes often take shape through formal features that create the feeling that there are intimate bonds between beings on different sides of ontological and temporal divides: between narrator and character, between narrator and reader,

between past and present states of being. These include attribution (stories of responsibility), description, metalepsis, and prolepsis. These features serve as a membrane between world and novel, a membrane that allows us to feel as if a balance of experience is shifting between domains. My journey through Victorian accounts of experience, in other words, led me to a new understanding of the psychological dimensions of key aspects of novel form. Ultimately, my goal is to urge a view of literary realism as built out of such affective, psychological structures for the feeling of living, rather than as an imitation of life.

Victorian writers had a great deal to say about the idea of experience, and Chapter One will explain how and why the era's novelists, critics, and philosophers debated it so hotly. But their core definitions of the term usually do not stray too far from the commonsense definitions that I am offering here. Experience is understood to be the feeling of living, the sense of having truly been present. The Victorian philosopher Shadworth Hodgson defined experience as "a mass of feelings, perceptions, and thoughts ... whereby we seem to exist as Persons, in a world of Persons and Things, Actions and Events."[1] The conceptual edges of experience are more porous than those of related Victorian terms of human being, such as "consciousness" or "sensation," in that they extend beyond the mental to include the environment or object-world in which persons find themselves. Experience either takes place in the present tense or has a quality of ongoingness. In this regard, it is expressly distinct from memory, although crucially, it refers to the way that a feeling of living in a certain way builds up over time, so it becomes yours. In this respect, it can be acquired, stockpiled, learned from, fallen back on as a source of authority. It has not only a temporal, but also a spatial dimension—it is happening here rather than there—and yet it is often on the move. For all of these reasons, experience can feel both aspirational and elusive: "Experience is never limited, and it is never complete."[2]

For example, for Tennyson's Ulysses—to cite a very canonical piece of Victorian experience-talk—experience seems frustratingly out of reach. The traveler-hero complains:

> I am a part of all that I have met;
> Yet all experience is an arch wherethrough
> Gleams that untravelled world, whose margin fades
> For ever and for ever when I move.[3]

In this knotty metaphor, experience seems strangely *un*experienced. The metaphor unglues the person from his experience: Ulysses's "I" is in one place, looking through the arch constituted by "all experience" toward another location.[4] The distinctiveness of this detaching of experience from the person, and from the gleaming "world" itself, can be affirmed by contrasting Ulysses's view

with that of Matthew Arnold's Empedocles. That ancient philosopher-hero sees experience as drenching all it comes into contact with: he declares that "experience, like a sea, soaks all-effacing in."[5] By contrast, in Ulysses's view, experience hovers above, arch-like, framing an untraveled world that is both gleaming and fading. The best-case scenario, the metaphor implies, is that you could pass through the arch of experience on your way to the "untraveled world"; but that world is a moving target "whose margin fades / For ever and for ever" as you move. The implication is that, as the margin fades, some of both the gleaming and the fading—and thus of the moving-target-ness of that world—is shared by the arch of experience itself.[6] Tennyson's lines move forward in their stately, enjambed way; Ulysses moves forward; the arch of experience moves forward; and the margin of the world fades.

While this passage from "Ulysses" describes the very particular predicament of Tennyson's mariner-hero, these lines can serve as an introduction to two things that will be featured repeatedly in my analyses. The first is what we could call the *dynamics of experience*, as the texts prompt questions about what experience is moving, and where. The second is what we could call (to borrow a phrase from Marion Milner, who was always looking for moments when "real experience, new and indescribable, flooded in") "*the texture of experience*": experience is often represented with particular visual or tactile qualities, as gleaming or fading, thick or thin.[7]

Readers most interested in the historical emergence of literary and philosophical discussions of experience in Victorian England may wish to skip ahead to Chapter One. In the remainder of this Introduction, I will describe some concepts that led me to shape my study of the psychology of the novel in the ways that I have, and that have determined my choice of the particular novels and texts that are at the centers of my four chapters. These concepts appealed to me as promising openings into a fundamental problem in theorizing the realist novel: that—as I will discuss most explicitly in this book's final chapter—theories that treat realist novels as reflections of reality may not be enough to explain what binds us to them, and that an enduring challenge is finding ways to theorize how novels engage us psychologically.[8] They (these concepts) may be thought of as a few umbrellas that have helped me, at different times, travel through stormy weather on my way here, but which are shortly going to be left at the door.

Experience on the Move: Transitioning, Transferring, Containing

Readers will notice that the title of this study, *The Location of Experience,* echoes the British psychoanalyst D. W. Winnicott's 1967 essay, "The Location

of Cultural Experience," which theorized that cultural artifacts—works of art and literature, for example—do their work on us by crossing through a transitional space between mental, inner experience and the outside world. *The Location of Experience* is neither a work of psychoanalytic literary criticism, nor an exploration of the relationship between psychoanalysis and the novel. Psychoanalytic authors will not appear much in the following chapters. However, there are some concepts from British psychoanalysis, from both Winnicott and those who followed after him, that have shaped my approach to experience and the form of the novel.

In "The Location of Cultural Experience," Winnicott suggested that the way that humans engage with works of culture is analogous to children's play: it takes place in an area on the borderlands between internal, psychological reality and outer, other-people reality. Moreover, the capacity of a human to enter that in-between space is crucial to their having a true sense of the difference between inner reality and an outer reality populated by other people: it is a way of testing out the borders. Winnicott articulated this view of play in an earlier essay, "Transitional Objects and Transitional Phenomena," and in spite of the top billing he gave to the transitional object—the thing a child uses to mediate between inner and outer in this way—Winnicott's emphasis was always on processes and experiences. For example, in "The Location of Cultural Experience," he did not elaborate on what he meant by "culture": he professed that he proceeded "without being certain that I can define the word 'culture.'" But, he continued, "the accent indeed is on experience."[9]

In Winnicott's discussions of movements, processes, experiences and transitions, there is a passage that particularly catches my eye. In "Transitional Objects and Transitional Phenomena" he remarks, "it is not the object, *of course*, that is transitional. The object represents the infant's transition from a state of being merged with the mother to a state of being in relation to the mother as outside and separate" (emphasis mine).[10] With the "of course" in this sentence, Winnicott schools the naïve reader not to be misled by his term: even though he has been talking about transitional *objects*, objects do not move, only people do. But for a moment we may feel something akin to how we feel when, looking out the window as our airplane pushes back from the gate, we realize, belatedly, that it is not the world outside the window that is moving, but us. This is the point for Winnicott: although what is transitioning from one place to another, from one moment in time to another, is not an object but a person, the nature of psychical experience creates an optical illusion in which the object appears transitional.

As I studied the ways in which texts by and about Victorian fiction manipulate the movement of experience across locations, I often felt that I was

experiencing the optical illusion of the airplane pushing back from the gate. For example, when (as we shall see in Chapter One) late nineteenth-century writers imply that Emily Brontë's experiences had entered Charlotte Brontë's writing, do they "really" mean that, or are they, rather, themselves making a shift of attention from one Brontë to another? And conversely, when other Brontë-commentators strenuously insist that there was absolutely no crossing of any Brontës' lived experience into their fiction (also in Chapter One), or when Margaret Oliphant (as we will see in Chapter Two) mournfully implies that she is unable to enter into the fictional worlds that she created, what other human motions are keeping those boundaries between lived and literary experience seemingly so fixed? At other times I felt that I was contemplating phenomena that, like the winds and the clouds in Wordsworth's "Resolution and Independence," "moveth all together, if it move at all."

The idea of experience as something elusive that cannot really be represented, but can only be transformed, transferred, and reexperienced in relationships, is at the center of psychoanalytic thought.[11] The phenomenon called "transference," in which a person's feelings about a parent or loved one in real life are transferred onto the psychoanalyst, activates the consulting room into "a living relationship," and renders psychoanalysis into a process "in which something is always going on, where there is always movement."[12] In his difficult, yet influential, *Learning from Experience*, W. R. Bion hypothesized that a person cannot really be said to experience their experience until it has been transferred to another person. He reconstructed "a developmental sequence in which the infant communicates his [sic] experiences to the mother in affect and action; the mother takes them into her own emotional life and gives them meaning; and the infant takes in from her both a more bearable version of his own experience and the maternal capacity to think and represent it."[13] It is important to stress that Bion's experience-transfer schema is considerably weirder than the more palatable cliché, that telling someone about your experience makes it somehow more real. In Bion's schema, experience is transformed as if by chemical process, as it is transferred back and forth between two people, like a liquid between two beakers. He often referred to the person—be it the mother, the analyst, or another—who serves as the vessel for the other's experience as the "container," and the process of transferring, transferring back, and thus transforming the other's experience as the process of "containment."[14]

It needs to be stressed that Bion's experience-transfer process does not really "actually" happen. According to our commonsense understanding of what experience is, experience comes stamped, like some train tickets, "non-transferable." The story of the transfers of experience emerged as a recon-

struction from Bion's work with very ill patients whose ability to connect with their own experience, and in consequence to learn from experience, was tragically curtailed. It is a reconstruction in analysis of what did not seem to have happened, a story whose outlines are revealed in the negative. However, Bion's account of the emergence of "experience," reconstructed from the consulting room back to a person's earliest developmental stage, ought to raise the question of where, or on what ontological level, experience is located. Is it a fantasy, or a reality? Is it yours or someone else's? Might entertaining Bion's schema serve as a reminder to those of us who study fiction that, as William Flesch puts it, "vicarious experience is genuine experience,"[15] and not an imitation of it?[16] It is important to stress that the movements of experience in and around the literary texts under discussion in this book are always taking place at the level of fantasy; but this is not to say that they are not real.

I focus on the feelings of experience that shift locations in and in relation to realist novels, because doing so gives purchase to the psychological relations—between authors, narrators, characters, readers—that structure fiction. The psychoanalytic theories touched on in this Introduction—theories that emphasize in the transitional, transferrable nature of experience—speak to an intuition that the experience of reading fiction involves the crossing of boundaries between inner and outer, real and virtual worlds. I find resonance with literary scholars who have put object-relations psychoanalysis and literature together (Jacobus; Schwab; Smith; Christoff). In her study of the relation between Victorian fiction and object-relations theory, for example, Alicia Christoff attends to the many relations among narrative modes and aesthetics on the one hand, and modes of care that have deep origins in the parent-child relationship on the other—whether giving another a "resting-place,"[17] or the capacity to move, to get unstuck, to experience "aliveness."[18]

Victorian novelists' ways of moving readers around are often found in their signature ways of making narratological gestures of care for their readers. Trollope's narrator frequently reminds the reader that he is taking special care of her, as when, in *Framley Parsonage*, he notes that, while a letter from Chaldicotes to the parsonage will take many miles and days to arrive, he can move the reader to the parsonage, and close to the letter in a much quicker, and more comfortable, way.[19] George Eliot's early novels feature gestures of invitation to the reader, as for example, when we are enjoined to "enter very softly" a drawing room in *Adam Bede*.[20] But these benign and literal gestures are but surface manifestations of more complex ways in which a structure of care may be baked into the form of the novel even when—perhaps especially when, as Talia Schaffer notes in her study, *Communities of Care*—such

gestures are refused or absented.[21] I am intrigued by the suggestion—offered by scholars of Bion's relationship to Samuel Beckett, who was briefly his patient—that Bion's very notion of containment may contain traces of the form of the novel, and as I look at the thick Victorian novels ranged on my shelves, I wonder if it is helpful to think of them as containers.[22] I think about my practices as a novel reader in relation to Winnicott's declaration that "the task of reality-acceptance is never completed, that no human being is free from the strain of relating inner and outer reality, and that relief from this strain is provided by an intermediate area of experience."[23]

Narrative Relations, Novel Worlds

The most ordinary way in which experience can be said to move in the nineteenth-century novel is along the axis of plot, as for example, along the progressive-cumulative narrative of the novel of development, or bildungsroman, in which a character starts out with little or no experience and then gradually gets a life. For example, at the beginning of Charlotte Brontë's *Villette*, the protagonist Lucy Snowe finds herself alone in an inn for the first time, "unfurnished with either experience or advice." As she moves abroad to Villette, she marvels that "Experience of a certain kind lay before me, on no narrow scale," and toward the end of her narrative she issues a platitude: "the longer we live, the more our experience widens."[24] But less progressive-cumulative movements happen as well, and one of the principles of this study is that we can learn a great deal about novel form by tracking them.[25] In order to do so, *The Location of Experience* draws on selected terms and conversations in the field of narrative studies. For example, I find it useful throughout to focus on the ways in which intradiegetic movements and relations—that is, movements and relations within the story—intersect with movements that pertain to relations between extradiegetic (outside of the story: authors, sometimes narrators, and readers) and diegetic (inside the story: characters, fictional events) entities. Novels theorize experience, I argue, by crosscutting intra- and extradiegetic relations. In this context, it has been useful to drill down into narrative modes of motion that explicitly depart from gradual narrative progress, such as "metalepsis"—which narratologists use to describe a particular kind of crossing or transfer, when a narrator crosses the boundary separating the experience of narrating, and that of the fictional world being described—and "prolepsis," in which narrators hurl their readers and characters forward to experiences which have not yet taken place.[26]

By conceiving of narrators "hurling" and transitioning across dividing lines, as well as by distinguishing between extra- and intradiegetic relations,

I might seem to be affirming that novels draw distinct boundaries separating them from the actual world. Yes and no. On the one hand, thinking of novels as fictional "worlds," as containers whose contents have a unique, world-like plenitude, and thinking that the world of readers and writers is (this is Bakhtin) "set off by a sharp and categorical boundary from the *represented* world of the text,"[27] can open and clarify a host of questions. In *Fictional Worlds*, for example, Thomas Pavel advocates for distinguishing between metaphysical questions about fictional beings (their essence, their relation to truth) and what he calls "demarcational" questions about whether fictional worlds are sharply bounded from reality.[28] On demarcational questions, it is possible to distinguish further what Pavel calls a "segregationist" stance (the fictionality of novels separates it utterly from other forms of discourse, other entities, like oil from water), from stances that explore the porousness of fictions to the world. As I have worked on this book, I have kept in mind the semantic, logical, and ontological complexities that have been gained by theorists extending to literature "possible worlds" philosophy.[29] But, on the other hand, novels, as many possible worlds theorists themselves caution, do not have all the properties of the kinds of "possible worlds" hypothesized in philosophy to study the logic of how we talk about what could be but is not. I take seriously Elaine Freedgood's charge that conceiving of ontologically distinct worlds may prevent us from thinking about the globe that we share, equitably: for her, refusing to see novels as fictional worlds is a crucial part of decolonizing the novel.[30]

However, in this study I view the idea of a "sharp, categorical boundary" around the world of a novel from a pragmatic, context-dependent orientation. When novelists create the appearances of movement, they fix our sense that there is a border to be breached; conversely, when novelists focus our attention on borders, they create the illusion of moment. Is the world sliding out from under us, or is the airplane pulling back from the gate? My context-dependent approach to borders between worlds responds to images of weightiness, intimations of gravity shifting from one place to another.[31] The interplay of movement and borders of fictional worlds is also manifested through a focus, throughout this study, of a group of images that appear in the work of the Brontës, Gaskell, Eliot, and Oliphant: images of thresholds, approaches, windows, and lines. These images are often where the novelist both models and manipulates the borders of the fictional world and also gives texture to the experience on either side. My context-dependent, pragmatic, and psychological approach to the movements of experience between real and fictional worlds can be further sharpened through a contrast with a remark in Yi-Ping Ong's account of experience in and of the nineteenth-century

realist novel in *The Art of Being*. Distinguishing her existentialist approach from what she calls empiricist and sociological accounts of fictional worlds, she writes, "it is not uncommon for debates over the value of novel-reading to proceed as if any plausible defense of the practice depends on *a quite literal transfer of knowledge or experience from forays into the other-world of the novel to the realm of this world*." (emphasis mine)[32] The transfer of experience may not be "quite literal," but it may be psychologically not *not* real: the emphasis here is on the consequences of what is felt.

In deciding how to think about the worlds of fiction and our relation to them, we may feel that we have a choice between focusing on structure, or on process: we can focus on the structural differences or separations between the real world and the storyworld, or we can focus, more dynamically, on how we get in and out of there. But perhaps, the opposition of structure and process is a question of perspective, or a choice of emphasis. It may be that moments in which there seems to be a transfer of experience, or a crossing of a divide, are the unfolding in language of structures that are already there. For example, John Plotz's *Semi-Detached: The Aesthetics of Virtual Experience Since Dickens* shares some of the concerns of the present study: how can readers feel as if the experience going on inside a fictional world is so much more real, more absorbing, when in fact our own experience is on the outside? Plotz focuses on a structure of simultaneity, analyzing a wide range of texts which model a structure in which a reader feels herself to be both half in and half out of a fictional world, in both places at once. Aesthetic experience, he argues, is often "the experience of living inside two worlds at once."[33]

One of Plotz's paradigm cases is the situation of the narrator in the opening paragraphs of George Eliot's *The Mill on the Floss*. The novel opens with an observer/narrator who appears to be in the diegetic space with Maggie Tulliver, resting his arms on a stone bridge and watching her play by the river as the day closes:

> It is time the little playfellow went in, I think; and there is a very bright fire to tempt her: the red light shines out under the deepening gray of the sky. It is time, too, for me to leave off resting my arms on the cold stone of this bridge ...
>
> Ah, my arms are really benumbed. I have been pressing my elbows on the arms of my chair and dreaming that I was standing on the bridge in front of Dorlcote Mill, as it looked one February afternoon many years ago.[34]

For Plotz, the narrator is in two places at once, both on the cold bridge and in the chair, her elbows pressing on both; as such it can serve as a model for that peculiar situation of the fiction reader, detached enough from her

"own" experience to feel that she is also in that of the story world. And yet, while "in two places at once—seeing and dreaming" is a structural account of Eliot's narrator's situation at the beginning of *The Mill on the Floss*, as the passage unfolds there is a narrative—what Plotz calls a "'phase-shift' moment"[35]—in which the narrator realizes—and we along with her—that her experience is really "here," not "there." Eliot's most striking appeal to the reader in this passage is the ellipses, in which the reader must make an adjustment: temporal and spatial movement has happened. In other words, my reading of this moment in *The Mill on the Floss* differs from Plotz in that he emphasizes structure, where I emphasize movement.[36] It is in the vertigo of that movement that the strangeness of fiction is felt.

The Organization of This Book

In order to advance my exploration of the dynamic movements of experience in the novel, the four chapters of this book are organized conceptually. Chapter One has the biggest chronological reach, extending from the Brontë sisters' writings from the 1840s to those of early twentieth-century Brontë lovers, discussing them in dialogue with the Victorian philosophers of experience from T. H. Green to Shadworth Hodgson. This chapter, called "Transfers of Experience: Brontës, Gaskell, Meynell, Sinclair," argues that women's writings about the Brontës—from their contemporary Elizabeth Gaskell through the great, early twentieth-century novelist and idealist philosopher (and Brontë fan) May Sinclair—obsessed about whether Charlotte and Emily Brontë's novels derived from their "experience" in order to craft a philosophical definition of the term, in dialogue with both British empiricism and idealism. It is only, I contend, by delineating the contexts of Victorian philosophies of experience, of women's interest and exclusions from philosophy, and of late nineteenth-century women's literary culture, that the distinct features of the approaches to experience at stake here can be understood. The idea of experience gets shaped through a relay of displacements as it gets transferred from the Brontës to Gaskell to Meynell to Sinclair, and ultimately is seen as residing in a dense, yet paired down, mode of description.

Chapters Two and Three make a move from Chapter One's focus on transfers of experience among writers and readers, to movements of experience within and around works of fiction. They are organized around metalepsis and prolepsis, respectively. Chapter Two, "The Story of O: Margaret Oliphant and Anti-metalepsis," bears witness to Oliphant's longing for—and curious resistance to—transfers of experience across the ontological divide between life and literature, as expressed in her *Autobiography*, her literary criti-

cism, and her fiction. In Oliphant's writing, I argue, both the desire for, and prohibition against, such crossings are modeled on the relationship between parent and child, encompassing both protection and restraint. In her writing, experience gets defined, paradoxically, as what you feel when you are absolutely debarred from action, unable to cross over to help someone, as in the case of the parent with the intractable child, or the reader yearning fruitlessly to help fictional characters. Thus, Chapter Two proposes a reinterpretation of metalepsis as a psychological, as well as a narrative structure, one that can play a crucial role in creating the feeling of experience. Chapter Three, "George Eliot: Prediction, Prevention, Protection," provides a reconsideration of narrative prolepsis in realist fiction by focusing on the pull of the future in Eliot's fiction, above all on the psychology of temporal displacement in *The Mill on the Floss,* "The Lifted Veil," and *Silas Marner.* I demonstrate that Eliot makes analogies between storytellers who hint at narrative endings, and ordinary people's tendency to imagine the worst possible future scenarios as a means of magically preventing them. By intertwining foreshadowing and magical thinking, I argue, Eliot links narrating with the desire to care for another, and the crossing between present and future becomes analogous to crossings between literature and life.

Readers interested in discovering how this book contributes to the study of literary realism will find the history and theory of that concept most explicitly addressed in Chapter Four, "Regret, Remorse, and Realism in Elizabeth Gaskell," which carries forward the questions of experience and literary description from Chapter One, and puts the argument of this book squarely in conversation with the history of theorizing realism—from Erich Auerbach to the present. Chapter Four begins by circling back to Gaskell's *Life of Charlotte Brontë* (a text central to Chapter One) but is centered on the fiction that she wrote in the wake of that work, including *Sylvia's Lovers, Wives and Daughters,* and above all *Cousin Phillis.* In that novella, I show, feelings of remorse and gestures of recompense are transferred among author, narrator, and characters, and imaginary experience is seen as transferrable to real life. Gaskell explores not only the pathos of literature's limited means of evoking a world, but also the ways in which these limits can link literary realism with both emotions of remorse and regret, and gestures of recompense. In Chapter Four and elsewhere, my choices turn away from the marriage plots and happy conjugal endings often seen as the essence of the nineteenth-century novel: I may be charged with presenting atypical slices of these particular novelists' works. However, I conclude by stressing how the nineteenth-century novel's parallel dramas of responsibility, protection, and remorse, light up some of the broader psychological structures of novel reading.[37]

The readers of this Introduction will already have intuited the methodological diversity that will be found in the pages of this study. In *The Location of Experience*, I eschew the dichotomy between historicist and formalist modes of analysis, because they go hand in hand. The philosophical-historical story in Chapter One is the essential context that explains why the Victorian women writers discussed throughout could pursue their investigations of, and formal experiments in, transferring literary experience. Moreover, accessing the psychological resonances and patterns of my authors' handling of experience, I found, required juxtaposing their writing with a diverse range of texts—from psychoanalytic theory to narrative theory to poetry—and diverse modes of reading, close, distant, and intertextual. All of these methods are designed, individually and in concert, to register the movements, shifts, and feelings of experience among different locations in the experience of reading.

Women Writers, Women Readers, Feminist Theory

This is a book that revolves around writing by and about women novelists. However, its themes—the locations of experience in novels and novel reading; the psychological dimensions of formal devices of storytelling; the pull of familial relations at play in narrative relations; the emotional construction of literary realism—do not apply exclusively to women writers. As we shall see in Chapter Two, for example, Anthony Trollope's tendency to talk of his literary characters as his children drove Margaret Oliphant slightly crazy; and in the prefaces to his novels, Henry James famously wrote about his relation to his story and characters with a peculiar blend of detachment, intimacy, and emotional neediness (in the preface to *The American*, for example, filling an "aching void" by "clinging to my hero as to a tall, protective, good-natured elder brother.")[38] At the heart of the psychoanalytic approach to transfers of experience discussed earlier is the idea that maternal gestures or aesthetics of care can happen across a wide variety of locations, persons, and relations. However, the question of how experience is privileged, qualified, and reframed as a function of fiction is intimately related to a further set of questions about the kinds of experience available, or not, to Victorian women. And it is a hard fact that many of the women writers featured in this study reflected on the way in which family feeling reverberates through narrative choice. George Eliot referred to *The Mill on the Floss* as her "youngest child," and George Henry Lewes described her writing of the novel as a form of parental care, rocking the cradle of the "new 'little stranger.'"[39] Oliphant and Gaskell—as we will see in Chapters Two and Four—mobilized the

intertwining of family relations and narrative relations, the two-way tug of desire and prohibition in the plotting of character trajectories.

The locations of experience had distinct contours for nineteenth-century women writers, because it was not really clear whether they were thought to have had any. Particularly, according to what Theo Davis calls "logic of possessive experience"—according to which "you are what you've been through"—women often seemed to come up short.[40] This deficit shaped the discussion of the Brontës throughout the nineteenth century, as we shall see in Chapter One. But George Eliot also explores the experience deficit in a scene in *Middlemarch*. When a dejected, lovesick Fred Vincy reproaches his childhood sweetheart Mary Garth with the charge that "a woman is never in love with any one she has always known—ever since she can remember; as a man often is. It is always some new fellow who strikes a girl," Mary replies, "Let me see. . . . I must go back on my experience."[41] But the catalog of "experiences" she then runs through as she considers Fred's claim are all those of literary characters: "There is Juliet—she seems an example of what you say. But then Ophelia had probably known Hamlet a long while," she begins, and after citing a host of other literary examples, Mary concludes "altogether my experience is very mixed."[42] The effects of Mary's claiming literary examples as "my experience" are themselves "very mixed." On the one hand, as Daniel Hack observes: "Mary's labelling of her reading as her experience is mischievous and mocking; it seems to signal a refusal to take Fred's fatuous generalization seriously. The implication is that neither Mary's nor anyone else's actual experience is being described, and these examples therefore neither support nor debunk Fred's claim, which is too silly to take seriously."[43] But on the other hand, through Mary, Eliot is reminding us of how circumscribed the "experience" of women and girls could seem; and falling back on one's reading as one's access to experience and example could be both a blessing and a curse. The uneven experience deficit was also a symptom of the pivoting of that term—for women—exclusively around the switch point of sexuality: marriage was either the beginning, or the end, of experience. When one of the early twentieth-century sisters in Lawrence's *Women in Love* asks the other, "You don't think one needs the *experience* of having been married?" the other replies, "Not really . . . more likely to be the end of experience."[44]

The legacy of Victorian discussions of women and experience reached far into twentieth-century feminism. Focusing a study on the locations of experience in and around the novels of the Brontës, Eliot, Gaskell, and Oliphant calls up the centrality of those authors to the growth of feminist literary criticism, particularly in the 1970s, and the crucial, but contested, location of

experience in that body of criticism. One of the goals of this groundbreaking body of feminist scholarship was to demonstrate that literary writing was uniquely formed to redress the experience deficit by revealing—and thus restoring and revaluing—women's ordinary experience. Victorian women realist novelists were the core around which formative works of 1970s Anglo-American feminist literary criticism—such as Patricia Meyer Spacks's *The Female Imagination* (1975), Ellen Moers's *Literary Women* (1976), and Elaine Showalter's *A Literature of Their Own* (1978)—revolved. Looking back on *A Literature of Their Own* twenty years later, Showalter affirmed her book's thesis that women's writing moves "in the direction of an all-inclusive female realism, a broad, socially informed exploration of the daily lives and values of women within the family and the community."[45]

However, the location of experience became a lightning rod for decades of debate in feminist criticism and theory. In 1985, Toril Moi argued that Showalter's *A Literature of Their Own* hinged on a naïve understanding of literary realism (which she termed "reflectionism"): an unstated, insufficient theory that "a text should reflect the writer's experience, and that the more authentic the experience is felt to be by the reader, the more valuable the text."[46] Showalter vigorously refuted these charges, notwithstanding her affirmation of an "all-inclusive female realism" exploring women's "daily lives" quoted above. Feminist theorists across the disciplines took to debate, in reaction to concerns about "women's experience" as the unquestioned foundation of 1970s feminist politics and scholarship. In "The Evidence of Experience," Joan Scott urged feminist historians not to take women's experience as the grounds for knowledge, but argued, rather, for the necessity of seeing "what counts as experience" as itself "that which we seek to explain, that about which knowledge is produced."[47] Not a prelinguistic real, "experience" in this view is constructed through language, "is always contested, and always therefore political."[48] Feminist philosopher Linda Martín Alcoff countered that feminism reduces experience to a "linguistic event" at its peril, and advocated for a phenomenological approach to embodied experience as a crucial source of feminist knowledge.[49] Toril Moi later returned to experience, championing the role that Anglo-American ordinary language philosophy could play in correcting a course that poststructuralist theory had charted, arguing that feminist theory had "become abstract and overgeneralizing, operating at a vast remove from women's concrete experiences."[50] Because of feminism's central questioning of the grounds for knowledge, it is perhaps inevitable that its account of location of experience—Is it in language? In the body?—should have repeatedly shifted so dramatically.[51]

The Location of Experience is not (of course!) designed as a retro, seventies-

style, macrame-era feminist criticism of the Victorian novel. Nor does it consistently feature gender as a marginalized concept of analysis. In contrast to the 1970s, we now have a growing sense of the centrality of women writers to Victorian print culture, and of their participation in the era's major intellectual debates.[52] But, I hope that this study's focus on the locations of experience can provide some perspective on the ways that those locations have moved throughout the history of feminism, by demonstrating the ways in which nineteenth-century women's literature engaged with this topic. While feminist literary criticism of the 1970s turned to Victorian women novelists to learn about women's experience, I shift the focus to how these women novelists contribute to a theory of the novel that puts the movement of experience at its center. Although this book documents the ways in which Oliphant, Eliot, and Gaskell thought and wrote about each other, and how a broader reach of women writers across the nineteenth and early twentieth century—including Alice Meynell and May Sinclair—thought about experience as a philosophical and literary concept in relation to each other, it is not concerned with establishing a distinctive women's literary canon. However, *The Location of Experience* does take the author as a salient category of analysis: but not as an unquestioned location of experience, as the biographical entity who owns the lived experience that is then transferred to fiction. As will become clear in Chapter One, for example, the Victorian women writers themselves questioned the connections among authorship, experience, and the feelings of living. Authorship is revealed in this study as part of a layered, networked set of relations that emerges from the evidence of the reading and writing practices that linked all the writers that I study.[53]

Acknowledgments

In organizing this book around works by and about the Brontës, George Eliot, Elizabeth Gaskell, and Margaret Oliphant—and through them, giving conceptual prominence to experience, emotion, and the psychology of narrative relations—I am returning to books and questions that mark an intersection of literary history and personal history. The reasons why a nerdy adolescent girl in the late 1970s would have cleaved to the world of Victorian women novelists were overdetermined: the confluence of feminist studies and Victorian studies in that decade filtered into the nerdy adolescent girl's intuition that a path into books could also be a path into "real" experience. Although I could not have articulated that then, I am delighted to do so now.

I am also delighted to acknowledge the colleagues, friends, and institutions

who have supported the writing of these pages over the past thirteen years. Above all, this book has been massively shaped by years of conversation with, and advice and inventive suggestions from, my two close colleagues and friends Danny Hack and Yopie Prins. Danny and Yopie have read almost every word, lending their own keen insights and interests to this project. I feel deeply my good fortune in having them as friends and colleagues. David Kurnick generously read a large chunk of the manuscript in draft, at a time when it really mattered. Thank you to the many friends and colleagues who discussed or read portions of this project over the years: Rachel Ablow, Amanda Anderson, Elaine Auyoung, Alicia Christoff, Ann Cvetkovich, William Flesch, Elaine Freedgood, Lauren Goodlad, Anna Henchman, Don Herzog, Virginia Jackson, Tina Lupton, Deidre Lynch, Richard Moran, Jeff Nunokawa, John Plotz, Leah Price, Talia Schaffer, Scott Shapiro, and Gillian White. Sections of *The Location of Experience* were presented at Yale, Harvard, Northwestern, Rutgers, Cornell, and the conferences of the North American Victorian Studies Association. Members of the audiences at all of these venues made extremely helpful, generative comments, and helped make this book what it is.

I am grateful to the Radcliffe Institute for Advanced Study at Harvard for a fellowship in 2017–2018, and to my fellow fellows for their feedback and ideas, especially Erica Edwards, Shireen Hassim, Maurice Lee, Sharon Marcus, Jana Prikryl, and Janina Wellmann. Didier Fassin kindly made it possible for me to be a visitor at the Institute for Advanced Studies in 2019–2020; I am grateful for the support of the friends there who provided feedback on my work: Alexander R. Galloway, Susana Narotzky, and Laura Weiger. Grateful acknowledgment of funding is due, as well, to the John Simon Guggenheim Memorial Foundation.

Thank you to the University of Michigan for years of support, and in particular for a Michigan Humanities Award in 2014. The students in my graduate course on feminist literary theory and criticism at the University of Michigan, in Winter 2017 and Fall 2020, provided a forum in which I could reflect and think out loud about some of the issues in this book. Thanks to my departmental graduate office's first year summer research program, I have been lucky to have crucial research assistance from the following PhD students: Dane Anderson, Rachel Cawkwell, Anne-Charlotte Mecklenburg, Lauren Sirota, Adam Sneed, and Sarah Van Cleve. They have each contributed to the materials presented here. Sarah heroically returned to the project at the end to give her meticulous, eagle-eyed attention to the manuscript in its final phases. Librarians at the University of Michigan and the Institute for Advanced Study navigated access to research materials

during the COVID-19 pandemic lockdowns of 2020 and 2021; I am grateful in particular to Marcia Tucker of IAS, and Sigrid Anderson at Michigan. Thanks also to Robert Haley for sharing his invaluable knowledge of early photographs of Haworth parsonage.

I could not have finished this book without the enthusiasm of Tom Lay of Fordham University Press, and Lit Z series editors Sara Guyer and Brian McGrath. My thanks to Tom, Sara, and Brian, as well as two anonymous reviewers, for their shrewd advice and support, and to Lis Pearson for her expert copyediting. Parts of Chapter Three appeared as "*The Mill on the Floss* and "The Lifted Veil": Prediction, Prevention, Protection," in *A Companion to George Eliot*, edited by Amanda Anderson and Harry E. Shaw (Blackwell, 2013), 117–28, and parts of Chapter Four appeared as "Half Mended Stockings; or, Reality Sensing in Elizabeth Gaskell," in *ELH* 83, no. 3 (2016): 821–37. A few paragraphs from the Introduction and Chapter One found their way into "Transitioning, Transferring, Containing, Caring," in *Syndicate Lit* (2022), and "Experience," in the "Keywords Redux" special issue of *Victorian Literature and Culture, Culture* 51, nos. 3–4 (Fall/Winter 2023). Many thanks to the editors of these publications for their assistance, and to the publishers (John Wiley & Sons, the Johns Hopkins University Press, the Syndicate Network, and Cambridge University Press, respectively).

I have been inspired during the many years that this project has been with me by my mother, Judith Pinch, who was the person who encouraged me to start reading Victorian women's fiction, and by my incredible daughter Clara Keane, whose transformation into adulthood is, in many ways, documented in this book. A special thank you to my brother Adam Pinch, who still remembers the first book that I ever wrote (in elementary school), "Three Hoofed Mammals of the World," when I had completely forgotten it. My greatest thanks go to my husband Webb Keane who has read, listened to, and supported the writing of this book with love, perspective, knowledge, and incisive, transformational thinking.

1. Transfers of Experience: Brontës, Gaskell, Meynell, Sinclair

Introduction

This chapter charts the rise and shape of Victorian discussions of the meaning of "experience" by bringing together some philosophical texts with commentaries on the Brontë sisters by some Victorian and Edwardian women writers. I argue that these writers' attunement to what they identify as moments when "experience" shifted for a Brontë from one domain to another—from life to literature, from literature to life, from one Brontë to another—and ultimately, from a Brontë to one later woman writer to another—captures best their era's literary-philosophical dilemmas about how to categorize the feeling of living. Focusing on the Brontës may seem like an unusual way to access the phenomenal rise of interest in the category of experience in Victorian writing, and indeed this approach will take us on an unconventional journey through some varied literary and philosophical terrain, spanning the mid-nineteenth through the early twentieth centuries. The Brontë sisters themselves will, by and large, appear here only through layers of mediation and commentary. I am indebted to the work of previous scholars of the Brontës' legacy and reception, although my aims are quite specific: to determine how and why writings about the Brontës intersected with the philosophical conversation about experience, and to explain why this conversation suggests how the transference of experience, more than its life-life representation, may be key to the Victorian novel's affective afterlife.

Before turning to the philosophical literature, I would like to clarify further what I mean by "transfers of experience." As I proceed, it might seem as if I am describing a process of "identification"—identification between two people, so that one person feels as if they are experiencing what the other is. As in: "Nelly I *am* Heathcliff—he's always, always in my mind—not as a pleasure ... but, as my own being—."[1] But *transfers* of experience are, rather,

shifts of gravity from one person or domain to another, or from one moment in time to another. One thing gets more real, another less real. Imagine the feeling of shifting a sandbag: one part gets heavier, as another gets lighter. So, what Heathcliff once was, now I am. Or, what Heathcliff once did, now I am doing.[2]

Perhaps the best way to capture the poetics and phenomenology of transfers of experience surrounding the Brontës is a short visit to a passage from a contemporary poem. Anne Carson's "The Glass Essay" is a long meditation by a speaker who is coming to terms with a romantic separation from a man named "Law," and whose intense, overidentified relationship with her mother is intertwined with her intense, overidentified relationship with Emily Brontë. Crossings between parent and child both model, and are modeled by, imagined crossings between reader and the long-dead author, and between experience in real life and experience inside *Wuthering Heights*. The speaker visits her mother on a lonely, Wuthering Heights-like moor, and when she reads *Wuthering Heights,* she goes into a free fall:

> I was downstairs reading the part in *Wuthering Heights*
> where Heathcliff clings at the lattice in the storm sobbing
> Come in! Come in! to the ghost of his heart's darling,
>
> I fell on my knees on the rug and sobbed too.[3]

In the scene in *Wuthering Heights* to which this passage alludes, Heathcliff does not fall on his knees on the floor. The novel's narrator, Mr. Lockwood, has just spent a disastrous night at Wuthering Heights and describes his encounter with Catherine's ghost to Heathcliff, and then documents Heathcliff's astonishing response:

> I stood still, and was witness, involuntarily, to a piece of superstition on the part of my landlord which belied, oddly, his apparent sense.
> He got on to the bed, and wrenched open the lattice, bursting, as he pulled at it, into an uncontrollable passion of tears.
> "Come in! come in!" he sobbed. "Cathy, do come. Oh do—*once* more. Oh! My heart's darling, hear me *this* time—Catherine, at last!"
> The spectre showed a spectre's ordinary caprice; it gave no sign of being; but the snow and wind whirled wildly through, even reaching my station, and blowing out the light.[4]

In Carson's poem, the speaker's vertical motion, her fall onto a rug, has no counterpart in *Wuthering Heights*. It is a kind of gravity attack. Carson's speaker's dropping down echoes an instance of the force of gravity featured

in an oft-repeated anecdote about Emily Brontë herself: right before she died, too weak to comb her hair, her comb slipped from her weakening hand and clattered down into the fireplace. May Sinclair, one of the later nineteenth-century women writers whose relation to Emily Brontë we shall study later in this chapter, returned "over and over again" to the image of Emily's comb dropping, falling, slipping.[5] The transfer of experience is a heavy feeling—or, as we will see later on in this chapter—a hairy, thick, or dense feeling.

We can further specify the peculiar transfer of Emily Brontë-ness that Carson is getting at, weighing her down, making her—in Joni Mitchell's words—"heavy company," by contrasting the effects in "The Glass Essay" with accounts of what we could call Emily Brontë impersonators "stumping"[6] around. The popular, late-Victorian novelist Jessie Fothergill, a *Wuthering Heights* superfan who had Yorkshire roots, styled herself, in her interview with the author of *Notable Women Authors of the Day*, as a kind of Emily Brontë tribute artist. She declared her Brontësque delight in "the rough roads, the wild sweeping moors and fells, the dark stone walls, the strange uncouth people, the out-of-the-worldness of it all. And the better I knew it, the more I loved it, in its winter bleakness and its tempered but delightful summer warmth. I loved its gloom, its grey skies and green fields. . . . I loved my wild rambles over the moors, along the rough roads."[7] Fothergill mouths, here, a kind of Brontë-lite; it is a set of phrases that exist outside of her.

In contrast, the curious effects that Carson describes are registered, in particular, in her speaker's description of what happens to her body. When she says that she feels as though she is turning *into* Emily Brontë, she describes feeling "my lonely life around me like a moor,/ my ungainly body stumping over the mud flats with a look of transformation."[8] The phrase "ungainly body" catches one's eye, as the word "ungainly" clearly caught Carson's. The question of Emily Brontë's bodily presence was, even in the decades following her early death, a vexed one for her followers and fans. Some eyewitnesses described her as a light and ethereal being ("lithesome, graceful").[9] Vague accounts such as this were seized on eagerly by many readers, who preferred a disembodied Emily (A. Mary F. Robinson: "her natural movements had the lithe beauty of the wild creatures that she loved").[10] The poet Charlotte Mew, for example, declared that "it seemed little matter for regret that no reliable likeness of Emily exists." "Our mental presentiment is not marred," she continued; it was possible to continue to conceive of Emily as having had no body, as "almost unearthly light."[11] To the poet and essayist Alice Meynell, Emily is the shadow of a shadow, a "brilliant fugitive, the bird of a broken snare, [who] snatched her very shadow out of sight."[12]

But against this bodiless Emily emerged the dour account of an acquaintance, Laetitia Wheelwright, who described her (in contrast to tiny Charlotte Brontë) as "tall and ungainly"—a phrase that also got handed down selectively by some biographers.[13] Thus, Anne Carson's choice to emphasize the ungainly, rather than the ethereal, Emily may be seen as a symptom of the transferential nature of her speaker's experience. Not a transparent, weightless, mental identification, the transfer of Emily Brontë-ness onto the speaker is akin to physical mass, making her heavy and ungainly. While Carson's representation of an Emily-transfer seems particularly heavy, it can make us—as we shall see in the later sections of this chapter—attuned to the shifts and shades of emphasis in the words of all of the writers (Robinson, Meynell, Sinclair) who were, as Michael Moon terms Emily Dickinson, Emily Brontë's "friends from the future."[14]

Or here is another example of a different kind of transfer of experience, from the mother of all Victorian Brontë texts, Elizabeth Gaskell's *The Life of Charlotte Brontë* (1857). Gaskell asks Brontë if she has experienced the effects of opium:

> I asked her whether she had ever taken opium, as the description given of its effects in "Villette" was so exactly like what I had experienced—vivid and exaggerated presence of objects, of which the outlines were indistinct, or lost in a golden mist, &c. She replied, that she had never, to her knowledge, taken a grain of it in any shape, but that she had followed the process she always adopted when she had to describe anything which had not fallen within her own experience: she had thought intently on it for many and many a night before falling to sleep;—wondering what it was like, or how it would be,—till at length, sometimes after the progress of her story had been arrested at this one point for weeks, she wakened up in the morning with all clear before her, as if she had in reality gone through the experience, and then could describe it, word for word, as it had happened. I cannot account for this psychologically, I only am sure that it was, because she said it.[15]

This passage demonstrates in a nutshell (or in a drop of opium) something that many readers have pointed out about Gaskell's *The Life of Charlotte Brontë* as a whole: that its true subject is not so much the life of Brontë, as the peculiar relation between Gaskell and Brontë. At stake in *The Life of Charlotte Brontë* is not only the question, whose life story is this, Brontë or Gaskell's? But also, as Sarah Allison has argued, in *The Life of Charlotte Brontë*, Gaskell was clearly engaged in theorizing the distinctiveness and overlays between fact and fiction at a time when—in spite of the preeminence of the novel—those distinctions were surprisingly still up for grabs.[16] Here, the

only actual experience is Gaskell's own experience of taking opium.[17] The passage begins and ends with Gaskell's first-person account; the "experience" of taking opium is handed off to Charlotte Brontë in the middle; and she is able to transfer it from imagination, to real feeling, to fictional. Things like this happen in *Villette* itself: Brontë sometimes sets up a similar narrative structure that makes the protagonist Lucy Snowe's experience available for the reader to experience, even at moments when Lucy is not experiencing her own experience.[18] But how especially odd that the experience that Gaskell uses as a test case for Brontë's experience-transferring abilities is that of taking opium! In which ordinary sensory experience is distorted in all directions, objects becoming both "vivid" and "indistinct"! Two last points in relation to this passage: first, in taking up the issue of whether the Brontës wrote about what they had experienced, or wrote about what they had *not* experienced, it prefigures, as we shall see, the central issue of later Victorian Brontë appreciation. Second, what exactly does this passage say about what Victorian writers understood "experience" to mean?

Experience in Victorian Philosophy

In the Gaskell paragraph above, two different shades of meaning of the word "experience," two different variants of the concept, seem to be at play. There is, in Gaskell's second usage of the word, the fundamentally biographical meaning: experience as the things someone has done. It is something you can claim as your own.[19] The problem for Charlotte Brontë, in this paragraph, is that opium is not part of her biography: it "had not fallen within her own experience." But playing around Gaskell's first usage—when she describes what her own experience of taking opium *was like*—"vivid and exaggerated presence of objects, of which the outlines were indistinct, or lost in a golden mist, &c."—is what we can call a phenomenological account of experience, a focus on sensory apprehensions and qualities in the moment. Versions of these two shades of "experience"—one cumulative, one more immediate and sensory—can be found throughout the history of attempts to define the term. The two shades have their analogues, for example, in the distinction, in the German tradition, between *Erfahrung*—which suggests a more developmental, cumulative, totalizing way of thinking about experience—and *Erlebnis*, a more ephemeral, present access to sensory stimuli. Raymond Williams called these "experience past" and "experience present," but noted how inextricably tied these two versions of experience were throughout the nineteenth century.[20] Gaskell's opium paragraph exemplifies how closely these two shades of "experience" are tethered together through

narration. On the one hand, Gaskell implicitly participates in a narrative in which biographical, continuous experience is made up of multitudes of moments of sensory experiences.[21] But, on the other hand, Gaskell is fascinated by Brontë, precisely because she seems to exemplify both the possibility of experience's virtualization, and the possibility of abstracting sensory from biographical experience. As this chapter proceeds through the sometimes-dizzying array of Victorian experience-talk, the balance will, at times, shift between the biographical and the phenomenological, but the one always shadows the other. We will see, across the Victorian experience-talk, an array of definitional and conceptual possibilities: they range from isolating the biographical from the phenomenological, to conflating the two, attempts to disambiguate different classes of "experience"—scientific, epistemological, religious, aesthetic—and to attempts at coming to a unified account.

And talk about it they did. From the middle of the nineteenth century through the first decades of the twentieth, "experience" seems to have reached the status of a fashionable concept, of urgent interest to writers and readers across many fields, topics, and genres of writing. We can find blunt measuring sticks to document an uptick in experience-fever by conducting digital searches in a number of corpora of British English printed texts from the century, spanning between 1817–1917 (the latter date was chosen because it is the publication date of the latest text that is central to the story that this chapter has to tell, May Sinclair's *Defence of Idealism*); all demonstrate an upswing in the appearance of the noun "experience," with particular peaks of usage in the last few decades leading up to the turn of the nineteenth century into the twentieth.[22] What is remarkable is not only the sheer volume of books and articles that contain "experience" in their titles, but also the diversity and range of topics that the publications appear to address. Many are autobiographies, such as the Anglo-American reformer Georgiana Bruce Kirby's ultra-blandly titled *Years of Experience: An Autobiographical Narrative* (1887), narrower accounts such as "The Musical Experiences of a Pianoforte Student" (Bettina Walker, 1893), or claims of firsthand knowledge: *Eight Months' Experience of the Sepoy Revolt* (Sir Charles D'Oyly, 1891). Most striking is the swelling of the ranks of books and essays that address the topic of experience as a matter of urgent religious or philosophical importance. Even the London alchemist and occultist Herbert Stanley Redgrove was moved to publish a serious attempt at philosophy called *The Magic of Experience* (1915)! Many among this group were written by clergy and theologians, such as the Anglican William Newbolt's *The Gospel of Experience* and Wilfrid John Richmond's *Experience: A Chapter of Prolegomena*, both published in 1896.

But there is, of course, William James's psychological investigation, *Varieties of Religious Experience* (1902) and, as we shall see, clusters of philosophical investigations of the term.

Why this increase of writing about experience? We could start to answer by saying that "experience," as a basic way of thinking about human life, got caught up in the great division and professionalization of the disciplines in late Victorian intellectual life. The later nineteenth century saw the birth of many of the fields of the human sciences in their modern forms, as for example, psychology separated itself out from moral philosophy as a discrete field, and anthropology, economics, and sociology emerged as academic disciplines. In this increasingly divided terrain, the object of the human sciences became the distinct "varieties" (to use James's term) of experience. Experience-titles multiplied because it seemed possible to think about religious experience, as distinct from musical experience, as distinct from, say, educational experience—each studied through the lens of an emerging discipline.[23]

But crucial to the mushrooming of experience-talk toward the end of the century was the concept's prominence in the schools of philosophy that came to dominate the philosophical airwaves. It was, in part, a result of the rise of idealism in British philosophy. While the uneasy assimilation of Platonism as well as German idealist philosophy in Britain—Kant, Fichte, Schelling, Hegel—has a long and tortured history, idealism flourished in Victorian Britain. The causes of its rise were first, moral, social, and political. The philosophers T. H. Green and Bernard Bosanquet, above all, turned to idealism to undergird an alternative to the dominant social and political philosophy of mid-Victorian England, utilitarianism, which seemed to them a shriveled account of ethics with no sense of social totality.[24] But the Victorian idealists also saw themselves as correcting the methodological and metaphysical errors of the fundamentally empiricist way of thinking about experience that dominated British science and philosophy. In taking individual, observed experience of the natural world as the basis for all knowledge, the empiricist tradition had produced (in the idealists' view) an atomized, fragmented world of multiple experiences. Victorian idealists such as T. H. Green and F. H. Bradley strove for "Absolute Experience" (capital A, capital E): a total, authentic experience that overcomes the divide between subject and object.

In the methodological first book of his posthumously published *Prolegomena to Ethics* (1883), T. H. Green's discussion of "experience" begins with a critique of empiricism that is, as he acknowledges, "broadly the Kantian view."[25] Empiricism erroneously sees mind and ideas as passively formed through experience of the world as it is. Like all idealists, Green insists on the priority and generativity of mind. But he does not want to abandon the

concept of experience; he rather redefines experience *as* consciousness. He rejects utterly the idea of experience as a passive "passing through" the world:

> Experience in the sense in which, for instance, a plant might be said to experience a succession of atmospheric or chemical changes, or in which we ourselves *pass through* a definite physical experience during sleep or in respect of the numberless events which affect us but of which we are not aware (emphasis mine).[26]

There would be no "learning from experience," of course, if experience were a plant-like unconsciousness. Therefore, experience must involve sense-making consciousness—not only consciousness, but consciousness of relations, "of events as related or as a series of changes."[27] Without concepts such as relatedness, time, and space, there could be no experience; mental activity makes experience. Furthermore, if there is a capacity that is conscious of relations and concepts, it must be a capacity with enduring continuity and unity:

> If there is such a thing as connected experience of related objects, there must be operative in consciousness a unifying principle, which not only presents related objects to itself, but at once renders them objects and unites them in relation to each other by this act of presentation; and which is single throughout the experience. The unity of this principle must be correlative to the unity of the experience.[28]

Green then illustrates this with a leap that catapults the idea of experience into the stratosphere:

> If all possible experience of related objects—*the experience of a thousand years ago and the experience of to-day, the experience which I have here and that which I might have in any other region of space*—forms a single system; if there can be no such thing as an experience of unrelated objects; then there must be a corresponding singleness in that principle of consciousness which forms the bond of relation between the objects (emphasis mine).[29]

Experience radiates backward a thousand years! and into all potential "regions of space" as a "single system": this is a Victorian account of experience that seems very, very far from either the biographical or sensory dimensions of the term in Gaskell's usage. It is a transcendental principle.[30]

More influential—and even more transcendental—in late Victorian intellectual life was the approach to experience of F. H. Bradley's *Appearance and Reality* (1893). Bradley thought that Green's concept of experience was far too intellectual, too abstract. He sought to solve the problem by posit-

ing layers of experience, beginning with "immediate experience," which he associated above all with "feeling." It is preconceptual, "seamless," "it is all one blur with differences, that work and are felt, but are not discriminated."[31] "Immediate experience" in the world is the ultimate starting point for philosophical inquiry: it is the basis for a developmental sequence which leads to "relational experience" and then "absolute experience." Thus, while immediate experience is broken up and analyzed in thought, it carries within itself the impulse toward its own transcendence: "The Absolute is one system, and ... its contents are nothing but sentient experience. It will hence be a single and all-inclusive experience, which embraces every partial diversity in concord."[32]

Bradley's account of an absolute, totalizing, authentic experience, which offered a passionate account of a world united by a single, all-encompassing spirit or mind, may strain a commonsense account of the term "experience." But it speaks to a desire to reinvest the world with metaphysical understanding, a desire to overcome a refusal to take the nature of reality for granted and, above all, a desire to overcome the worldview offered by the empiricist common sense and the empiricist disciplines, in which there are multiple individual experiences, and discrete kinds of experience. It flourished alongside Victorian cultural movements to reenchant the world with extra-empirical forces (spiritualism, occultism), and sparked in response newer, alternative philosophical accounts of "experience," including the "radical empiricism" that William James described in "A World of Pure Experience" (1904). James's late-life metaphysics involves a monist vision of something he terms "pure experience" which is the stuff of reality, both mental and physical: mental events and physical things are not intrinsically distinguished but are simply aggregates "cut out" from the stream of experience. Further, for James, "the same bit of pure experience that is a part of my mind is capable of being a part of someone else's mind as well, thereby rejecting solipsism from the start. Experience is not 'private.'"[33] In later sections of this chapter, we will see how clearly influential the idealist version of experience was for one woman writer's approach to the Brontës—May Sinclair. However, we should see the presence of the idealist account of experience—and the challenges that it spawned—as putting pressure on a range of Victorian writings about experience, from philosophy to literary criticism.

But the most astounding late Victorian monument to the meaning of experience was Shadworth Hollway Hodgson's massive, four volume *The Metaphysic of Experience*, published in 1898. "Currently all but completely forgotten," Hodgson was a quirky philosopher who devoted a lifetime to crafting an alternative to both British empiricism and idealism; his

proto-phenomenological approach to experience anticipated Bergson and Husserl.[34] A gentleman of independent means who never held an academic post, Hodgson was educated at Oxford, got married right after leaving the university, lost his wife and only child to illness three years later, and thereafter single-mindedly devoted the rest of his long life to the consolations of philosophy. He was one of the last serious professional, nonprofessional philosophers, a writer for whom philosophy was a branch of literature. He belonged to many of the important intellectual London circles of the day, was crucial to the early years of the journal *Mind*, and was a founder and first president of the Aristotelian Society.

Much of what we know about Hodgson as a person, and in particular about his struggles to analyze experience, emerged from his friendship with William James, whose own grappling with the topic developed in relation to Hodgson's. After reading *The Metaphysic of Experience*, James wrote to Hodgson: "if I ever hitch ahead positively at all in my own effort, it will now be thanks to the terms in which you have written."[35] We can, however, see some of Hodgson's goals emerge in an exchange relatively early in their friendship. In response to a letter in which James expresses his concern that Hodgson is always trying to eliminate "the Mind" as a unit of philosophical speculation, Hodgson responds energetically that "the Mind" as concept was already dead. "I found it *gone*, broken up by its inherent contradictions; and generating nothing but skepticism by its putrefaction." "This being so," he continued, "I resolved to base philosophy (no longer on an assumption but) on *experience* . . . my aim is not to get rid of mind as agent, but to replace it; to have a philosophy based, not on it, but on experience."[36]

Nevertheless, at times Hodgson positioned himself squarely within a native British, commonsense, empiricist philosophic tradition he calls "Experientialism" and describes as akin to scientific method. He maintained the urgency of the topic by appealing to national character, calling experience a "principle [which] has always specially recommended itself to Englishmen."[37] Toward the end of an 1885 lecture to The Aristotelian Society, he declared:

> Experience patiently watched and carefully analyzed is the only secure foundation for philosophy, just as it is the only foundation common to all observers . . . Experience alone can deliver us from the arbitrary, and the first form in which experience comes to us, the first body which any mass of experience assumes . . . is the shape of common sense, or experience of a world of common-sense objects.[38]

But even within this lecture, that "mass of experience," which takes the form of a knowable "body" in the phrase just quoted is, at times, much more

subjective, and akin to a boundaryless flow. Common sense objects "rise like an island out of a sea of nothingness, by consciously abstracting and isolating a concrete object from its context in the actually experienced stream of thought or consciousness."[39] Further, "the total panorama of real existence is conditioned, for the individual subject, by the way in which it is brought before him in his actual experience, that is to say, by a process of experiencing which is always going on during his lifetime, and is always incomplete, the past being always in the process of vanishing, and the future always in process of appearing."[40]

But in his massive *The Metaphysic of Experience*, Hodgson sought—in contrast to the idealists, for whom "experience" became more and more totalizing and comprehensive—to narrow down and focus the lens. Described to William James as his "constant companion for eighteen years,"[41] *The Metaphysic of Experience* sought to nudge the concept of "experience" toward something more subjective and phenomenological: "it is our experience of Being . . . this mass of feelings, perceptions, and thoughts . . . whereby we seem to exist as Persons in a world of Persons and Things, Actions and Events."[42] His careful process of isolating, narrowing down "experience," can be compared to the process of "bracketing" in phenomenology, excluding all extraneous considerations. But reducing it to the lowest common denominators, Hodgson defines experience through a simple equation: it is feeling + time. Time and feeling are the irreducible elements that are themselves indefinable: "time and feeling are ultimate elements in all consciousness and all experience; and as such are incapable of strict definition."[43] He continues:

> The lowest conceivable empirical moment of experience contains both time and feeling, and the lowest empirical moment in experience as it actually comes to us contains both sequence in time and difference in feeling. . . . We see, then, that time and feeling together are experience. They are elements of experience in inseparable relation with each other; and this is at once the simplest and most general of all the facts of experience.[44]

Even more precisely, the time of experience is the present moment:

> Whatever we are actually experiencing is always the content of a present moment of experience. . . . We have no actual experience which is not included in the content of the empirical present moment. . . . The term *actual* expresses the reality of the present content, when and while it is present in consciousness.[45]

In fact, in Hodgson's analysis, experience is truly present only as a momentary thickening as it is on its way past us. In his discussion of the relationship between experience and time, "the empirical present" is always carved up

into two sections, a part felt as coming or growing stronger, and a part felt as receding or growing fainter. Our actual experience of the empirical present is weighed toward the latter. Each moment of present experience is only really experienced insofar as it is immediately transferred into a "retained object," as what Hodgson called the "whatness" of a moment of experience occurring in real time is transitioned into its "thatness": the form in which it is grasped in retrospect. "How this all works is often disconcertingly vague," in the words of one commentator; but "at bottom Hodgson's point remains that we perceive the world not so much as it comes upon us but as it takes its leave from us."[46]

Indeed, as the bulk of *The Metaphysic of Experience* goes on to experiment with what gets included in, and excluded from, "actually present experience,"[47] you feel the fullness of experience slipping away, not "actually" existing, but existing, if at all, only on the thin pages of this thick book.[48] Hodgson's four-volume project of reconstructing the steps by which we experience experience is more than a little bit crazy. But the truth, of course, is that questions about whether experience feels like it is happening now or just past, or deferred to some future point—and whether it inheres in books, or in life—tend to feel like urgent questions to all bookish people, who may worry that their experience is highly mediated, displaced, or deferred. This was certainly, to be sure, true of my nerdy adolescent self, who sat in a library basement poring over books about—as it happens—the Brontë sisters, consciously waiting to grow up so I could have an actual life with actual experience.

The following sections of this chapter will take us from late nineteenth-century philosophies of experience to a body of literary writing in which the term looms large. In moving from the philosophical to the literary discussions of experience, I have sometimes wondered if I am comparing apples to oranges. But the concerns of philosophy, the concerns of literary writing, and the concerns of ordinary language are not that far apart: the uneasy slippages and shades of meaning of the term "experience" slide across all modes of writing. Shadworth Hodgson's account of the slipping away of "actually present experience," as I just suggested, is not exclusive to philosophers. The writers discussed in the following sections may be thought of as seeking solutions to the elusiveness and urgency of the concept.

The Brontës and Experience

In subsequent sections of this chapter, we will put one writer at the center of this investigation: May Sinclair. A super bookish person—poet, idealist

philosopher, and novelist—Sinclair, like Shadworth Hodgson, was deeply invested in finding a philosophical alternative to British empiricism, deeply invested in reevaluating "experience," *and* deeply invested in the Brontës. In fact, for Sinclair, as well as other Victorian and early twentieth-century women writers, engagement with the Brontës functioned as a forum for philosophical debates about experience.

But first, some crucial pieces of context are in order for explaining the extraordinary flourishing of Brontë-related writing by women in the last decades of the nineteenth century and the beginning of the twentieth, the particular patterns of this writing, and especially the prominence of the category of experience in it. It is not surprising that other genres of writing would serve women writers as vehicles for philosophical concerns. Philosophy—as a profession, an academic discipline, and a form of writing—presented Victorian women with considerable barriers. Even after the opening of the women's colleges at Oxford and Cambridge, relatively few British women had academic training in philosophy, and their entry into the teaching of philosophy, and into philosophy's professional associations such as the Aristotelian Society, lagged until the 1920s.[49]

By contrast, the literary tribute essay became, for women, a common entrée into professional writing.[50] The climate of the *fin de siècle* publishing industry—as it fervently embraced and expanded author love and literary celebrity—opened up a new vein of writing about the Brontës, which women writers turned to different accounts. For some, it was a way to participate in the women's suffrage movement, casting the Brontës as feminist figures who manifested in their work the values of women's equality, women's independence, women's "genius."[51] Late nineteenth-century Brontë writing was a transatlantic phenomenon, and it was a genre practiced by both men and women: Swinburne's writings about the Brontës, and later T. Wemyss Reid's and Clement Shorter's were crucial. But the wave of writing by women about the Brontës from the 1870s through the 1920s may be seen as a crucial prehistory to the 1970s and '80s feminist critical debates that I touched on in the Introduction to this study, and similarly, a writer's stance on feminism and the question of experience could go in several directions. The Brontës' narrow little lives at Haworth—and their extraordinary imaginative / literary / linguistic output—together represented an intriguing case against which to try the meaning of "experience." While Victorian writers' emphasis on whether the Brontës' writings reflected the sisters' own experience or not may strike us as a lame mode of doing literary criticism, it becomes much more interesting if we reframe it as women writers' way of doing philosophy.

Many writers followed in the footsteps of some of the Brontës' contemporaries by insisting that everything in their fiction derived from their experience. In his 1847 review of *Jane Eyre* in *Fraser's Magazine*, for example, George Henry Lewes curiously distinguished between "facts" and "experience": he asserted that the novel "*is* an autobiography,—not, perhaps, in the naked facts and circumstances, but in the actual suffering and experience."[52] Lewes's "facts" versus" experience distinction points to the unstable, differential nature of these terms, and reveals "experience" as a concept, not only highly fungible, but also as fundamentally a matter of feeling.[53] In the Brontë circles, the appeals to the claims of experience could be strategic. For example, in her preface to the second edition of *Wuthering Heights*, Charlotte defended Emily Brontë against critical charges of coarseness and vulgarity by claiming that Emily just wrote about what she experienced.[54]

It can be helpful to further clarify the fungibility of experience-talk in writings about the Brontës by looking at some comparison cases. In nineteenth-century *belles lettres*, it was not only the writings of the Brontës that were attributed to the author's experience. Byron, in particular, was viewed as a heroic, experience vacuum cleaner, and about *Don Juan* in particular, critics took for granted that "Byron in writing did but hold up the mirror to himself and his own experiences."[55] But in the case of Byron, one often feels writers suggesting that Byron engineered his experiences in order to then write about them; they harbor a very specifically Byronic idea of what experience is (adventure, suffering). In discourse about Jane Austen, by contrast, "experience" tends to emerge as an aesthetic derivative: Austen's writings seem so closely observed, so close to the ground, that they *must* have had their origin in her own experience. "In imagination, of all kinds" wrote an early reviewer, Austen "appears to have been extremely deficient; not only her stories are utterly and entirely devoid of invention, but her characters, her incidents, her sentiments, are obviously all drawn exclusively from experience."[56] That she wrote from experience is extrapolated from the commentator's sense of the real in her work.

In contrast to both the heroic-Byron-experience-discourse and the realism-Austen-experience-discourse, discussions of the place of experience in the life and works of the Brontës were much more volatile, varied, and at times, bizarre. Particular moments in the Brontës' lives became flashpoints for discussion. Did a sense of living shift from the mind (or books) to actual living, for example, when Charlotte and Emily finally left their home in the north of England, Haworth, for Belgium?

For many writers, Charlotte Brontë's "sojourn in Brussels"[57] was the moment when "experience," for Charlotte, transferred from the realm of books

and dreams to the realm of real life: it was, it often appears, like the transition from black and white to Technicolor. In Gaskell's words, "at length she was seeing somewhat of that grand old world of which she had dreamed."[58] In T. Wemyss Reid's, she was "gathering fresh experiences every day."[59] And from that point onward, in many accounts, Brussels was synonymous with "experience," and Charlotte's novels were, in the words of Laura C. Holloway, author of *An Hour with Charlotte Brontë; or, Flowers from a Yorkshire Moor* (1883) "a literal transcription of actual facts,"[60] "mainly delineations of actual experience."[61] This view of the sojourn in Brussels as flipping on the experience switch, and of Charlotte as an experience-transcriber, received extra oxygen in the early twentieth century, when the *Times* published (on July 29, 1913) four letters from Charlotte Brontë to her Brussels teacher Constantin Heger, which seemed to confirm the romantic nature of her feelings for him. The letters established definitively (claimed one of the nerdiest and Brussels-centric of the Edwardian Brontë-writers, Frederika Macdonald) that Charlotte was no inexperienced "school-girl, as some reckless modern impressionistic critics . . . would have us believe," but rather a grown woman who "underwent experiences and emotions, that were not transient feelings, nor sensational excitements."[62]

As Macdonald's language suggests, writers' emphasis on Charlotte Brontë's experience in Brussels clearly exploits the ways in which, for women, experience was often narrowed down to sexual experience. But the language of the critical accounts also features two phenomena that we are tracking. First, it is striking how frequently the phrase "actual experience" pops out of these accounts, as well as an unstable cluster of interlocking terms, as authors sometimes distinguished, for example, between the "actual" and the "real," sometimes treated them as synonymous. This cluster of terms is an area of overlap between the Brontë criticism and the philosophical debates. "Actual Experience," for example, is the title and mantra of a philosophical essay, written in the footsteps Shadworth Hodgson, by the Anglo-American idealist Edmund Montgomery (1899). A second notable feature is the way that writers, beginning with Gaskell, emphasize what we could call the texture of experience in their accounts of Brussels. The physical environs of the city are emphasized: it is crowded, deep, out of scale, thick. The environs of the Pensionnat Heger are richly textured, "filled up" with images, featuring trees "sweeping," things touching, and contoured with "shadow"s and "shade"s.[63] It is crowded with pageantry and incense, markets and colors, its streets were "decked with boughs and strewn with flowers," its windows "ablaze at night with jewels."[64] The implication is that this thickness provided the texture of

the novels. Charlotte, in this view, wrote novels that were, to borrow a phrase, "carpeted with experience."[65]

If the partisans of the "Brontës wrote about their own experience" school emphasized the rich textures of experience, members of the opposition—who stressed Brontë imagination over Brontë experience—evoked frictionless textures, or anti-textures. The poet A. Mary F. Robinson sought to stress the Brontës' imaginative transcendence over limited circumstance, first by casting them as experience-virgins. "So destitute of all experience were they," she marvels toward the beginning of her 1883 book;[66] and of Emily, she declares at the outset, "she is without experience."[67] However, Robinson modifies this position as her thesis develops, arguing not simply for Emily's inexperience but rather, that while *Wuthering Heights* did emerge from "her experience," her experience was, she cautions, "limited and perverse."[68] In this view of Emily's "purity," there is something genuinely perverse. It is not exactly that she had no experience, but that she was experience-resistant, an experience-repeller. Robinson describes it as:

> That purity as of polished steel, as cold and harder than ice, that freedom in dealing with love and hate, as audacious as an infant's love for the bright flame of fire, could only belong to one whose intensity of genius was rivalled by the narrowness of her experience—an experience limited not only by circumstances, but by a nature impervious to any fiercer sentiment than the natural love of home and her own people, beginning before remembrance and as unconscious as breathing.[69]

Robinson casts Emily's "experience" as limited, not only by circumstances, but by her "impervious nature." This is a metallic, subzero "purity" to whose polished surfaces no experience will stick. This pattern of imagery—in which a slick, smooth surface or edge is associated with the absence of experience—will appear again in the next two sections.

May Sinclair

While there are exceptions like Mary Robinson, for the most part Brontë-loving writers strove to emphasize that the Brontës could be claimed—even if only briefly—to have had experiences, and that those experiences were the kernel of their writing. In her essay on the Brontës, Margaret Oliphant pursued a "divide and conquer" strategy on the experience question: Charlotte Brontë had the experience of no experience. She described Charlotte as "having experienced in her own person and seen her nearest friends under

the experience, of that solitude and longing of women, of which she has made so remarkable an exposition," and further specified that nonexperience experience: "the long silence of life without an adventure or a change, the forlorn gaze out the windows."[70] That there is a quality of protesting too much in some of these accounts—"literal transcriptions" of experience!—is a symptom both of the Brontës' exceptional natures, and of the peculiar contours concerning discourses around experience and women. Writers who insisted on Brontë experience wrote out of a complex mix of literary, feminist, and philosophical motives. These motives remained in the background.

In contrast, May Sinclair's main goal, in her passionate, beautiful, book-length essay, *The Three Brontës*—the culmination of many decades of writing about them—is to demonstrate that the Brontës owed nothing to experience. Writing obsessively about the Brontës was for Sinclair—author of two philosophical treatises on idealism, and many philosophical essays—a way of doing philosophy by other means.[71]

Sinclair's commitment to philosophical writing was long-standing and deep; it began during her one year as a student at Cheltenham Ladies' College (1881–1882), where she was encouraged to read T. H. Green by the headmistress Dorothea Beale, and published essays on Descartes and Plato in the school's magazine. She went on to publish—in addition to the fiction for which she is best known—a philosophical dialogue in verse (1891); an essay on "The Ethical and Religious Import of Idealism" (1893); and two book-length studies, *A Defence of Idealism* (1917) and *The New Idealism* (1922).[72] Like many other late Victorian women whose interest in philosophy we have evidence of, Sinclair was and always remained an idealist. Although women were unlikely to have access to philosophical study, they did increasingly study languages and classics at the university level, and often absorbed an interest in philosophy that way. The study of German brought students closer to German idealism, while the study of the classics was infused with Platonism.[73] A rare figure of comparison for Sinclair is her near-contemporary Hilda Oakeley (1867–1950), who (unlike Sinclair) had the means to attend Somerville College, Oxford, and devoted a long career to teaching philosophy to women students on both sides of the Atlantic. When Oakeley arrived at Oxford in 1894, F. H. Bradley was the dominant figure; and Oakeley, like Sinclair, remained committed to idealism well into the twentieth century, even as British philosophy took its analytic turn under the influences of Bertrand Russell and G. E. Moore.[74] It could be argued that for women, pushed to the sidelines of institutional philosophy and thus relatively impervious to academic trends, idealism may have had an enduring appeal. Sinclair knew that there was something off-center about what she,

only half-jokingly, called "my devout adhesion to the Absolute."[75] She begins *A Defence of Idealism* by noting that the defender of idealism circa 1917 is not unlike a clueless party guest at risk of showing up at the wrong time: "you cannot be quite sure whether you are putting in an appearance too late or much too early."[76]

Sinclair's early essay, "The Ethical and Religious Import of Idealism," is an attempt to extend the work of T. H. Green. For Sinclair, as for Green, the key to ethics lies in the fact that the individual's will is tethered to a consciousness larger than his or her experience, narrowly construed. She begins this passage by dismissing the empiricist view of experience as nothing but "a flux of unmeaning sensations":

> It is obvious that the world of our experience presents itself to us, not as a flux of unmeaning sensations, but as a system of intelligible relations, the "infinite variety" of which cannot disguise from us its essential unity. That the many should be *related* implies that they are in some sort one. But such a unity in difference is only possible in and for thought ... The *individual* self cannot be the source and upholder of that order which, as revealed to his reason, stretches before and after, beyond the date of his favorite days, but a self-consciousness which is higher than his individuality is the key to his limited experience.[77]

For Sinclair, as for Green, ethics is derived from this metaphysical principle. It is crucial that humans are not determined by nature, but by "the system of intelligible relations" that make all experience "one."

One of the main goals of Sinclair's 1917 *A Defence of Idealism* is combatting what Theo Davis calls "the logic of possessive experience," according to which "you are what you've been through."[78] In her idiosyncratic book, Sinclair considers virtually all approaches to mind, existence, and experience—among them mysticism and panpsychism—circulating in Britain at the turn of the nineteenth century into the twentieth (except, notably, pragmatism, which she dismisses in her preface, hilariously, with this epigrammatic one-liner "It does not sterilize its instruments before it uses them"[79]). While, as one reviewer said, her "general conclusions are plainly intended to be in harmony with those of Mr. Bradley,"[80] one of the distinctive developments in Sinclair's theorization of experience in *A Defence of Idealism* is her early processing of the philosophical implications of psychoanalysis. A founder and board member of one of the first psychoanalytic institutions in London, the Medico-Psychological Clinic (1913–1922), Sinclair was deeply curious about psychoanalysis.[81] She found the psychoanalytic challenge to the Lockean notion that memory is the essence of personal identity to be compatible with the idealist conception that experience is bigger than the individual:

> The facts of multiple personality, telepathy, and suggestion, the higher as well as the lower forms of dream-consciousness, indicated that our psychic life is not a water-tight compartment, but has porous walls, and is continually threatened with leakage and the flooding in of many streams.... It may be that a self can only become a perfect self in proportion as it takes on the experiences of other selves.[82]

The accumulation of experiences across multiple selves and generations is evidence of an infinite spirit, one of which we merely partake. "I may say I do not know whether my experience is really mine, or whether I am simply part of an experience labelled mine for convenience' sake."[83] The "experience" that is not mine is both the Absolute, and a transfer to me of experience from absent others. Psychoanalysis and idealism have converged to create an account of experience as transpersonal and transferrable.

Sinclair's writings about the Brontës—the Introductions that she wrote for new Everyman editions of the novels (and of Gaskell's *Life*) between 1908 and 1914, her book-length study *The Three Brontës*, and her Brontë-inspired works of fiction—took place alongside her philosophical endeavors: the two pursuits—the Brontës and philosophy—are thoroughly intertwined. She was able to build on the discourses of experience in late nineteenth-century Brontë-talk, lifting the philosophical contours of the debates to the surface. She uses *The Three Brontës* to push back hard against an empiricist account of experience. "The artist must bring to his 'experience' as much as he takes from it," she notes, her ambivalence about the term indicated by the quotation marks.[84] Sinclair is contemptuous of Brontë interpreters who viewed the "sojourn in Brussels" as Charlotte and Emily's entry into experience,[85] or who suggested that they suffered something like experience in their dealings with Branwell Brontë.[86]

While Sinclair, at times, categorically describes Charlotte as having lived "a life singularly empty of 'experience,'"[87] she sometimes equivocated. She was willing to concede that Charlotte Brontë's "imagination waited to some extent upon experience."[88] The publication of the M. Héger letters, discussed earlier as extra oxygen for Charlotte's claims to experience, was a challenge for Sinclair. In the first, 1912 edition of *The Three Brontës*, which came out the year before the publication of the letters, she brushed off the idea that Brontë's relationship with M. Héger amounted to anything. In a letter to the *Times* shortly after their publication, Sinclair sounded a slightly chastened note: obviously, she suggests, I revise what I wrote in my book in light of the letters—but the experience the letters hint at, she hastens to add, is rare and inaccessible: "the tragedy and the passion are of a quality such as the average

man and woman cannot experience."[89] But by the time Sinclair prepared a second edition of *The Three Brontës* several months later, she had dug in her heels: in her preface to the new edition, she insisted that the M. Héger letters changed nothing.[90] Sinclair, moreover, sometimes swaps in—in order to acknowledge Charlotte's encounters with empirical realities—another term, the "actual." Arguing that in *Villette,* Charlotte Brontë achieved "positive actuality,"[91] Sinclair quotes Gaskell's account of that novel's opium description and glosses it this way: "to a mind like that the germ of the actual was enough. Charlotte Brontë's genius, in fact, was ardently impatient of the actual: it cared only for its own. At the least hint from experience it was off."[92] It seems that Charlotte's mind can do a brief touchdown, or drive-by encounter, with the actual, and then she is "off," like a racehorse out of the gate.

But Emily—Sinclair's favorite—was, in her view, an absolute experience-virgin: an experience-virgin in thrall to the Absolute. Sinclair echoes Mary Robinson in declaring that Emily was "a woman destitute of all emotional experience,"[93] but she punches it up and makes the claim into a polemic: Emily is a woman who "shows the emptiness, the impotence, the insignificance of all that we call 'experience,' beside the spirit that endures."[94] Sinclair's language about Emily—who was, in her words, "in love with the Absolute"[95]—is echoed in her self-description of her own philosophical fervor, her own "years of devotion to Mr. Bradley's Absolute."[96] Sinclair's identification of Emily as a fellow traveler may have received some additional fuel from persistent questions about whether Emily's study of German led her to read German philosophy.[97] Like many writers, Sinclair repeats an anecdote from Gaskell's *Life,* in which Emily studies German from a book propped up on the kitchen table as she kneads bread dough.[98] Emily Brontë is the ideal subject of Idealism (with a capital I), who captured "all the hunger and thirst after the 'Absolute'" (with a capital A), who had a direct line to the "Real" (with a capital R): "the incredible, unapparent harmony that flows above, beneath, and within the gross flux of appearances."[99]

A Distributed-Brontë Theory of Experience

In the next section, we will explore further Sinclair's philosophically driven quest to purge the Brontës' world of "the gross flux of appearances." However, I first want to point out that even experience-hating Brontë lovers, like Sinclair, sometimes cast the Brontës as sealed off from experience in order to produce something *like* experience through chains of vicarious living-through and writing-about the sisters. Writings about the Brontës

may, thus, be seen as pondering—much as Shadworth Hodgson's *Metaphysic of Experience* did—whether "actually present experience" is felt only in fleeting moments when experience seems to transfer from one domain to another. So, for example, Sinclair—who described Emily Brontë as "a woman destitute of all experience"—also argued, nevertheless, that the source of Charlotte's writing was not her own experience, but Emily's. While, as noted, Sinclair was contemptuous of critics who saw "Brussels" and "experience" as synonymous sources of Charlotte's work, she writes: "and yet an experience did *come to her* in that brief period"[100] (emphasis mine): it was Charlotte's experience of reading *Wuthering Heights*, and not her own personal experiences in Brussels, that jump-started her great novels.

Conversely, the Edwardian novelist Maude Goldring even suggested that *Emily* suffered a wholesale, unspoken transfer of *Charlotte*'s experience in Brussels to enter into herself, and onto the pages of *Wuthering Heights*:

> It is pleasant to picture Emily thrusting her manuscript into Charlotte's hand. Did she know or did she guess the extent of Charlotte's experiences? We know that Charlotte had laid it upon herself not to talk of M. Héger to Emily. Emily's powers as a seer were not small, but we cannot tell if she loved Charlotte well enough to be a diviner here. Be that as it may, Charlotte's emotions must indeed have been intense as she found her own ideas, so carefully withheld from the tame pages of *The Professor*, glowing in *Wuthering Heights*.[101]

While Goldring's assertion of feeling-transfer seems outlandish, it may help to note, that—like a surprising number of *fin-de-siecle* women writers—she was a devotee of the eccentric Victorian physician and mystic James Hinton, who she uses elsewhere in her book to gloss the transcendent "force" of Charlotte Brontë's life and work after her death: "James Hinton, a mystic thinker of our own day, has admirably expressed the secret of the decrees ruling Charlotte's fate ... to use Hinton's terms, the storing up of force is 'nutrition' that feeds others,"[102] or elsewhere, a "powder magazine."[103] In this view, Charlotte Brontë is an explosive device that can detonate in anyone, anytime.

But the person whose experience exploded throughout the Brontë family the most was, of course, Branwell's. Starting with Gaskell, many commentators sought to heighten the exceptional trauma visited on the Brontë sisters by the misbehavior, failures, addictions, and psychic turbulence of their brother Branwell Brontë. (Notably, Margaret Oliphant demurred from the consensus that Branwell was a colossal world-class loser; in her eyes he was merely a garden-variety specimen, with which she was lamentably well

acquainted.)[104] Branwell's experience made up, in this view, for his sister's inexperience. Mary Augusta Ward declared:

> There can be no question that Branwell's opium madness, his bouts of drunkenness at the Black Bull, his violence at home, his free and coarse talk, and his perpetual boast of guilty secrets, influenced the imagination of his wholly pure and inexperienced sisters. Much of "Wuthering Heights," and all of "Wildfell Hall," show Branwell's mark, and there are many passages in Charlotte's books also.[105]

While Mary Robinson rejected persistent rumors that Branwell was actually the author of *Wuthering Heights,* she quotes, approvingly, a lecture by T. Wemyss Reid:

> It was in in the enforced companionship of this lost and degraded man that Emily received, I am sure, many of the impressions which were subsequently conveyed to the pages of her book. Has it not been said over and over again by critics of every kind that "Wuthering Heights" reads like the dream of an opium-eater? And here we find that during the whole time of the writing of the book an habitual and avowed opium-eater was at Emily's elbow.[106]

If one of the puzzles for Elizabeth Gaskell was how Charlotte Brontë managed to simulate the experience of taking opium, through a complex process of experience transfer, in this ridiculous account of *Wuthering Heights*, Branwell spontaneously transfers his druggy experience to Emily by sitting at her elbow, not unlike Milton's Satan sitting like a noxious toad by innocent Eve's ear. Sinclair describes experience as a second-hand smoke, exhaled by Branwell and inhaled by Charlotte, in accounting for the transfer of Branwell-experience to Charlotte in *Jane Eyre*: "It was Branwell's experience, not Charlotte's. Branwell's experience, which hung about him like a poisonous atmosphere, and was all the air which his sisters' genius was allowed to breathe."[107]

Branwell Brontë's experience, in other words, was described as having a kind of miasmic, adhesive quality that allowed even commentators, committed to a Teflon-like Emily, to begin to articulate a kind of family-systems approach in which experience is transferred among the siblings. It is a person-to-person model of what Hodgson called "a connected chain of experience."[108] But all of these accounts of what I have come to think of as the "Distributed-Brontë Theory of Experience" challenge us to conceive of them on three levels. On one level, transfer-talk is a mode of emotional intensification; it heightens our sense of the intense forces of influence and

emotional connection among the Brontës. But on the second level, we are challenged to truly think about these accounts as experiments in theorizing experience that run adjacent to the postindividualist, idealist theories of experience articulated by Sinclair.

On a third level, however, we should think of these accounts of the family transfer of experience as expressions of the kind of optical illusion discussed in the Introduction to this study. That is, the imagery in Goldring, Reid, and Sinclair that has experience being inhaled, exhaled, and silently moving from one Brontë to another, might be seen, not as indicating a true belief in such an account of experience, but as a symptom of a shift of attention. Movement is happening, perhaps, among the Brontës—about whose relations we, of course, only have partial evidence—but certainly in the attentions of their readers as they shift from one Brontë to another, seeking a method of reading and writing about this heavy family.

Indeed, *reading* provided one template for describing the ways in which the Brontës related to and exchanged ideas amongst each other. Robinson called Branwell "a page in the book in which his sister studied."[109] Sinclair demurred, but in the process affirmed that reading *is* experience. Referring to Robinson by her married name, she comments, "but, when Mrs. Gaskell and Madame Duclaux invoked Branwell and all his vices to account for Charlotte's experience, they forgot that Charlotte had read Balzac, and that Balzac is an experience in himself."[110] The elimination of the gap between reading and experience will be discussed in the next section, as we return in detail to the ways in which Sinclair and others represented the Brontës' world.

Images of Haworth

We can see Sinclair's philosophically motivated drive to purge the Brontës' world of "the gross flux of appearances" in the descriptions of Haworth that grace the opening pages of her book *The Three Brontës*. It had become canonical for all nineteenth-century Brontë books to begin with a version of Gaskell's cinematic rendition in the *Life of Charlotte Brontë,* of a traveler's approach to Haworth parsonage—from the sweeping views of the bleak Yorkshire moors, up through the desolate town of Haworth, arriving at the even more desolate Haworth parsonage surrounded by the graveyard. Juliet Barker has demonstrated how populous and lively Victorian Haworth actually was, and in *The Brontë Myth,* Lucasta Miller writes persuasively about why Gaskell and other writers preferred the distorted image of Haworth as super isolated.[111] A Haworth erased of all people, both amplified the Brontës' achievements and absolved them from the charges of "roughness" lobbed at

their writing by some of their contemporaries. Sinclair's version, however, was hyperstripped-down:

> It is impossible to write of the three Brontës and forget the place they lived in, the black-grey, naked village, bristling like a rampart on the clean edge of the moor; the street, dark and steep as a gully, climbing the hill to the Parsonage at the top; the small oblong house, naked and grey, hemmed in on two sides by the graveyard, its five windows flush with the wall, staring at the graveyard where the tombstones, grey and naked, are set so close that the grass hardly grows between.[112]

This is the world of "appearances," limned down to an almost invisible ("grey," "naked") palette and pure geometry, as if almost nothing will stick to the "clean edge of the moor." It is all outlines and lines. In Sinclair's description of Haworth, the Teflon-like qualities that Mary Robinson attributed to Emily Brontë are projected onto the landscape, onto Brontë-land itself. The landscape described thus, is the embodiment of pure form, the ideal, whereas—in most writings about the Brontës from Gaskell onward—experience gets cast as color, fuzziness, heaviness, and thickness, something often akin to what another Brontë lover / experience-hater, Sylvia Townsend Warner, referred to as a "slab of experience, like a slab of pudding that had lain all night solidifying in the larder."[113]

Sinclair's description is of a piece with recurrent patterns of emphasis on lines, angles, and shapes in Haworth descriptions: the oblong shapes of the church and parsonage, the square garden, the rectangles of the graves. Writer and suffragette Bessie Parkes described Haworth as "a dreary, dreary place, literally *paved* with rainblacked tombstones, and all on the slope ... not a tree."[114] Parkes's "literally *paved*" suggests that part of what was unnerving about Haworth was a combination of its excess with its extreme parsimoniousness and its materials. Graves seem to do double duty as paving stones, and the shape that a tomb and a paving stone share comes to the fore. Many took note of a small detail from Gaskell's description of Haworth: that the paving stones of the steep main street "are placed end-ways"[115]: while, as in Parkes's description, the ostensibly vertical gravestones take on the horizontality of paving stones, the streets bristle with paving stones—normally set horizontally—that have been set vertically. Haworth seems resistant to anything warm and living: although the paving stones of the street have been set endwise to "give a better hold to the horses feet," the horses "seem to be in constant danger of slipping backwards."[116] Others hit the same geometrical notes: Haworth is "painfully steep"; the house is a "bare, stone, squarely-built house"; a "lone, grey square house" with a "square grass plot"; an "oblong"

churchyard.[117] The words "bare" and "naked" in these accounts are attached to the landscape, but implicitly to the lives of the Brontë family members. G. H. Lewes, we recall, distinguished between "naked facts" and "actual experience" in his account of the relationship between *Jane Eyre* and Charlotte Brontë's life.

However, the stripped-down, naked eye, bare facts emphasis of the descriptions of Haworth was always heavily layered and mediated, in particular inseparable from the depiction of Haworth parsonage on the title page of Gaskell's *Life of Charlotte Brontë* (see Figure 1). The wood engraving by the radical activist, writer, and wood-engraver W. J. Linton appeared on the title page of most Smith, Elder editions of Gaskell's *Life,* from the fourth edition of 1858 through the mid-1870s—where it was sometimes replaced with a less gothic image of Roe Head School—and into the first decade of the twentieth century.

May Sinclair focuses on the illustration on the title page:

> The title page was adorned with one bad wood-cut that showed a grim, plain house standing obliquely to a churchyard packed with tombstones, tombstones upright and flat, and slanting at all angles. In the foreground was a haycock, where the grave grass had been mown. I do not know how the artist, whose resources were of the slenderest, contrived to get his overwhelming but fascinating effect of moorland solitude, of black-grey nakedness and abiding gloom. But he certainly got it and gave it.[118]

Linton's illustration is, curiously for Sinclair, both a "bad" and an "overwhelming but fascinating" work of art. To me it seems neither particularly "bad," nor particularly "overwhelming and fascinating": one suspects Sinclair's reaction is overdetermined.

We may begin to understand Sinclair's reaction by noting that the young Virginia Woolf was also struck by this illustration: in her essay "Haworth, November 1904"—her first piece of writing ever to be accepted for publication—she moves seamlessly between what seems to be her own perceptions of Haworth during her visit there, and a description of the wood engraving:

> The old edition of the *Life* had on its title page a little print which struck the keynote of the book; it seemed to be all graves—gravestones stood ranked all round; you walked on a pavement lettered with dead names; the graves had solemnly invaded the garden of the parsonage itself, which was a little oasis of life in the midst of the dead. This is no exaggeration of the artist's, as we found; the stones seem to start out of the ground at you in tall, upright lines, like an army of silent soldiers.[119]

THE LIFE

OF

CHARLOTTE BRONTË,

AUTHOR OF

"JANE EYRE," "SHIRLEY," "VILLETTE," "THE PROFESSOR," &c.

BY

E. C. GASKELL,

AUTHOR OF "MARY BARTON," "RUTH," "NORTH AND SOUTH," ECT.

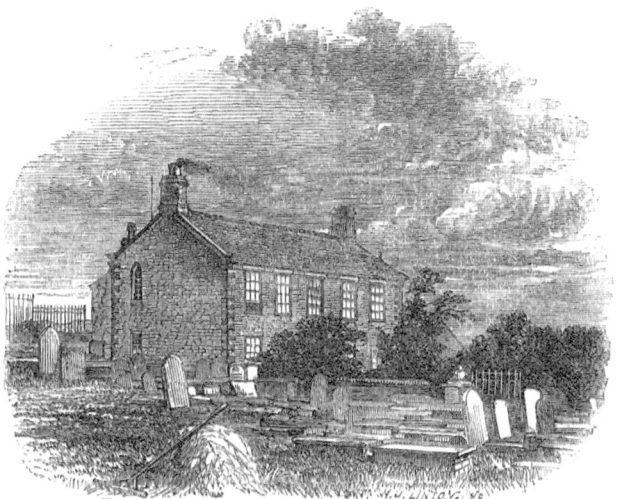

HAWORTH PARSONAGE.

LONDON:
SMITH, ELDER AND CO., 65, CORNHILL.

1858.

Figure 1. Title Page, Elizabeth Gaskell, *The Life of Charlotte Brontë* (1858)

In addition to interweaving description of the title-page picture and real observation, Woolf also breaks down the border between graveyard and garden, life and death, stones and humans. But above all, between the book and the landscape. There is, at Haworth, a claustrophobic ("narrow," "close" are the watchwords), concentric nesting sequence of the house, the beds, the coffins, the books, and then the minds of the Brontës. We have noted the repetitions of rectangles at Haworth—the tombs, the endways paving stones. For Sinclair, page and grave are melded, as well. In her "Introduction" to the 1908 Everyman edition of *The Life of Charlotte Brontë*, she dwells on one of the curious features of Gaskell's opening chapter, which ends with a page that reproduces the graves of all the Brontës in large font bold type, beginning with "HERE / LIE THE REMAINS OF / **MARIA BRONTË, WIFE.**"[120] Rectangles are nested into, and collapsed into, each other, as the oblong house contains the little narrow coffins of the dead little Brontës, and their tombstones are subsumed into the rectangular shape of the book, and their epitaphs into the book's language itself.[121]

For Sinclair and for others, I am suggesting that the fixation on the title-page image, and its demonstrable power to shape the views of Haworth, is connected to the trauma of reading *The Life of Charlotte Brontë*. Astonishingly for those of us who were twentieth-century children—for whom *Jane Eyre* was often the prepubescent gateway drug that hooked us on grown-up reading—Gaskell's biography was, according to Alice Meynell, often "put into the hands of a child, to whom *Jane Eyre* is allowed only in passages."[122] For Victorian children—particularly Victorian girls, Meynell claims—*The Life of Charlotte Brontë* was the primal scene of traumatic reading, which one only repeated with dread. To read it "again is to open once more a wound which most men perhaps, certainly most women, received into their hearts in childhood" In her "Introduction," Sinclair uses a similar language of trauma: "The passages which forced tears from you when you read them in your childhood are as unbearable, as unapproachable almost, now as then. You know that they are coming and you shrink from the pain."[123] She "could hardly bear" to read it as a child, and "there are pages in it that I shrink from approaching even now," she declared in 1912.[124]

In her account of her primal scene of reading, upon accidently stumbling upon *The Life of Charlotte Brontë* in her father's library as a child,[125] Sinclair suggests that the shock of the cover image caused her to flee into the inside of Gaskell's book, reading it without stopping ("I opened that book and read it through . . . I could not, in fact, put it down").[126] I am reminded of the young Elizabeth Bishop's flight into reading when she is shocked by the images in the *National Geographic* that she chances to pick up in "In the Waiting

Room." "I read it straight through. / / I was too shy to stop."[127] However, perhaps for the young Sinclair the fright goes the other way, from text to image. Bishop describes her child-self stemming the free fall of reading by carefully studying, with her "eyes glued" to it, the cover of the magazine: "And then I looked at the cover: / the yellow margins, the date."[128] That is, it seems equally plausible to suggest that Sinclair, Meynell, and Woolf—all little Victorian girls—fled from the "unbearable" "wound"'s (Meynell's words) inside *The Life of Charlotte Brontë*, to the title image: that the vividness of the title image serves as a cover (as it were) for the trauma of reading about the little Brontës' deaths.

With this in mind, we can return to what is distinctive in particular about Sinclair's account of Haworth: its emphasis on the play of straight edge versus texture. It seems especially interesting that she focuses on the haycock in Linton's image—that lump in the front—into which the "grave grass" has been mown and raked. Linton's wood engraving would seem to be based on a contemporaneous photograph of Haworth parsonage (see Figure 2). In late 1856 and early 1857, Gaskell's publishers, Smith and Elder, sent the photographer John Stewart north to Haworth to take some photos that might be seen as the basis for illustrations for *The Life of Charlotte Brontë*. The photographs he brought back, however, were initially deemed "unengravable"[129] and left out of the first three editions. It is unclear how, or why, Stewart's image of Haworth might be seen as "unengravable"—and it is also unclear

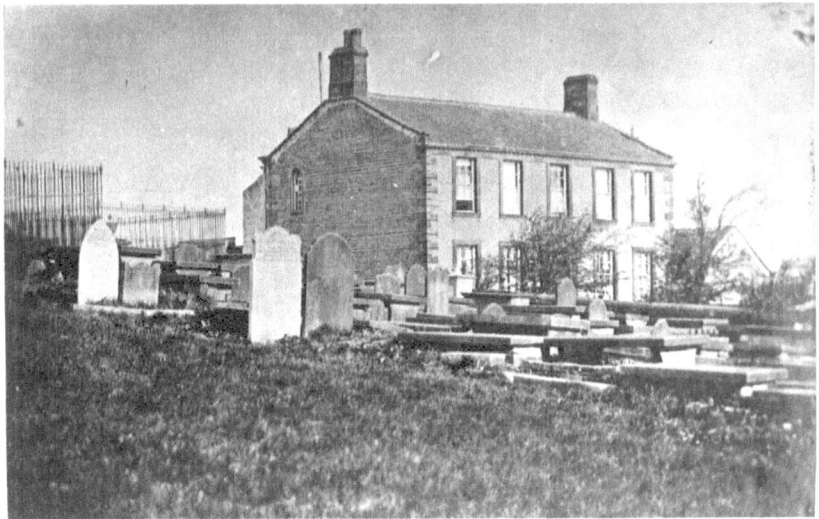

Figure 2. Photograph of Haworth parsonage (circa 1857)

whether the photo above is definitively by Stewart—especially as readers like Meynell, Sinclair, and Woolf soon found the engraved version unforgettable. But perhaps its extreme barrenness made it resistant to picturesque, engraved illustration tradition. The only change to the photo that Linton made was the addition of the haycock and rake in the front left of the image. It assimilates the image of Haworth into a pastoral, picturesque image tradition—specifically a southern, rather than a northern more barren one. The haycock not only adds the pastoral note, but also suggests that the unadorned lines of Haworth are an accomplishment, not a given: it is a well-mown graveyard, not a stark, barren place. Recall that in her opening description of the clean, Teflon-like surfaces of Haworth, to which no experience will stick, Sinclair said that the grass "hardly grows." Here, we seem to be seeing some of the bare, naked, experience-resistant nature of Haworth in the making: experience raked up into a shaggy lump.

It might not be too much to ask readers to think of Sinclair's interplay of sharp edge and texture as similar to what happens in another well-known text—one where, similarly, a northern landscape affords a traumatized child a way to manage feelings by focusing on the alternation of bareness and texture. This is one of Wordsworth's "spot of time" in *The Prelude* (written in 1804, first published in 1850) in which the poet remembers being lost on the moors as a child and stumbling upon the traces of the abandoned grave of a murderer. He flees, and the "visionary dreariness" of the images that follow take their intensity from the child's fear of death—that of the murderer who marks the spot, that of Wordsworth's mother, who died shortly before this episode. The peculiar vividness, in other words, marks the images as a "screen memory," Freud's term for especially vivid, yet seemingly arbitrary, memory-images that stand as substitutes for a trauma that does not wish to be remembered.[130] Wordsworth recalls:

> The grass is cleared away, and to this hour
> The characters are fresh and visible:
> A casual glance had shown them, and I fled,
> Faltering and faint, and ignorant of the road:
> Then, reascending the bare common, saw
> A naked pool that lay beneath the hills,
> The beacon on the summit, and, more near,
> A girl, who bore a pitcher on her head,
> And seemed with difficult steps to force her way
> Against the blowing wind. It was, in truth,
> An ordinary sight; but I should need

> Colours and words that are unknown to man,
> To paint the visionary dreariness
> Which, while I looked all round for my lost guide,
> Invested moorland waste and naked pool,
> The beacon crowning the lone eminence,
> The female and her garments vexed and tossed
> By the strong wind...[131]

The similarities of Wordsworth's "spot" to Sinclair's engraved Haworth include: the paring away of grass; the way that the imagery alternates bareness (bare, naked) with texture (the fluttering garments) as a defense against absorbing too much pain. That the managing of texture may be a childhood response to emotion might be further affirmed by a phrase from James Merrill's childhood memory poem, in which a table is a "tense oasis of green felt."[132] The "green *felt*" homonymically links texture and feeling, the table quarantines it in an oasis that is "tense." A green felt, a "carpet" of experience, a "slab" of experience, a shaggy haycock, all partake of an aesthetic pattern in which a texture is associated with experience and then cordoned off and replaced with a purer geometry of lines and forms.

Lest my reader be skeptical of the connections I am drawing here, between accounts of experience and a particular pattern of imagery: it is important to remember that Sinclair's description of the Haworth wood engraving occurs in her return to the concept of experience at the very end of *The Three Brontës*. Sinclair concludes her book by noting, first:

> There has been too much talk about experience. What the critic, the impressionist, of the Brontës needs is to recover, before all things, the innocence of the eye. No doubt we all had it once, and can remember more or less what it was like. To those who have lost it I would say: Go back and read again Mrs. Gaskell's *Life of Charlotte Brontë*.[133]

From there ensues her vivid account of stumbling across Gaskell's book—"a small shabby volume"—in her father's library as a child. The most "actually present experience" (Hodgson again) described in Sinclair's *The Three Brontës* is Sinclair's own first-person account of reading Elizabeth Gaskell's *The Life of Charlotte Brontë*. Sinclair claims that when she read Gaskell's *Life*, she "was in the grip of a reality more poignant than any that I had yet known.... There are pages in it that I shrink from approaching even now, because of the agony of realization they revive."[134] "All through" the book, she says, she found "an invisible, intangible presence, something mysterious, but omnipotently alive."[135] Through the medium of Gaskell's evocations of life at Haworth

parsonage, she experiences a total transfer of Brontë experience. "I knew every corner of that house," she declares.[136] Via Gaskell, Sinclair becomes the little Brontë sisters, but in this scene of reading Gaskell on Brontë, she also becomes the little Jane Eyre, sitting alone and poring over the woodcuts in Bewick's *History of British Birds*. Sinclair ends *The Three Brontës* by describing her first-person account of reading *The Life of Charlotte Brontë*—with its dense layers of reading and living, its swift relays of real and fictional first persons—as an "innocent impression."[137] But we are in the zone where an "innocent impression," or "the innocence of the eye," is indistinguishable from a thick, powerful experience.

To begin to sum up: through descriptions of Haworth, and in particular of the image of Haworth on the title page of Gaskell's *The Life of Charlotte Brontë*, May Sinclair ultimately offers an account of the truth of experience as something that is apprehended as texture, lodged in particular patterns of descriptive language that alternate between bareness and fuzziness. In implicitly attaching experience to language, she situates experience neither quite as empirical hard fact, nor as transcendent, nor as a temporal phenomenon to be either stockpiled or apprehended fleetingly. This is not to suggest that late nineteenth-century women's writing sidestepped the philosophical problem of how we define and make sense of "experience." They may also be reminders that a bigger picture of something as elusive as the concept of experience may emerge if we think literarily as well as philosophically. May Sinclair's philosophical writings, and her writings about the Brontës, as we have seen, must be read together.

But the writer who most explicitly deflects the question of experience onto language and style is Alice Meynell. In her 1896 review of Clement Shorter's *Charlotte Brontë and Her Circle*, and then in her longer essay "Charlotte and Emily Brontë" (originally published in *Dublin Review*, 1911), Meynell developed an idiosyncratic account of Charlotte and Emily as prose stylists. Emily she views, curiously, as an unadorned literalist whose prose is bereft of images:

> Emily was one who practiced little or no imagery. Her style had the key to an inner prose which seemed to leave imagery behind. . . . [She] seems to have a quite unparalleled unconsciousness of the delays, the charms, the pauses and preparations of imagery. Her strength does not dally with the parenthesis, and her simplicity is ignorant of those rites. Her lesser work, therefore, is plain narrative, and her greater work is no More.[138]

Meynell seems to imply that Emily's mind is both too low to the ground and too transcendent to "dally" with flourishes and figures of speech, which represent a kind of middle ground. "On the hither side—the daily side—of

imagery she is still a strong and solitary writer; on the yonder side she has written some of the most mysterious passages all in plain prose."[139] Equally curiously, Meynell develops an account of Charlotte Brontë's significance to literary history as consisting principally of her breakthroughs as a prose stylist. In Meynell's view, Charlotte single-handedly rescued English prose from the trough of mediocrity in which it had languished for much of the late eighteenth and early nineteenth centuries: since Edward Gibbon, she claims! Needless to say, this is a ludicrous claim (one that leaps over the gorgeous, unusual writing of the Romantic essayists: Lamb, De Quincey), and we may be tempted to view it as Meynell—the great, the consummate stylist—making over Brontë in her own image. But there is evidence that Meynell is strategically using her exaggerated claims about Brontë's style to flout critical commonplaces about Brontë experience. Marveling over Brontë's style against the background of dismal mid-nineteenth-century British prose, she announces, for example, that "it is less wonderful that she should have appeared out of such a parsonage than that she should have arisen out of such a language."[140] Meynell is both mocking Brontë experience-talk ("wonderful that . . . parsonage"), and putting it to rest.

In Meynell's account, Charlotte Brontë began by writing in the same shopworn phrases, the same stuffy Latinate diction as her contemporaries (Meynell's examples of Brontë's early, bad language include, for example, phrases like "for the toys he possesses he seems to have contracted a partiality amounting to affection"), until pure suffering knocked the bad language out of her, and knocked her into a new language. The Brontë passages that Meynell loves are the imagistic ones, but also the nonimaginable, the abstract, the dreamy. She cites a description of "nameless experience" from *Villette* ("a nameless experience that had the hue, the mien, the terror, the very tone of a visitation from eternity"). She makes a show of *not* citing a key passage from *Jane Eyre*; her noncitation is worth citing in full, because here is where Meynell most explicitly makes her argument about language and experience:

> Finally, is there any need to cite the passage of *Jane Eyre* that contains the avowal, the vigil in the garden? Those are not words to be forgotten. Some tell you that a fine style will give you the memory of a scene and not of the recording words that are the author's means. And others again would have the phrase to be remembered foremost. Here, then, in *Jane Eyre*, are both memories equal. The night is perceived, the phrase is an experience; both have their place in the reader's irrevocable past.[141]

We should stop to pause on the notably nonparallel construction of the phrase "the night is perceived, the phrase is an experience." Why not "the phrase is experienced"? Meynell's slightly awkward alternative isolates "experience" as

a thing, not a transitive verb: people perceive, but experiences exist. Moreover, she is boldly asserting that units of language—a "phrase" in a "fine style"—is not simply the delivery system for a scene or image but is itself a species of experience. That the actual phrase or phrases from *Jane Eyre* are occulted in Meynell's discussion serves to emphasize, further, that "the phrase" has become "pure experience." The words have simply become part of us, part of an "irrevocable" past. Meynell has cast experience as style, something that is not quite lived empirical reality, yet an irrevocable part of us.

Coda: Little Brontës

As this chapter has demonstrated, late nineteenth-century women writing about the Brontës spun accounts of the category of experience that both rivaled and solved some of the problems that riveted the philosophical discussions of the term. For Sinclair, Meynell, and others, the solution was to cast "experience" as inhering in language, style, and image-texture, which hover somewhere between lived reality, object of perception, and immaterial transcendence. It is a crucial dimension of Brontë-commenters' access to these insights about experience that they imagine themselves as child readers, traumatized by reading too young in Gaskell's *The Life of Charlotte Brontë* about the deaths of the little Brontës. There is an intense investment in imagining not just themselves, but also the Brontës, as vulnerable children. This imagining of the Brontës as vulnerable children is colored, of course, by the indelible images from the Brontë sisters' novels themselves: of the young Jane Eyre reading in her hiding place at Gateshead, the young Catherine Earnshaw scribbling out her woes in the margins of her book in *Wuthering Heights*. But the actual Brontë children—that is, when they were actually children—busied themselves imagining worlds featuring personages who were more grown-up than themselves. Their voluminous juvenile writings featured swashbuckling soldiers, dashing lovers, overbearing aristocrats, and imperial conquerors.

Beginning as early as ages ten and eleven, Charlotte and Branwell Brontë—and shortly afterward the younger siblings Emily and Anne, too—constructed over a hundred tiny books and "magazines," no bigger than the palm of an adult hand. Through these tiny writings, they opened up a huge, fantastic, invulnerable, private world. Scholars of the Brontë juvenilia have persuasively argued that the tiny scale of the writings accomplished two things simultaneously: first, it preserved the privacy and inviolability, the separateness from the real adult world, of the Brontë children's fantasy worlds. This seems, in other words, a case where some of the language with which

theorists of fictional worlds draw a strong barrier between the real world and the fictional world discussed in the Introduction to this study—what Thomas Pavel, in *Fictional Worlds*, calls "demarcational" features,[142] and what Bakhtin termed real life "set off by a sharp and categorical boundary from the represented world of the text"[143] seems remarkably apt. Second, the minimalism of the format was actually crucial to unleashing the vastness of scale of those fantasy worlds. The scale of the object and the scale of the power in and of the represented worlds were inversely linked, and that inversion was crucial to the psychological power of the writings for the children.[144]

Inequities of scale, vulnerability, and power are central to the earliest body of the Brontës' childhood writings from 1829 to 1832, when the children were all between nine and sixteen: the materials surrounding the invention of "Glass Town," an ever-morphing city / state / confederation of kingdoms imagined to be on the coast of, or islands off the coast of, western Africa (the Brontë children were enthusiastic Tory imperialists). There are *Gulliver's Travels*-like crazinesses of scale. For example, there is a huge, giant Genius who seems unimaginably large, but in the next sentence: "we looked round and saw a figure so tall that the Genius seemed to it but a diminutive dwarf."[145] Authorship, authority, and power were variously distributed. While Branwell and Charlotte wrote the texts, they were often narrated by a plural first person "we" internal to the adventures, a variety of aliases, and sometimes attributed to persons whose existence could be said to be both outside and inside the fictional world, such as Charlotte's favorite personage, the Duke of Wellington's son Charles Wellesley. The territories, moreover, were described sometimes as under the ultimate control of "the little kings and queens," sometimes as getting either protection or domination from four "Genii" who were versions of the four children: Tallii (Charlotte), Branii, Emmii, and Annii. The children were "both creators and characters in their plays."[146]

In the Brontë juvenilia, the vividness and separateness of fictional worlds is influenced by the working of the vicissitudes of parental power and childhood vulnerability into the themes and narrative structures. There are stories that imagine volatile family dynamics in the Duke of Wellington's relations with his two sons Charles and Arthur, who sometimes seem to morph from babies to young men in the space of a paragraph.[147] There is a story about the torture and abuse of a generic child (who is called, generically, "L'Enfant"!) who is first sent up a chimney, then stomped on the ground, who is lost and then joyfully found by his father. Both Charlotte *and* Branwell Brontë wrote their own overlapping versions of the story of "L'Enfant"; but at times they coauthored stories, and signed them "UT," for "us too."

Most interestingly, such vicissitudes of parent-child dynamics of love, solicitude, anxiety, resentment, and abuse sometimes take place across the divide that separates the real(ish) world of the child-Brontë narrators, and the fictional world narrated. For example, the remarkable "First Volume of the Tale of the Islanders" begins in the real world of Haworth as the Brontë children talk through their "play of the Islands," then documents the construction of the fictional world ("In June 1828 we erected school on a fictitious island, which was to contain a thousand children"), then abandons the real-world framing as it gets deeper into the fictional world, describing at length the island and the school. However, once the narrative goes down into a dungeon where the bad children are kept, Charlotte and Emily appear to have metaleptically crossed into the fictional world, as protectors of the children:

> These cells are dark, vaulted, arched, and so far down in the earth that the loudest shriek could not be heard by any inhabitant of the upper world; and ... the most unjust torturing might go on without any fear of detection, if it was not that I keep the key of the dungeon and Emily keeps the key of the cells, and the huge, strong iron entrances will brave any assault, except with the lawful instruments.[148]

They try to get the Duke of Wellington to be the children's "governor," but he will only assume this title as "an honorary distinction," as he writes to the Brontës in a letter—addressed "Little King and Queens (these are our titles)"—explaining that he cannot take on any more "subordinates."[149] The fictional children, however, do not remain free from harm under this arrangement: the Duke's two sons Arthur and Charles are put in charge of taking the children for walks. "They lead them into the most wildest and most dangerous parts of the country, leaping rocks, precipices, chasms, etc., and little caring whether the children go before or stop behind, and finally coming home with about a dozen wanting, who are found a few days after in hedges or ditches with legs or heads broken."[150]

Thus, although the Brontë children would seem (and of course really do have) omnipotent power over the fictive children, they do not protect them from harm, and open themselves up to charges of abuse and neglect. Most strikingly, moreover, the fictive vulnerable children—as well as, significantly, adult inhabitants of the fictional world who position themselves as children—write back to the real children in their role as adults. Branwell penned a notice in a Glass Town newspaper in the character of one of the inhabitants of Glass Town, protesting against treatment by the Genii. "A Few words to / The Chief Genii," it begins:

When a Parent leaves his children young and inexperienced. And without a cause absconds, never more troubling himself. About them those children according to received notions among men if they by good fortune should happen to survive. This neglect and b[e]come of repute in society are by no means bound, to believe that he has done his duty to them as a parent. Merely because they have risen. Nor are they indeed required to own or treat him as a parent. This is all very plain.

"And we believe that 4 of our readers will understand our aim in thus speaking," the writer, who signs himself "A child of the. G-ii"—concludes pointedly, addressing himself to the four Brontë children-as-Genii.[151] As Laura Forsberg points out, the Glass Towners are mouthing, here, a version of Lockean social contract theory.[152] But what is striking is the way that the parent-child dynamics serve as a model for the crossing of the divide between "real" and fictional, the imaginers and the imagined, as the Brontë children imagine fictional worlds and beings, and then imagine those fictional beings imagining them back, registering the comparative "existential vulnerability" of both real and imagined people.[153]

That Charlotte and Branwell's metafictional, metaleptical mode—in which they imagine the imagined figure imagining the imaginer—is overlayed with parent and child dynamics, with questions of vulnerability and power, has come to seem to me neither arbitrary nor accidental. Imagining each other imagining the other—and constructing fantasies that represent that mutual imagining—is a part of the way that parents and children relate to each other. Psychoanalyst Lucy LaFarge stresses that a fluid set of interlocking representations—in which parents and children imagine each other, and then imagine each other imagining each other—is crucial to the development of the "capacity to think and represent."[154] She identifies a constellation of fantasies that emerge in analysis, from both the patient and the analyst. The fantasies are, of course, highly variable and specific to each analytic pair, but she writes:

> Each of these fantasies includes a representation of the parent who imagines the inner world of the child; a representation of the child who communicates his experience for the parent to imagine; and a representation of the effect that the parent's imagining of the child's inner world has upon it.[155]

LaFarge puts this pattern of imagining and representation in the context of W. R. Bion's account of the transfers of experience between parent and child that I discussed in the Introduction to this study, which hypothesized that a person cannot really be said to experience their experience until it has

been transferred to another person. She notices, in some of her interactions with patients, that Bion's hypothesized, early pattern of experience-transfer between parent and child actually has a representational form; she calls these often shape-shifting, role-reversing representations "fantasies of the imaginer and the imagined."

We can use this concept to specify the formal features of the Brontë juvenilia. Scholars have argued that the representations of parent-child dynamics offered the young Brontës a way to overcome their own vulnerability[156] and that the metaleptic, metafictional play of the juvenilia offered Charlotte, in particular, a laboratory in which to learn the layers of fiction writing[157]—both things seem true. But it is precisely the conjunction of these two dimensions—the overlaying of parent-child relations with metaleptic crossings between narrative layers—that creates their psychological power. Dramas of parents and children, and shifting balances of power, animate the power and vividness of fictional worlds. The sandbag that shifts the heavy feeling of experience across the divide between real and fictional worlds gets tossed back and forth like a bean bag in the Brontë juvenilia.

There is evidence that, at times, the children's fictional world was the Brontës' true home, and that they themselves recognized the philosophical conundrums this posed. In Juliet Barker's view, Charlotte diagnosed Emily's homesickness during her brief times away from Haworth as, in fact, homesickness for the fictional worlds without which she could not live. "Nobody knew what ailed her but me—I knew only too well."[158] This was because Charlotte similarly felt the enduring pull of what she described in a letter to Branwell, written from Brussels, as the pull of "the world below" when—according to Gaskell and many of the later nineteenth-century Brontë writers—real experience started. "It is a curious metaphysical fact," she wrote to Branwell in 1843, "that always in the evening when I am in the great Dormitory alone—having no other company than a number of beds with white curtains I always recur as fanatically as ever to the old ideas, the old faces, & the old scenes in the world below."[159] The images and rhythms of Charlotte's letter—the fluttering curtains, the triplet "old faces," "old ideas," "old scenes," are clearly echoes of Tennyson's 1830 poem "Mariana," which she knew well:

> Old faces glimmer'd thro' the doors
> Old footsteps trod the open floors,
> Old voices called her from without.[160]

"Mariana" is a poem about being trapped in one world, remembering another. It is curious that Charlotte Brontë regarded her "fanatical" attachment

to the old scenes as a "curious metaphysical fact" (rather than, say, an emotional or psychological one). With this "metaphysical fact," she recognized that the childhood imagining of imagining adults entailed a compelling case of how displacements of experience can produce a sense of an ontologically distinct realm, more real and vivid than life.

At the end of her essay on the Brontës' lives and works, Margaret Oliphant deplores the ways in which the Brontës had become, in her words, "the first victims of that ruthless art of biography which is one of the features of our time," as each available detail of their experience is pinned down as a source of the work.[161] Oliphant argues that there is only one thing that can stave off a writer's vulnerability to the mixing up of her life and work: the existence of actual children. She insinuates that Elizabeth Gaskell cleverly insulated herself from the fate of the Brontës in this regard, by having children: "Mrs. Gaskell, wise woman, defended herself from a similar treatment by will, and left children behind her to protect her memory."[162] The world's childless writers—the Brontës, the Carlyles—have no one "to rise up in their defense."[163] It is an irony, she notes—a "curious pathos"—that this situation sheds "a not unsuitably tragic light upon a life always so solitary that this [endless biographical speculation] should all have passed in silence because there was *actually no one to interfere*."[164] All the experience-talk surrounding the Brontës, she is suggesting, ran rampant because "there was actually no one" on the ground "to interfere." But there is also a "curious pathos" in Margaret Oliphant's belief that having actual children could protect one from interference, short-circuiting the promiscuous circulation of one's experience. The way that children—real or imagined, present or absent—might stabilize the borders between life and writing will be at the center of my next two chapters.

2. The Story of O: Margaret Oliphant and Anti-metalepsis

Introduction

Chapter One traveled through late nineteenth-century British writings, some by philosophers, some by devotees of the Brontë sisters, that—read together—suggested that the contours of defining "experience" emerged most vividly in accounts of moments of life when experience seems to get displaced: from one moment in time to another, from one person to another, from one world—say, a fictional world—to another. This chapter and the next will investigate these spatial and temporal transfers of experience as they were given shape through two of the formal features of Victorian fiction: metalepsis and prolepsis.

Metalepsis—the name for moments in fiction when persons seem to cross over the ontological divide separating the real world and a storyworld—may prove to be a helpful concept for talking about the concerns of this book: transfers of experience, shifts of gravity across boundaries. As we noted in Chapter One, in their juvenile, collaborative writing, the young Brontës used metaleptic crossings between the insides and outsides of their storyworlds in order to gauge where the center of gravity might lie. Metalepsis may allow us to reopen a number of issues, such as the relationship between an author's experience and a realist fictional text. We no longer tend to treat the nineteenth-century novel as a kind of experience-dump, the way that some later nineteenth-century readers treated the Brontës' books. That approach to the Brontës' fiction—any fiction—may seem impossibly lame to us. But we also tend to feel that there is an impossibly irrefutable common sense in acknowledging that there is a crossing-over between an author's experience and their fiction. The concept of metalepsis—etymologically to "jump across"—can help us rehabilitate and complicate this feeling. That metalepsis

is a feeling—rather than a clearly defined formal technique—is one of the burdens of this chapter. In both this chapter and the next I delineate how both the crossing of narrative levels and attempts to theorize them come to bear, in the words of Kent Puckett, "big, messy emotional questions":

> Narrative theory's broad commitment to understanding the play between levels of story and discourse appears not simply as a local methodological innovation but rather as an effort to engage ... with some of the key problems of modern life (Puckett, *Narrative Theory*, 18).

One of the "key problems" that metalepsis can be seen as addressing is, I suggest, the painful circumstances under which experience comes to be felt as such.

Defined by Gerard Genette in the 1970s, metalepsis used to be associated with the metafictional, self-conscious frame breaking of postmodern fictions and their eighteenth-century precursors by Fielding and Sterne. It seemed fundamentally anti-mimetic in nature, yanking readers out from their temporary belief in a fictional world.[1] Here (for example) is a real-world critic helping Tristram Shandy get his father and uncle to bed! However, recently some scholars of the nineteenth century have affirmed that metalepsis can, in fact, function to deepen fiction's reality effects. This is Monika Fludernik's position on George Eliot's metalepses—as when, for example, the narrator of *Adam Bede* acts as if she and the reader are in the same space as the book's characters: "Let me take you into the dining-room, and show you the Rev. Adolphus Irwine. . . . We will enter very softly, and stand still in the open doorway, without awakening the glossy-brown setter who is stretched across the hearth."[2] Fludernik notes that in instances such as this one, we experience, not a breaking of illusion, but rather:

> an enhancement of sympathetic effect ... deepening the reader's involvement in the fiction rather than disrupting immersion ... the strategy succeeds in authenticating the reality of the fictional world, transforming the invented events of the novel into the supposed factuality of the narrator's personal past. The logical contradiction this entails fails to bother the reader, whose willing suspension of disbelief has made such strides that it reinterprets this logical irritation as a corroboration of the credibility of the narrator persona.[3]

Elaine Freedgood takes a more radical approach, using a broad redefinition of metalepsis that encompasses all appearances of properly named locations of the real world in the fictional world: Daniel Deronda rows on the Thames; Sherlock Holmes lives on Baker Street.[4] From this point of view,

nineteenth-century realism is threaded through with metalepsis, composed at its essence of this kind of "hetero-ontologicality," as she terms the overlays of real and fictional worlds:

> It is precisely [nineteenth-century realist fiction's] connectedness to the real that makes realist fiction perhaps the most fundamentally ruptured fiction we have . . . that such ruptures do not feel like ruptures may be the most significant thing about them.[5]

Realism, in this view, does its work to the extent that we have naturalized its fundamentally metaleptic nature.

As the examples of Fludernik and Freedgood should suggest, one of the challenges of thinking about metalepsis is that critics are now using the term in wildly different ways, as a narrow(ish) narratorial trick, or as a fundamental aspect of reference. In the field of narratology alone, there has been—since Gerard Genette first introduced the term—a dizzying division of the terrain into subspecies of metalepsis. Along one axis there is, for example, "authorial metalepsis," in which an author seems to fall into his or her own text. Genette's example is, "Virgil has Dido die"; at the other end of this line is "reader's metalepsis": a reader's feeling of falling into the text.[6] This is, after all, what an immersive reading experience almost always feels like. We live in a novel, we live with its characters, we wish to be able to address them. Diderot writes of the people in Samuel Richardson's *Clarissa*, "we take part in their conversations, we approve, we blame, we admire, we become angry or indignant." "How many times," he continues, "have I not found myself exclaiming, as children sometimes do when they are taken to the theatre for the first time, 'Don't believe him, he's deceiving you! If you go with him, you're lost!'"[7] Metalepsis has been described as either descending (as when an author or narrator seems to descend a level in order to enter the fictional world) or ascending (as when a character seems to leap up into the real world).[8] Ontological metalepsis—in which entities genuinely bring their ontological essence into alien territory—has been distinguished from a mere "rhetorical metalepsis," in which ontologically discrete entities seem, instead, to merely call to each other across the divide.[9]

This diversity of species and approaches can however suggest, intriguingly, that there is a range of ways of redefining realism from the point of view of metalepsis. Doing so fundamentally alters the way that we think about the relationship between the real world and the fictional world: not as a relation of reference or mimesis, but as a species of transfer. In this view, life, rather than being reflected in the mirror, crosses over to the other side, like Alice stepping through the looking glass. This view allows us to analyze aspects of

realism that mimesis cannot capture—not only the feeling of crossing that accompanies the reading of realist fiction, but also fiction's aura of ontological lability. For example, Bell and Albers invite us to think about the experience of metalepsis in terms borrowed from possible worlds philosophy and do what they call a "cognitive reconstruction" of metaleptic "jumps." Would it be possible, they ask, to describe what happens in metalepsis as a version of Saul Kripke's understanding of an individual's "transworld identity"—his or her ability to travel to a potentially infinite number of possible ontological domains?[10] Another way to mobilize the concept of metalepsis to approach the ontological lability and psychological peculiarity of realist fiction would be to link it, as Freedgood does, to the experience of transference in psychoanalysis. The analyst seems to cross the boundary between the real world of her office and enter the world of your family, fantasies, and memories; patient and analyst are in both worlds at once. Freedgood muses: "You then operate as a fictionalized character in a world that is the same or structurally very similar to the one you live in"; "you gain a kind of diegetic mobility in these practices; you are living in both your own diegetic space and in fictional space at the same time."[11]

You are, and yet you are not. You feel the tug of transferring your experience from one place to another, but you know you cannot. To dwell in metalepsis is, as Richard Walsh suggests, to strain against "the iron law of non-contradiction."[12] Metalepsis has always been associated with both desire and prohibition. Insofar as the older body of scholarship on metalepsis viewed it as a violation of the rules of realism, it often seemed akin to violence.[13] Genette's primary examples often featured violence of a gendered, sexualized kind, as the author reached in to mess with his (always his) characters: "Virgil has Dido die in Book IV of *The Aeneid*," but also from Diderot's *Jacques le Fataliste*: "who would prevent me from marrying off the master and cuckolding him?"[14]

In this chapter, we will see a nineteenth-century realist writer also mobilizing a prohibition against metalepsis, but in a very different way: not as an occasional eruption of a transgression against the laws of fiction, but as a desire that is ever present, and often stoically refrained from. Metalepsis is better conceived as an emotional pressure that manifests itself as much in its prohibition as in its instantiation.[15] I will argue that metalepsis can be tangled up with feelings of protection and care for another person, but also with the feelings of the limits of one's ability to care. I will arrive at this thesis via a circuitous route that will seem to leave metalepsis behind for a while. My route goes through the writing of Margaret Oliphant. No one was more attuned to, and more sophisticated in her thinking about, the relationship

between writing and the painful inability to protect the ones that you love. My chosen texts will be Oliphant's *Autobiography*, passages from her fiction, her literary criticism, and her speculative essays. In them, Oliphant meditates on the impossibility of being able to truly intervene in the lives of loved ones; in in her literary criticism, she articulates a compelling account of a similarly deadly combination of desire, relation, and prohibition as subtending between authors and readers, and fictional persons.

My methodology responds to the patterns and family resemblances among Oliphant's linguistic self-fashionings in her many modes of writing, both fictional and nonfictional. It responds, as well, to the sheer volume of her prose. Oliphant was one of the most prolific writers of the Victorian era, publishing over ninety novels, as well as scores of stories and essays. Distant reading—sampling of words and sounds gathered with a concordancing computer program—are integrated with close as well as middle-ground readings of Oliphant's plots.

The Story of O

"I was reading of Charlotte Brontë the other day, and could not help comparing myself with the picture more or less as I read. I don't suppose my powers are equal to hers—my work to myself looks perfectly pale and colourless beside hers—but yet I have had far more experience."[16] In her autobiography, Oliphant repeatedly admits that she is no Brontë, and no George Eliot: but what she is, however, is the novelist of experience. Oliphant thought constantly about the relationship between writers and their work.[17] On the one hand, she was mystified by what seemed to her a huge gap between the life of George Eliot (who she viewed as having lived "in a mental greenhouse") and her novels;[18] on the other hand, she was "astonished...beyond measure" at Trollope's ways of talking about his fictional characters as if they were real people.[19] The former seemed to have cordoned off her life—which from Oliphant's perspective seemed like that of a hothouse flower, excessively and exclusively cerebral, and buffered from real life by the constant care of G. H. Lewes—from her fiction; the latter seemed promiscuously, blithely, to ignore the difference between the persons of real life and of fiction. (In a characteristic moment in his *Autobiography*, Trollope describes his tendency to reuse his characters the way that an introvert describes their reluctance to make new friends: "I . . . found myself so frequently allured back to my old friends. . . . I got round me a circle of persons."[20]) Oliphant's invidious comparisons of herself to Brontë, Eliot, and Trollope are painful to read, by turns searingly self-critical, self-justifying, and self-aware. But she comes

back, again and again, to the idea that the presence of real people in her own life—people to whom she felt often crushingly bound, in particular her children—has made her unable to treat fiction (especially her own) as real. Oliphant's astonishment at Trollope's way of talking about his characters as loved ones was matched by her befuddlement at the comparative absence of Trollope's actual children from his own *Autobiography*. Here is Oliphant in a passage that does not mention Trollope by name, although he is clearly one of the "some people" that she is talking about:

> Perhaps my life has been too full of personal interests to leave me at leisure to talk of the creatures of my imagination, as some people do, or to make believe that they were more to me in writing than they might have been in reading—that is, my own stories in the making of them were very much what other people's stories . . . were in the reading. I am no more interested in my own characters than I am in Jeanie Deans, and do not remember them half so well, nor do they come back to me with the same steady interest and friendship.[21]

There are creations, and then there are creatures, Oliphant seems to be saying: I know who my real children are.[22]

The sad truth about Oliphant's *Autobiography*, however, is that it is a story of dead children and live books. Written in fragments at moments spanning three decades (from the early 1860s to 1895), the *Autobiography*, as we know it today, alternates retrospective narration of Oliphant's life and career with present-tense outpourings of raw grief at the deaths of three of her children.[23] For example, the opening pages take us straight into a harrowing account of a turning point in her career, when, as a young widow, she was turned away by the Blackwood brothers for some bad writing, walked home in tears, and then pulled herself together and started writing her best novels, *The Chronicles of Carlingford* series. But, into this memory of authorial triumph erupts (in the present time of writing) the death of the writer's beloved ten-year-old daughter Maggie. The passage quoted at the top of this section—about contrasting her experience and Charlotte Brontë's—falls directly after an outpouring of grief about Maggie. Another example: toward the end of the *Autobiography*, as she is writing her memories of her children in their younger years, Oliphant shocks the reader by informing them that her last son's corpse is lying in the next room, even as she writes: "while I write, October 5, 1894, he, the last, is lying in his coffin in the room next to me—I have been trying to pray by the side of that last bed—and he looks more beautiful than ever he did in his life."[24]

Oliphant represents herself as working ceaselessly and furiously to support her changing cast of dependents, only to feel, to her horror, that her own

energy and vitality seems to be vampirically sucking the life out of them, rather than sustaining them. Before starting her *Autobiography*, she had already buried several children who died in infancy, as well as her husband who died of tuberculosis in Rome, leaving her with two young children and pregnant with a third. Its writing narrates, in real time, the deaths of three of her children—not only Maggie, but also her two sons, who led lives as feckless loiterers before dying in their thirties—as well as the deaths of her two hapless, dependent brothers and a nephew whom she had adopted. Oliphant describes herself as having "a spirit almost criminally elastic,"[25] and genuinely feared that she was unperishable. "All this misery does not give me even a headache," she despaired: "I neither eat nor sleep for days together and I am as well at the end of them as at the beginning. What is to become of me, shall I never die?"[26] She wondered if she was "a sort of machine, so little out of order, able to endure all things, always fit for work whatever has happened to me."[27] Right up until shortly before her final illness, she wrote so much that she "worked a hole" into her finger with her pen. In a letter from 1896, apropos of nothing in particular, she observes with detachment: "I have worked a hole in my right forefinger—with the pen I suppose!—and can't get it to heal,—also from excessive use of that little implement."[28]

In spite of Oliphant's representation of her superhuman strength, however, in the pages of the *Autobiography* she appears raw to pain: the hole never heals. Her ability to work through calamity seems to kill, rather than sustain, everything around her. The specter of a connection between maternal work and the death of children appears to be confirmed for Oliphant when she meets the translator and children's book author Mary Howitt—"Who," she says,

> frightened me very much, I remember, by telling me of many babies whom she had lost through some defective valve in the heart, which she said was somehow connected with too much mental work on the part of the mother.[29]

"A foolish thing, I should think," follows up Oliphant, but then she adds, "yet the same thing occurred twice to myself"—presumably in relation to two of the three of her own children who died in infancy. But Oliphant's most painful self-lacerations occur in relation to the pathetic lives, and adult deaths, of her two sons. In spite of (or because of: that is the question) everything that their mother did on their behalf—moving to Windsor so that she could have them educated at Eton yet still have them live with her, lobbying her friends to give them work—neither son ever achieved even a speck of financial or personal independence.

Oliphant loved them desperately and suffered endless anxiety on their behalf. Most painfully, she agonized about whether she had made things too

easy for them, had interfered too much in their lives. "I have done everything for my boys—I have been very faulty in their education, but what was wrong was done in love, and not wrongly meant."[30] And yet, had she not provided everything for them, she laments, "they might have learned habits of work which now seem beyond recall."[31] She knows that other people thought that she had spoiled them: "They say," she frets, "that I have been foolish in my treatment of them. One cruel man the other day told me that I had ruined my family by my indulgence and extravagance."[32] But, she confesses, "it was a kind of forlorn pleasure to me that they had never wanted anything, but this turns it into a remorse."[33] At one of her lowest moments, she suggests that it would have made no difference, given how little the two boys' lives amounted to, had they died as children: "how very, very little difference would it have made ... it would all have ended so much sooner—whereas there has been between [that is, between the time of her husband's death, and the deaths of the two sons] nearly thirty-five years of warfare and hard labor and this is the end."[34]

Oliphant gives occasional glimpses of what the level of tension in the house with the two thirty-something sons must have been like, and also how the sons themselves experienced their mother's controlling love. For example, there is an episode toward the end of the alcoholic older son Tiddy's life when he is temporarily housebound, delirious with fever. Oliphant reports her expression of fear of him dying, and then, remarkably, reports Tiddy's cruelly accurate response: "No," he says to his mother, "I'll tell you what you are afraid of. You are afraid of the time when the doctor will say I may go out again."[35] Tiddy knew that, more terrifying to his mother than Tiddy unwell, was Tiddy well and able to go out at all hours of the night, and Oliphant feared that the boys were better off dead than failing. At the same time, as her biographer Elisabeth Jay notes, as long as they lived, there was at least the fiction of an alternative future: "Whilst her sons were still alive her capacity to hypothesize an alternative future, in which they would be neither drunk nor disagreeable, had held her life together, but their death had rendered this an impossible fiction."[36] Oliphant knew, as she wrote of one of her fictional characters, "what it was ... to have lost ... ideal children."[37]

"No One to Interfere"

Once her sons were dead, Oliphant thought long and hard about the possibilities of effective intervention in other peoples' lives, and about whether things could have been otherwise. She meditated on whether relations between parents and children are stabilized when there is someone to inter-

fere or when, as she wrote in the essay on the Brontës with which I ended Chapter One, there is "actually no one to interfere." Nowhere is this more moving than in her highly autobiographical essay "The Fancies of a Believer," begun in the shadow of her last son's death.[38] In this long, loopy, beautiful essay, Oliphant seeks to demonstrate that even within orthodox Christianity, there is ample room for the devout to speculate on matters that remain fundamentally mysterious. You could say that "The Fancies of a Believer" is Oliphant's way of looking back, at the century's end, at Victorian-era debates about faith, doubt, and science. But it is also a continuation of the *Autobiography* in a new, more imaginative mode of writing. She imagines worlds on stars![39] She imagines our world as an experiment in some bigger world: "Is this world, then, a great, a wonderful experiment among the worlds?"[40] This cosmic widening of the frame is a way of thinking about whether there are others looking after us, or whether we are on our own. Oliphant comes down, in this essay, on the side of God's "noninterference"[41] and the human's own self-determination. Our own world is "a world of which will is the prevailing characteristic, a world of individual souls all distinguished by the power of choice, of contradiction, of decision for themselves."[42] We cannot force any other soul's free will.

Oliphant illustrates her position on the ineluctability of the will with the following argument, one whose affiliations with some of the material in the *Autobiography* is devastatingly clear:

> We are moved alike by these two things: they are, one the impossibility of securing that those whom we love should choose, as we hope we have done, the worthier way; and the other, and to some the more terrible, as more evidently beyond their power to affect one way or other—the impossibility of securing the lives of those we love, or of saving them from being suddenly seized and hurried away from us by the irrevocable and incurable separation of death.[43]

We are "moved alike" by these two things, Oliphant asserts: our inability to prevent a loved one from choosing the wrong path in life, and our inability to prevent them from dying, are equally awful. Before we go on to see what she says next about this, it is worth pausing to note that this kind of "which is worse" thinking, particularly with regard to her children, happens frequently in the *Autobiography*. In the full force of her grief at ten-year-old Maggie's death, she tries to persuade herself that she probably would have "lost" Maggie—to marriage—within the next ten years anyway, and tries to reason that maternal loss and self-sacrifice are roughly the same, whether occasioned by death or marriage:

Had she lived to be married or to sustain any of the great changes of life I must, when the time had come, have stood back and refrained from interfering with her happiness even if to do so had made an end of my own. Early, very early, and more absolutely than would have been possible had she lived, *the same sacrifice has been demanded of me* (emphasis mine).[44]

In Oliphant's novel *The Marriage of Elinor,* after Elinor has made her horrible marriage, Mrs. Dennistown comments: "this separation by marriage was dreadfully like the dreary separation by death, and in one respect it was almost worse; for death ... takes away at least the gnawing pangs of anxiety. He or she who is gone that way is well; never more can trouble touch them; their feet cannot err."[45] In the *Autobiography*, Oliphant argues that the sacrifice would have been the same, whether a daughter dies or gets married, and equally—and this is also relevant to "The Fancies of a Believer"—Oliphant must have "refrained from interfering."

In *both* the *Autobiography* and "The Fancies of a Believer," in other words, Oliphant's theme is the same: the sad inability or restraint—whether imposed by our own selves, or by a higher being—that limits our ability to rescue others. In the essay, her reasoning often seems weird and twisted. For example, the passage from the essay quoted above continues: "To some it is the first of these two miseries [inability to prevent a loved from falling off the right path] which appears the greater, perhaps because they have not experienced the other [the inability to prevent death]." So far so good. We expect that Oliphant's point is that once we have experienced our helplessness before death, nothing will ever seem as bad. However, Oliphant reveals that it is our inability to prevent failure that is her true subject. Here is how she continues:

> And it [the former misery—preventing failure] is the most unaccountable. In these days we think a great deal of education, and many suppose that all faults are to be cured and all evil inclinations subdued by that. But education does not change the will nor bring the offender into the right way.[46]

It does not take rocket science to infer that Oliphant is writing about her sons. She knows from experience the cycles of despair and hope that she summarizes in this passage:

> He whom we love most has taken perhaps the downward path. The next we may hear of him may be something worse than death. Shame may come, horror may come, sudden and dreadful catastrophe; but, ah the difference! Hope too may come again! Hope comes on the slenderest foundation—the least step in the right direction makes the heart bound; the deeper the downfall was,

the more ecstatic will be the recovery; and one aspiration towards the good and true will make us believe that all will now be well. That is life with its possibilities, with sharp anguish but hope, with every chance, as we call it, still to come.[47]

You may not be able to educate anyone off the "downward path," but as long as they are alive, Oliphant is saying, you cannot stop hoping.

Moreover, Oliphant continues, if education does not help, neither really does prayer on the ne'er-do-well's behalf. We may feel, she notes, that in praying for our loved one to find the right path, that "we are praying for what is God's will. There is no question here of holding our wishes subordinate to perhaps another different conclusion which the Father knows to be better for His child."[48] The earthly parent and the heavenly parent surely both want the errant child to find his way. "How many altars would rise by every path, where fathers and mothers would lay their very hearts on the stone, and pour the water and light the consuming flame!"[49] However, Oliphant's argument is that neither education, nor prayer, nor parental self-immolation and self-sacrifice, nor anything else on heaven or earth can intervene in the pathetic loser's will to fail. "We cannot turn the will or change the career of those who are most dear and precious to us."[50] And nothing can save us from "the heart-breaks, the remorses, the vivid realizations of what might have been, the agonies of conscience for ourselves and of sorrows for others."[51] The parent is helpless. Oliphant writes in the *Autobiography* of the closest synonym of "helplessness, which of itself is despair."[52]

Emphasizing our limited powers and the need for restraint, Oliphant's "The Fancies of a Believer" belongs squarely within Victorian Christian Stoicism.[53] But it is also part of the complex of desiring to help and failing to help that Talia Schaffer has identified as an integral part of the Victorian culture of care.[54] In its emphasis on the psychology of helplessness, it is striking how close "The Fancies of a Believer" is to identifying a structure that Oliphant also identified in the novels of Jane Austen. She describes Austen's philosophical stance toward other people as a "feminine cynicism" characterized by:

> A certain soft despair of any one human creature ever doing any good to another—of any influence overcoming those habits and moods and peculiarities of mind which the observer sees to be more obstinate than life itself—a sense that nothing is to be done but to look on, to say perhaps now and then a softening word, to make the best of it practically and theoretically, to smile and hold up one's hands and wonder why human creatures should be such fools.[55]

The affect that Oliphant sees in Austen's stance is, of course, very different from the agonies of her later autobiographical writing. Here, the helplessness of the onlooker to correct another's obstinate foibles is synonymous only with a "soft" despair: it is a detached, bemused throwing up of one's hands. Oliphant continues, "She is not even their censor to mend their manners; no power has constituted her brother's keeper."[56] The Austen essay was written much, much earlier than "The Fancies of a Believer," at a time when her sons were promising students at Eton. But structurally, what we have here is the emphasis on one's helplessness, one's inability to intervene in the lives of others, that is the theme of the later essay.

In his essay "Perfectly Helpless," Andrew H. Miller takes up Oliphant's insight on Austen to argue that Austen's stance toward her characters is mirrored in her representation of the constraints that prevent her characters from helping each other, and in turn, dramatizes the helplessness of readers in the face of the travails of Austen's characters. Perhaps, he suggests, the force of Austen's representations of helplessness:

> Derive their peculiarly powerful aesthetic effect from our helplessness before the events about which we read. All Austen's characters are like Willoughby [the cad from *Sense and Sensibility*]: they *are* there, but they do not look at us, and we cannot speak to them.[57]

In this regard, Austen's novels—and Oliphant's insight into them—tap into a readerly incapacity which "is something like a transcendental condition of reading."[58] Miller hypothesizes that we are drawn to reading about literary characters who are, themselves, in the grip of constraint, incapacity, because it is "as if they have come to join us in that state in which we have languished since we first lifted the cover of the book ... debarred from the characters whose lives we nonetheless suffer."[59] Miller's essay is a beautiful meditation on the moral and psychological consequences, for us, of this peculiar dimension of reading novels. The ontological status of fictional characters—sealed off from our intervention, yet infinitely available for our emotional operations—is central to how fiction does its work. It affords, among other things, a theater in which to explore the conundrums of the weakness of will—"Did I fail to act because my will was weak, or because I was objectively constrained?"[60]

Leveraging Oliphant's account of Austen's narrator's stance toward her characters, Miller's "Perfectly Helpless" forms part of our current discussion of metalepsis—or ought to; he does not use the term. But the feeling that Miller describes—"this sense that I can't do anything for these characters,

not just that they are out of earshot (being both too close and too far for that) but that I am absolutely debarred from their world"[61]—is the feeling of metalepsis. It is the feeling that one wishes one could do something, that you could be "un-debarred," that you could cross that bar. Anti- or un-metalepsis and metalepsis are two sides of the same coin; they form an emotional whole. If Miller leverages Oliphant in order to write so compellingly about what we can identify in his article as the psychology of readerly metalepsis, Oliphant herself can now more clearly be seen in her treatment of helplessness, as a surprising theorist of metalepsis. The theme of being unable to jump in and intervene, so prevalent and heartbreaking in Oliphant's real life, was clearly central to her thinking about literature, as well. It was an ever-present hope and desire. The intertwining of parental helplessness (you want to help them, but you cannot) and authorial prohibition (you want to treat your characters as real, to be in their world with them, but you should not pretend you can) provides us with a new way of thinking about the relationship between motherhood and writing (for so long a topic of Oliphant scholarship) in her work. We can see motherhood, that is, less as a theme in her fiction, or as a fact of her life that interfered with her writing, than as a name for this structure of feeling that animates her writing.[62] It explains Oliphant's indignation at Trollope's excessively familial treatment of his characters, and it may illuminate some features of fiction. It emphasizes Oliphant's insight into a crucial dimension of the psychology of reading realist fiction: she was in touch with the readerly helplessness that activates the passionate "non-causal bargaining"—rooting for some outcomes for fictional characters while conceding others—that William Flesch has argued is fundamental to the way that readers process fictional narratives, "brightening"—to borrow his phrase—"its colors."[63]

"Let Me In!"

In Oliphant's fiction, instances of narratorial metalepsis of the kind that you can find in Charlotte Brontë, Trollope, and George Eliot—such as, for example, the passage from *Adam Bede* that I quoted at the beginning of this chapter—are relatively rare. Furthermore, Oliphant often uses vaguely metaleptic gestures of authorial entry into the storyworld not, as in some of Eliot's usages, as expressions of care for the reader, but as dramatizations of restraint. "I am not sure that Mary did not allow it to be understood that she had met this young hero," for example, she comments on a character's behavior in her late novel *Kirsteen*.[64] A closer comparison of a passage from Oliphant with the passage from Eliot's *Adam Bede* is instructive. In *Adam Bede*, the

narrator generously invites us in, taking care both for us and for the sentient beings in the story, including the dog: "We will enter very softly, and stand still at the open doorway, without awakening the glossy brown setter who is stretched across the hearth." There is a comparable passage at the beginning of Oliphant's *The Doctor's Family*: but here the personages on either side of the divide—narrator and reader on one side, characters on the other—are poised as adversaries. "Perhaps you would prefer to go up-stairs and see for yourself what was the skeleton in Edward Rider's cupboard, rather than have it described to you," the narrator says by way of introducing us to Edward's brother Fred. We are invited in, only when Edward's departure creates an opening:

> His drag came to the door an hour ago, and he went off with Care sitting behind him, and a certain angry pang in his heart, which perhaps Bessie Christian's wedding-veil, seen far off in church yesterday, might have something to do with. His looks were rather black as he twitched the reins out of his little groom's hands, and went off at a startling pace, which was almost the only consolation the young fellow had. *Now that he is certainly gone, and the coast clear, we may go upstairs. It is true that he all but kicked the curate down for taking a similar liberty, but we who are less visible may venture while he is away* (emphasis mine).[65]

We are then presented with Fred, who is passive-aggressively confrontational. He "turns his bemused eyes to the door when his invisible visitors enter. He fancies he hears someone coming but will not take the trouble to rise and see who is there" (69). In contrast to the passage from *Adam Bede*, we are made to feel most unwelcome here, both by Fred and by the absent doctor: we are not wanted—the way in is forbidden to us. The proximity of metalepsis and anti-metalepsis in Oliphant's work makes itself felt.[66]

Oliphant's concern with the aesthetics and psychology of unwelcome visits, and the overstepping of boundaries, may also be seen in the plots, patterns, and character types in her novels. Her plots skew heavily toward dramas of interference and helplessness. She carved out a specialty in superbossy characters, from *Miss Marjoribanks* to *Hester*. Lucilla Marjoribanks's reign over Carlingford is surprisingly frictionless, as she engineers solutions to almost everybody's problems. She is a fiction of pure interventionism, "a fantasy of political power."[67] Like her literary model, Austen's Emma Woodhouse, Lucilla Marjoribanks is also readable as a fantasy of authorial power. She treats the people of Carlingford as literary characters whose destinies she can move around. Of the "metafictional qualities" of the novel, Erik Gray notes that "*Miss Marjoribanks* provides as suggestive a commentary on novelistic methodology as any work of the Victorian period."[68] The bossy heroines

are author surrogates through whom Oliphant explores her ambivalence about authorial intervention. The later novel *Hester* revolves around Catherine Vernon, who runs the family bank and the fates of her family members. Hester—a poor relation, who does not fully know how compromised and dependent on Catherine Vernon she and her mother are—bristles at Catherine's reach into every aspect of her life: "'Mamma,' said Hester..., 'it appears Catherine Vernon says I ought not to wear your pearls. Has she anything to do with your pearls? Has she any right to interfere?'"[69] When, Oliphant's fiction frequently asks, has anyone any right to interfere?

In his discussion of Oliphant's explorations of the pressures of other people, John Plotz notes that her envy of George Eliot may have stemmed, as well, from their different experiences at John Blackwood's editorial hands. Blackwood treated Eliot with kid gloves, while Oliphant had to put up with, by contrast, more intrusive editorial meddling—"just," Plotz suggests, "the sort of irritating, meddling incursions that Oliphant so astutely anatomized in her work."[70] There may be some structural similarity between the editor's hands reaching in to meddle with her fictional world-making and the meddling hands in her fiction; in other words, that form part of the anti-metaleptic stance that I have been exploring here. The flip side of her powerful meddlers, such as Lucilla Marjoribanks and Catherine Vernon, is Oliphant's endless emphasis on characters who cannot intervene. From her earliest to her last fiction, her books are full of instances where a character feels helpless to rescue another from his or her own worst impulses, where a parent, a child, a sibling, or a spouse is agonizingly incapable of preventing someone from going wrong. Among her later novels, for example, there is *The Railway Man and His Children* (1890), in which the title character and his wife struggle to manage his disappointing children. In *The Marriage of Elinor* (1891), both the title character's mother and her cousin try in vain to prevent her from rushing headlong into a disastrous marriage: as her cousin exclaims, "Poor Nelly, standing upon the edge of that precipice, and the helplessness of every one to save her."[71]

Oliphant's starkest, most electrifying exploration of the dynamic interrelation between intervention and helplessness—their consequences for feelings of aliveness—is in her short novel *The Doctor's Family*. It not only treats Hester's question—"Has she any right to interfere?"—as a moral question about our responsibilities to others, but also reveals how fundamental such questions are to Oliphant's anti-metaleptic aesthetic. The third of the *Chronicles of Carlingford*, *The Doctor's Family* centers on the travails of Dr. Rider, whose upstairs room we visited—only to be rebuffed—a few paragraphs ago. Chief among Dr. Rider's problems is his brother, Fred—a former physician

who long ago lost his livelihood to alcoholism—who stared back at us belligerently. Oliphant lavishes on the glacially sedentary Fred her most stunning language of loserdom: he is a "large indolent shabby figure," a "useless hulk," a "heavy encumbrance" with a "nerveless slovenly frame."[72] He is a Biblical "cumberer of the ground" (102, 147). But most remarkable in Oliphant's treatment of Fred, is how he sparks a multifaceted moral consideration of the nature of responsibility for others, the "right to interfere" (116), and the possibilities of intervention. Dr. Rider himself is understandably, but culpably, prone to find ways *not* to intervene in the lives of Fred, his equally helpless wife Susan, and three wild little children who arrive unexpectedly from Australia. They are a "household of incapables" (87). He alternately excuses and condemns himself: both his excuses and self-reproaches are prompted by the arrival of Fred's superbossy Australian sister-in-law, Nettie Underwood. "Susan, you are not able to manage this; leave it to me" are among Nettie's first words in the novel; she is a pure interventionist (76). But while Nettie certainly belongs to the same family as Oliphant's other hypercompetent, unflappable young women such as Lucilla Marjoribanks and Phoebe Junior, she seems possessed of an energy that exceeds theirs. She is "always alert, decided, uncompromising" (104); she moves "impatiently" (197) with "restless activity" (95) and "agitated haste" (95).

Nettie is a more energetic "little autocrat" (199) than the others in Oliphant's canon because none of the others has such a spectacularly damaged individual as Fred Rider as a foil. Nettie's power and energy grow the more completely that she needs to intervene in Fred Rider's family. She "place[s] herself between the husband and wife ... balancing these extremes of helplessness and ruin" (87). She finds them a place to live, single-handedly moves them in, supports them financially, supervises the children, and sews all their clothes. Her impetuousness blossoms as they dither: a review of the dialogue in *The Doctor's Family* reveals that Nettie frequently interrupts other speakers, breaking off their words with a dash. In spite of her "feeble"ness (85), Susan shrewdly accuses Nettie of effectively making her family all the more helpless the more she steps in (190). They are experiencing learned dependency. The idea that Nettie and the Fred Rider family have developed through a kind of schismogenesis—one party gaining energy from the other's lassitude and vice versa—can be confirmed by studying a key physical feature that Oliphant uses in *The Doctor's Family* to characterize their differences: their hands. Nettie is characterized repeatedly through her "tiny hands" (78, 82, 89) with "rapid fingers" (88, 195). Fred Rider has "large heavy limbs" and in particular a "long arm" that ends in "flabby hands" (87, 79, 111). It is almost like a case of divergent evolution, whereby two species with differing appendages emerge

from divergent experience, the large, incompetent, flabby-handed species, versus the small, capable, quick-handed species.[73]

Oliphant's exploration of the intersections of interventionism, helplessness, and aliveness takes on a more complex shape, however, in the case of Dr. Edward Rider. He seesaws between self-justification and self-incrimination (120). He feels he ought to intervene, feels helpless to do so, and is told he has no right to, anyway (108, 109, 116). He is irrationally allergic to his brother's completely innocent children. He knows his refusal to house or support his brother's family is selfish, and he feels both guilty and angry about the extraordinary burden on Nettie. But he also knows that he faces—as Susan's resentment of Nettie affirms—a no-win, thankless situation: while Dr. Rider is wrong not to act at all, Nettie's experience confirms that no amount of assistance, financial or otherwise, would ever dig Fred and his family out of their hole. (This hopeless situation is only resolved at the end of *The Doctor's Family* when Fred drowns, drunk in a ditch, and Susan quickly agrees to marry an Australian adventurer and return to the colony with her children).

But the interesting thing about Dr. Rider is that he seems to draw energy from his frustrating predicament. Fred's presence, his very mode of being, is a constant irritation that pushes Dr. Rider to the verge of violence. We may wish to recall that Dr. Rider's irascibility was aimed at *us* in the opening metaleptic moment discussed above. There, the narrator invited us upstairs while the doctor was away, noting that "it is true that he all but kicked the curate down for taking a similar liberty," adding "but we who are less visible may venture while he is away" (68). It is part of Oliphant's characterization of Dr. Rider that he has so much energy that he threatens to burst through the fourth wall. We are saved from the threat of Dr. Rider metaleptically breaking the frame in order to kick us out, by the fact that we are "less"—note not "in"—visible. But the more that Dr. Rider feels helpless—any usefulness stymied by his own ambivalence and by Nettie's preemptive action—the more irascible energy he seems to manifest. He is like an electric wire, animated by the current of helplessness. Frustrated by his helplessness, he drives around Carlingford "furiously" (69) in his "drag" (carriage) at "break-neck" (199) speed, a "startling pace" (68), sometimes leaping out of it before it stops moving (199).

To summarize, while Nettie Underwood seems to come to life "with an imperious distinctness and energy" (104) the more she reaches her quick and lively hands into the lives of others, Dr. Edward Rider seems to derive twitchy energy ("he twitched the reins out of his little groom's hands," 68) from his sense that there is nothing he can do, that his family—and Nettie—thwart him at all turns. Needless to say, these two live wires get

married at the end of the novel and settle into more sedate minor figures in the remaining *Chronicles of Carlingford* novels. But the point is that the two poles alike—of helplessness at one end and intervention at the other—are animating; they create a force field that brings these characters to (strenuous, active, twitchy) life. Oliphant's mode of bringing her main characters to fever-pitch life in *The Doctor's Family* is complemented by the curiously prominent presence of the sun—the ultimate life-giver—in the novel. Dr. Rider's salient memory of Nettie is of "how Nettie's little shadow *dropped across the sunshine* that first morning when he saw her in his own room" (115; emphasis mine). But in *The Doctor's Family*, the sun most often appears, not exactly sunshiny, but almost garishly red. "It was a foggy frosty day, brightened with a red sun, which threw wintry ruddy rays across the mist" (113). There is "red morning sunshine" (198), "red gleams" (195). "The air was still with a winterly touch ... yet every sound rang sharply through that clear cloudless atmosphere, reddened without being warmed by the sun" (169). At a tense moment, "the doctor ... had all his attention concentrated upon the windows of the cottage, in which the sun was blazing red" (171). While you could say that some of these red suns are a consequence of Oliphant's choice to set key events at sunrise and sunset, I would argue that it is the other way around: it is not the time stamp but the red sun that is salient. It is the sun as fire, as energy source, rather than source of illumination.

At times, however, the sun illuminates striking visual effects. Oliphant describes one of Dr. Rider's furious drives with a kind of Turneresque impressionism: he "plunged down Grange Lane in a maze of speed which confused horse, vehicle, and driver in one indistinct gleaming circle" (199). As the sentence continues, we learn that it is specifically Nettie who perceives Dr. Rider as part of an "indistinct gleaming circle." This is significant because Oliphant earlier described Nettie herself at the center of a magic circle that provides "visionary, ineffable solacement" (160). It is a circle of protection that seems to be composed out of a mixture of Nettie's own personal qualities and some unnamed transcendent force: "Sweet nature, gentle youth, and the Magician greater than either, came round her in a potent circle and defended Nettie" (160). I suggest that these become overlapping circles. Dr. Rider's "gleaming circle" appears to Nettie shortly before he proposes to her (actually, fittingly, she kind of proposes to him!). We could say that Nettie and Dr. Rider move from standing outside, to inside, each other's circles. For Oliphant, the significance of radiant circle shapes, with insides and outsides, will be further elaborated in the next section of this chapter.

Oliphant's anti-metaleptic aesthetic can also explain some of the plots and patterns of her supernatural short fiction, which frequently features barriers

that may or may not be crossed. In "The Open Door," a retired Colonel Mortimer rents an estate in Scotland haunted by a ghost who cannot get in a door which is wide open. The story's refrain is the ghost's repeated cry: "Oh, mother, let me in! oh mother, mother, let me in! oh, let me in!"[74] The door is truly wide open—it is a gaping door in an old stone ruin—a fragment of a wall—on the estate. It is an aperture made radiant by the rising sun (55), but it is "a door that led to nothing" (8, 38). Here is how it looks from the Colonel's vantage point, along with his moralizations:

> The ruined gable looked due east, and in the present aspect of the sun the light streamed down through the doorway ... throwing a flood of light upon the damp grass beyond. There was a strange suggestion in the open door—so futile, a kind of emblem of vanity—all free around, so that you could go where you pleased, yet that semblance of an enclosure—that way of entrance, unnecessary, leading to nothing. (55)

The story is set in motion when the colonel's youngest and only surviving son, Roland, falls ill upon hearing the ghost's refrain by the ruined, open door. In order to save Roland ("If I could not find any help—and what help could I find?—Roland would die," 60), Mortimer assembles a team of ghost-busters. All of them fail, including the colonel's brave and burley bat man, Bagley, who freaks out and simply shouts "Come In! come in! come in!" at the ghost, to no avail (42). Finally, Mortimer enlists a rustic Scots clergyman, the wise and empathetic Dr. Moncrieff, who correctly identifies the ghost as Willie, the ne'er-do-well son of a former housekeeper on the estate, who returned home only as his mother was dying. Dr. Moncrieff exorcises the ghost, urging him to stop trying to get into the ruined door of his mother's former home, and to go, instead, to the door of heaven, where he will be let in with open arms. You are at the wrong door he tells the ghost; your mother is in the "everlasting habitation" of heaven. "Let it be at heaven's gate, and no [sic] your poor mother's ruined door," Moncrieff implores (62). "Lord," he prays, "let that woman there draw him inower! Let her draw him inower!" (63). "Inower" is Scots for "over a fence or boundary into the space within."[75] The ghost vanishes, and Mortimer walks Dr. Moncrieff to his own door, where his housekeeper is waiting to let him in (67).

"The Open Door," in other words, is designed to teach us that even doors that seem wide open cannot be passed "inower." There are places where those of us who are outside cannot get inside. Oliphant returned to thresholds, apertures, and borders that cannot be crossed in some of her later supernatural tales. In "The Land of Suspense," for example, another feckless youth comes to a place that he thinks is his home, imagines that he will be received as a prodigal son, but finds himself "shut out" of "a great wide

doorway full of . . . sunshine from the west." A chorus of mysterious beings on the other side of the threshold, who may or may not be his family intone: "those who are unclothed as you are, alas! They cannot come in. Brother, we have no power, and you have no power."[76] In her story "The Library Window," the central question is whether a surface is a wall, a window that can be seen through, or a threshold that can be passed through. In this story, a young woman, sitting in her own drawing room window and reading, becomes tormented by what seems to her to be a window in the college library building across the street. Everyone else says it is just a bricked-up wall, but to her it is a window through which she gradually sees more and more: first just indistinct, shadowy library furniture, but eventually a young man studying. The narrator becomes more and more anxious to cross over into this other world, and more frustrated by the people around her. At the climax of the story, the young man opens the window and beckons to her. "The Library Window" reminds me of Isobel Armstrong's account of glass as "*the* disputed space of the [nineteenth] century," never a figure for smooth transitivity or transparency, but of the difficulty of passage.[77] Margaret Oliphant's husband Francis (or Frank) was a stained glass artist who devoted his short professional life to conceiving of glass not as "a thoroughfare for the light," as he wrote in his treatise *A Plea for Painted Glass*, "but a radiant medium." Stained glass thickens into a barrier; it liberates you from the desire to pass through: "You no longer feel a necessity to look *through*, but are able to look *at*, the window."[78] We might see the now-solid, now-transparent surface in question in "The Library Window" as a response to Frank Oliphant's writings on stained glass; but we should reflect that the story revolves around a *library* window. Is a book a window, a door, or a wall?

In Oliphant's fiction, there are no easy crossings between narrative or ontological levels. There is none of the elation of crossing between different storyworlds in *Through the Looking-Glass*-like ways. "Oh, what fun it'll be, when they see me through the glass in here, and can't get at me!" says Alice when she has just stepped through the glass.[79] Oliphant's work expresses, at best, the agony of not being able to make it through. "Oh, mother, let me in! oh, mother, let me in!" from "Open Door" is not unlike the ghost of Catherine Earnshaw at the window in *Wuthering Heights*, who cries, "Let me in! Let me in!" or Heathcliff when she leaves, who cries, "Come In! Come In! . . . Oh do—*once* more! Oh!"[80]

The Story of "Oh!"

Speaking of "oh": the syllable "oh" appears in Oliphant's fiction much more frequently than in fiction by other novelists of her era, and her usage of it

climbed in her later work. As I began my work on this chapter, my research partner in our PhD program, Rachel Cawkwell, did some preliminary digital analysis of the corpus of Oliphant's fiction using AntConc, which is, in the words of its creator Laurence Anthony, a "freeware corpus analysis toolkit for concordancing and text analysis."[81] Margaret Oliphant is an ideal candidate for big data analysis because she was so prolific. Rachel's preliminary corpus consisted of seventeen Oliphant novels, spread out evenly over the course of the novelist's career, which were easily available as plain text files, and for purposes of comparison, selected novels by other authors over the same period. Using AntConc, Rachel was able to determine the frequency of the expression "oh," relative to the total word count, in these works and the rate at which Oliphant's usage of "oh" rose from the earlier to the later novels. She was also able to provide preliminary documentation of Oliphant's higher usage of "oh" in relation to other Victorian novelists (see Table 1).

The overwhelming majority, but not all, of "oh"s in all of the novels occur in dialogue: minimally, what we can infer from this is that Oliphant's novels are heavily dialogue-dependent compared to those of her contemporaries. I would go further and say that the quoted "oh" is an index of fictionality itself, in that "oh" is typically a feature of spoken language (that is, there are not many genres of writing in which "oh" appears naturally), and fiction is in the business of representing quoted speech more than other prose genres. We could build on Jonathan Culler's famous essay on apostrophe in lyric poetry, and say of the "Oh" (and sometimes "O") of prose fiction what Culler says of the open "O of apostrophe": that it is a "sign of a fiction which knows its own fictive nature;"[82] that it represents a pure "'now' of discourse ... a fictional time in which nothing happens but which is the essence of happening."[83] The "oh" of prose fiction differs from the O of poetry in that the latter is a figure of address, while the former is an exclamation of surprise, perhaps, or despair.[84] One of Oliphant's characters, on the brink of speechlessness, splits the difference between "O" and "Oh": "He expressed the difficulty he had in carrying on the conversation by a hesitating and puzzled 'O-oh.'"[85] In cases like this one, "Oh" is an involuntary, wordless voicing of helplessness. The "Oh" of prose fiction is a mark of fictionality, not (as Culler argues about the "O" of poetry) because no one in real life says "oh" (we do!) but because very few other genres of writing have occasion to quote people saying "oh." Together, all of these many "oh"s fictionally issued from the fictional mouths of Oliphant's multitudinous fictional characters are performing their fictional being.

Yet not all of the "Oh"s in Oliphant's novels come clearly anchored to fictional characters, corralled in quotation marks. A small segment of them

Year Published	Author	Title	Average Occurrence of "Oh" per Word Tokens
1851	Margaret Oliphant	Merkland; or Self-Sacrifice	1 / 1831
1857	Margaret Oliphant	The Days of My Life: An Autobiography	1 / 1036
1861	Margaret Oliphant	The House on the Moor	1 / 1414
1863	Margaret Oliphant	Salem Chapel	1 / 685
1864	Margaret Oliphant	The Perpetual Curate	1 / 895
1866	Margaret Oliphant	Miss Marjoribanks	1 / 1465
1866	Margaret Oliphant	Madonna Mary	1 / 917
1872	Margaret Oliphant	At His Gates	1 / 677
1876	Margaret Oliphant	Phoebe, Junior	1 / 769
1883	Margaret Oliphant	Hester	1 / 642
1883	Margaret Oliphant	The Ladies Lindores	1 / 1024
1883	Margaret Oliphant	Sir Tom	1 / 576
1883	Margaret Oliphant	It was a Lover and His Lass	1 / 527
1884	Margaret Oliphant	The Wizard's Son	1 / 749
1886	Margaret Oliphant	A Country Gentleman and His Family	1 / 556
1890	Margaret Oliphant	Kirsteen	1 / 536
1891	Margaret Oliphant	The Marriage of Elinor	1 / 470
1847	Charlotte Brontë	Jane Eyre	1 / 1662
1857	Anthony Trollope	Barchester Towers	1 / 1302
1860	George Eliot	The Mill on the Floss	1 / 908
1862	Mary Elizabeth Braddon	Lady Audley's Secret	1 / 2927
1872	George Eliot	Middlemarch	1 / 1999
1874	Thomas Hardy	Far From the Madding Crowd	1 / 701
1875	Anthony Trollope	The Way We Live Now	1 / 1331
1892	Thomas Hardy	Tess of the D'Urbervilles	1 / 951

Table 1. For these nineteenth-century novels, the word "Oh" appears, on average, once for every given number of word tokens (the unit used by AntConc, which is approximately the word count). For the two Thomas Hardy novels, the count includes instances of "O," instead of just "Oh," due to their high frequency.

is part of the fabric of narration itself. Within these, there is a spectrum of "oh"s. Some are very free, indirect discourse(ish), as in this example from *The Curate in Charge*: "This was all she could get from him; and, oh, how glad he was when he was permitted to go to bed, and be done with it!"[86] But there are other "oh"s which seem to issue forth from the narrator, responding to, rather than channeling, characters. We can find an example in Oliphant's 1884 novella—one of her "Stories of the Seen and Unseen"—*Old Lady*

Mary. The novella concerns a wealthy, ancient woman, who dies before having passed on her last will and testament, which was to have left her house and possessions to the companion of her later years, a young distant relative who is also named Mary. In the afterworld, Old Lady Mary is wracked with guilt about having left young Mary destitute and homeless. She asks the other residents of the afterworld whether she might convey a message back to the living to clarify her intentions, but she is told "No one can carry your message for you; that is not permitted."[87] She is given special permission to try to go back to the land of the living herself—perilous though she is told it will be. Back in the land of the living, however, Old Lady Mary discovers, to her distress, that she is invisible and inaudible. Ignored by acquaintances who turn unknowingly away from her on a wintry street, she thinks "It is hard to be left out in the cold when others go into their cheerful houses."[88] Left out in the cold, unable to break through to the other side to rectify the situation of young Mary, Old Lady Mary is a prime instance of an Oliphant character who is perfectly helpless, unable to break through a seemingly insuperable barrier between ontological domains, in order to intervene in the life of another.

It turns out—as seems often to be the case with ghosts—that very young children can detect Old Lady Mary's presence when no one else can. She invisibly visits her former housekeeper, who happens to be entertaining her daughter and her daughter's baby: the baby reaches for Old Lady Mary, who is overcome with maternal sentiment, coos to the infant, and bends to pick her up. The baby's own mother freaks out at seeing her baby strain after an invisible presence, scoops her up, and carries her off, crying "oh my baby, my baby!" After the commotion dies down, the narrator exclaims: "Oh, the pang that was in the heart of the other whom they could not hear!"[89] The propositional content of this utterance—there was a pang in the heart of Old Lady Mary—is about her, rather than by her: the sentence is less free, indirect discourse(ish) than some of the other narratorial "Oh"s. And the structure of relationships in this scene curiously puts the narrator outside of Old Lady Mary, rather than inside her. The narrator's "oh" is positioned as analogous to the "oh" of the baby's mother, responding empathetically to a being to whom one is intimately connected, yet exterior to. The housekeeper and her daughter cannot hear Old Lady Mary, but the narrator can. This analogy also weirdly positions the narrator as exterior to Old Lady Mary, but interior to the scene: the mother is to the baby as the narrator is to Old Lady Mary. In another analogy, Old Lady Mary is in the scene yet invisible/inaudible to the other people in the scene; the narrator seems to be in the scene but is

invisible/inaudible to all of them. The position of the narrator—empathetic, present, yet sealed off—is like Old Lady Mary's.

And yet, the narrator is not sealed off from the storyworld. What I am suggesting is that the narrator's "oh" in this passage is the token of a metaleptic gesture. Further, I am arguing that although I have painted Oliphant's stance as fundamentally anti-metaleptic—committed to keeping real experience on one side of a divide and literature on another, and as mournfully skeptical of anyone's ability to cross over any affectively charged line to intervene in the lives of others—some of the most unusual effects in her fiction may emerge from furtive modes of metaleptically crossing over. If—and this, again, is my thesis—metalepsis is reframed as a feeling, a desire that brings a prohibition with it rather than as a narrative technique, then the difference between metalepsis and anti-metalepsis becomes attenuated.

That the emotional pull of metalepsis/anti-metalepsis should pool around the sound/letter Oh/O—and that, further, it should coalesce around maternity and femininity—has come to seem unsurprising. The "Oh"s of *Old Lady Mary* that are inside and outside the diegesis, simultaneously suturing and dividing intergenerational relations between women, reminds me of the "Oh!" that the young Elizabeth Bishop hears in "In the Waiting Room." This "Oh!" ostensibly comes from her guardian aunt sitting in the dentist's chair, but it triggers a free fall:

> Suddenly, from inside,
> Came an oh! of pain
> —Aunt Consuelo's voice—
> Not very loud or long.
>
> What took me
> completely by surprise
> was that it was me:
> my voice, in my mouth.
> Without thinking at all,
> I was my foolish aunt,
> I—we—were falling, falling[90]

The "*oh!*," the "cry of pain that could have/got loud and worse but hadn't," crosses between inside and outside—whose experience is it??—in a moment of both identity and difference (ll.87–88). The O is the open birth canal, the place where the self turns itself inside out. Needless to say, the choice of O as the name of the otherwise anonymous protagonist of the 1954 French

novel *The Story of O* exploits the meanings of O—as moan, as cry, as bodily orifice—explicitly.

Elizabeth Bishop, *The Story of O*, and Margaret Oliphant may seem like superstrange bedfellows. But in her later novels, the sound / shape / letter O seems never far from questions of generation. In *The Railway Man and his Children*, the very existence of the eponymous children elicits an "O": "Lady Leighton gave vent to an 'O!' which was rounder than the O of Giotto. Horror, amazement, and compassion were in it. 'He has children!' she said faintly."[91] Oliphant's figure of speech requires a bit of unpacking. It derives ultimately from a (fictive) anecdote about the painter in Vasari's *Lives of the Artists*, in which Giotto astonishes the pope with his ability to draw a perfect circle freehand. It entered the lexicon of late nineteenth-century aestheticism. The phrase "the O of Giotto" was attractive to Victorians writing about literature and art as an apt image for—as Thomas Carlyle explains when he uses it to describe the narrative flow in the novels of Sir Walter Scott—"the free dash of a master's hand."[92] That Oliphant should have picked this phrase out of the (aesthetic) air to describe a sound, attests to the sheer sound appeal, the rhyming, of the phrase "O of Giotto," but also points to O's overdetermined properties as both a sound and a suggestive shape. It evokes a sound; it evokes the shape of Lady Leighton's mouth in making the sound (Bishop: "my voice, in my mouth"); it is a sound described as a shape; it is one of the letters of the alphabet, which are always both sound and shape.[93] It is the magic circles in *The Doctor's Family*. It is the sound of crossing over in the Scots language that Oliphant—a proud Scotswoman—used in "The Open Door": "inower."

This is a way of suggesting that Oliphant, curiously, used the syllable "oh" as a token or signature for herself throughout her fiction. This may not be as outlandish as it might seem. As Andrew Hass suggests in his book *Auden's O*, there are other instances, other authors, for whom "O" served as an alternative to "I"[94] But how could this be? How can anyone own a letter, a sound, a syllable? Here is one piece of evidence to add, in addition to the demonstrable presence of "oh" in her fiction. Oliphant's maiden name was Margaret Wilson, but her middle name was Oliphant, which was her mother's (also named Margaret) maiden name. When she married her first cousin Frank, she became Margaret Oliphant Wilson Oliphant. She often signed herself M. O. W. O. and preferred this on the title pages of her books. She insisted on this funny-sounding signature, writing to her editor John Blackwood early in her career, "I should like to retain all this accumulation of syllables."[95] Why refer to M. O. W. O. as an "accumulation of syllables" rather than as, more properly, an accumulation of letters? Or of names? A syllable is

a sound. In this story of "oh," Oliphant is claiming as her signature a sound, a cry, which is heard / not heard both inside and outside the storyworld: M. O. W. O. "inower!"

We are now in a position to specify a crucial feature of the structure of Oliphant's *Autobiography* which, as noted earlier, is divided between retrospective narration and eruptions of the present scene of writing. Scholars of autobiography have long argued that the writer of autobiography is what we used to call a "split subject": there is the "I" that writes, and the "I" that is written about, and the two are never completely identical.[96] In its alternation of present-tense outbursts and deep personal history, Oliphant's *Autobiography* dramatizes this split especially vividly. But what threads together the two "I"s—the two stories of "O"—is the syllable "Oh," which appears with extremely high frequency throughout, crossing back and forth between the scene of writing and the scene of retrospection, like an amphibious vehicle. "I did not know when I wrote the last words that I was coming to lay my sweetest hope, my brightest anticipation for the future, with my darling in her father's grave. Oh this terrible fatal miserable Rome," she cries at a moment of writing.[97] But looking back at an earlier moment, when at the writing she is "old and desolate and alone": "Oh, the bonnie little dear faces! The rapture of their wellbeing and their happiness, all clinging round mamma with innumerable appeals."[98] The "Oh"s of the *Autobiography* create the curious impression of Oliphant falling metaleptically into her own story.[99]

The O of Experience and the World Stack

I have suggested in this chapter that for Margaret Oliphant, "experience" gets defined, not simply as having lived, but having lived along the axis of a psychology of helplessness, in which caring for others, and knowing how little one can do, wanting to jump in, and stoically refraining, converge. I have sought to identify this psychology in Oliphant's writing, both her fiction and nonfiction, noting the ways in which boundaries between loved ones—particularly parents and children—and boundaries between narrative levels become intertwined. I have identified Oliphant's desire, and her restraint from crossing the barriers separating real and fictional persons with metalepsis. I have argued that Oliphant understood well how, paradoxically, the stance of helplessness, of being barred from crossing, could amplify the intensity of one's experience.[100]

But it is worth stressing further how distinct the emotional tone of Oliphant's stance is, in comparison to that of other authors' gestures of narratorial restraint, which are often showy (or gentle) demonstrations of tact,

sometimes mockery, in practice, paradoxically intrusive. Consider this example, from Hawthorne's *House of Seven Gables:* Hepzibah Pyncheon "arose from her solitary pillow and began what would be a mockery to term the adornment of her person. Far from us be the indecorum of assisting ... at a maiden lady's toilet! Our story must therefore await Miss Hepzibah at the threshold of her chamber."[101] It is also instructive to contrast Oliphant's noninterference pact with her characters with Henry James's. In the "Prefaces" to his novels, James famously expresses his faith in his characters' autonomy, his tactful lack of interference.

For example, concerning the fortunes of Christopher Newman, the protagonist of *The American,* James professes, "once the man himself was imaged to me (and that germination is a process almost always untraceable), he must have walked into the situation as by taking a pass-key from his pocket."[102] James stays passively out of the way while his character has his own means of unlocking the door to, and sauntering into, the plot. Such gestures are in the service of an aesthetic of detachment, a modest expression of effortless genius, combined with a horror of forcing anything. James describes the reappearance of Princess Casamassima, who played a role in his early novel *Roderick Hudson,* in the later novel that bears her name, as if she had engineered her own resurrection, "not consenting to be laid away with folded hands in the pasteboard tomb" (74). The phrase both underscores the putative indignity of being a mere character of fiction in a pasteboard book, and figures character freedom from authorial intervention as a Lazarus-like crossing of the border between life and death. In my analysis of the writing of Margaret Oliphant, the presence of children—real or imagined—often serves to both stabilize the border between real and fictional worlds, and as prime prompt to cross that border: "let me in!" To the extent that there is anything parental about James's stance toward his characters, it is an expression of parental detachment. For example, on the situation in *The Wings of the Dove*, he declares "my business was to watch its turns as the fond parent watches a child perched, for its first riding-lesson, in the saddle" (293). James describes one of his stories as hovering beyond his reach: "it was 'there'—it had always, or from ever so far back, been there, *not interfering with other conceits, yet at the same time not interfered with*" (241; emphasis mine).

James's aesthetic—and indeed ideological—commitment to his characters' freedom and his own noninterference makes his work ripe for an account of the boundary between real and fictional worlds that is helpfully different from my own: Yi-Ping Ong's existentialist approach to the novel, *The Art of Being*. Ong's stance is rigorously anti-metaleptic (no authorial touching of characters allowed!) because she views the maintenance of the "aesthetic

boundary" separating author and character as essential, paradoxically, to the dissolving of the barrier between reader and storyworld. The novel must "convince the reader of the independent existence of its characters, to the point that the aesthetic boundary separating the reader from the novel virtually vanishes, giving rise to the effect of immersive inhabitation within the fictional reality of the characters' lives and world."[103] Anti-metalepsis, and the illusion of a totally porous travel across the boundary, go hand in hand here. What strikes me, however, is the rigorousness of Ong's partisanship for character freedom. What is to be avoided at all costs, "the recurrent specter of authorial interference" or "the interventionist power of a still-living author to render the life of her character into a fixed, immobile form, a mere tool or extension of authorial desire" (95–96)? In the first pages of this study's next chapter's discussion of prolepsis, we will return to consider further Ong's commitment to an "open future" (67) for literary characters. Her book unfolds, vividly, the intensity of the narrative theorist's desires for "the lived experience of a character" (11).

In contrast to both James's studied detachment and Ong's existential struggle, Oliphant's ethic of restraint is both more intimate and more pained. It is, we should acknowledge, a very austere, even perverse, stance for a novelist to take. Fiction writers, it could be said, do nothing but intervene in the lives of their characters. Virgil has Dido die, as Genette writes, and Oliphant had her characters fall in love, marry, take up a living, run a bank. One might reasonably expect that the ability to make these interventions in a fictional world would provide relief from the distresses of real life, in which successful intervention seemed so elusive. Oliphant refused, at least, to write about that kind of relief. But perhaps we can hear some kind of sigh of relief in the collective "oh" of her fiction.

I conclude with two final "O"s, both of which evoke the possibility of relief, of lightening of a load. First, in his taxonomy of mental functioning and ways of knowing, W. R. Bion—whose account of the interpersonal transfers of experience I discussed in the Introduction to this study—used the letter "O" to designate the ultimate horizon of relief from mental suffering. O in his schema, is the reality of experience which cannot be represented, approachable only through unconscious reverie in the space between two persons in the consulting room: "what takes place in the consulting room is an emotional situation which is itself the intersection of an evolving O with another evolving O."[104] Bion's alphabetical system sometimes proceeds predictably. Knowledge, for example, is abbreviated with a "K." The reason for his choice of "O" to name unrepresentable, ultimate reality is more mysterious. He sometimes claimed that "O" stood for "origin"; it could also

suggest "at-one-ment."[105] But he also associated it with the shape of an egg and the shape of a planet. These associations—egg, planet—find poetic form in my second "O," from Seamus Heaney's "Alphabets":

> As from his small window
> The astronaut sees all that he has sprung from,
> The risen, aqueous, singular, lucent O
> Like a magnified and buoyant ovum.[106]

Metalepsis and anti-metalepsis are formal, narratological functions, but also deeply psychological phenomena. In her essay "Metaleptic Machines," narratologist Marie-Laure Ryan suggests that "metaleptic texts make us play with the idea that we are fictional, the product of *a mind that inhabits a world closer to the ground level than we do*" (emphasis mine).[107] If authors and readers can entertain the idea of reaching into a book and touching the fictional beings in that world, she is suggesting, by implication, we must entertain the fantasy that there are some other beings, in some other worlds, who can do that to us.[108] I find most provocative about Ryan's formulation the idea of a "mind that inhabits a world closer to the ground level": if we are fictional, we are held from beneath—lest we float weightlessly free. We are somewhere in what Ryan describes as a "stack" of worlds, in different narrative levels, each stack layered on and in each other, with different degrees of gravitational pull. Like the astronaut in the Seamus Heaney poem quoted above, who now sees the world, without its gravitation pull, as a "risen, aqueous, singular, lucent O" even though he, of course, is the one who has "risen," the reader of fiction may feel herself moving among worlds. I am reminded of Oliphant's trippy speculations in "The Fancies of a Believer": "is this world, then a great, a wonderful experiment among worlds?"[109] This is a way to suggest that—as logically, epistemologically, ontologically, and even politically fraught the idea of multiple layers and possible worlds in fiction may be, such a belief in a stack of worlds, and a belief in our astronaut-like travel among them, held in space yet attached—has an emotional appeal, a balance of lightness and gravity.[110]

3. George Eliot and Prolepsis: Prediction, Prevention, Protection

Introduction: Rethinking Prolepsis

In Chapter Two, I unpacked the narratological concept of metalepsis into its psychological components, its characteristic move of transferring a person across an ontological boundary revealed as a drama of freedom, constraint, care, helplessness, and relief. Perhaps most surprising is the way that these dramas make use of the always-moving wall between the real and the fictional, as Margaret Oliphant staged again and again the desire to cross that wall, and the impossibility of doing so.

In Oliphant's imagination, George Eliot was immune to the kinds of agonies of caring for others that she herself experienced. Eliot was the cared-for, protected one, safely ensconced inside. "How I have been handicapped in life!" Oliphant exclaimed. "Should I have done better if I had been kept, like her, in a mental greenhouse and taken care of?"[1] Oliphant found contemplating Eliot's life painful: it prompted invidious comparisons. This envious distinction—Oliphant wracked by care and caring, Eliot the cared-for—obscures, of course, the extent to which Eliot shared some of Oliphant's fundamental concerns.

In this chapter, I turn to Eliot via another classic concept from narratology—prolepsis. Metalepsis and prolepsis emerged together in Genette's *Narrative Discourse*, where prolepsis is defined as "any narrative maneuver that consists of narrating or evoking in advance an event that will take place later."[2] However, the genetic, deep, structural connection between the two has not been fully explored. Metalepsis may be thought of as framing or encompassing prolepsis in the following way: the movement in metalepsis across the divide between the real and the fictional is homologous to the movement in prolepsis across the divide between the present and the future. One motion takes place along a spatial axis, one across a temporal axis, but

they have a structural similarity—a crossing. The homology between metalepsis and prolepsis uncovers the nature of the future that prolepsis crossed over to. It underscores that the future always has an ontological status that marks it off—not unlike fiction—from empirical reality.[3] The future, like fiction, has not happened; like fiction, it is speculative, hypothetical. The future is another country—so is fiction.

Intuitions of the connections between metalepsis and prolepsis provide us with a starting point for our investigations. One scholar of prolepsis comes close to collapsing it into metalepsis altogether! Mark Currie focuses on what he calls a "proleptic excursion from narrated time to the time of narrating, a kind of flashforward which," he claims, "abounds in fiction." This kind of "excursion," he continues, "can be found whenever a narrator intrudes into narrated events to remind a reader of the time locus of narrating," and lists instances from Fielding, from *Tristram Shandy*, and "many metafictional experiments in the novels of the late-twentieth century."[4] "It is also worth pointing out here," he notes, "that the crossing of diegetic levels in fiction of this kind *is also designated by the term 'metalepsis'*"[5] (emphasis mine). An intuitive grasp of the connection between metalepsis and prolepsis—and of the encompassing of the latter by the former—was manifested in a conversation about a book that I read aloud with my then six-year-old daughter. About the characters in the novel, who were about to walk into some danger which we as readers could see clearly but they could not, I casually commented: "they have no idea what's about to happen." My daughter responded: "they *don't even* know that they're in a book!!" In this view, the characters' ignorance of the future was folded into their ignorance of their generally benighted, fictional status, the reader's ability to foresee events, and the desire to reach in and forewarn, one and the same.

There is justification, in other words, for seeing prolepsis as a subset of metalepsis, and for using some of the discoveries about nineteenth-century metalepsis that we explored in Chapter Two to guide our exploration of prolepsis here. Gestures of readerly anxiety that take a metaleptic form involve futurecasting. The classic example of metalepsis from Diderot—the desire to jump into *Clarissa* to save her from her fate—is prompted by the reader's sense of being able to see around the corner to a future that the character cannot.

Before proceeding further on the shared, related terrain of metalepsis and prolepsis, a few words about other overlapping terms. I will provisionally be using "prolepsis" and its vernacular near equivalent, "foreshadowing," almost interchangeably. But both terms—prolepsis and foreshadowing—can cover a vast range of instances; some narratologists treat them as synonymous.[6]

Rather than getting involved in taxonomic distinctions, it is most important to evaluate specific effects and instances. Within his discussion of prolepsis, however, Genette makes a (confusingly termed) distinction that may be of use moving forward. Genette first discusses what he calls the proleptic "advanced notice"[7]: these are the explicit narrative gestures such as "as we shall see," "for years afterward," "later." In *Middlemarch,* for example, Eliot looks forward to a change of mind by Mr. Brooke: "Mr. Brooke on this occasion little thought of the Radical speech which, *at a later period,* he was led to make on the income of bishops"[8] (emphasis mine). "Life did change for Tom and Maggie," the narrator of *The Mill on the Floss* warns us, "and yet they were not wrong in believing that the thoughts and loves of these first years would always make part of their lives."[9] Genette contrasts such explicit "advanced notices" with what he (rather confusingly) calls "mere advance mentions."[10] "Mere advance mentions" for Genette are "simple markers without anticipation, even an allusive anticipation, which will acquire their significance only later on and which belong to the completely classic art of 'preparation.'"[11] They are "seed"s[12] of narrative; they are the gun that appears in the first act that goes off in the last. The difference between "advance notices" and "advance mentions" concerns the level of what narratologists call the "discourse"—the choices and activities of the storyteller—or the level of what they call "the story"—the events and circumstances, including characters, being described. Genette's "advance mentions," in other words, take place at the level of story (as opposed to the "as we shall see" "advanced notices" that take place at the level of discourse); they are instances of what might be more familiarly called narrative "foreshadowing." Genette, in other words, views seeds of foreshadowing embedded in a story as a subspecies of "prolepsis." But can we always decide whether we are dealing with an "advance notice" or an "advance mention," whether to attribute future knowledge to a narrator stepping in and messing with characters' lives, or to an uncanny prefiguring quality of the story itself? The question of whether a look forward to later events comes from within the story, or without, can reveal the places where the overlap between metalepsis and prolepsis is closest.

Moreover, like metalepsis—whose place in nineteenth-century realist novels has been, until recently, misunderstood or overlooked—prolepses of all kinds have long seemed alien to the narrative unfolding of the realist novel. Genette opined that the realist novel "does not easily come to terms with such a practice."[13] In his screed against foreshadowing, *Narrative and Freedom*, Gary Saul Morson maintains that George Eliot and Jane Austen do not do it.[14] Daniel Hack—himself a rare defender of foreshadowing—has demonstrated the ways in which this literary technique has suffered from its

association with high school pedagogy. Novelistic hints of what is to come can seem clunky, overly dramatic, bad narrative housekeeping, a tool from the highschooler's toolbox of narrative theory.[15] Bruce Robbins—another rare defender of prolepsis—claims that Dorrit Cohn says that the realist novelists did not do it.[16] For Genette, the technique seems most at home in retrospective, first-person narratives—like his favorite book, Proust's *A La Recherche du Temps Perdu*, of course—in which the narrator, looking back on a long life, can quite naturally narrate events from his life in light of what he knows comes next. In the third-person narration, critics argue, proleptic gestures become unnatural, opening up a gaping hole between life as we know it and the lives of literary characters. Here is Morson, conducting an odd, thought experiment designed to demonstrate, not only how unnatural a real life endowed with foreshadowing would be, but also how emotionally bereft and morally shriveled:

> As the moral equivalent of characters in a novel, people alive today would lose their claim to any special attention and concern. Their lives would truly be already over and would always have been already over. Their choices would be illusory, for they would already have been made. Those aware of this depressing fact would then not so much live their lives as *live out* their already-plotted lives.[17]

The problem with prolepsis, in this view, is that it exacerbates the always already present condition of the characters of narrative fiction—that their lives are already scripted. Realist fiction, in Morson's view, succeeds only to the extent that it finds ways of pushing back against narrative predetermination. To engage in foreshadowing is to give up the fight.

As Morson's dismal view of a life lived under foreshadowing suggests, objections to narrative futurecasting have a strong moral dimension: it is a reminder of unfreedom. It is not only an aesthetic but an ethical, existential, failure on the part of authors, in that they are compromising the free will of their characters. Yi-Ping Ong argues that in order for fiction to "grip" readers in the grasp of a fictional "lived experience," "the reader must be convinced of the illusion of *an open future* in the novel in a way that recalls the indeterminacy, possibility, and freedom of her own existence"[18] (emphasis mine). Prolepsis is a technique that lays bare the superior abilities of authors and narrators over characters. Genette asserts that "all forms of prolepsis ... always exceed a hero's capacity for knowledge."[19] Foreshadowing is the literary equivalent of "totalitarianism," reducing literary characters to victims.[20] Fiction, in this view, is a zero-sum game in which futurecasting by authors is an excessive assertion of agency on their part which takes place

at the expense of their characters. "Everything that makes foreshadowing possible is not available to the character."[21] Chapter Two revealed metalepsis as harboring a drama about authors' and readers' fundamental helplessness to bring aid to a fiction's characters. Critics of prolepsis, by contrast, seem to marshal a concern for the fundamental helplessness of fictional characters themselves. All the more reason to study metalepsis and prolepsis together: they expose questions of will in relational dramas that are baked into the structure of fiction.

This view of realist fiction—as riven by "tension" between authorial plotting and characterological freedom, as an endeavor in which authors must always cover up the traces of the former in order to promote the illusion of the latter—seems to set up fiction as doomed to fail. Furthermore, this view does not acknowledge that, in fact, most nineteenth-century realist novels are remarkably more tolerant of things that signal authorial agency—not just tolerant but structured through and through. What if we saw the relations between authors and characters, not as an existential struggle, a zero-sum game, but a productive, dynamic relationship? And specifically, is prolepsis in this view unfair to characters, rendering them somehow helpless to determine their destiny, by flashing ahead and revealing something that ought to be allowed (from the character's point of view) to gradually unfurl over hundreds of pages? Does prolepsis, in fact, seem out of place in grand, nineteenth-century realist fiction because the *bildungsroman* is so centrally its form? Does prolepsis rob young characters of their right to develop, of their right to learn from experience?

But perhaps prolepsis—as a hastily leaping forward, "already there" claiming of the future—could be a banner flown proudly by youth, impatient with normative development. In *The Juvenile Tradition: Young Writers and Prolepsis 1750–1830*, Laurie Langbauer suggests that, in fact, to be young is to be oriented around prolepsis, bravely seeking to leap over apprenticeship and live as if already in future glories. Not just freakishly precocious child writers, perhaps, but other kinds of nonnormative youth may be thought of as pushing past, or pushing back against, ordinary developmental paths. George Eliot's young Maggie Tulliver, from the novel that will be central to this chapter, *The Mill on the Floss*, thinks that she is always already impatiently ahead of everyone. She already knows what is in the books that she has not read; she is already ready to be Queen of the Gypsies; she already knows Latin before her brother does. "'O, I can't help it,' said Maggie impatiently."[22] I am reminded of compelling, recent accounts of the cultural narratives of nonnormative children: Kathryn Stockton writes of the queerness of children who seem to grow "sideways" instead of "up"; Stephanie Hershinow writes

of eighteenth-century narratives of youthful experience that are strangely resistant to development; Carolyn Steedman focuses on the disabled child to explore how close nineteenth-century ideas of development were to deformity. The best readers of *The Mill on the Floss* itself have rightfully viewed it as a painful exploration of the perils of growing upways, sideways, anyways.[23] In Vanessa Smith's account, the path to development in *The Mill on the Floss* is littered with toys that "never quite get put away."[24]

Prolepsis puts pressure on narratives of experience. Of the writing in *The Mill on the Floss*, Christoff declares that "development itself is problematized in the novel, both for its violent effects and its failure to capture how deeply regression, and not simply progress, shapes experience."[25] She draws on W. R. Bion's accounts of working with patients who expressed a "hatred of the process of development itself . . . a hatred of having to learn from experience at all."[26] In the Introduction to this current study, I touched briefly on Bion's torturous, but fascinating, account of the dynamic, intersubjective relations that made having access to experience at all possible. He described a process of the transference of experience back and forth between parent and child as that which makes experience tolerable, reconstructed from his work with very ill patients whose ability to connect with their own experience, and in consequence, learn from experience, was curtailed. In Bion's view, learning from experience counterintuitively requires two people—you do not really learn from your "own" experience. Even more counterintuitively, what Bion meant by "learning from experience" was not truly about—as we might be inclined to think—getting a better handle on reality, but about gaining the capacity to dream.[27] Thinking about prolepsis as a form of resistance to narratives of development can make us question what it would mean to "learn from experience," which is, as Wittgenstein reminds us, a slippery idiom: "But how does experience *teach* us, then? *We* may derive it from experience, but experience does not direct us to derive anything from experience."[28]

However, from another point of view, prolepsis may be viewed, not as the unnatural opposite of experience or natural development, but as part of it. Before we turn to George Eliot, I would like to lay out some of the ways in which prolepsis has been used as a psychological, as well as a narratological, concept. We can find this idea in the work of developmental psychologists who, following the twentieth-century Russian psychologist L. S. Vygotsky, emphasize the interpersonal and social dimensions of development. In this tradition, prolepsis is used to describe the ways in which both parents and children look forward, impatiently, to future capacities that do not yet exist. In this schema, development is a matter of playing catch-up to already imagined futures. Development never proceeds in forward motion alone, but

in multiple, temporal schemas, anticipatory and retrospective, a "spiral" of anticipations and realizations.[29]

One of Vygotsky's followers makes a distinction—rivaling Genette's taxonomies!—between autoprolepsis, in which a child imagines that her future has already happened, and that she can do grown-up things already, and heteroprolepsis, in which a parent treats the child as always already her future self.[30] Vygotskyans are most interested in the latter, as it opens up the area of others' expectations—relations with others, and hence the social and cultural—to development. Vygotsky called this area the "zone of proximate development"—that area in between what the child can do on her own, and what she can only do with others.[31] Ordinary examples of heteroprolepsis include parents speaking to very young infants as if they can understand. A mother, for example, "sees something that is not there yet—and that is how she virtually sculpts a child's new behavior. She starts to communicate with her child when the child is not yet capable of communicative activity, but because of that the child in the end is drawn into that activity."[32]

Strikingly similar to the Vygotskian heteroprolepsis is the imagining of the future between parent and child in Hans Loewald's influential "On the Therapeutic Action of Psycho-Analysis" (1960). Loewald turned psychoanalysis "on its head" by intimating the importance, not of a patient's past but of her future, and in particular, her future as imagined by the analyst.[33] The analyst's use of the patient's future is based, of course, on the parent's:

> The parent ideally is in an empathetic relationship of understanding the child's particular stage in development, *yet ahead in his vision of the child's future* and mediating this vision to the child in his dealing with him. This vision, informed by the parent's own experience and knowledge of growth and future, is, ideally, a more articulate and more integrated version of the core of being which the child presents to the parent. This "more" that the parent sees and knows, he mediates to the child so that the child in identification with it can grow. The child, by internalizing aspects of the parent, also internalizes the parent's image of the child—an image which is mediated to the child in the thousand different ways (emphasis mine).[34]

To be a parent, then, is to be always seeing the child proleptically. It is a practice of "vision," to use Loewald's key word in the passage above, of imagining. A child makes a gesture, and you see in the arc of the gesture, its future.[35] You communicate—in "a thousand different ways"—the future shadowed forth by the gesture to the child, who grows to make it real. Another key word in the Loewald passage, however, is "ideally." Psychological proponents of prolepsis normalize it as part of the ordinary, and interpersonal,

course of development. But readers of literature know, alas, that prolepsis is most frequently associated with intimations of tragedy, disaster, and death.[36]

Foreshadowing is usually a dark shadow. In *The Book of Ephraim*, James Merrill anatomizes the melancholy of foreshadowing with the wisp of a passing cloud:

> The cloud passed
> more quickly than the shade it cast,
>
> Foreshadower of nothing, dearest heart,
> But the dim wish of lives to drift apart.[37]

In this literalization of the idea of foreshadowing, there are multiple timelines at play, a sense of things hurtling into the future even more quickly than that which is supposed to foreshadow them. The insouciant speaker claims that the cloud's shadow prefigures "nothing," but it is indeed everything: a lurking, inevitable, entropic drive in human life toward separation. The sense of the inevitable is underscored here by the ways in which rhyme serves as poetry's own mode of literary foreshadowing: the sweetness of the speaker's interjected address to his lover—"dearest heart"—seems touchingly, yet cruelly, undercut by the rhyming, inevitability, of the ways in which "heart" is followed by "apart."

This chapter will use this cluster of ideas—prolepsis and debates about determinism and authorial power, prolepsis and the affections and loss ("dearest heart"), and prolepsis and the growth and separation of children—as touchstones for its investigation of some of the fictions of George Eliot's early period: "The Lifted Veil" (1859), *The Mill on the Floss* (1860), and *Silas Marner* (1861). It is well-known that George Eliot was deeply concerned with the ethics of looking forward into the future, and with the future in, and of, fiction. "We are saved by making the future present to ourselves," says her character Felix Holt.[38] Debra Gettelman's beautiful essay, "Reading Ahead in George Eliot," is fundamentally concerned with Eliot's "investment in future-imagining."[39] Eliot, she demonstrates, struggled to manage readers' desires to know, to predict, what was going to happen in her fictions. My approach here builds on Zemka's work on the ethics of futurecasting in Eliot, and Gettleman's treatment of fictional futures as a stress point between Eliot and her readers. My focus is on the relations between Eliot and her characters. In weaving together—as I have in these pages so far—prolepsis between parents and children, and prolepsis between authors, characters, and readers, we are touching on narrative and psychological dynamics somewhat similar to those discussed in Chapter Two. There, in Margaret Oliphant's writing, we

saw stories of children growing, children stalling, children dying, structuring both the form and the emotions of a narrative technique. I will argue that like metalepsis, prolepsis can embody a desire to protect, and an inability to do so. As the clairvoyant narrator of "The Lifted Veil" knows, there is a huge gap between knowledge and action, between knowing something will happen and being able to prevent it from happening.

But in this chapter, I will also uncover Eliot's treatment of a peculiar species of prolepsis in which a person predicts the future *in order to* prevent it from happening. In this introduction we have seen, in psychological literature, theories about the ways in which parents may forecast their children's futures in order to help them through the "zone of proximal development" to reach those futures. But there is an equally common, and scarier, parental move which involves anticipating future calamity as a form of care.

Beginnings and Endings

Both begun right around the time of the publication of *Adam Bede* in 1859, Eliot's second novel, *The Mill on the Floss*, and her gothic short story, "The Lifted Veil," are curiously intertwined. The earliest mention of the beginnings of *The Mill on the Floss* appears in Eliot's journal entry of January 12, 1859: "We went into town today and looked in the Annual Register for cases of *inundation*," she noted, making clear that the plan for the flood at the end of the novel, for which so many readers have found themselves catastrophically unprepared, was present from the beginning.[40] By March or April of 1859 she had drafted the first several chapters of the novel: it had a beginning and ending, but no middle.

The mystery concerns what happened next. Eliot put aside her work on *The Mill on the Floss* and wrote "The Lifted Veil." Her journal entry for April 26, 1859 notes: "Finished a story—'The Lifted Veil'—which I began one morning at Richmond, as a resource when my head was too stupid for more important work."[41] The next day, she resumed her work on *The Mill on the Floss*, completely rewriting the first two chapters, and then researching and drafting the rest at an astonishingly accelerated pace. She wrote the last words on March 21, 1860, sent it off to her publisher, and set off on a much-anticipated trip to Italy with her partner George Henry Lewes the next day.

Given the story of the intertwined writing of *The Mill on the Floss* and "The Lifted Veil," it has been compelling to think of the two as fitting together like pieces of a puzzle: two pieces of unequal size, "The Lifted Veil" as the little, jagged, dark piece. It has been irresistible, that is, to see the writing of that short story as having enabled George Eliot—after an aborted

or false beginning to her novel—to have begun *The Mill on the Floss* again, and to bring it to completion. This possibility has seemed as perplexing as it is alluring: how could the gothic horror short story about clairvoyance and blood transfusion have anything to do with the intense, emotional, yet fundamentally realist novel? "The Lifted Veil" has been read variously as "a sort of dumping ground" for dark emotions stemming from events in the author's life in 1859—the pain of her brother's rejection, her sister's death, anxieties about the public controversy surrounding her unconventional life and authorial identity—that needed to be "exorcized" through writing before *The Mill on the Floss* could proceed.[42] As Eliot's only fiction narrated in the first person, "The Lifted Veil" has been viewed as a place where the author worked out a mode of self-representation before writing the novel that is most clearly drawn on, in transmuted forms, her own life[43] and anxieties about female authorship.[44] Pessimistic about the virtue of sympathy and the knowledge of other minds, "The Lifted Veil" has been seen as a skeptical counterbalance to, or crash test dummy for, some of the key philosophical values embodied in *The Mill on the Floss* and Eliot's later novels.[45]

All of these interpretations are partially correct. It is essential to see Eliot's shift from realist to gothic mode as a shift to a much more self-conscious form of writing about writing itself. It is crucial to take seriously the role of the biographical crises of 1859 as part of the rupture, just as it is crucial to take seriously the deep links between *The Mill on the Floss* and the author's childhood memories. Compelling as such interpretations are, however, they represent speculative reasoning from facts back to possible causes. It is impossible to know whether there was actually a relationship of cause and effect between the writing of "The Lifted Veil" and the successful completion of *The Mill on the Floss*. However, we can certainly use the intertwined origins of these fictions to intertwine our understandings of them, using one work to illuminate the other. Chronologically, "The Lifted Veil" is embedded inside *The Mill on the Floss*. But in what follows, the embedded text will be used to frame a crucial way of reading the larger novel; and in what follows, there will be a shift away from beginnings—and stories of beginnings—to endings, as well as a shift away from the writer's experiences to the reader's. Both the short story and the novel are fictions fundamentally and unusually oriented around their endings, and around the ways in which the ends of fictions loom as their characters' futures. The opening line of "The Lifted Veil" is: "The time of my end approaches"[46]; Maggie Tulliver in *The Mill on the Floss* asks: "How long will it be?"[47] Both written in a year in which George Eliot felt that "the weight of my future life . . . presses upon me almost continually,"[48]

The Mill on the Floss and "The Lifted Veil" explore the "resources" in, and of, fiction for orienting life and literature toward the future.

The Future in "The Lifted Veil"

Different in genre and mood from anything else that Eliot wrote, "The Lifted Veil" is a tale of supernatural powers. The first-person narrator, Latimer, describes—for a reader he imagines in the future after his death—his sensitive, morbid childhood, his early loss of his mother, his strained relations with his wealthy father and his indifferent older brother, and his aborted scientific education. A childhood illness while living in Geneva leaves him with strange mental powers: first visions of the future, and then the ability to read the thoughts of people around him. After his brother's death, Latimer marries the brother's fiancée—the cold, inscrutable Bertha, who he loves precisely because her thoughts alone are hidden from him—in spite of his clairvoyant knowledge that in the future she will come to hate him. Indeed, after their marriage, the veil hiding her thoughts is lifted. The story culminates in an outlandish episode in which Bertha's dead servant, Mrs. Archer, is fleetingly brought back to life by a blood transfusion, and in her brief return to life reveals Bertha's plan to murder her husband. Like Mary Shelley's *Frankenstein*, Eliot's venture into gothic fiction allowed her, not only to experiment with narrative technique, but to also explore contemporary debates in science and pseudoscience: about psychological phenomena, vivisection, and medicine.[49]

It is important, however, to discriminate among Latimer's mental powers because they extend in several directions. His ability to know the minds of others has, not surprisingly, received the most critical attention. It seems a power so close to that of the omniscient narrator of the psychological realist novel as Eliot was developing it, and so seemingly bound up with the values of understanding and sympathy central to Eliot's ethics. Not long after completing "The Lifted Veil," and back at work on *The Mill on the Floss*, she professed: "If Art does not enlarge men's sympathies, it does nothing morally ... the only effect I ardently long to produce by my writings, is that those who read them should be better able to *imagine* and to *feel* the pains and the joys of those who differ from themselves in everything but the broad fact of being struggling erring human creatures."[50] For Latimer, access to the pains, joys, and the "stream of thought" of other human creatures is horrific.[51] It is like "an importunate, ill-played musical instrument, or the loud activity of an imprisoned insect" that only makes him recoil, with greater misanthropy, from the pettiness of others, rather than enlarging his sympathies.[52] "The

Lifted Veil" has thus been a crucial text for critics wishing to think critically about sympathy and omniscience in Eliot's work, some taking the gloomy story as license for a skeptical account of sympathy,[53] others arguing that Eliot, in fact, theorized sympathy as a virtue distinct from identification with, and knowledge of, others.[54]

But "The Lifted Veil" presents Latimer's mind reading powers as a subset of a larger, broader power—seeing into the future. His first freaky experiences include a hallucinogenic vision of Prague, which corresponds exactly to his visit to that city several pages later,[55] and a preview of his first meeting with Bertha, which is realized one page later.[56] Latimer sees his ability to see into minds as unfolding from there: "My prevision of incalculable words and action proved it to have a fixed relation to the mental process in other minds," he says.[57] The forecasting dimension of Latimer's powers has, on the whole, received less critical attention than the mind reading,[58] perhaps because it seems less philosophically rich, more preposterous and crystal ball(ish) than does an engagement with the problem of other minds. However, to recognize the ways in which "The Lifted Veil" subordinates mind reading to future-casting might shift the ways in which we interpret this gothic tale's potential for helping us understand George Eliot's writing by helping us think about the pull of the future in her narrative art.

In "The Lifted Veil," George Eliot rattles our sense that the primary verb tense of fiction is the past tense, that fiction is about the conferral of the reality-effect of the past tense on things that never happened.[59] The opening paragraphs of "The Lifted Veil" describe what never happened, but also what *hasn't* happened. It is an account of what will happen "one month from this day" of the time of narration: "For I foresee when I shall die, and everything that will happen in my last moments."[60] The opening page takes Latimer right to the brink, modulating into the present tense: "Darkness—darkness—no pain—nothing but darkness; but I am passing on and on through darkness; my thought stays in the darkness, but always with a sense of moving onward . . ."[61] At the end of the story, after the retrospective narration that makes up the body of "The Lifted Veil," the narration returns to this moment, on the brink of Latimer's death: "It is the 20th of September 1850. I know these figures I have just written, as if they were a long familiar inscription. I have seen them on this page in my desk unnumbered times, when the scene of my dying struggle has opened upon me . . ."[62] What is most striking about comparing the two passages just quoted is their similarities, not their differences. That is, while we may be tempted to read the latter utterance as taking place right in the moment of death itself, the play of verb tenses and markers in both utterances do not make clear that Latimer has

"really" arrived in the future at the end. The present tense of "it is the 20th of September" was present in the futurecasting version at the beginning, as well. The "now" of the end may not be the real future, or the future finally arrived in the present, but another futurecasting vision of this moment, which has been repeated "unnumbered" times. The undecidability of the time in the story at the end, of whether a month has "really" transpired in the story since the opening frame, of course makes us aware that the only real present is the "now" of narrative discourse, and above all, the now of reading, "this page" coming to signify, not the page Latimer has written, but the page we are reading.[63]

The revelation of the centrality of the future in "The Lifted Veil" to the time frame of fiction may be further underscored by the ways in which Latimer and his creator take pains to naturalize his visions of the future, as if his presentiments of the future are not that different from those of ordinary mortals. First, his previsions seem highly selective. Unless we attribute to him unusual levels of deliberate withholding of information, Latimer seems to have had, for example, no idea what was to transpire at Mrs. Archer's deathbed. Such a highly fallible clairvoyant narrator reinforces our sense that it is the author herself who is the only person who can see around a fiction's future corners. Like ordinary mortals, Latimer finds himself looking back and wishing that he "could have had a foreshadowing" of other events, lamenting "that if I had foreseen something more or something different," things would have worked out differently.[64] Freaky as his powers are, he appeals to his readers to recognize an affinity between his own glances into the future, and their own: "Yet you must have known something of the presentiments that spring from insight at war with passion; and my visions were only like presentiments intensified to horror."[65] His futurecastings, Latimer suggests, are only intensified versions of the ordinary presentiments, forebodings, and fearful obsessions about the future that are part of life, and according to *The Mill on the Floss* (as we shall see), part of love: "love gives insight," Philip Wakem tells Maggie, "and insight often gives foreboding."[66]

The notion that forecasting the future is akin to ordinary modes of thinking is an idea that finds support in several important sources in George Eliot's intellectual milieu. Eliot was enormously influenced by her friend and early intellectual mentor Charles Bray's *Philosophy of Necessity* (1841). Bray's "law of consequences"—the principle that all events are necessitated by the conditions that precede them—tethers future outcomes closely to present causes.[67] In October 1859, Eliot was reading Auguste Comte's *Catechism of Positive Religion,* just translated by her neighbor Richard Congreve,[68] in which Comte predicts the logical outcome of the practice of the principles

of positivism in a future where the "religion of Humanity" replaces all other religion. In Comte's religion of Humanity, a "Positive conception of the future life" is one in which individuals live on through collective bonds.[69] In the early 1850s, Eliot had herself contemplated writing a book to be called *The Idea of a Future Life*, influenced by Feuerbach's *The Essence of Christianity*, which interprets the Christian idea of the future life as simply an imaginative extrapolation of the present: "The future life is this life once lost, but found again, and radiant with all the more brightness for the joy of recovery ... it is the beauteous present intensified."[70] Neil Hertz notes that in this conception, the future resembles fiction itself: in turning to the writing of fiction in the later 1850s, he suggests, Eliot had found another way to write books about the idea of a future life.[71] In Eliot's intellectual world, in other words, there was a perhaps unusually high interest in, and optimism about, the knowability of the future. Both "The Lifted Veil" and *The Mill on the Floss*, however, derive a great deal of their pathos from the ways in which a commitment to predicting the future renders ever more acute an inability to prevent it.

Predicting the End in *The Mill on the Floss*

To think about *The Mill on the Floss* is to think about its catastrophic ending, in which Maggie and Tom Tulliver are swept to their deaths in a flood of the river Floss that smashes the mill and destroys parts of the town of St. Oggs. It is the single biggest interpretive issue in the novel, and the thing that creates an enormous gulf between an innocent first reading and a second reading. Any subsequent reading is dominated by the intense, gravitational pull of the ending, and a sense of dread and helplessness in the face of coming disaster. It could be objected that *The Mill on the Floss* shares this with any tragic dramatic or narrative work, and indeed theories of tragedy have always loomed large in critical discussions of this novel, from contemporary reviews to more recent assessments of the novel in light of Eliot's own writing on Greek tragedy.[72] But the dread and helplessness of the repeat reader, as she feels herself sucked toward the end of *The Mill on the Floss*, is distinctive for at least two reasons. One is the fact that the tragic conclusion involves a sudden and massive natural disaster, which extracts tragic outcome from any causal chain of human agency among the characters and pins it on authorial choice. The other reason involves genre. Tom and Maggie Tulliver are protagonists of a bildungsroman, the genre whose plot tracks the growth and development of a literary character from childhood. While *The Mill on the Floss* was certainly not the only tragic bildungsroman, or anti-bildungsroman,[73] the way that

it demands the witnessing of the proximity of development of children to destruction brings special pain.

These factors may explain why there has been such vigorous debate, since the novel's publication, about whether the tragic ending of *The Mill on the Floss* is justified, or sufficiently prepared for.[74] An early reviewer complained that right up to the end, the novel's "development is languid and struggling," and, using the novel's own persistent water imagery: "the slow, placid, and somewhat turbid stream too suddenly changes to a rushing waterfall; the canal ends in a cascade."[75] The Victorian novelist Edward Bulwer-Lytton explicitly contrasted the novel to the standard of classical tragedy: "The Tragic should be prepared for and seem to come step by step as if unavoidable. But that is not the case here."[76] On the other side are readers who have either seen the tragic ending as completely woven into the fabric of the novel as a whole,[77] or viewed the particularly shocking nature of its ending as entirely necessary. Over the past forty years, the most eloquent voices expressing the latter view have been feminist critics, who have read the novel's ending as a woman novelist's indictment of the limited plots available in the European literary tradition for female characters such as Maggie;[78] as a symbolic, liberating upwelling of female desire and power;[79] or as Eliot's drastic symbolic sacrifice of her characters' unconventional life so that she could live, and write, her own.[80] The feeling that Eliot engaged in some kind of violent, willful, premeditated sacrifice of her character hangs heavy throughout Eliot criticism, and indeed can be, perhaps, detected in a remark that she made assenting to some of the criticism of poor pacing in the novel. "My love of the childhood scenes made me linger over them," she wrote, "so that I could not develop as fully as I wished the concluding book in which the tragedy occurs, and which I had looked forward to with *attentive premeditation*" (emphasis mine).[81]

Having begun her work on the novel researching "cases of *inundation*,"[82] Eliot had indeed premeditated the end from the beginning; it was no last-minute sacrifice. But the letter just quoted—with its language of authorial love, development, and "attentive premeditation"—may help us be attentive to the kinds of intimations of the end there are in *The Mill on the Floss*. Far from failing to prepare readers for the ending, there is, in fact, plenty of forecasting, some of a surprisingly unsophisticated nature. Some of it is voiced by the novel's most unsophisticated character: the unimaginative, bewildered Mrs. Tulliver. "Maggie, Maggie," she nags, "where's the use o' my telling you to keep away from the water? You'll tumble in and be drowned some day, an' then you'll be sorry you didn't do as mother told you."[83] "They're such

children for the water, mine are," she says of both Maggie and Tom: "they'll be brought in dead and drownded some day."[84] Both Mrs. Tulliver and her sister Mrs. Glegg, at different times seriously jump the gun, rushing to the conclusion that Maggie has drowned long before she does.[85]

Mrs. Tulliver's utterances function as a *prolepsis*: they are narrative devices by which an author flashes forward to what will be coming down the road.[86] Moreover, this species of prolepsis, in which a character within the story itself seems to predict what will happen in it ("homodiegetic prolepsis")[87] can seem ridiculously artificial, even embarrassing, in the work of so sophisticated a novelist.[88] The likelihood that we will view Mrs. Tulliver's utterances as a clumsy narrative device is utterly dependent on our assessment of her character—provincial, limited, unprophetic. We can sharpen our sense of the unusual awkwardness of Mrs. Tulliver as an instrument of narrative prolepsis by contrasting her utterances to the prophetic utterances of other Eliot characters. In "The Lifted Veil," Latimer's prophetic remarks are integrated into who he is as a character and as a narrator. Later Eliot characters who seem gifted with foresight, such as the visionary mystic Mordecai in *Daniel Deronda*, similarly strike us as characters whom the novelist has fully vested with special powers. By contrast, Mrs. Tulliver's homely prophecies can be seen as rudimentary examples of what Roland Barthes termed "the completeness" ("*la complétude*") of even the most sophisticated realist novels, the way that they seem to contain archaic forms of storytelling that put a premium on everything in the story "matching up," thus creating a kind of surplus of meaning through which all the parts of the fiction legitimate each other.[89]

Mrs. Tulliver's predictions, then, contribute to our sense of *The Mill on the Floss* as a novel in which literary realism—including the painstaking evocation of the social contexts that determine the limited worldview of a provincial woman such as Mrs. Tulliver—works in tandem with narrative events, forces, and effects that feel archaic and elemental. As one earlier reviewer put it, such aspects of *The Mill on the Floss* "seem to crop out of the rich culture of [Eliot's] mind like the primitive rocks of an earlier world . . . vestiges of a Titanic time, before the reign of the peaceful gods commenced."[90] We can further specify the role of Mrs. Tulliver's utterances in the fabric of the novel by focusing on them as species of a particularly powerful, perhaps "primitive," but certainly "rich" mental phenomenon. While the sophisticated reader may instantly decode Mrs. Tulliver's utterances as a narrative device, those exclamations are also instances of psychological phenomena that George Eliot was extremely interested in, not only in *The Mill on the Floss* but also in her later novels: forms of magical thinking.[91]

In *The Mill on the Floss*, as elsewhere, Eliot is highly attentive to the psychology of magical thinking: forms of wishful thinking attended by a belief, or at least a hope, that thinking about something might make it happen—or not happen. In *Daniel Deronda*, for example, Eliot asks for a toleration of Gwendolen Harleth's belief that her thinking has killed her husband. Her belief, while irrational, is a valuable index of moral growth.[92] Magical thinking is often wishful thinking about the future, such as the "mirage" of future glory that Maggie Tulliver paints on "the desert of the future,"[93] Rosamond Vincy's tendency to "rapid forecast" in *Middlemarch,* or Hetty Sorrel's dreams of her future as a great lady in *Adam Bede*.[94] In contrast to these more common, self-flattering and obviously consoling forms of magical thinking, Mrs. Tulliver's predictions that Maggie will drown—especially when she utters them, not to Maggie in warning, but to herself "without reflecting that there was no one to hear her"—are instances of apotropaic magic.[95] They are, that is, instances of the way that our minds rush forward to imagine the worst in the hope that the worst, therefore, will be warded off. Eliot's own term for this kind of thinking is "foreboding," and in *The Mill on the Floss*, foreboding is not only associated with love ("love gives insight, and insight often gives foreboding"), but it is also the defining prerogative of adulthood—and in particular, parenthood. In one of the novel's many celebrated utterances about the perspectivelessness of childhood, Eliot notes: "While the possible troubles of Maggie's future were occupying her father's mind, she herself was tasting only the bitterness of the present. Childhood has no forebodings, but then, it is soothed by no memories of outlived sorrow."[96]

Lines such as Mrs. Tulliver's "They'll be brought in dead and drownded some day," in other words, partake of a perverse, although surprisingly common, folk psychology particular to parenthood: that we can protect our children from the worst by imagining it for them instead. As fatalistic as they sound, such lines may be thought of as a kind of death line that is really a kind of lifeline for both parent and child, a sentence designed to serve as rope with life preserver tied to the end. We can find mordant, parental magical thinking in the diary that George Eliot's contemporary novelist, and admirer, Elizabeth Gaskell kept of the early years of her first child's life. The diary is full of these kind of death line / lifeline sentences that express, simultaneously, the need for vigilant attention to signs of danger in the child, the need to prepare herself for possibility of the child dying, and the wishful thinking that, in attending and writing about this possibility, she could prevent it. "Oh! May I not make her into an idol, but strive to prepare both her and myself for the change that may come at any day."[97] "Death," Carolyn Steedman comments, "its nervous anticipation, and the taming of it by evocation were

the regular apostrophes of her diary."[98] Both Eliot's and Gaskell's emphasis on a kind of parental attentiveness that is inseparable from apotropaic foreboding suggests that such thinking is as integral a part of parental care as feeding and clothing. While clearly deluded (in that telling someone they are going to fall into the river and drown does not actually protect them), you would not want parents not to do it; it is part of the parent-child relationship, and a kind of reality-testing of levels of responsibility for others.

To think of Mrs. Tulliver's dire predictions for Maggie and Tom in this context presents us with some interesting interpretive possibilities. It might seem that the two possibilities outlined thus far—seeing her predictions either as a clumsy narrative device to prepare the reader for tragedy, or as instances of a superstitious, but common, form of parental care—pose a stark choice, like an optical illusion that forces you to see a picture of either a rabbit or a duck. It is a choice between reading at the level of "discourse"—the choices and activities of the storyteller—or at the level of what they call "the story"—the events and circumstances, including characters, being described. But the emotions that cling to the level of discourse and the level of story are never quite as distinct as the narratologists sometimes make them out to be. As readers, we may register Mrs. Tulliver's statements as belonging to both registers at once, coloring each other: the narrative device of prolepsis borrows some of the psychological and emotional weight of parental magical thinking.

To make such a link between narrative function and parent-child relations may seem uncomfortably close to suggesting that George Eliot viewed her novels as her children. There is actually some evidence that she did: she referred in a letter to *The Mill on the Floss* as her "youngest child," and George Henry Lewes described her writing of the novel as a form of parental care: rocking the cradle of the "new 'little stranger.'"[99] Furthermore, reaching the end of writing *The Mill on the Floss* was intimately bound up with Eliot's anticipation of a new future that involved parenthood.[100] Throughout the time of the writing of *The Mill on the Floss,* she was assuming a new role, via letters, as a virtual stepmother to George Henry Lewes's three sons, all away at boarding school. At this moment they were her "dream children"—as the nineteenth-century essayist Charles Lamb famously described imaginary children—forged in a relationship through writing, hovering between the present and future. As she raced to finish the novel, Eliot was preparing for a journey which would involve meeting the boys for the first time. One of them was to come live with them: "I hope my heart will be large enough for all the love that is required of me," she confided to a friend.[101]

Critics, biographers, and ordinary readers wishing to connect *The Mill on*

the Floss to Eliot's own life have overwhelmingly stressed its relation to her past, as well as the novel's emphasis, in general, on history and memory. Set in the English provinces in the decades after the Napoleonic Wars, *The Mill on the Floss* both commemorates the slow disappearance of a preindustrial way of life and evokes Eliot's own childhood. Clearly based on the author's close, but painful, relationship with her own brother, Isaac Evans, the evocation, not only of the relationship between Maggie and Tom Tulliver, but also of the joys and pains of childhood, have been viewed by critics as responses to William Wordsworth's modes of making poetry out of memory.[102] But emphasizing the connections between the end of *The Mill on the Floss* and events in the author's future life allows us to think about the ways in which the novel is oriented around the future, rather than the past.[103]

More significant than these associations between writing, parenthood, and the idea of a future life, may be the way in which the curiously parental nature of prefiguring the ending resonates throughout *The Mill on the Floss*. Metaphors evoking parental care and anticipation are structured into the fabric of the novel, attaching to characters in often unexpected ways. For example, near the end of the novel, when Maggie's hopes for a meeting with her cousin Lucy—a meeting that she both longs for and dreads—are dashed by the news that Lucy has already left town, Eliot compares Maggie's feelings to the feelings of "those who have known what it is to dread their own selfish desires as the watching mother would dread the sleeping potion that was to still her own pain."[104] In this complex metaphor, care for others is modeled on the excruciating vigilance of the mother who stays up watching over a (perhaps) sick child, a mother whose worst fear seems to be that she might choose sleep over vigilance: a vigilance about vigilance. That this metaphor is about Maggie Tulliver—so often the object of others' worries—underscores the extent to which *The Mill on the Floss* revolves around anticipating future calamity as a form of care, a desire to protect.

Will, Determinism, Necessity, and Narration

Both the intense, gravitational pull of the ending of *The Mill on the Floss*, and Eliot's way of conceiving of care and responsibility for others as foreboding about their futures, shape the central philosophical issues at the heart of this novel: the relations among freedom of will, weakness of will, determinism, and necessity. The flip side of conceiving of care as "attentive premeditation" (again, Eliot's phrase to describe the end of the novel) is helplessness. The watchful mother cannot protect her child from harm just by watching; Mrs. Tulliver cannot actually prevent Maggie from drowning by predicting that

she will. In the essay discussed in Chapter Two, Andrew H. Miller suggests that nineteenth-century English novels, from Jane Austen to Thomas Hardy, prompt readers to reflect on their own feelings of helplessness with respect to the events unfolding in the novel that they are reading, by providing models of helplessness among the characters.[105] *The Mill on the Floss* certainly belongs in this company. But, unlike the urbane constraint of Jane Austen's characters whose hands are tied by propriety, as well as circumstance, or the helplessness of Hardy's tragic characters in the hands of an ineluctable, absolutely predetermined fate, *The Mill on the Floss* hones in on the intermediate helplessness of parents and children, where the boundaries between one person's will and another's are blurred. Eliot's famous aside in *The Mill on the Floss* about how "we have all of us sobbed so piteously, standing with tiny bare legs above our little socks, when we lost sight of our mother" evokes childhood helplessness at its most primal.[106] The impotence that Mr. Tulliver feels at his failure to provide for his family, prompts him to force Tom to swear to revenge him.[107] Tom, who embodies more than anyone else, a belief in free will and self-determination, is always, for all of his heroic enterprise, following his father's script.

The complex mixture of freedom and constraint that inheres in relations between parents and children may provide a model for thinking about the novel's great questions: Is Maggie's tragic end the necessary outcome of events that were predetermined? Maggie would seem to exemplify the unfreedom of literary character, crushed by authorial plotting, imagined by the foes of foreshadowing, such as Gary Paul Morson, discussed in the introduction to this chapter. However, as I have sought to suggest through *The Mill on the Floss*, there are ways to view prolepsis that provide a much less stark picture. We have learned to think of prolepsis as more ambiguously distributed among partners in a "zone of proximal development"; we have seen, through *The Mill on the Floss*, the complicity of narratorial prolepsis with parental care and magical thinking.

The question of whether *The Mill on the Floss* illustrates a belief in the determination of human destiny by some necessity within or without us, or whether it illustrates a belief in free will, has been debated as much as the question of whether Eliot prepared her readers for the flood at the end. The two questions, one about the narrator's "discourse" and the other about the characters' "story," are intertwined, much as Mrs. Tulliver's forebodings point to both author's and character's attempts to determine Maggie's future. In general, older criticism viewed the novel as illustrating a deterministic worldview. Some Victorian reviewers were troubled by what they saw as the novel's tendency to vitiate free will, and they linked this moral problem to

the novel's very realism: the painstaking evocation of the social context in which Maggie lives seemed to script and hem her in.[108] Feminist critics have viewed Maggie's lack of free agency as an indictment of the limited choices for women in Victorian society.[109] Other scholars have returned to Eliot's intellectual roots, and have argued that, for the novelist, as for some of her philosophical and scientific contemporaries, a belief in determination and a commitment to individual responsibility and will were not incompatible: the two were viewed as necessarily working hand in hand.[110]

Any attentive reader of *The Mill on the Floss*—and in particular of Book 6, "The Great Temptation"—should certainly come to the conclusion that, doctrinally, the novel presents a mixed view of the interplay of determinism and will, and that Maggie herself embodies a messy mix of weakness of will and heroic action. So much of Maggie's action, in particular in Book 6 as she alternately resists Stephen's appeals, finds herself drifting down the river with him "without any act of her own will,"[111] then chooses not to elope with him but to return alone, all appearances of dishonor against her, to St. Ogg's—seem poised between conscious choice and involuntary action. In a phrase that painfully captures the compatibility of strength and weakness of will, Eliot compares Maggie's last act (at the end of Book 6), as she takes her final leave from Stephen, to "an automatic action that fulfills a forgotten intention."[112] Maggie articulates strong principles for her decisions: the feelings of others,[113] and the sanctity of the past.[114] But as Rosemarie Bodenheimer argues, "the novel allows for such variant readings" of Maggie's choices that "it allows us to feel that Maggie's final choice is simultaneously an act of moral heroism and one of masochistic self-destruction." She is "perpetually in the position of making choices she does not act upon, acting upon choices framed by others' needs, and being judged as the agent of her actions."[115] The principle that Maggie's moral struggles most illustrates is that, in fact, no one principle can be the standard for moral decisions. This is the position that Eliot articulates in the famous passage criticizing what she calls "the men of maxims": the people who have "minds that are guided in their moral judgments solely by general rules, thinking that these will lead them to justice by a ready-made patent method."[116] In contrast, Eliot asserts, "moral judgments must remain false and hollow unless they are checked and enlightened by a perpetual reference to the special circumstances that mark the individual lot," and shaped by "the insight that comes from a hardly earned estimate of temptation, or from a life vivid and intense enough to have created a wide fellow-feeling with all that is human."[117] Maggie's story is less about the content of her moral reasonings than about delineating "the hopelessly tangled stresses of competing claims which constitute acts of choice"[118]; and

above all, in engaging readers in the motions of moral processes, framed by the story of an inevitable future that we wish we could prevent, but cannot.

But above all, any attempt to understand the interplay of free will and necessity in *The Mill on the Floss* must take into consideration how Eliot allows us to see Maggie from the outside and the inside, using narrative techniques that sometimes meld together, and sometimes separate, the narrator's and the character's points of view. Readers have often been struck by the closeness of the narrator to Maggie's mind. "In very few works of fiction has the interior of the mind been so keenly analyzed," marveled one Victorian reviewer, who continued: "There are parts of the story where the style gives a kind of consciousness of reality, as if you heard the words spoken by a voice shaken with the emotions so well described."[119] For example, when Maggie wakes up after her night on the boat with Stephen, the narrative voice follows the rhythms of a voice "shaken by emotions":

> There was at least this fruit from all her years of striving after the highest and the best—that her soul, though betrayed, beguiled, ensnared, could never deliberately consent to a choice of the lower. And a choice of what? O God—not a choice of joy—but of conscious cruelty and hardness; for could she ever cease to see before her Lucy and Philip with their murdered trust and hopes?[120]

Certainly, by the second sentence—with its involuntary exclamations of anguish, its questions, its jagged punctuation—we feel that Eliot is, via free indirect discourse, getting right to the truth of Maggie's inner thoughts and feelings. Narrator and character seem completely one. Yet readers may feel that the first of these two sentences—with its high-minded diction about "striving after what is highest and best"—sounds more like something a George Eliot narrator, rather than a Maggie Tulliver, would write or say. That in this instance, Maggie has become a mouthpiece for Eliot's doctrine of self-abnegation. Faint alternations and overlaps of the voices of narrator and character cultivate in the reader a discriminating sense that there is a choice to be made at every moment about whose will, whose freedom is at stake.

Furthermore, in some of the many instances such as this one, in which a view of Maggie's predicament, from a third-person narratorial and a second-person intimate point of view, interrupt each other, the distinguishing feature of the eruption of the third-person view within the second is the presence of an eye toward the future. For example, as Maggie finds herself mired in conflicting commitments to Philip Wakem and to her brother, this passage of mostly free, indirect discourse concludes with a sentence that may strike us as one of the narrator's statements, rather than Maggie's thoughts:

She used to think in that time that she had made great conquests, and won a lasting stand on serene heights above worldly temptation and conflict. And here she was down again in the thick of a hot strife with her own and others' passions. Life was not so short, then, and perfect rest was not so near, as she had dreamed when she was two years younger. There was more struggle for her—perhaps more falling.[121]

One of the reasons that we may be likely to feel, in the last sentence, that we are hearing the narrator's thoughts rather than Maggie's, is that it sounds like a prediction; at the same time, one of the reasons this sentence sounds like a prediction—rather than as a statement of fact—is that it sounds like the narrator, rather than Maggie, speaking. The two impressions reinforce each other: narration in *The Mill on the Floss* is associated with orientation toward another's future.

Crucial as it is to focus on the narrator's closeness to Maggie's inner feelings and thoughts, it is just as crucial to think about the emotional relationship between the narrator and Maggie when their modes of thinking diverge, or when thinking itself is distributed unequally between them—that is, when the narrator is thinking, but Maggie is not. "Maggie, we know, was apt to forget the thing she was doing"[122]; we find her sometimes "ceasing to think."[123] There is, for example, the incident of the dead rabbits at the beginning of the novel. A chance comment by the miller Luke shocks the young Maggie into the sudden realization that she has completely forgotten a promise to Tom, away at school, to take care of his pet rabbits, now dead. The care required of Maggie was not the mundane care of feeding the rabbits—that devolves on a mill hand named Harry[124]—but simply remembering them. As Maggie says, "O Luke, Tom told me to be sure and remember the rabbits every day—but how could I, when they did not come into my head, you know?"[125] This incident, which has the sickening contours of a bad dream, seems to confirm that thinking about others—keeping them in your head—is necessary to their survival. A lapse of vigilance equals a failure to protect, equals death.

In *The Mill on the Floss* it sometimes seems as if there are two modes of mental activity, one being an "eager prefiguring imagination" or hypervigilance that sees around every corner, the other being not thinking at all.[126] These two modes of mental function correspond on the level of discourse to an opposition, set up in the very first chapter of the novel, between narrating on the one hand, and sleeping, dreaming, or blanking out on the other. In the Introduction to this book, I discussed *The Mill on the Floss*'s

opening, present-tense evocation of the mill on the Floss, which culminates in a description of the young Maggie standing by the edge of the river, gazing at the water with rapt, absorbed contemplation. The chapter ends with the narrator "waking" and addressing the reader: "Before I dozed off, I was going to tell you what Mr. and Mrs. Tulliver were talking about as they sat by the bright fire in the left-hand parlour on that very afternoon I have been dreaming of."[127] The next chapter commences that "tell"ing. This present-tense narrative frame establishes Maggie as the narrator's mental object—her dream child. This impression is strengthened by the intensely emotional feel of the imagery of the opening reverie, which saturates the rustic scene of the mill and its environs with the language of love, touch, and embrace. Highly personified, the river and the sea, the soil and the crops, the horse and its master, the willows and the water, and the narrator and the ducks, are all bound together in love, and in a shared, drowsy, semiconscious, "half-drowned"ness or "deafness."[128]

The presence of these two modes of mental functioning in *The Mill on the Floss*—dreamy unconsciousness versus hypervigilant foreboding—is distributed between the narrator and the characters. Thus, the question of responsibility, of whose will is causing things to happen, is bound up in our perception of who is doing the thinking. *The Mill on the Floss* seems to cast vigilant, foreboding thinking as a form of protection and care for others, but the question of who is protecting who is always shifting. For example, as the flood waters of the Floss rise during the final, fatal night, Maggie is awake while others sleep, and becomes extraordinarily active, surprising some of those she seeks to help, including Tom Tulliver's friend Bob Jakins:

> The fact that Maggie had been up, had waked him, and taken the lead in activity, gave Bob a vague impression of her as one who would help to protect, not need to be protected.[129]

Who is the protector, and who is the protected? "I thought she was protecting me," says the mother of the severely ill infant in Patricia Lockwood's *No One Is Talking About This*.[130] Protecting and being protected are constantly reversible in the imagination, as is the question of who is imagining whom. Who is the imaginer, and who is the imagined?[131]

Development, Education, and the Futures of *The Mill on the Floss*

The Mill on the Floss is unique, even among tragic bildungsromane, in its evocation of the inherent proximity of development to devolution. Although

Eliot read Darwin's *Origin of the Species* in 1859 during its composition, the novel unfurls a version of evolution without evolutionism's typical commitment to progress: "development, for George Eliot, also entails loss."[132] There are precedents for *The Mill on the Floss*'s embrace of development and decay in other arenas of Victorian science as well, such as cell theory and physiology, which intuited that, at the level of the individual organism, the ultimate trend of individual growth was its own individual extinction. *The Mill on the Floss*, and other theories of development that express development's elegiac side, confront what *Bildung* can look like from the point of view, not of the one developing, but of the looker-on: the hard, unstoppable fact that "a child grows up, and goes away."[133]

In *The Mill on the Floss*, one important aspect of Bildung, formal education, gets a pretty mixed report card,[134] and Maggie's own most significant experience of book learning is one in which she only learns half the lesson, missing "the inmost truth."[135] Accidentally coming across the medieval mystic Thomas à Kempis's book of meditations, *The Imitation of Christ,* Maggie half learns its lesson of self-renunciation: she throws herself enthusiastically into what seems to her a heroic life of self-denial without embracing the hard truth, that "renunciation remains sorrow." This episode of reading is designed to illustrate Maggie's passionate nature, and to protest against the limited possibilities for a young woman coming of age in the world of *The Mill on the Floss*, a world in which self-denial might appear a rational choice. But in this description of an encounter between a book and a reader, the deck seems overwhelmingly stacked against the reader: the book itself appears more uncanny, more genuinely creepy, than anything in the gothic "The Lifted Veil." The "little, old, clumsy" copy of *Imitation of Christ* that falls into Maggie's hands seems strangely alive:

> It had the corners turned down in many places, and some hand, now for ever quiet, had made at certain passages strong pen and ink marks, long since browned by time. Maggie turned from leaf to leaf and read where the quiet hand pointed.... She went on from one brown mark to another, where the quiet hand seemed to point, hardly conscious that she was reading—seeming rather to listen [to] a low voice.[136]

Pushing out of the past and into what is its future—Maggie's present—this old book seems to compel her, "with all the hurry of an imagination that could never rest in the present," to imagine a strange future for herself.[137]

The futures of all books lie in the hands of readers. Indeed, throughout the scholarly literature on prolepsis is a strain of thinking that views prolepsis as the fundamental structure of the relationship between a text and its

readers.[138] Maggie Tulliver—with that "hurry of an imagination that could never rest in the present"—knows that to read a novel is to be engaged in hurrying forward and forecasting the novel's end. This is what she does with Sir Walter Scott's *The Pirate* and with Madame de Stael's *Corinne*: she predicts the endings.[139] Maggie cannot tolerate the unhappy futures that she forecasts for Scott's and de Stael's heroines: for the former, she invents an alternative future; for the latter, she refuses to read on. The future is indeed an often-intolerable place for novel characters, and for novel readers. In a short story called "Brother Jacob," George Eliot alludes to the "heroes" of certain novels by the French writer Honoré de Balzac, "whose foresight is so remarkably at home in the future."[140] It is hard to know what Eliot means by this. What would it mean for foresight to be "at home" in the future? Does it just mean foresight that turns out to be right? In "The Lifted Veil," Latimer is someone whose foresight is right, but nothing about him seems at home in the future, or anywhere else. But the people who are at home in a book's future are its readers. *The Mill on the Floss*'s future began when it fell into the hands of readers and continues to do so. For readers of *The Mill on the Floss*, there is no "quiet hand" making little brown marks to point us to the moral, to lift for us the veil that reveals meaning, or to draw a veil for us over the painful parts. But just as we can, if we wish, speculate about the origins of *The Mill on the Floss*, we can speculate on its futures—including its futures that are already past.

The Mill on the Floss's impact on the development of its readers, particularly of generations of nineteenth- and twentieth-century women intellectuals, has been enormous. For example, the French philosopher, novelist, and feminist Simone de Beauvoir was bowled over by Eliot's novel at the age of eleven and returned to it again and again.[141] In her eighties, she discussed with her biographer what *The Mill on the Floss* had meant to her. Her biographer summarizes:

> It was somehow comforting to read and reread that Maggie Tulliver had no control over the circumstances of her life and her tragic death. It helped Simone de Beauvoir to deal with her own adolescence and to accept how little control she had over it.[142]

The Mill on the Floss also prompted de Beauvoir to imagine a future as a writer.[143] Somehow Eliot's novel made it possible for this reader to tolerate the pain of reading tragic endings that seem scripted from the beginning. Perhaps learning this—and learning to tolerate responsibility for oneself and for others, but also to tolerate the painful limits of that responsibility—is the best development that anyone can make.

Coda: *Silas Marner*

After finishing *The Mill on the Floss,* George Eliot worried that she had foreshadowed the whole plot of her next novel even before her reader reached the first page. She chose an epigraph for the title page of *Silas Marner* from Wordsworth's poem "Michael," and immediately second-guessed it. The epigraph reads:

> A child, more than all other gifts
> That earth can offer to declining man,
> Brings hope with it, and forward-looking thoughts.[144]

"Do you think it indicates the story too distinctly?" she fretted to her publisher, John Blackwood.[145] The epigraph prefigures, of course, Silas Marner, a "declining man"'s mysterious acquisition of the child Eppie, whom he and others in Raveloe consider a kind of gift. The last phrase of the epigraph clinches the association of children and future thinking, which has been central to this chapter.

In *Silas Marner,* as in *The Mill on the Floss*, affective relations between parents and children and narrative forecasting seem to be woven into the signifying structures of the novel. As we saw, the curiously parental nature of prefiguring the ending resonates throughout *The Mill on the Floss*. Metaphors evoking parental care and anticipation are structured into the fabric of the novel, attaching to characters in often unexpected ways, as in the simile comparing Maggie to a "watching mother" who holds a child in her vigilant gaze.[146] Very early in *Silas Marner*—before Eppie is a glimmer in anyone's eye—Eliot uses an abstract image of a child's instinctive, unknowing desire for her parent as a figure for abstraction, and for the cognitive difficulty of abstraction itself. Here she seeks to convey how instinctive was the barely literate Silas's early religious experiences:

> A weaver who finds hard words in his hymn-book knows nothing of abstractions; as the little child knows nothing of parental love, but only knows one face and one lap towards which it stretches its arms for refuge and nurture.[147]

What an odd simile to gloss Silas's mental habits! How strange to use "parental love" as an example of an abstract category! First and foremost, the simile is designed to portray the young Silas as childlike, "primitive." But the simile has its own interests. First, in making the point that in practice, for children, parental love is, of course, not experienced as an abstract concept but is embodied in a singularity, the simile paradoxically renders "parental love" the exemplar, not only of abstraction, but of symbolization—it is analogous

to the "hard words" in Silas's hymn book. Second, there is a funny mismatch between that abstraction—"parental love"—and the hypothetical child's experience. The phrase "parental love" most immediately refers to parents' love *for* children, but the singular instance that Eliot offers—the one lap toward which it stretches its arms—is actually about the *child's desire for the parent*. As with the similar, complex metaphor of the abstracted "watching mother" in *The Mill on the Floss* discussed earlier, this simile of "parental love" reinforces the abstract(ability), transferability, and reversibility of parent-child bonds. As I have been arguing throughout this chapter, "parental love" is shockingly crucial to Eliot's early fiction, not as theme and subject matter, but precisely as an abstract substratum that characterizes key aspects of her narrative form, including her uses of prolepsis.

However, for anyone who is not a first-time reader of *Silas Marner*, the most striking thing about the image in the "parental love" simile is the way that it foreshadows the events of *Silas Marner*: to read the simile of the child who does not know or care what "parental love" is but knows the "one lap" toward which it stretches its arms, is to conjure up the image of the infant Eppie, indifferent to the fact that Silas Marner is not her parent, but clinging to his neck,[148] seizing his head in her arms,[149] nestling in his lap a few chapters later. Symbolization, parental love, and prefiguration are conjoined here.

The association between children and futurity has also been material for queer critiques of *Silas Marner*, who have seen the novel as embodying a normative, reproductive social order, oriented around futurity by glorifying the child Eppie: "the novel, then, as if 'naturally,' offers us Eppie, in her relation to Marner, as the material embodiment of futurism . . . who affirms the endless renewal of time."[150] But what an unnatural child Eppie is! She seems to come out of the blue; she either is, or is not, equivalent or exchangeable for a bag of gold. She is made out of Wordsworthian allusions: not only does she fulfill the foreshadowing of the epigraph, but she is made to embody "Three Years She Grew In Sun and Shower."[151] Structurally her story most resembles that of a Shakespearean heroine: like Perdita in *The Winter's Tale*, she is absent from us for sixteen years, appearing only as a very small child, and then later as a young woman.

The missing sixteen years in a single sheet of paper between Part 1 and Part 2 are the most notable thing about *Silas Marner*. It is a novel with a beginning and an ending, but no middle. It is typological in its structure: everything that happens in (the dramatically shorter) Part 2 fulfills a mystery—from the characters' perspectives, although not from the readers', who saw these events in Part 1—from Part 1. In Part 1, Dunstan Cass mysteriously

disappears forever, having fallen to the bottom of a watery grave; in Part 2, the draining of the old pit reveals his remains. In Part 1, Silas's gold is mysteriously stolen; in Part 2; the gold is found alongside Dunstan's bones. In Part 1, the secret of Eppie's parentage is known only to her father Godfrey Cass; in Part 2, he confesses it. In Part 1, Godfrey utters a deluded skepticism about the future which itself foreshadows a newfound belief in the inevitability of outcomes in Part 2. He initially justifies his concealment of Eppie's parentage by insisting that "nobody could tell how things would turn out": perhaps she would be better off not knowing.[152] But he comes to express a belief—at least in retrospect—in foreknowledge: "I might have known this would be the end of it," and later he admits that "everything comes to light . . . sooner or later."[153] The reader's "surplus of knowledge"—the fact that the reader, at times, knows much more than the characters—characteristic of foreshadowy narratives, weighs heavily on *Silas Marner*.[154] In Kate Brown's words, "the narrative's sixteen-year gap promotes a theory of consequentiality that denies contingency . . . the narrative cannot sustain its attention to the present, cutting instead to the future."[155]

The sixteen-year gap in *Silas Marner* is also, I would contend, the most notable thing about Eppie. If *The Mill on the Floss* is an anti-bildungsroman, by demonstrating the inseparability of development and disaster, *Silas Marner* dispenses with Bildung altogether. The weird, unaccountable daughter is shrunk into a token. She is so often indicated via synecdoche; she is a head of golden curls.[156] Kate Brown refers correctly to the fundamental "non-narrativity of Eppie."[157] Eppie's nonnarrativity allows her to flourish in readers'—as well as the characters'—minds as a shimmering object of exchange, substitution, or compensation in this fable-like novel. The central, critical crux concerning *Silas Marner* has always been how to pinpoint the nature of Eppie in relation to Silas's stolen gold coins. Is she a substitute for the gold, and if so, what kind? In what ways can a baby be said to be an equivalent to gold? Do we stress the similarities between Silas's attachment to the gold and his love for Eppie, or the differences? Should we think of her as the gold itself, metamorphosed, translated into human form? Is the baby a compensation for the lost gold, or a figure for its loss, or a corrective to Silas's idolatrous devotion to it?[158] Eliot wrote that *Silas Marner* was designed to set "in a strong light the remedial influences of pure, natural, human relations."[159] In this view, Eppie is a vehicle for remediation, restoration, and amelioration. Eppie is imagined to exist in multiple, interlocking relations of remediation. Her biological father, Godfrey Cass, believes that belatedly adopting her could make up, not only for his failures as a father, but also for his shortcomings as a husband to

both Eppie's mother, Molly, and to his current wife Nancy. The questions surrounding Eppie cannot be given a single answer, but they ought to prompt the most uncomfortable question of all: what are children *for?*

We have focused in this chapter on how the modes of thinking and narrating that go under the heading of *prolepsis* are so often associated with parents' relations to their children. Specifically, we have focused on the peculiar psychology of the particular form of parental future thinking that involves fearing the worst. But *Silas Marner* reminds us that children are so often viewed, not only with such forward-looking negative emotions, but with what philosopher R. Jay Wallace groups together as the "negative retrospective emotions": guilt, remorse, and regret.[160] For Wallace, all of the "retrospective negative emotions" are bound up with love, attachment, and value—as well as pain. In its improbable tale of odd adoptive parenthood, *Silas Marner* discloses the ways in which parents often imagine children in relation to past pains and regrets. As Kate Brown argues, the novel reveals, not so much the child as emblem of "reproductive futurism,"[161] but the child as emblem of the past, and even more, the elusive present that is always on its way to being past. Grooving on the structure of *Silas Marner*—with its missing sixteen years of Eppie's experience of development—Brown is moved to meditate on the ways in which "the present is already in the process of change so irremediable that it constitutes a kind of loss." "This recognition of the ephemerality of the present," she continues:

> Is best symbolized, perhaps for ourselves as well as for Victorians, by the child: its future uncertain except to the extent that it will incalculably follow from and remake the past, the child brings the present into view as that which is precious because it is already going, already gone.

Implicitly—but lightly—channeling Melanie Klein, Brown's contemplation of *Silas Marner* moves her to tap into the fundamentally "mournful"[162]— or to use Klein's term, "depressive"—position of both the mother and the writer of fiction:

> Meticulously observing and describing that which can be possessed only in remembrance, as an unexternalizable psychic treasure, the morality signified by the maternal gaze is constitutively mournful. This is finally, of course, to say that the ethical, fostering, maternal gaze is also the gaze of the novelist, which likewise privileges the body and the present moment from the position of disembodiment and retrospection; that is, from the position of loss.[163]

Readers may feel that there is a lot taken for granted in Brown's "this is of course to say" in this passage; some readers may wish to not take for granted,

in particular, the conflation of the "maternal gaze" with "the gaze of the novelist." Yet Brown is capturing a *position* of the narration in Eliot's early work, one which structures fictions through the temporalities—past and future—of affects and responsibilities.

The summer that I started writing this chapter, I had a dream that I was responsible for removing a millrace (or, perhaps, an earthen embankment that created a millrace) from a dammed-up river near my house, causing a flood. The effect of the dream was guilt, and bewilderment that I had caused such accidental harm; the thought of the dream was "whoops, I didn't mean to do that." In fact, at the time, there was a public discussion about the need to either remove or replace an aging dam on the river in our neighborhood. But clearly, in my dream, I was channeling both the George Eliot who caused a flood in *The Mill on the Floss*, and the Maggie Tulliver who unintentionally causes her brother's rabbits to die ("O ... how could I ... ?").[164] It is the essence of George Eliot's fiction that it prompts both intense thoughts and feelings about responsibility and about gray areas where it is not clear where responsibilities lie. In Neil Hertz's influential account, these stories of responsibility are always bound up with questions about the agency of writing:

> These are novels that bring the question of the responsibilities of authorship—the guilt or innocence of the novelist, the aggressive willfulness, or perhaps only the will, inherent in plotting a story—into touch with a thematics of rudimentary gestures like weaving, marking, or incising in ways that so reframe the question that we are obliged ... to put words like "guilt" or "innocence" within quotation marks. Silas's weaving, "like the speaker, from pure impulse, without reflection," comes to serve as an emblem not for the innocence of authorship but for its roots in a form of motion or agency to which words like activity or passivity, guilt or innocence, cannot do justice.[165]

Hertz's argument here is that Eliot links the agency of writing to the various author-surrogates—the craftspeople such as Adam Bede the carpenter, Silas Marner the weaver—that populate the novels. Doing so, Hertz argues, renders responsible agency into pure motion.

But in my view, Eliot's novels also articulate an intense fear of doing harm—from Maggie and the rabbits to Gwendolyn Harleth's fear of causing her husband's death in *Daniel Deronda*—and also explore the desire to predict, prevent, and also compensate for harm. In Chapter Four, I shall explore the ways in which a related nexus of inadvertent harm, regret, and the desire to compensate shapes the very form of Elizabeth Gaskell's fiction. We might wish, as we move forward, to keep in mind Gaskell's diary of her daughter Marianne's first years, which made a guest appearance earlier in

this chapter. Gaskell discovered, with surprise, how completely continuous with each other were her experiences of writing and parenting. "I had no idea the journal of my own disposition and feelings was so intimately connected with that of my little baby, whose regular breathing has been the music of my thought all the time I have been writing," she exclaims; "it is difficult to know when to begin or when to stop when talking, thinking, or writing about her."[166] And thinking and writing about Marianne seemed to prompt—and be prompted by—fears of harming her, and anxieties about her future. As discussed earlier, the diary is strung together with ritual anticipations of Marianne's death. "Oh! May I not make her into an idol, but strive to prepare both her and myself for the change that may come at any day."[167] The fact that Marianne, at six months old, seems happy and healthy ("she is so good that I feel as if I could hardly be sufficiently thankful that the materials put into my hands are so excellent and beautiful") seemed only to increase Gaskell's apprehensions. "And yet it [Marianne's goodness] seems to increase the responsibility. If I should misguide from carelessness or negligence!" she exclaims.[168] Next, we turn to questions of responsibility, fear of doing wrong, regret, remorse, and realism in Gaskell's fiction.

4. Regret, Remorse, and Realism in Elizabeth Gaskell

Introduction

A year before the birth of her daughter Marianne, Elizabeth Gaskell had a stillborn baby. Three years afterward—and two years after Marianne's birth—Gaskell connected the dots between living and dead infants in a sonnet, "On Visiting the Grave of my Stillborn Little Girl, Sunday, July 4th, 1836." Poems addressed to dead infants—literary "little coffins"—were ubiquitous presences in the nineteenth-century literary landscape.[1] In penning this poem, Gaskell joined many other women poets who mourned lost children, such as Lydia Sigourney ("The Lost Darling," "Death of an Infant," for example, also from the 1830s). Expressions of grief, and records of women's experiences of infant mortality, poems addressing dead infants were also appeals to poetic tradition, and affirmations of piety and Christian consolation.[2] But Gaskell's lost baby poem is striking for the ways in which it is conditioned by a second, living child, Marianne:

> I made a vow within my soul, O Child,
> When thou wert laid beside my weary heart,
> With marks of death on every tender part
> That, if in time a living infant smiled,
> Winning my ear with gentles sounds of love
> In sunshine of such joy, I still would save
> A green rest for thy memory, O Dove!
> And oft times visit thy small, nameless grave.
> Thee have I not forgot, my firstborn, thou
> Whose eyes ne'er opened to my wistful gaze,
> Whose sufferings stamped with pain thy little brow;

> I think of thee in these far happier days.
> And thou, my child, from thy bright heaven see
> How well I keep my faithful vow to thee.[3]

Staged carefully in a specifically dated, present moment of happiness ("these far happier days"), the sonnet's remembrance of the lost baby takes the form of remembered anticipation. This is, moreover, a patently fictitious past moment of anticipation: it strains the imagination to believe that—right after delivering a stillborn infant ("when thou wert laid beside my weary heart")—a newly bereaved woman would already be looking forward to happiness with a "living infant," and striking a bargain with the future: if I have another baby, I will remember you! The living infant of the present moment pulls the poem's attention away from the grave, taking up valuable, scarce sonnet real estate by "winning my ear with gentles sounds of love / In sunshine of such joy," while Gaskell insists that she nevertheless "*still* would save" a thought for the dead one. Like almost all nineteenth-century poems of mourning motherhood, "On Visiting the Grave" imagines the lost child looking down from heaven, but without either the anguished ambivalence or the pious resolution that we find in poems by Sigourney, Piatt, and others. While the manifest content of the sonnet is the mother's remembrance of, and faithfulness to, the lost infant, the latent content is the replacement of the dead baby with a live one. Gaskell's biographer Jenny Uglow's characterization of the sonnet's mode is exactly spot-on: "serene, not submissive, realistic, not pious, the poem is remarkable for the honesty with which Gaskell accepts without guilt that the joy of another child has a healing power as great as, if not greater, than the religious consolation."[4] In Chapter Three, I noted that that Eliot's *Silas Marner* raises the uncomfortable question of what children are for, whether it is fair to ask a child to compensate or make amends for past losses. Gaskell, in this poem at least, suggests that one child may compensate for the loss of another.

The point of dwelling on this surprising poem is not to pass judgment on Gaskell's maternal sentiments, but to note it as an instance of the centrality of dynamics of exchange, transfer, and compensation in Gaskell's life and writing. And above all, *between* her life and writing. An oft-cited origin story for her first novel, *Mary Barton*, has Gaskell managing her grief at the death of yet another infant a few years later through the writing of fiction: "The tale was formed" she wrote, "when I was obliged to lie down constantly on the sofa, and when I took refuge in the invention to *exclude* the memory of painful scenes which would force themselves on my remembrance" (emphasis mine).[5] Moreover, the substitution of live child for dead child in "On

Visiting the Grave" gives context for the fears and prophylactic gestures in *My Diary*, Gaskell's record of the poem's "living infant" Marianne's first year. A sense of the new child as compensation for the lost one conditions the intense fear of doing accidental harm to the living one. In other words, while Uglow's identification of the poem's "serene" contemplation of its substitution of one child for another is correct, it is also true that this substitutive logic brought onto Gaskell an endless anxiety—"mother's fears," she called them—to make sure that the substitute survived, was good enough, was spared any accidental harm.[6]

Gaskell seems to have been especially alive to narratives that cycle through loss, serene accounts of amends made or promised, and fear of accidental harm.[7] We can see this cycle clustered, not only around births and deaths of children, but in relation to her writing.[8] The writing of *The Life of Charlotte Brontë*—a text central to Chapter One of the present study—is a case in point. Commissioned by the Reverend Patrick Brontë shortly after his daughter's death, Gaskell's biography of her late friend was written in a fever of anxiety—anxiety, above all, to both get the real, true story, and to defend Charlotte Brontë's reputation. Gaskell researched, interviewed survivors, and consulted documents provided to her by the Brontës' family and friends. Her letters record the psychological predicament of the biographer of a recently dead, and still mourned, friend. There is a direct line between her survivor's guilt, her regret at having dropped the ball at the end of Charlotte's life ("I never wrote to her again after that October letter; and I do so regret it now!"), and her desire to record faithfully "her wild sad life, and the beautiful character that grew out of it."[9] As she struggled with *The Life of Charlotte Brontë*, she balanced losses and gains, the things that she was able to put into her biography and the things that she was advised to take out (such as, for example, an account of Thackeray in tears over the pages of *Jane Eyre*), balancing the "too much" information versus the "not enough." "If my readers find that I have not said enough, I have said too much," she writes at the conclusion of *The Life of Charlotte Brontë*.[10]

In practice, however, the math between the "too much" and the "not enough" felt wrong, not only to Gaskell but also to many of the survivors. After submitting the manuscript of her biography to her publisher, Gaskell fled to Europe for a few months, but on her return found herself in a "Hornets' nest."[11] Many people felt hurt by the book, claiming that they or their loved ones had been misrepresented, in some cases threatening libel suits. "Every one who has been harmed in this unlucky book complains of something," she exclaimed.[12] The subsequent months were consumed with making amends, offering appeasements, and working on revisions for a new

edition. Her letters record emotional swings between regret about having unintentionally injured people,[13] and irritation and impatience to find solutions that would allow her to make amends and move on. Her sensitivity and ambivalence are manifest in a joking proposal to her publisher, cooked up, she claimed by one of her defenders. How about, she suggested, slapping onto all future editions of *The Life of Charlotte Brontë* a blanket apology like this: "If anybody is displeased with any statement in this book, they are requested to believe it withdrawn, and my deep regret expressed for its insertion, as truth is too expensive an article to be laid before the British public."[14]

It is impossible to overestimate the importance of *The Life of Charlotte Brontë,* in the history of biography and as a turning point in nineteenth-century literary publishing.[15] And as a complex event in the history of the book: some of the deliberations over the book's frontispiece—an image that was remarkably resonant for Victorian readers—involving the negotiations of the transmission of photo to engraving, were discussed in Chapter One of the present study. Remarkably, for all the controversy about the book's "harm" to living survivors at the time of its publication, *The Life of Charlotte Brontë*—as we saw in Chapter One—lived on as a book that subsequent generations of readers and writers experienced as distinctly weaponized and wounding. Assigned as suitable reading for the next generation of Victorian children, it was remembered as a book that caused lasting pain. In Alice Meynell's words, we recall, to read it "is to open once more a wound which most men perhaps, certainly most women, received into their hearts in childhood."[16] To read it involved a "pain" "hardly bear"able even to the adult rereader.[17] These commenters on the effects of reading Gaskell's book, as we have noted, tended to put themselves in the position of vulnerable children, imagining themselves as child readers, traumatized by reading, too young, about the deaths of the little Brontës. Their patterns of imagery suggested that it was the little narrow coffins of the Brontës that were so wounding, and that seemed to prompt a flight into descriptive patterns in which texture is replaced with lines. It is hard not to feel in the later writers' "pain," as well, a somewhat uncanny echo of its original readers' "harm." One wonders if Gaskell would have extended her "deep regret"—ambivalent as it was—to the readers of the future.

It may be appropriate at this point to reprise the role of Elizabeth Gaskell in this study thus far, for *The Life of Charlotte Brontë*'s strange wounding of later writers has been only one of the ways in which she has appeared. As author of *The Life of Charlotte Brontë*, a book that made an indelible, often traumatic, mark on other writers, Gaskell looms over accounts of the Brontës' relationship to "experience" as a category. She shaped images and patterns of

description that became associated with "experience" in Brontë reception that got handed down, transferred among the later writers. We have seen Gaskell, moreover, as a fascinated investigator of transfers between real and vicarious experience ("I cannot account for this psychologically," she wonders at Charlotte Brontë's ability to write about opium). Although, as we saw, she was viewed by Margaret Oliphant as protected, insulated from future mining of her experience by the presence of actual children, we have also seen Elizabeth Gaskell as an unsparing spokesperson for maternal vigilance and its relation to writing. This study's version of Elizabeth Gaskell—which focuses on this cluster of psychological considerations and aftereffects—may seem somewhat outside the orbit of the central concerns of most Gaskell readers and scholars, so often focused on her place in Victorian literary realism, in particular in her great "social problem" novels, *Mary Barton*, *North and South*, and *Ruth*.[18] In this chapter, however, I build on the cluster of Gaskell appearances across *The Location of Experience* to argue for her importance as a theorist of the psychology of literary realism. Gaskell's writing, I contend, highlights not only the ways in which fiction can evoke a world, but also its limits in doing so. In this way, we shall see, she can serve as an ideal guide to the links of literary realism with both emotions of remorse and regret, and gestures of recompense.

In turning to remorse and regret in Gaskell's novels, I am not only pursuing into her fiction some of the shades of feeling in her poem and letters with which I started this chapter. I am also exploring the role in fiction of emotions closely linked to those studied in Chapters Two and Three. A desire to protect; a desire to reach across a barrier to help; a feeling of helplessness; a failure to do so: these are all things that wind up in the territory of remorse and regret. In the pages at the end of this chapter, my approach to these terms, and my intellectual debts, will be clear. However, a few words of terminology are in order here. Moral philosophers following Bernard Williams often distinguish between remorse and regret: remorse is what we feel when we have knowingly harmed another, while regret is a much more capacious emotion that can express a wish that things were otherwise in cases where our own agency is, perhaps, only distantly at stake. The distinction is a way to parse crucial questions about agency, responsibility, and freedom.[19] In practice, most usage—including Gaskell's own—tends to use the terms as practically synonymous, or on a spectrum in which remorse marks out the more emotionally intense end. In general, without avoiding altogether the pressing questions of agency and culpability, I will do the same. Perhaps more relevant is a different contrast, which may overlap partially with the

distinction between regret and remorse: a distinction between existential regrets about the self, and regret/remorse that exist in interpersonal relations. The literary dimensions of the most existential forms of regret—the ones that accompany the question, what if things had been different?—have been explored by Andrew H. Miller, who details how regrets about lives unled put pressure on the very idea of experience.[20] The Gaskell narratives that I treat ask different questions: How could I have done this to another person? How can I make amends? "I stood by . . . wondering what I could do to remedy the present state of things."[21]

This chapter focuses on this cluster of concerns—regret, remorse, realism, and remedy—emphasizing Gaskell's later fiction, written in the wake of her experiences navigating the writing of *The Life of Charlotte Brontë*. As early as right after Gaskell's death in 1865, there emerged a consensus that these later works form a distinctive set. In the posthumous "Conclusion" to *Wives and Daughters*, *Cornhill Magazine* editor Frederick Greenwood declared that "it is clear in this novel of *Wives and Daughters*, in the exquisite little story that preceded it, *Cousin Phillis*, and in *Sylvia's Lovers*, that Mrs. Gaskell had within these five years started upon a new career . . . with a mind which seemed to have put off its clay and to have been born again."[22] In particular, Greenwood marveled, "when you read any of the last three books . . . you feel that this is, at least, as real a world as the other."[23]

In turning to Gaskell here, in other words, I am also returning to the questions about what makes up a fictional world, and where experience is located, addressed in the Introduction to this study, and to the place of description and detail. In Chapter One, where we noted Gaskell's philosophical fascination with Charlotte Brontë's experience-shifting across imagined and real, we also tracked a pattern in which claims about the Brontës' relation to experience got formulated along an axis of descriptive language: the absence or irrelevance of experience coded as slick, smooth surfaces, as experience itself gets cast as color, fuzziness, heaviness, and description—pure texture and detail. The history of theories of literary realism has been persistently riven between approaches that emphasize story and approaches that emphasize detail—between narration and description. In what follows—in which we will focus on lines, textures, and story—I hope to show that this need not be a choice.[24]

I focus primarily on *Cousin Phillis*—the last completed work published in Gaskell's life—a work that is made up of both textures and lines, but also in which feelings of remorse and gestures of recompense are transferred among author, narrator, and characters, and in which imaginary experience is seen as transferrable to real life. And I begin with a pile of stockings.

Half-Mended Stockings

To put stockings and realism together is to conjure the famous brown stocking for which Erich Auerbach named his final chapter of *Mimesis: The Representation of Reality in Western Literature* (1946)—a book that, for decades, shaped understandings of literary realism. It is a "reddish-brown hairy stocking"; Mrs. Ramsay is knitting it for the lighthouse keeper's son in Virginia Woolf's *To the Lighthouse*; and it is central to Auerbach's account of modernism's mode of apprehending reality.[25] He zeroes in on an extended passage in which Mrs. Ramsay's attempt to measure the brown stocking against her own son's leg ("was it too long, was it too short?") is the "insignificant ... exterior ... framing occurrence" that, in Auerbach's words, serves to "release" Woolf's excursus into the inner lives of multiple characters.[26] The insignificance of the brown stocking itself, the "randomness and contingency of the exterior occasion" of its measuring, and by extension all modern fiction's "chance occasion"s and "minor, unimpressive, random events," are absolutely essential to Auerbach's understanding of modern literature's mode of lighting up an "objective reality" "which appears as established fact."[27] To be modern is to have "confidence that in any random fragment plucked from the course of a life at any time the totality is contained and can be portrayed."[28] "What realistic depth," Auerbach exclaims, "is achieved in every individual occurrence, for example the measuring of the stocking!"[29] Woolf's brown stocking points to "nothing less than the wealth of reality and depth of life in every moment to which we surrender ourselves without prejudice."[30]

With sixty years' hindsight, we can see how very modern Auerbach's own faith in the reality was—the richness of the unhierarchized, "random" details of life. In claiming to choose literary details like the brown stocking at random ("the great majority of the texts were chosen at random," he says)[31] Auerbach followed a method that mirrored the modernist literary technique that he celebrated.[32] With historical distance it is also possible to emphasize Auerbach's embrace of the real-as-random as itself less than random: as a "negative condition"; as a means of rescuing "the real" from the determinations of ideology and history at the height of fascism; as an appeal to a democratic vision in which every bit of experience is equal to every other.[33] Auerbach's palpable love for the brown stocking has also come to seem less than random in the ways in which it exemplifies the "emotionally charged" nature of *Mimesis* as a whole, ringed round, as it was, by Auerbach's circumstances during its writing: the sadness, the survivor's guilt, the sense of exile.[34] "It's too short," says Mrs. Ramsay, sadly, of the stocking, "ever

so much too short." "Never did anybody look so sad," says the narrator of Mrs. Ramsay.[35]

Here, I introduce another stocking, raveling and unraveling in another literary text—Elizabeth Gaskell's beautiful 1864 novella *Cousin Phillis*—in order to affirm what may have been latent in *Mimesis*: that literary realism may be as much an effect of feeling, as an "imitation of real life."[36] Rightly called a "masterpiece," and "the most perfect story in the language,"[37] *Cousin Phillis* excels—via its first-person narrator, a railway engineer's clerk named Paul Manning—at placing before us a detailed, three-dimensional, sensory experience of its world, in passages such as this one. The narrator is sitting with his cousin Phillis and her mother, "cousin Holman":

> Cousin Holman gave me the weekly county newspaper to read aloud to her, while she mended stockings out of a high piled-up basket, Phillis helping her mother. I read and read, unregardful of the words I was uttering, thinking of all manner of other things; of the bright colour of Phillis's hair, as the afternoon sun fell on her bending head; of the silence of the house, which enabled me to hear the double tick of the old clock, which stood half-way up the stairs; of the variety of inarticulate noises which cousin Holman made while I read, to show her sympathy, wonder, or horror at the newspaper intelligence. The tranquil monotony of that hour made me feel as if I had lived for ever, and should live for ever droning out paragraphs in that warm sunny room, with my two quiet hearers, and the curled-up pussy cat sleeping on the hearth-rug, and the clock on the house-stairs perpetually clicking out the passage of the moments. By-and-by Betty the servant came to the door into the kitchen, and made a sign to Phillis, who put her half-mended stocking down, and went away to the kitchen without a word.[38]

This passage is typical of *Cousin Phillis* in painting a kind of thin, artificial pastoral—the very model of nineteenth-century quaint, domestic coziness, curled-up pussycat and all—and at the same time a very thick description: thick to the point of fuzzy. The thickness arises from its 360-degree spatial, tactile, visual, and aural components. There is the clock that is halfway up the stairs: not at the bottom, not at the top of the spatial field, but in its halfway-upness, creating a space with not only a middle, but also a bottom and top. The space is filled out with silences and sounds: "double ticks," clicks, inarticulate murmurs, and the drone of a reading voice.

In its slowing and stopping of narrative time, and in its sensory fullness, this passage from *Cousin Phillis* is an instance of the "new realism of affect" that Fredric Jameson sees as a crucial component of nineteenth-century European realism in *The Antinomies of Realism*. Jameson charts the emergence

of a new "scenic impulse" which evokes a transformed "sensorium" of bodily sensations and perceptions which is in tension with the temporality of narration.[39] In its plenitude of sensory, textured description, *Cousin Phillis* seems miles away from the pared-down, Teflon-like descriptions of Haworth that Gaskell created in *The Life of Charlotte Brontë*, discussed in Chapter One of this study. However, the passage evokes a world that is, actually, both fuzzily full and incomplete at the same time: like the overflowing basket of woolly stockings, versus Phillis's half-mended one. It is hard to know, when Paul says he feels as "if I had lived for ever, and should live for ever droning out paragraphs in that warm sunny room," whether this sense of being suspended there forever is a kind of pastoral nostalgia for a moment of perfect plenitude, or some version of hell. When Paul follows his country cousin, Phillis, into the kitchen two sentences later, he finds her—not unlike Emily Brontë reading German philosophy propped up while she kneaded dough—reading Dante's *Inferno* as she does her chores.[40] In this paragraph, as throughout, *Cousin Phillis* can be seen in its simultaneous fullness and flatness to exemplify in miniature the heartbreaking game of making amends for life's inadequacies that William Empson identified as one of the "tricks" of pastoral:

> The feeling that life is essentially inadequate to the human spirit, and yet that a good life must avoid saying so, is naturally at home with most versions of pastoral; in pastoral you take a limited life and pretend it is the full and normal one, and a suggestion [exists] that one must do this with all life, because the normal is itself limited.... Conversely any expression of the idea that all life is limited may be regarded as only a trick of pastoral, perhaps chiefly intended to hold all our attention and sympathy for some limited life.[41]

In *Cousin Phillis,* the "feeling"—to use Empson's word—of both wishing away, and wresting with, pathos from the inadequacies of life, inadequacies that seem both normal and not, attaches itself to realism's representational dramas. By "realism's representational dramas," I mean the ways in which, when we read fiction, what is close before us—words on a page—flickers in between being just enough and reminding us of all we do not have before us: an actual sensory world. The mathematics of balancing saying "too much" versus "not enough"[42] are on the brink. *Cousin Phillis* is both a deeply moving tale, and a theorization of realism's affective ends. The domestic, rural, small-scale, up-close realism of Gaskell's novella—for all of its fuzziness and closeness—is best thought of as akin to the distant, limited sensing—using means of triangulation, geometry, abstraction—used by the novella's first-person narrator and his railroad engineer boss (who are also two points of the novella's romantic triangle, along with the narrator's cousin

Phillis) to construe reality as they crisscross the English countryside surveying railroad lines. I will proceed, in fact, with lines and triangles, although I will thread my way back to stockings and feelings later.

Lines and Angles

Cousin Phillis is a story of lines: not only the twisting, wooly lines of half-mended stockings, but also straight ones.[43] It takes place around the laying out of a new railroad line—"a little branch line"[44]—in the countryside. This is Paul Manning's first job, moving down the line with his boss, a dashing engineer named Holdsworth. The narrative line of the novella completely follows this little railroad line from point A to point B, from the story's opening in the market town where the line begins, to its progress through the countryside, to its winding down as the characters convene nearer the village where the line comes to its "end."[45] The convergence of railroad line, plotline, and other forms of literary line in *Cousin Phillis* is one source of its "subtle metafictional reflexiveness."[46] For there are many literary lines in *Cousin Phillis*, from the lines from Dante's *Inferno* that Phillis fruitlessly seeks Paul's aid with;[47] to the "Latin lines" from Virgil's first *Georgic* that Phillis and her father, the farmer/minister Reverend Holman, love;[48] to the "lines" from Wordsworth's poem "She dwelt among th'untrodden ways" that Paul quotes to describe his cousin.[49] So alive to the meanings of lines—of keeping on the straight and narrow, of finding an engineering solution, of finding a "steady bottom" in a mossy patch of land "over which we wished to carry our line"[50]—is Paul Manning, that with great understatement he describes the utterance that is the novella's moral and dramatic crisis: "I had stepped a little out of my usual line in telling her what I did."[51] At the risk of getting ahead of my own line: what Paul did, was to tell his cousin Phillis that his dashing boss Holdsworth loved her, and would surely come back to marry her; what actually happens is that Holdsworth moves across the ocean and marries someone else, and Phillis's life goes off the rails.

The geometry of *Cousin Phillis*, in other words, is not just about lines that go from point A to point B, but lines that make up triangles: romantic and personal triangles, but also angles and triangles that, even in their bare abstract geometry, allow us to flesh out a world. *Cousin Phillis* describes a world curiously built out of three-cornered things. Paul Manning starts off his story describing with pride the "little three-cornered room"[52] above a "three-cornered shop"[53]—a pastry shop—that is his lodging during this, his first job: it is his residence of adulthood. Dropped off by his father, he settles in:

I stowed my eatables away in the little corner cupboard—that room was all corners, and everything was placed in a corner, the fire-place, the window, the cupboard; I myself seemed to be the only thing in the middle, and there was hardly room for me.[54]

The Reverend Holman has a "three-cornered chair,"[55] and has a study that has at least three corners—it is a "strange, many-cornered room."[56] Many cornered? How many corners, how many lines? It is difficult to plot this geometry, or imagine this room, of course, because there is not enough information. But a three-cornered room like Paul Manning's is likewise both a prompt and a challenge to mental imagining, a disorienting prod.

Why? If fictional worlds are sometimes viewed—as we saw in the Introduction to this study—as bordered by "sharp categorical boundaries"[57] that readers seek to cross, what if those boundaries form a triangle? What is it like to enter a fictional world via a three-cornered room, in which the narrator positions himself as surrounded by those three corners, "the only thing in the middle"? For Gaston Bachelard, corners are vanishing points that elude representation: rarely seen in literature, he claimed, they "bear the mark of a certain negativism"; they are "the geometry of ... indigent solitude."[58] Elizabeth Gaskell defies Bachelard's account: in *Sylvia's Lovers*, for example, she insists that the "'chimney corner' really was a corner" in the Robson family home. Here in Gaskell's fiction, there are corners, and here is a different explanation. One way to think about realist descriptions of domestic interiors—which Elizabeth Gaskell excelled at—is as if there is the kind of transparent "fourth wall" that theater theorists talk about, or the open fourth wall of a dollhouse. The remaining three walls that we feel, that we see, create the feeling of three-dimensional space. (Some fictional descriptions of domestic interiors, by contrast, explicitly ask readers to imagine taking off the roof of a house or room).[59] However, if there are only three walls to a room, where are we? The imaginative space both claims a particular spatial geometry and threatens to shut it down. The subtraction of a wall is likely to make Paul's room seem both more concrete and closer to us, and at the same time incomplete, somehow harder to enter.

Cousin Phillis, this is to say, starts readers off with a very strange floor plan, one that functions, as Frederic Jameson argued in his essay "The Realist Floor-Plan," less as a sign pointing to a particular content or meaning, than as a kind of reader-"reprogramming": an "active remoulding of the reader's 'mentality.'"[60] In Jameson's account, it is the function of the nineteenth-century realist novelists "not merely to produce new mental and existential habits, but in a virtual ... way to produce this whole new

spatial and temporal configuration itself: what will come to be called 'daily life,'... or, in a different terminology, the 'referent.'"[61] Building (as it were) on Jameson's "realist floor-plan," Anna Kornbluh asks us to think of novels as a "realist blueprint" that allows us to erect an entire three-dimensional structure. "What if this floor plan were extruded into a blueprint,"[62] she asks? What if we take mathematical and architectural modeling as our models for realist novels—"a projective composition of integral space," as "charrettes for sociality"?[63]

The idea that realist fiction does its work, not by faithfully painting what is actually already there, but by giving readers a new floor plan, a blueprint, a charrette, or "set of processing instructions" from which to "extrude" a new sense of reality, has gotten some traction from cognitive studies-inflected theorists of realism. The floor plan laid out in a few words, as well as the thickest of narrative descriptions, are in Elaine Auyoung's words, "a parsimonious set of cues" which effectively suggest something more. The verbal cues of fiction, in this view, are on a continuum with the various perceptual cues that human brains are good at using, "filling in" for the chronic "deficits of information" with which we all proceed.[64] We may not see the back of our new acquaintance's head, and she may not tell us anything about it, but we extrapolate from what we do see and from experience, that there is hair there: we can even extrapolate what that hair looks like. What is different about fictional cues is that the real that we extrapolate does not exist at all. As we shall see shortly, this kind of extrapolation of reality from limited points or cues finds an analogy in the profession to which Paul Manning has apprenticed himself.

To sum up so far, *Cousin Phillis* prompts a very geometrical kind of imagining that resonates with modern theories of realism that emphasize the reader's imaginative construction. To the three corners and angles, the need for four walls, the two dimensions, not only of the railroad lines, but of the two-dimensional page, we could add the triangulation made by the two-dimensional page and the point made by the reader's eye or mind. Indeed, in his attempt at "situating the beings of fiction" in his massive *Inquiry into Modes of Existence*, Bruno Latour describes the geometry that is obtained between reader and fictional character as an "equilibrium polygon," which is a fancy way of saying triangle.[65] All of these triangles depend on each other, and on all of these depend the detailed, pastoral-georgic-domestic descriptive texture of *Cousin Phillis*. "I myself seemed to be the only thing in the middle" of his three-cornered room, Paul says: the triangles of Gaskell's novella are less the avenues of mimetic desire and more the geometric containers that hold the fleshing out of the messier middle.[66] For every straight line, there

is the curve of the "curled-up pussy cat,"[67] the soft mounds and snakes of a basket of stockings. The straight lines are in an endless dance with the wiggly and the fuzzy: as Paul says of the engineers' attempts to lay a flat line over the boggy, mossy ground, "one end of the line [kept] going up as soon as the other was weighted down."[68] The aesthetic texture of the novella has been described as "Pre-Raphaelite" in its dazzling color and density—as Ruskinian in its visual inclusiveness.[69] Gaskell's editor at *Cornhill Magazine* saw the images of *Cousin Phillis* glowing "like gems in a cabinet,"[70] while Sylvia Townsend Warner compared Gaskell's "method" in the novella to that of Vermeer.[71]

The aesthetic texture of the novella, in fact, depends on fuzziness against lines. Here is an out-of-doors scene, in which Paul has gone to find Holdsworth, Phillis, and the Reverend Holman:

> So "out yonder" I went; out on to a broad upland common, full of red sandbanks, and sweeps and hollows; bordered by dark firs, purple in the coming shadows, but near at hand all ablaze with flowering gorse, or, as we call it in the south, furze-bushes, which, seen against the belt of distant trees, appeared brilliantly golden. On this heath, a little way from the field-gate, I saw the three. I counted their heads, joined together in an eager group over Holdsworth's theodolite. He was teaching the minister the practical art of surveying and taking a level.[72]

We can notice how the dark "belt" or line of trees in the back of the scene sets off the flaming fuzzy furze-bushes. We can notice how Paul says he actually "counts" the three heads. And we can notice that what the three heads are doing is using a surveying instrument, one of Paul's and Holdsworth's tools of trade.

The "theodolite" that the three heads in the passage above are bent over is the instrument used to measure both vertical and horizontal angles in a landscape (see Figure 3). It is used to take the measurements of distances and also the heights of landscape features—topographical irregularities, hills—remotely, from a fixed point.[73] The challenge that the engineers in *Cousin Phillis* face, for example, in laying out their little line is the existence of "bogs, all over wild myrtle and soft moss, and shaking ground" between point A and point B: "the shaking, uncertain ground was puzzling our engineers," notes Paul.[74] By allowing a surveyor to measure accurately angles between the theodolite's chain, or plumb line, and one or two known points, the theodolite allows the surveyor to triangulate from, extrapolate from, these known facts to the distance and height of something not known.

Triangulation may be described, then, as a process of using a very limited kind of information—an angle number—about reality in order to extrapolate a more complete picture. Described this way, "triangulation" might be defined as the process by which, according to the theories of literary realism that we have been exploring here, readers take the partial, limited cues of realist fiction and from thence extrapolate a world (see Figure 4). We could

Figure 3. Victorian theodolite from *Trousset Encyclopedia* (circa 1886)

Figure 4. Triangulation diagram from Edward V. Gardner, *An Easy Introduction to Railway Mensuration* (1847)

say that, in *Cousin Phillis*, Gaskell is training readers—right from the novella's opening three-angled floor plan—to perform acts of triangulation, similar to those that Paul Manning is being trained to do. It might be objected that extrapolating a world from the verbal cues of fiction is categorically different: in that, unlike triangulating features in a landscape, fiction involves construing a world that does not already exist. I suggest, however, that we think of this difference as a matter of degree, rather than kind.

In engineering, as in fiction, learning to create a world from triangulated points depends on learning to transfer experience from one domain to another, in an imaginative apprenticeship. The author of *An Easy Introduction to Railway Mensuration* (a mid-Victorian guide addressed to young, aspiring engineers: real-life Paul Mannings) E.V. Gardner recommends imagining as a way to get from "theoretical" to "practical" "experience":

> That experience may be obtained, even before he ventures to offer himself to an engineer, by occasionally practicing in the field and there imagining a "proposed line;" and should the locality not possess the difficulties which may actually present themselves in *a bona fide* survey, he might, in many cases, draw further on his imagination, by *supposing* them.[75]

Gardner's suggestion is fascinating, because it asserts that make-believe experience in an imaginary topography can transfer to actual experience. Gardner's aspiring engineer is the opposite of the highly experienced railway man

in the opening meditation on language and imagination in George Eliot's essay "The Natural History of German Life," whose mind is totally filled by his prodigious experience:

> But suppose a man to have had successively the experience of a "navvy," an engineer, a traveler, a railway director and share-holder, and a landed proprietor in treaty with a railway company, and it is probable that the ranges of images that would by turns present themselves to his mind at the mention of the *word* "railways," would include all the essential facts in the existence and relations of the *thing*.[76]

By contrast, Gardner's experience-virgin engineer's process resembles that in Gaskell's report on Charlotte Brontë's method of manufacturing experience:

> she had thought intently on it for many and many a night before falling to sleep;—wondering what it was like, or how it would be,—till at length, sometimes after the progress of her story had been arrested at this one point for weeks, she wakened up in the morning with all clear before her, as if she had in reality gone through the experience.[77]

If "experience" can cross between the real and the imaginary, perhaps then, we can think of the relationship between triangulation in reality, and in fiction, as on a continuum rather than as categorically different.[78] The writer or reader of fiction, laying out what Elaine Scarry calls "an inhabitable space for imaginary persons," may be thought of as in an apprenticeship that, unlike the young railway engineer's, never ends.[79]

But to be a perpetual apprentice, always hitching a ride on a virtual experience, has its sorrows as well as its pleasures. In extrapolating fictional worlds, the limited or minimal cues on the pages are also everything in that nothing else actually exists. And while, as lovers of realist fiction, we often marvel at the sufficiency of the words on the page, there are times when fiction's incomplete set of cues to a nonexistent world can seem unconsoling. The glass can seem half full or half empty, the stockings overflowing or unraveling. Here, it may be useful to advert again to that other, more famous, woolly literary stocking, the one that Mrs. Ramsay is knitting in *To the Lighthouse*, celebrated by Auerbach as an index of "nothing less than the wealth of reality and the depth of life."[80] But Mrs. Ramsay's stocking is, as you will recall, either too short or too long, too little or too much: referring to its own mode of referentiality, it indexes its partiality or excess. It is as incomplete as Cousin Phillis's interrupted, half-mended one. The potential for recognizing the limits, never-endingness, or incompleteness of imaginary constructs may

be more acute in fiction than in real life, and *Cousin Phillis* makes use of this fact with special pathos.

What Never Happened

Nothing much happens in *Cousin Phillis*. It moves along a very slow line, describing a slow way of life, and incrementally building up the gently triangulated relations among the small cast of characters until the train wreck that happens when Paul tells Phillis—who is clearly in love for the first time with Mr. Holdsworth—that Holdsworth planned to return from Canada to marry her. The epistemic status of what Paul says, as well as its moral and dramatic nature, needs to be clarified. What Paul tells Phillis is not a lie: before the railway company shipped Holdsworth to Canada, he did confess his love for Phillis to Paul; and the evidence has been before the reader's eyes for some time. The problem is that it turns out not to matter: Holdsworth quickly takes a French-Canadian wife. More gravely, once Holdsworth's marriage is known, Paul's communication puts Phillis officially into the category of the jilted young woman. What Paul says to Phillis is not exactly revelatory. Holdsworth and Phillis's feelings for each other have been there for all to see; but Paul's utterance makes these feelings into social facts for the three of them. The philosopher Charles Taylor advocates for the existence of "social goods" that are "irreducibly social"—that is, not simply the aggregate of individual or private goods.[81] Adapting Taylor, we could say that Paul's utterance transforms Phillis's predicament into an "irreducibly social *bad*" formed in the triangle of acknowledgment among Paul, Holdsworth, and Phillis. Without Paul's communication, it is implied, Phillis might have recovered silently from an unacknowledged, unrequited love; with it, she suffers from hopes raised, dashed, and betrayed. Her situation becomes real, in other words, through the ways in which Paul's utterance draws lines of acknowledgment between himself, Holdsworth, and Phillis: a triangle, not of mimetic desire (Paul abdicates any romantic interest in his cousin early on), but of social recognition. Realized within the triangle of acknowledgment among the three of them, Phillis's abandonment becomes, as we say, a thing—"that thing," Paul calls it. He alludes to his "want of wisdom in having told 'that thing'" ("under such ambiguous words I concealed the injudicious confidence I had made to Phillis").[82]

With this sentence, Paul joins a long line of Gaskell speakers who say the wrong thing, whose fatal utterances have a complicated relation to truth: lies, half-lies, wrong messages, failed messages.[83] This line includes Philip

Hepburn, in *Sylvia's Lovers*, who decides not to pass on a message to Sylvia from her lover; Mary Barton and her less than candid testimony about what she knows about the murder of Harry Carson; and Margaret Hale's misleading responses to the police inspector, and to Mr. Thornton, about what happened the night of Leonard's murder in *North and South*. Although Paul's communication is ostensibly more truthful, like these other Gaskell characters, he knows the line that he fed Phillis was totally out of order; the whole narrative, as we shall see, is part and parcel with his remorse.

However, although *Cousin Phillis* is primarily Paul's story, it is impossible—especially if you experienced adolescence as a nerdy, isolated, overprotected girl, for whom experience seemed to belong elsewhere, maybe in books—not to identify intensely with Phillis, even though—or perhaps even because—we only see her from the outside. She bears her classical, pastoral-poetry-shepherdess name awkwardly. Paul quotes from Wordsworth's "She Dwelt Among Th'untrodden Ways": "A maid whom there were none to praise,/ And very few to love," and comments: "somehow those lines always reminded me of Phillis; yet they were not true of her either."[84] To use the important word from the last line of that poem ("But ah, the difference to me!"), there is a fundamental "difference" to Phillis. She is a pastoral figure, rather, in the quirky definition of Empson, discussed above. Her life is so painfully secluded, overprotected, "limited" to use Empson's word, although everyone around her pretends "it is the full and normal one."

Even when her life veers toward tragedy—after news of Holdsworth's marriage reveals the enormity of Paul's mistake in telling her what he did—Phillis's tragedy is really, in a way, nothing; it is about nothing. Nothing really happened between Phillis and Holdsworth. There was no engagement broken, nothing really real to back Paul's words, "that thing," as he calls it. The combination of specificity (that thing, not another one) and emptiness in his phrase, is exactly right. What is it? What there is, however, is a convergence between the nothing that happened to Phillis—her wounding by empty words—and the nothing that backs the fictional text. In his analysis of missed opportunities in fiction, William Galperin articulates a dynamic that speaks to Phillis's condition. The missed opportunity, he writes, "makes the loss of something a condition of its having 'happened' however fleetingly," while "the resuscitation of details and things . . . has the effect . . . of placing the 'never' of 'what never happened' under erasure."[85]

Once news of Mr. Holdsworth's marriage reaches Phillis's family, her parents try to pretend that nothing has indeed happened, that life will go on as normal. The Reverend Holman tries to keep up the pretense, first by reading aloud his favorite lines from Virgil's *Georgics* while beating the measures on

his knee with a ruler, interrupting himself to marvel aloud on how perfectly the poem's ancient agricultural advice measures up to real-time farming. "It [the poem] is all living truth in these days," he exclaims.[86] Phillis, frayed by the news of Holdsworth's marriage, breaks down and leaves the room. When she returns, her parents—for the first time getting a "glimpse" of what Paul calls, not "that thing," but "the real state of the case"[87] and newly alive to their daughter's suffering—redouble their efforts to pretend that life is normal. The Reverend desists reading and beating, and begins "talking":

> in a happier tone of voice about things as uninteresting to him, at the time, I verily believe, as they were to me; and that is saying a good deal, and shows how much more real what was passing before him was, *even to a farmer*, than the agricultural customs of the ancients (emphasis mine).[88]

Paul's "even" in "even to a farmer" curiously suggests that, as the Reverend himself exclaims ("all living truth") the book is, under normal circumstances, "more real" than what is passing before him. Domestic reality pops up as a rival claim to book reality. The truth of books to reality is affirmed, even as it is displaced by another *real* which turns out to be, in a way, a nothing: that there is nothing between Phillis and Holdsworth. Or, in Galperin's words again: "'What really happened' doubles alternately and retrospectively as 'what never happened' or ... as 'what ... happened' before it was suddenly 'all ... over.'"[89]

Gaskell's handling of loss that is both imperceptible, yet catastrophic—and *Cousin Phillis*'s response—resonates with its Virgilian intertexts—not just the evocation of pastoral throughout, but also with the Reverend Holman's beloved *Georgics*. Viewed by nineteenth-century agriculturalists like the Reverend as a valuable guide to farming, *Georgics* was also widely believed to be a deeply personal poem of making amends in the wake of catastrophic loss. Hovering behind nineteenth-century reception of the poem was the story of land confiscation and reparations in Virgil's native Mantua (which Virgil's family was believed to have narrowly escaped), and the writing of the poem itself as a gesture of healing—healing conflicts over land, and the land itself. This view is breathlessly summarized in the "Biographical Notice" of Joseph Davison's English translation, widely reprinted throughout the nineteenth century:

> Italy being now reduced to extremity, the grounds lying uncultivated, and the inhabitants being in want of the very necessaries of life, the fatal but natural consequences of a civil war, insomuch that the state seemed to be in danger, the people throwing all the blame on Augustus; Mæcenas, sensible of the great

parts and unbounded knowledge of Virgil, set him about writing the Georgics for the improvement of husbandry, the only means left to save Italy from utter ruin; in which Virgil succeeded so well, that, after their publication, Italy began to put on a new face, and everything went well; for the Georgics are not only the most perfect of all Virgil's works, but the rules for the improvement of husbandry are so just, and at the same time so general, that they not only suited the climate for which he wrote them, but have been found of such extensive use, that the greatest part of them are put in practice in most places of the world at this very day.[90]

Set into *Cousin Phillis*—with its overlay of the methodical transformation of the countryside by engineers laying down railroad tracks, and the sufferings of unrequited love—the *Georgics* can provide a model for literature of/as loss and reparations.

Remorse, Narration, Description

Thus far I have not addressed *Cousin Phillis*'s first-person narration. To some readers, *Cousin Phillis* is a study in naïve or unreliable narration.[91] This means emphasizing the distance between the author and the male narrator who only realizes, belatedly, the huge mistake that he has made, and seeing his personality, particular set of relations, and point of view imprinted on everything narrated here. My own read is that—as distinctive a character as Paul is—the sensory texture of the world narrated is such that there is, in fact—with some exceptions—very little daylight visible between this first-person narrator and Gaskell's characteristic, realist mode. The emotional pull of *Cousin Phillis* derives exactly from this convergence. It is an ideal text through which to explore some of the affective, rather than epistemological, dimensions of first-person narration and descriptive detail.

Here, for example, are some scraps of description that, in Paul's words "rise like pictures in my memory."[92] After reading the letter announcing Holdsworth's marriage:

> I held the letter loosely in my hands, and looked into vacancy, yet I saw the chaffinch's nest on the lichen-covered trunk of an old apple-tree opposite my window, and saw the mother-bird come fluttering in to feed her brood,—and yet I did not see it, although it seemed to me afterwards as if I could have drawn every fibre, every feather.[93]

Retrospection and emotion invest the visual scene—the lichen, the tree trunk, the bird—with both ordinary solidity and hallucinatory hypersharp-

ness. Similarly, when Paul goes for a solitary walk in the woods to think things over, "and, alas! to blame myself with poignant stabs of remorse," the description is crowded with particulate matter:

> I lounged lazily as soon as I got to the wood. Here and there the bubbling, brawling brook circled round a great stone, or a root of an old tree, and made a pool; otherwise it coursed brightly over the gravel and stones. I stood by one of these for more than half an hour, or, indeed, longer, throwing bits of wood or pebbles into the water, and wondering what I could do to remedy the present state of things.[94]

"Remorse," "remedy": these affects and impulses are distinctively central to Gaskell's literary form, both to her plots and to her mode of realism.

In order to explore the ways in which realism and remorse are linked in Gaskell's work, I will widen my lens before returning to *Cousin Phillis*'s first-person narration. Remorse is central to her plots throughout her fiction. There is, for example, Peter Jenkyns's remorse at having run away from home in *Cranford*; John Barton's remorse at having murdered Harry Carson in *Mary Barton*; the remorse of the parents of the prodigal daughter in the short story "Lizzie Leigh"; and the remorse of Bridget Fitzgerald in "The Poor Clare," when her curse falls on her innocent granddaughter.[95] Remorse is an especially prominent feature Gaskell's later fiction. "Lois the Witch," set in Salem, Massachusetts in the era of the witch trials, culminates in a flash-forward to the next generation when the community feels remorse at having executed Lois for witchcraft. In Gaskell's unfinished, posthumously published novel, *Wives and Daughters*, Squire Hamley spurns his eldest son Osborne, and after his death is overwhelmed with remorse ("do you know now how bitter and sore is my heart for every hard word as I ever spoke to you?"[96]). He seeks to repair the damage done by doting on Osborne's infant son, and—in a distant echo of the cycle of substitution and anxiety discussed at the beginning of this chapter—suffering anxiety about the child's health. Most astonishing in this regard is Gaskell's late novella *A Dark Night's Work*, the entire second half of which is one big remorsefest, as all of the characters fall into a cascading chain of remorse for events set off by that one dark night's work: Mr. Wilkins for having murdered Mr. Dunster, Ellinor Wilkins and Mr. Dixon for having covered it up, the inconstant Mr. Corbet for having abandoned Ellinor.

A particular, affective formation that besets many of Gaskell's heroines is one in which regret unleashes romantic attachment. For example, it is Mary Barton's regret at not having appreciated Jem Wilson's devotion until it seems to be too late that awakens her love for him. Similarly, in *North and South*, Margaret's regret at having slighted and lied to Mr. Thornton is

inseparable from her yearning for him. This pattern—regret as prelude to love—usefully illustrates some aspects of remorse and regret of interest to moral philosophers. As noted in the introduction to this chapter, the most influential figure has been Bernard Williams, who discriminated between remorse—a feeling you have when you have caused voluntary harm to another—and among different gradations of regret—involuntary harm, missed opportunities—in order to theorize agency, will, and their limits. "One's history as an agent," he writes, "is a web in which anything that is the product of the will is surrounded and held up and partly formed by things that are not."[97] More recently, in *The View from Here,* Jay Wallace has extended Williams's understanding of regret as part of a web, but shifts the focus from a web of agency to a web of affects. For Wallace, all of the "retrospective negative emotions" are bound up with love, attachment, and value as well as pain. In fact, in his account, emotional attachment and negative retrospective affects are mutually constitutive: attachment "consists in part precisely in a susceptibility to retrospective emotions of these kinds."[98] This position is affirmed by the experience of the Gaskell heroines for whom feeling regret seems to be the only way of falling in love. That Gaskell's fiction often turns on plots of lies, secrecy, and truth-telling is well-established.[99] But we are now in a position to understand her emphasis on plots of lies from the other side, as it were: from the point of view of the aftermath. Gaskell's plots of lies are ways to mobilize remorse and attachment.

We can learn a bit more about the ways in which Gaskell moved remorse along the axis of plot by studying a passage from the novel that Gaskell wrote right before *Cousin Phillis*: *Sylvia's Lovers*. It is a historical novel set in a northern whaling town during the early nineteenth-century wars with France. The grayscale palette of the setting, and abstraction of the scenes into shapes, is more reminiscent of the Haworth descriptions in *The Life of Charlotte Brontë* than of the woolly pastoral of *Cousin Phillis*. A "chilly northern air"[100] is its medium, crystallizing everything: "The close-packed houses in the old town seemed a cluster of white roofs irregularly piled against the more unbroken white of the hill-side ... the sharp air was filled ... with saline particles in a freezing state; little pungent crystals of sea salt burning lips and cheeks with their cold keenness."[101] The emphasis of the book is on bare outlines, from "the outline of the land"[102] to the crude artistic renderings that Philip Hepburn swipes on his way out the door after his disgrace and self-banishment: "silhouettes, one of himself, one of Sylvia, done in the first month of their marriage, by some wandering artist, if so he could be called ... black profiles ... about as poor semblances of humanity as could be conceived."[103] The essential hard-edged shape of the novel is the love triangle

formed by Sylvia and her two lovers: Philip Hepburn a sober shopkeeper, and Charlie Kinraid a dashing whaler. The outlines of the plot are as stark as bleached whalebones, set off by the geometrical, crystalline structures and shapes of the looming, northern landscape—huge, lumbering, moving pieces of plot need to be set up and brought into alignment for the novel's central crisis to occur. The central crisis is that Sylvia loves Charlie and is indifferent to the steady but dour Philip. When Charlie disappears, everyone assumes he has been swept out to sea. However, he has been apprehended by a press-gang rounding up all able-bodied seaman to fight in the British navy. Philip happens to be present at the scene of Charlie's apprehension; Charlie extracts from Philip a promise to tell Sylvia that he loves her and vows to come back for her. Philip does not keep his promise, and Sylvia, believing Charlie is dead, eventually marries Philip.

Sylvia is consumed by "miserable regrets"[104] at having married Philip. But *Sylvia's Lovers* is largely Philip's book, emotionally. Philip's crime is the inverse of Paul Manning's in *Cousin Phillis*: the message that Paul conveys to Phillis—I am going away, but I love you and will come back to you—is an unauthorized version of the message that Phillip actually promises but chooses not to deliver. In the months following Charlie's abduction, Philip's remorse grows and morphs, and does so in coordination with his rumination on how the narrative that he is enmeshed in might realistically turn out. In an extended passage of free indirect discourse, Gaskell has Philip tormenting himself with "what ifs": What if Sylvia—surrounded by talk of war and press-gangs—suspects that the truth that Charlie might have been impressed into the navy? What if Charlie is alive and well? What if he writes to Sylvia? What if it becomes known that Philip promised to give Charlie's message to Sylvia?:

> If Kinraid should send word to Sylvia; if he should say he was living, and loving, and faithful; if it should come to pass that the fact of the undelivered message sent by her lover through Philip should reach Sylvia's ears: what would be the position of the latter, not merely in her love—that, of course, would be hopeless—but in her esteem? All sophistry vanished; the fear of detection awakened Philip to a sense of guilt.[105]

The reality of what he has done is associated with "bare fact" (the "bare fact of Kinraid's impressment"; "the fact of the undelivered message");[106] and the more that the outcomes he imagines seem real, the larger Philip's remorse grows. Conversely, when he reasons that the outcomes he fears are "unlikely": "his previous fancies shrank to nothing, rebuked for their improbability, and with them vanished his self-reproach"[107]:

> Then he began to perceive how unlikely it was that the *Alcestis* [the Navy ship that abducted Charlie] should have been lingering on this shore all these many months. She was, doubtless, gone far away by this time; she had, probably, joined the fleet on the war station. Who could tell what had become of her and her crew? She might have been in battle before now, and if so—
>
> So his previous fancies shrank to nothing, rebuked for their improbability, and with them vanished his self-reproach.[108]

Needless to say, it is morally lax to only feel remorse when you think your wrongdoing is likely to be revealed. Philip here can seem like a version of the shepherd with the Ring of Gyges in Plato's *Republic*, asking us to think about whether we would still do right even if we had a ring of invisibility to shield our wrongdoings from detection.[109] But what interests me here is Gaskell's extended thought experiment exploring a logic that keys feelings of remorse to the sense of an outcome's reality. "Likely," "probable": in the history of the theory of the novel, these are key terms used throughout the eighteenth and nineteenth centuries to designate a story's approximation of the events of real life.[110] Philip's anxious thinking seesaws between imagining plot outcomes that cause feelings of remorse to worsen, and tapping into feelings that cause outcomes to seem probable and real. Affects of remorse, and apprehension of an outcome's reality, are closely linked. This passage, moreover, has the potential to enlarge an understanding of the "negative retrospective emotions" and hypothetical, imagined words, in which "retrospection" itself is put in suspension. It is, of course, in the psychology of hindsight, in looking back, in evaluating things in light of what did—and did not—happen, that regret and narrative are most clearly intertwined. In *Wives and Daughters*, for example, Cynthia Kirkpatrick has occasional pangs of regret at having ditched Roger Hamley: "Yet often, in after years, when it was too late, she wondered, and strove to penetrate the inscrutable mystery of 'what would have been.'"[111] But in the pivotal crisis in *Sylvia's Lovers*, remorse is twinned with looking forward to what might yet happen, hypothetical futures. In its forward-looking dimension, Philip's "what ifs" bear some resemblance to the anxious foreworrying—both prophylactic and proleptic—in *The Mill on the Floss*, a book that Gaskell read just as she was writing *Sylvia's Lovers*.[112] As in Eliot's novel, in *Sylvia's Lovers* the characters' anxious "fancies" unfold in the narrative as realities. That Philip's "what ifs" turn out to be not counterfactuals, or prophylactic gestures, but the novel's own account of "what really happened," reinforces the narrative affordances of remorse. (By the end of *Sylvia's Lovers*, Philip has transformed himself into a morally richer human: he pays his debt and redeems himself by heroically

saving Charlie's life.) In fictional narrative, the line between what happens and what could have but did not happen is incredibly thin; and here we see how remorse both opportunistically grows on, and fuzzes out, that line.

Realism and remorse are connected, not only along the axis of narration, but also along the axis of description. Here, I will return to the question of *Cousin Phillis*'s first-person narration with which I started this section. R. Jay Wallace's expanded conception of negative retrospective emotions and attachment can also help us specify, not only the complexity of Paul Manning's feelings, but also the vividness of Gaskell's first-person narration. In the "remorse in the woods" passage quoted at the beginning of this section, Paul is experiencing both remorse along the axis of agency, and regret along the axis of attachment to the harmed object:

> I kept wishing—Oh! How fervently wishing I had never committed that blunder; that the one little half-hour's indiscretion could be blotted out.... Every day, every hour, I was reproaching myself more and more for my blundering officiousness. If only I had held my foolish tongue for that one half-hour; if only I had not been in such impatient haste to do something to relieve pain! I could have knocked my stupid head against the wall in my remorse.[113]

Paul Manning always, always, wants to do the right thing. His impulsive communication about Holdsworth arises from a desire to protect Phillis from suffering, a suffering he cannot "bear" to witness.[114] Attachment and agent-regret reinforce and intensify each other,[115] and gain both strength and pathos from what Lauren Berlant called cruel optimism: the belief that you can make things better is what messes things up.[116]

Furthermore, in *Cousin Phillis*, Paul's first-person narration of remorse and remedy, and Gaskell's realist project, are one and the same. The minute details of the first-person narrator's account of things are inseparable from his remorse at having engineered Phillis's crisis, as each detail is not only a point from which we triangulate a world but also an emotional pinprick, or grain of salt in his wound. "I saw the chaffinch's nest on the lichen-covered trunk of an old apple-tree ... I could have drawn every fibre, every feature" "I stood ... throwing bits of wood or pebbles into the water, and wondering what I could do to remedy the current present state of things."[117] What feels most real is what is most felt: remorse and the reality-effect are tethered tightly together. Psychologist Janet Landman called regret a "sticky" emotion.[118] Regret and remorse stick to things, down to the last details of memory. To quote Galperin one last time: "the resuscitation of details and things ... has the effect ... of placing the 'never' of 'what never happened' under erasure."[119] Documenting damage and loss is a mode of making rep-

aration; *Cousin Phillis*'s detailed evocation of a world is both a sign that something went wrong, and its recompense.[120] The significance of this double status of detailed world-building, for both theories of the novel and theories of experience, will be the subject of the Coda of this study.

That Gaskell was thinking about detailed storytelling and recompense in *Cousin Phillis* can be confirmed by what we know about her uncertainty as to how to end it. After her crisis, Phillis is stricken by a "brain-fever" and comes close to dying. The published version of the novella ends just as she is recovering. But in a letter to her publisher, Gaskell sketched out an alternate ending that spools out into Phillis's adulthood. Years later, Paul returns to the village which has been ravaged by typhus, and finds her:

> making practical use of the knowledge she had learnt from Holdsworth and, with the help of common labourers, leveling & draining the undrained village—a child (orphaned by the fever) in her arms, another plucking at her gown—we hear afterwards that she has adopted these to be her own.[121]

In this ending, Phillis gets compensated for her adolescent suffering by growing up to be a virginal, but maternal, village saint: in fact, a version of Romola at the end of George Eliot's novel of the same name, serialized in the *Cornhill Magazine* the year before *Cousin Phillis* was. But Phillis leveling the uneven ground? She loses the engineer Holdsworth, but turns engineer? Did she get to keep his theodolite? Gaskell's decision to cut off this excessive story of compensation affirms that the detailed narration of Phillis's story is not only compensation enough but is also the best instrument with which she could make new ground, make a floor plan, a blueprint.

Elizabeth Gaskell knew well that, as Talia Schaffer has demonstrated, women's writing was inevitably compared to needlework.[122] The two forms of making—writing and sewing—were closely stitched together. In a letter to an unidentified female correspondent who had asked her for advice about novel writing—specifically how to balance novel writing with domestic cares—Gaskell counseled interweaving writing and sewing: "I hope ... you understand the comfort of ... having always some kind of sewing ready arranged to your hand, so that you can take it up at any odd minute and do a few stitches."[123] Stitching is a mode of making, but it is also a mode of mending: and mending is a particular mode of making. Mending is a kind of provisional making-right; it is something that you do after the fact, in the aftermath of wear and tear. We might think of mending as an alternative to the anxieties of the proleptic and metaleptic inability to protect, studied in Chapters Two and Three. It acknowledges, and tolerates, that models of care

that imagine swiftly stepping in, or warding off harm in advance, are always attended by failure.[124]

Armed with an understanding of realist narration as a form of inevitably partial recompense, we may think again of *Cousin Phillis*'s piling up half-mended stockings. Unlike Mrs. Ramsay's reddish-brown hairy one, which will eventually reach completion, an overflowing basket of half-mended stockings provides an endless supply of rends and tears that will never be completely mended.

Coda

In a short essay looking back at twenty-first century criticism and theory of the novel, Dorothy Hale remarks that—for all its enormous impact—it is often overlooked that Eve Kosofsky Sedgwick first wrote her influential essay "Paranoid Reading and Reparative Reading" for a special issue of the journal *Studies in the Novel*. Hale asks us to think about how closely Sedgwick's theory of reparative reading is tied to novel form, and why. Perhaps "reparative reading," she suggests, "finds a home in the novel":

> The novel's importance to the task of reparative reading lies especially in its narrative structure: one of the strange things that fiction does is to project a real world that seems different from the acts of representation that in fact constitute it. The illusion of difference between story and discourse is precisely the condition of reciprocal construction that defines Sedgwick's definition of reparative reading: the position from which it becomes possible to "assemble" or "repair" the murderous part-objects into something like a whole.[1]

Sedgwick's reparative reading, we recall, is modeled on Melanie Klein's theory of infant development. In particular, on a position from which an angry, abandoned infant is finally able to move from violently imagining the parent as a mosaic of angry internal fragments, to acknowledging them as a whole person—a whole object, in the language of object-relations psychoanalysis. In Sedgwick's use of Klein, this move suggests the potential for the critical reader to transition from a perception of paranoia-inducing, fragmentary textuality to a loving appreciation of a text as a whole. The novel—a form of literary writing that we routinely treat as projecting a storyworld that hovers, somehow, beyond the cues of the text—may, Hale suggests, be particularly hospitable to such a way of reading. It suggests an affective acknowledgment of, and response to, the simultaneous flatness and fullness, partialness or everythingness, of the fictional texts that we have

been tracing in *The Location of Experience*. Hale continues, "on this view, the nourishment that novelistic structure offers ... is the satisfaction of both/ and rather than either/or made possible by the projected difference between the ideological real that is storyworld space and the interpretive satisfactions of discourse space."[2] Reparative novel reading not only acknowledges the difference between discourse and story, but also holds them both in a way that closes the gap. Perhaps this way of thinking of fictional worlds might be a way to gloss Lauren Berlant's assertion that "all novels"—even the most mordantly tragic—"are utopian, by definition," committed to possibility, to "a better idea."[3] That, in Berlant's words, is "the promise of realist representation."[4]

I end *The Location of Experience* with Hale's and Berlant's reflections on the built-in consolations of novel form because they resonate with fictions such as Elizabeth Gaskell's *Cousin Phillis,* which cast their own fiction-making as a gesture of reparation. In my closing paragraphs, I reflect, one final time, on my reading of the relation between remorse and realism in Gaskell's novella—as the first stepping stone toward some speculations on the implications of this study for theories of the novel and discussions of experience. *Cousin Phillis* is exemplary in the way that it raises questions of realism and remorse that we can also find in a tradition of twentieth-century novels. In it, Gaskell—who had a strong interest in dramas of saying and unsaying, in remorse and reparation—is mining a connection between remorse, atonement, and fictional world-making, fundamental to, for example, L. P. Hartley's *The Go-Between* (1953), William Maxwell's *So Long, See You Tomorrow* (1979), and Ian McEwan's *Atonement* (2001): all of them novels in which a young person says things they should not, meddling in others' romantic relations to disastrous consequences, and in which acts of fiction loop back into acts of reparation.[5] These books work through the intertwining of responsibility, at the level of story—as in, you made something happen—and responsibility, at the level of discourse—you are making it happen by narrating it.

This particular fictional formation speaks to a way of thinking about the losses, gains, and recompenses of fiction that has a long history in theories of the novel. We could, for example, gloss moments such as the ones in Gaskell's *Cousin Phillis* where the narrator slows down to detail "every feather" of a bird, or the water pooling around a stone, as particular species of the dynamic of documenting loss, and reconstituting gain, that Lukacs described as endemic to novelistic narration in *The Theory of the Novel*.[6] "Duration," he comments, "advances upon" an "instant and passes on, but the wealth of duration which the instant momentarily dams and holds still in a flash of conscious contemplation is such that *it enriches even what is over and done*

with." Lukacs terms the thickening and slowing of narration, the "putting of the value of lived experience" on events that seem unnoticed. He continues:

> It even puts the full value of lived experience on events which, at the time, passed by unnoticed. And so, by a strange and melancholy paradox, the moment of failure is the moment of value; the comprehending and experiencing of life's refusals is the source from which the fullness of life seems to flow.[7]

Lukacs's "strange and melancholy paradox" in which the moment of failure becomes the moment of fullness, is essential to fictions of recompense. To narrate something that you made happen is to make it happen again: it is a way to underscore and acknowledge your responsibility. Novels of regret and atonement tend to feature first-person narration, not only because, as both Bernard Williams and R. Jay Wallace point out, there is something fundamentally "first-personal" about retrospective negative emotions, but also because these fictions depend, for their moral and emotional work, on a gently metaleptic switch point between character and author.[8] In *Cousin Phillis*, for example, while Phillis's crisis is, diegetically speaking, Paul's responsibility, it becomes Gaskell's dilemma, and gets transferred onto the reader as a heightened sense of experience.[9]

The transfer of experience with which this book ends, in other words, is a way to describe the experience of reading. As I noted in the Introduction to this study, there may be conceptual and historical reasons for thinking together the psychological concept of the "container"—the vessel into which experience needs to be transferred in order to be experienced—and the form of the novel. But reading fictions that have the responsibility/reparation structure of *Cousin Phillis* makes me feel as if I have become the container. It affirms that fictional experience feels not represented but transferred. In Dorothy Hale's terms, with which I began this Coda: I feel the difference, the shift between story and discourse. Writers at the center of this study were concerned with situating readers in that space of difference, articulating a transfer-station structure of reading. We might consider the switch points between Phillis's story and Paul's/Gaskell's narration, and between the narration and the reader's experience, in light of George Eliot's famous concluding sentences of *Middlemarch*:

> We insignificant people with our daily words and acts are preparing the lives of many Dorotheas, some of which may present a far sadder sacrifice than that of the Dorothea whose story we know ... and that things are not so ill with you and me as they might have been is half owing to the number who lived faithfully a hidden life, and rest in unvisited tombs.[10]

We might, that is, think of Phillis's sad story (casualty of the advent of the railroad and unrequited love) as one of the "far sadder sacrifices" that Eliot alludes to when she addresses her readers as being in an apprenticeship of sorts. "But we insignificant people with our daily words and acts," she writes after summing up Dorothea Brooke's story, "are preparing the lives of many Dorotheas, some of which may present a far sadder sacrifice than that of the Dorothea whose story we know." What are we doing, exactly, to prepare, besides reading? How else are we preparing, except that as readers we are somehow transfer stations between the fictional Dorothea "whose story we know," and the hypothetical, maybe even sadder ones? And, how is it that—as much as being the prep station may seem like a heavy load—somehow Eliot suggests that the "sacrifices" these sad figures make is somehow, for us, so that there is also a lightening of our load, "that things are not so ill with you and me as they might have been"?

The Victorian writers—Eliot, Gaskell, and the others—at the center of *The Location of Experience* parsed the bookish, as well as the ephemeral nature of experience, the fine lines among vicarious, literary, and lived experience, between someone else's experience and your own. I have, in essence, extracted a theory of the novel from the writings of Eliot, Gaskell, and Oliphant, as well as from the commentary on the Brontës by the Victorian women writers discussed in Chapter One. In so doing, I have followed the lead of other scholars of the novel, who see novels as always at once both narrating and theorizing narrative, both theorizing their own grounds and theorizing their own reading.[11] It could be countered that, in fact, I have read the Victorian women writers through the lens of the theory of the novel: Gaskell through Auerbach and Lukacs in Chapter Four, Oliphant and George Eliot in relation to Genette in Chapters Two and Three. I concede that my modes of reading fiction have been shaped by narrative and novel theory. But these writers—plus, of course, writers such as Robinson, Meynell, and Sinclair (discussed in Chapter One) who wrote criticism about the Brontës—worked out their ideas about literature across so many different genres of writing, that it is compelling to see their fictions themselves as part of their intellectual investigations of the meanings of this literary form.

Central to the theory and practice of fiction studied in all four chapters of *The Location of Experience* is what, following Kent Puckett, I view as the essence of all theory of narrative: the relations among narrative levels, in particular between story and discourse.[12] I read Margaret Oliphant's desire to and constraint from reaching across the border separating the lived world and the fictional world as part of the discourse of metalepsis, which is *par excellence* a theory about negotiating the border between the narrative level on which a

story is told ("discourse," in Genette's terminology) and the events ("story") internal to the world of the fiction. I read Eliot's treatment of free will and determinism, the desire and inability to prevent disaster, through her uses of prolepsis, a technique that delaminates a narrative's telling from the timescale of the events of its story. The thematic concern in many of the writings explored throughout this book, with relations between parents and children, supply at the level of plot, the psychological tug of the vexed relations of story and discourse. The central question asked by the Brontë-commenters in Chapter One—did the Brontës' fiction correspond to their extrafictional experience?—is, in essence, a discourse/story question, in that it asks about the adequation between, and the porousness of, the worlds inside and outside the novels. As is the question of the adequacy of descriptive details that never seem to fully capture the story, central to Chapter Four—the stocking that is always half mended, always either too thick or too thin, too long or too short for the leg—is an apt figure for the always shifting relationship between discourse and story. From this perspective, we might also see the difference between story and discourse at stake in Shadworth Hodgson's philosophical story of the story of experience—his massive, four-volume *Metaphysic of Experience* discussed in Chapter One—where the sheer bulk of Hodgson's discourse seems simultaneously out of proportion to, yet completely inadequate to, capturing the fleeting, temporal story of experience: the "process of experiencing which is ... always incomplete."[13]

This is a way of suggesting that the central feature of narrative and narrative theory can shed some light on the problem of capturing and defining "experience," and can help establish why and how the novel as a genre has contributed to our understandings of what experience is. The philosophical-historical analysis in Chapter One is the essential context that explains why the Victorian women novelists discussed throughout this study could pursue their formal experiments in transferring literary experience. In focusing on how nineteenth-century novelists and novel critics used the affordances of the genre to contribute to debates about experience, moreover, *The Location of Experience* has sought to join, and build on, a growing number of philosophically oriented, critical studies of the Victorian novel, from Jami Bartlett's *Object Lessons* and Jesse Rosenthal's *Good Form*, to others that I have cited throughout this book.[14] I hope to have made a distinctive place for the women writers at this table.

I will conclude with a few more words on how we understand what experience is. As this study affirms, "experience" is a hugely capacious term, both essential and elusive, overlapping around the edges with other categories that describe human life. We have noted both the differences between, and

threads of connection between, the biographical and the phenomenological understandings of experience, what Raymond Williams termed "experience past" and "experience present," the adjacent terms *Erlebnis and Erfahrung*. I have come to feel that oppositions between different definitions and kinds of experience are highly context-specific ways of dividing up the pie of the feeling of living.[15] But as readers of fiction, we might want to puzzle over the salience of the phrase "lived experience" in ethical and political writing, teasing out its implications from the point of view of a theory of the novel. At a moment like ours, in which urgent claims to honor the lived experience of others collide with excitement about the technologies of virtual experience, looking into the meanings of this ubiquitous phrase seems especially pressing.

We can take as our starting point a recent usage in relation to works of fiction. Writing in the *London Review of Books* in 2023, Toril Moi contrasts her mode of reading the novels of Marguerite Duras during the 1970s—through the lens of feminist theory and Lacanian psychoanalysis—to her most recent rereading of a newly reissued edition of Duras's novel *La Vie Tranquille* (*The Easy Life*). "I now realize," Moi writes, "that I was treating the text as an intellectual puzzle rather than as an expression of lived experience."[16] While her contrast—reading for theory versus reading for lived experience—may evoke the specter of a "post-theory" shift in current feminism, it should not distract us from the fact that, of course, the idea of "lived experience" has a long theoretical history. It reveals Moi's own deep background in existentialism and phenomenology. In those traditions, the prefix "lived" was meant to emphasize both the sensuous concreteness, and singular distinctiveness, of the individual's experience. It was designed to indicate the irreducibly subjective character of experience, as well as its transparent self-presence to the person having it. "Lived experience" was crucial to Simone de Beauvoir's account of body and psyche as the sites of women's oppression in *The Second Sex*, and to Frantz Fanon's argument in *Black Skin, White Masks* that the reality of anti Black racism lies in consciousness. For both de Beauvoir and Fanon—as well as, of course, for Sartre—the phrase is "*experience vécu*." They derived the phrase from Merleau-Ponty, for whom it indicated the given, the very intersection of the embodied self and the world. For thinkers in this tradition, "*experience vécu*" pushed back against both empiricist accounts of experience (by emphasizing qualitative sensation, not just simply data gathering), and idealist accounts of absolute experience (by emphasizing the individual consciousness as opposed to totality).[17]

In both French and English, the modifying adjective (lived, *vécu*) is derived from the past participle of the verb "to live." It connotes the sense of having lived. Thus, even experience-talk, most concerned with capturing the

immediate, has a pastness clinging to it: experience is always already on its way out the door. The phrase's emphasis on experience that has been *lived* is crucial in claims by minoritized peoples for whom a life-deficit is often as pressing as the experience-deficit, as it was defined in the Introduction to this study. However, the "lived" prefix can also make the phrase seem redundant, simply a way of saying "experience." That is, the "lived" prefix can seem a marker of emphasis ("really, *really* experience"), rather than of theoretical significance. The internet is full of chatter to this effect, much of it from self-appointed language police and right-wing pundits, for whom the phrase "lived experience" is anathema, either laughable and lazy, or unthinkingly politically correct, or both. We could also, however, see invocations of "lived experience" as redundant-on-purpose. That is, part of the phrase's appeal may be a pseudo-redundancy, which is itself a way of signaling the difficulty of capturing and defining experience.[18]

As I have come to the end of this study, I have become increasingly committed to the nonredundancy of "lived experience," not only for the theoretically, ethically, and politically freighted reasons hinted at in the past two paragraphs, but from the perspective of my reflections on the locations of experience for readers of fiction. A commitment to the nonredundancy of "lived experience" is essential to the reader of novels. It is the only way to honor the reality of other modes of experience apart from the "lived," forms of experience that are impersonal, or transcendent, virtual or vicarious, transferred among locations, located wherever there is the feeling of living.

Notes

Introduction

1. Shadworth Hollway Hodgson, *The Metaphysic of Experience*, vol. 1 (London: Longmans, Green, 1898), 16, 34.

2. Henry James, *The Art of Fiction, And Other Essays* (New York: Oxford University Press, 1948), 10.

3. Alfred Lord Tennyson, *The Poems of Tennyson*, ed. Christopher Ricks (London: Longman, 1969), 18–21.

4. For a detailed discussion of the mutual externality of speaking subject, experience, and world in Tennyson's metaphor for experience in "Ulysses," see Matthew Rowlinson, "Mourning and Metaphor: On the Literality of Tennyson's 'Ulysses,'" *Boundary 2* 20, no. 2 (1993): 244–45.

5. Matthew Arnold, *Poetry and Prose*, ed. John Bryson (Cambridge, MA: Harvard University Press, 1960), 201.

6. In his "Analogies of Experience," Kant similarly turns to our perception of a ship moving downstream (compared to the way that we perceive a house) in order to sort out what is moving: our attention, or the object itself. Immanuel Kant, *Critique of Pure Reason*, ed. and trans. Norman Kemp Smith (London: Macmillan, 1929), 221.

7. Marion Milner, *A Life of One's Own* (London: Routledge, 2011), 81, 66.

8. In the broadest terms, I share common interests with many literary scholars who emphasize the affective, phenomenological, psychological, and cognitive dimensions of fiction. This list is not exhaustive, but I would like to record my debts to the works in my bibliography by: Auyoung; Christoff; Flesch; Jaffe; Jameson; Miller; Plotz; Scarry; Star. See Elaine Auyoung, *When Fiction Feels Real: Representation and the Reading Mind* (New York: Oxford University Press, 2018); Alicia Christoff, *Novel Relations: Victorian Fiction and British Psychoanalysis* (Princeton. NJ: Princeton University Press, 2019); Audrey Jaffe, *The Victorian Novel Dreams of the Real: Conventions and Ideology* (New York: Oxford University Press, 2016); Fredric Jameson, *Antinomies of Realism* (London: Verso, 2013); Andrew H. Miller, "'A Case of Metaphysics': Counterfactuals, Realism, 'Great Expectations,'" *ELH* 79, no. 3 (2012): 773–96; John Plotz, *Semi-Detached: The Aesthetics of Virtual Experience Since Dickens* (Princeton, NJ: Princeton University Press, 2018); Elaine Scarry, *Dreaming by the Book* (New York: Farrar, Straus and Giroux, 1999); Summer J. Star, "Feeling Real in 'Middlemarch,'" *ELH* 80, no. 3 (2013): 839–69.

9. D. W. Winnicott, *Playing and Reality* (London: Routledge, 1971), 99.

10. Winnicott, *Playing and Reality*, 14.

11. There are many romantic and postromantic bodies of thought that make claims about the unrepresentability of experience, some of which will be recorded in my foot-

notes. Here, I will just mention the poststructuralist tradition that includes works in my bibliography by Caruth and François. See Cathy Caruth, *Unclaimed Experience: Trauma, Narrative, and History* (Baltimore, MD: Johns Hopkins University Press, 1996); Anne-Lise François, *Open Secrets: The Literature of Uncounted Experience* (Stanford, CA: Stanford University Press, 2007).

12. Betty Joseph, "Transference: The Total Situation," *International Journal of Psychoanalysis* 66, no. 4 (1985): 447.

13. Lucy LaFarge, "The Imaginer and the Imagined," *Psychoanalytic Quarterly* 73, no. 3 (2004): 592.

14. See W. R. Bion, *Transformations* (London: Karnac, 1984), 90–91, and *Attention and Interpretation* (Lanham, MD: Rowman & Littlefield, 2004), 106–10. Helpful discussions of Bion's container-contained schema can be found in Ogden, "Reading Bion" and LaFarge "Interpretation and Containment. See Thomas H. Ogden, "Reading Bion," in *This Art of Psychoanalysis: Dreaming Undreamt Dreams and Interrupted Cries* (London: Routledge, 2005), 77–92; See Lucy LaFarge, "Interpretation and Containment," *International Journal of Psychoanalysis* 81, no. 1 (2000): 67–84.

15. William Flesch, *Comeuppance: Costly Signaling, Altruistic Punishment, and Other Biological Components of Fiction* (Cambridge, MA: Harvard University Press, 2007), 215.

16. See Schramm for excellent discussions of the theological and juridical, as well as literary contexts, in which the Victorians countenanced vicarious and transferred experience. Needless to say, my book may be viewed as affirming emphatically that the phrase "lived experience" is not necessarily redundant, contra the endless chatter on this topic on Twitter and Reddit. Jan-Melissa Schramm, *Atonement and Self-Sacrifice in Nineteenth-Century Narrative* (Cambridge: Cambridge University Press, 2012), 8, 15, 34.

17. Christoff, *Novel Relations*, 8.

18. Christoff, *Novel Relations*, 156, 19.

19. Anthony Trollope, *Framley Parsonage* (London: Folio Society, 1996), 42.

20. George Eliot, *Adam Bede*, ed. Carol A. Martin (Oxford: Oxford World's Classics, 2001), 49.

21. See Schaffer's excellent discussion of how failures of care can flourish at the level of literary style in Henry James's *The Wings of the Dove*, in *Communities of Care*. For Schaffer's acknowledgments of the ways in which discourses of care are always accompanied by the prospectus of failure, see 22, 123, 147, 192. Talia Schaffer, *Communities of Care: The Social Ethics of Victorian Fiction* (Princeton, NJ: Princeton University Press, 2021), 140–57.

22. Hunter Dukes, "Beckett's Vessels and the Animation of Containers," *Journal of Modern Literature* 40, no. 4 (2017): 75–89. Christoff, *Novel Relations*, 47–48, 83–85.

23. Winnicott, *Playing and Reality*, 13. A discussion of a particularly influential—but controversial—contribution to object-relations psychoanalysis' place in literary criticism, Sedgwick's "Paranoid Reading and Reparative Reading," can be found in the Coda of this study. To the relatively short list of British object-relations inflected approaches to the nineteenth-century novel should be added Cohen, "Envy"; also, Philip Davis, *The Transferred Life of George Eliot*, which is oriented around transfers between the novelist and her readers. See William A. Cohen, "Envy and Victorian Fiction,"

NOVEL: A Forum on Fiction 42, no. 2 (2009): 297–303; Philip Davis, *The Transferred Life of George Eliot* (Oxford: Oxford University Press, 2018).

24. Charlotte Brontë, *Villette*, ed. Margaret Smith (Oxford: Oxford World's Classics, 2008), 106, 145, 395.

25. Hershinow's book disentangles experience and development in the eighteenth-century novel. See Stephanie Insley Hershinow, *Born Yesterday: Inexperience and the Early Realist Novel* (Baltimore, MD: Johns Hopkins University Press, 2019). Goodlad situates the work of Wilkie Collins in relation to accounts of modernity's disarticulation of experience. See Lauren M.E. Goodlad, *The Victorian Geopolitical Aesthetic: Realism, Sovereignty, and Transnational Experience* (Oxford: Oxford University Press, 2015), 110–50.

26. The classic definitions of the narratological terms in this paragraph are in Gerard Genette, *Narrative Discourse: An Essay in Method*, trans. Jane E. Lewin (Ithaca, NY: Cornell University Press, 1980).

27. M. M. Bakhtin, *The Dialogic Imagination: Four Essays* (Austin: University of Texas Press, 1981), 253.

28. Thomas G. Pavel, *Fictional Worlds* (Cambridge, MA: Harvard University Press, 1986), 12.

29. Eric Hayot's *Literary Worlds* is an elegant, concise discussion of what is at stake in conceiving of literary texts as "worlds"; applications of possible worlds philosophy to literary theory include Pavel; Ronen; Ryan. Eric Hayot, *On Literary Worlds* (Oxford: Oxford University Press, 2012); Pavel, *Fictional Worlds*; Ruth Ronen, *Possible Worlds in Literary Theory* (Cambridge: Cambridge University Press, 1994); Marie-Laure Ryan, *Possible Worlds, Artificial Intelligence, And Narrative Theory* (Bloomington: Indiana University Press, 1991).

30. My debts to, and differences with, Freedgood's account of metalepsis are discussed in Chapter Two of this study.

31. On phenomenologies of weightiness and gravity as components of the lexicon of our experience of fictional worlds, see Kurnick, who articulates this quality in his account of reading the fiction of Roberto Bolano: "all of it radiated the same impression of reality, of what I thought of as gravity. Not in the sense of super-seriousness ... but in the sense of having a feel for how things are weighted, a sense of what was historically and personally important and what was less so, and a feel for what it's like to move in the vicinity of such importance." David Kurnick, *The Savage Detective, Reread* (New York: Columbia University Press, 2022), 14. That gravity or heaviness holds in place the relations between real, realist, and less real worlds is implicit in Samuel Delany's account of the way that science fiction works by unmooring the "gravitic value systems" (xvi) that vertically differentiate real and fictional worlds (xvi, 33, 159–61). Samuel R. Delany, *The American Shore* (Middletown, CT: Wesleyan University Press, 2014). I return to this concept, in relation to narratologist Marie-Laure Ryan's concept of the "world stack" in Chapter Two.

32. Yi-Ping Ong, *The Art of Being: Poetics of the Novel and Existentialist Philosophy* (Cambridge, MA: Harvard University Press, 2018), 44.

33. Plotz, *Semi-Detached*, 15.

34. George Eliot, *The Mill on the Floss*, ed. A.S. Byatt (Harmondsworth: Penguin, 1979), 55.

35. Plotz, *Semi-Detached*, 107.

36. See Freedgood for a different response to Plotz's reading of this puzzling yet paradigmatic passage. Elaine Freedgood, *Worlds Enough: The Invention of Realism in the Victorian Novel* (Princeton, NJ: Princeton University Press, 2019), 30–31.

37. In *Harm's Way,* Macpherson studies the arc of "tragic realism" from Defoe's *Roxana* and Samuel Richardson's *Clarissa*, arguing for the centrality of narratives of responsibility to the rise of the novel in the eighteenth century. Sandra Macpherson, *Harm's Way: Tragic Responsibility and the Novel Form* (Baltimore, MD: Johns Hopkins University Press, 2010).

38. Henry James, *The Art of the Novel: Critical Prefaces* (Chicago: University of Chicago Press, 2011), 39.

39. George Eliot, *The George Eliot Letters*, vol. 3, ed. Gordon Sherman Haight (New Haven, CT: Yale University Press, 1954), 335, 117.

40. Theo Davis, *Formalism, Experience, and the Making of American Literature in the Nineteenth Century* (Cambridge: Cambridge University Press, 2007), 7. Davis's study argues that in the work of Emerson, Hawthorne, and Stowe, an "experience" is associated with abstraction, typicality, the hypothetical, and the probable. In this view, which is enabled by American transcendentalism, literary form is a "property of experience" (4). Nevertheless, in spite of her emphasis on experience as an abstract, formal category, Davis occasionally falls back on something she calls "the actual experience of subjects" (9).

41. George Eliot, *Middlemarch*, ed. David Carroll (Oxford: Oxford World's Classics, 1996), 129.

42. Eliot, *Middlemarch*, 130.

43. Daniel Hack, "In Literature as in Life?" (manuscript, North American Victorian Studies Association Conference, 2017), 6–7.

44. D. H. Lawrence, *Women in Love* (Oxford: Oxford World's Classics, 1998), 5.

45. Elaine Showalter, "Twenty Years On: A Literature of Their Own Revisited," *NOVEL: A Forum on Fiction* 31, no. 3 (1998): 400.

46. Toril Moi, *Sexual/Textual Politics* (London: Routledge, 2002), 44, 4.

47. Joan W. Scott, "The Evidence of Experience," *Critical Inquiry* 17, no. 4 (1991): 780.

48. Scott, "The Evidence of Experience," 797.

49. Linda Martín Alcoff, "Phenomenology, Post-Structuralism, and Feminist Theory on the Concept of Experience," in *Feminist Phenomenology*, ed. Linda Fisher and Lester Embree (Dordrecht: Kluwer, 2000), 45.

50. Toril Moi, *Revolution of the Ordinary: Literary Studies after Wittgenstein, Austin, and Cavell* (Chicago: University of Chicago Press, 2017), 90.

51. For updated assessments of "experience" debates in feminist theory, philosophy, and politics, see Sonia Kruks, *Retrieving Experience: Subjectivity and Recognition in Feminist Politics* (Ithaca, NY: Cornell University Press, 2001); Alison Phipps, "Whose Personal Is More Political? Experience in Contemporary Feminist Politics," *Feminist Theory* 17, no. 3 (2016): 303–21; Johana Oksala, *Feminist Experiences: Foucauldian and Phenomenological Investigations* (Evanston, IL: Northwestern University Press, 2016). Heyes's book conceptualizes experience as having "edges," and tracks the politics of what counts as belonging within and without those edges. Cressida J. Heyes, *Anaesthetics of Existence: Essays on Experience at the Edge* (Durham, NC: Duke University Press, 2020). Also, in

the field of phenomenology, De Roo develops a theory of how experience mediates the intersection of the individual and the social. Neal De Roo, *The Political Logic of Experience* (New York: Fordham University Press, 2022). In a very different context, Felski turns to "experience" as a corrective to what has seemed to her to be an exhausted tradition of critique in literary studies. Rita Felski, *The Limits of Critique* (Chicago: University of Chicago Press, 2015). Finally, it is important to acknowledge that there are contexts in which it has seemed ethically and politically essential to see a person's or community's experience as fundamentally incommensurable or inaccessible. For example, see Saidiya V. Hartman, *Scenes of Subjection: Terror, Slavery, and Self-Making in Nineteenth-Century America* (New York: Oxford University Press, 1997), 10.

52. Representative of current research on women writers' centrality to Victorian print culture is Joanne Shattock, "The Feminisation of Literary Culture," in *The History of British Women's Writing, 1830–1880*, vol. 6, 10 vols., (London: Palgrave Macmillan, 2018), 6:23–38, edited by Lucy Hatley.

53. My approach to authorship as a category of analysis is influenced by the essays in *Taking Liberties with the Author* which "make a strong case for the continued persistence of the author as an analytic category, one that is powerful because of its abstract, nonhuman or suprahuman status. The idea of the author allows for a peculiar binding of abstraction and affection, the attachment of textual properties and intellectual property to a form of personhood." Meredith L. McGill, "Introduction: Someone Said," in *Taking Liberties with the Author: Selected Essays from the English Institute*, ed. Meredith L. McGill (Cambridge, MA: American Council of Learned Societies, 2013), https://hdl.handle.net/2027/heb90058.0001.001.

1. Transfers of Experience: Brontës, Gaskell, Meynell, Sinclair

1. Emily Brontë, *Wuthering Heights*, ed. Helen Small (Oxford: Oxford World's Classics, 2009), 82.

2. On the psychological inadequacy of the concept of literary "identification," see William Flesch, *Comeuppance: Costly Signaling, Altruistic Punishment, and Other Biological Components of Fiction* (Cambridge, MA: Harvard University Press, 2007), 16. For a history of the idea of identification among woman writers, see Laura Green, *Literary Identification from Charlotte Brontë to Tsitsi Dangarembga* (Columbus: Ohio State University Press, 2012). For a discussion of the legacy of *Wuthering Heights* that discusses some of these passages from Carson through the lens of identification, see Grace Moore and Susan Pyke, "Haunting Passions: Revising and Revisiting *Wuthering Heights*," *Victorians Institute Journal* 34 (2007): 244–45.

3. Anne Carson, "The Glass Essay," in *Glass, Irony, and God* (New York: New Directions, 1995), 75–78.

4. Brontë, *Wuthering Heights*, 27.

5. Suzanne Raitt, *May Sinclair: A Modern Victorian* (Oxford: Oxford University Press, 2000), 130.

6. Carson, "The Glass Essay," 22.

7. Helen C. Black, *Notable Women Authors of the Day* (Glasgow: David Black, 1893), 189–90.

8. Carson, "The Glass Essay," 21–22.

9. Harold Orel, ed., *The Brontës: Interviews and Recollections* (Iowa City: University of Iowa Press, 1997), 25.

10. A. Mary F. Robinson, *Emily Brontë* (London: W. H. Allen, 1883), 48.

11. Charlotte Mew, "The Poems of Emily Brontë," *Temple Bar* 130, no. 525 (1904): 154–55.

12. Alice Meynell, "Review of Clement Shorter, *Charlotte Brontë and Her Circle*," *The Bookman* 4, no. 5 (1897): 456.

13. Esther Alice Chadwick, *In the Footsteps of the Brontës* (London: Isaac Pitman, 1914), 226.

14. Michael Moon, "No Coward Souls: Poetic Engagements Between Emily Brontë and Emily Dickinson," in *The Traffic in Poems: Nineteenth-Century Poetry and Transatlantic Exchange*, ed. Meredith L. McGill (New Brunswick, NJ: Rutgers University Press, 2008), 248.

15. Elizabeth Gaskell, *The Life of Charlotte Brontë*, ed. Elizabeth Jay (Harmondsworth: Penguin Classics, 1998), 441.

16. Sarah Allison, "Narrative Form and Facts, Facts, Facts: Elizabeth Gaskell's *Life of Charlotte Brontë*," *Genre* 50, no. 1 (2017): 98.

17. Gaskell's modern biographer Jenny Uglow notes that Gaskell occasionally took opium for migraines and neuralgia that were attributed by her doctors to "spinal irritation." Jenny Uglow, *Elizabeth Gaskell: A Habit of Stories* (London: Faber and Faber, 1993), 265–66.

18. Elisha Cohn, *Still Life: Suspended Development in the Victorian Novel* (New York: Oxford University Press, 2015), 51.

19. For an account of the first-person nature of experience, see Richard Moran, *Authority and Estrangement: An Essay on Self Knowledge* (Princeton, NJ: Princeton University Press, 2001).

20. For an account of different versions of the distinction between *Erfahrung* and *Erlebnis*, see Martin Jay's very useful history of the concept of experience. Martin Jay, *Songs of Experience: Modern American and European Variations on a Universal Theme* (Los Angeles: University of California Press, 2006), 11, 66, 222–34, 313–18; Raymond Williams, *Keywords: A Vocabulary of Culture and Society*, revised edition (New York: Oxford University Press, 1985), 84.

21. For a compelling discussion of the novel as a genre which manages the relationship between phenomenal and biographical senses of experience, see Stephanie Insley Hershinow, *Born Yesterday: Inexperience and the Early Realist Novel* (Baltimore, MD: Johns Hopkins University Press, 2019), 5.

22. Digital searches revealing an increasing percentage of published materials in English with the word "experience" in the title, as well as a sheer increase in number of "experience" titles from the beginning of the nineteenth century to the beginning of the twentieth century, can be done using the following corpora: Google Books Ngram Viewer, Gale Primary Sources: Nineteenth-Century Collections Online, and C19: The Nineteenth-Century Index.

23. On the division of the disciplines in late Victorian Britain, see the essays in Amanda Anderson and Joseph Valente, *Disciplinarity at the Fin de Siècle* (Princeton, NJ: Princeton University Press, 2002).

24. On the social, political, and ethical dimensions of Victorian idealism, see David Boucher and Andrew Vincent, *British Idealism: A Guide for the Perplexed* (London: Continuum, 2012); W. J. Mander, *British Idealism: A History* (Oxford: Oxford University Press, 2011); Sandra M. Den Otter, *British Idealism and Social Explanation: A Study in Late Victorian Thought* (Oxford: Oxford University Press, 1996); A. J. M. Milne, *The Social Philosophy of English Idealism* (London: Allen & Unwin, 1962).

25. T. H. Green, *Prolegomena to Ethics [1883]*, ed. David O. Brink (Oxford: Oxford University Press, 2003), 40.

26. Green, *Prolegomena to Ethics*, 20.

27. Green, *Prolegomena to Ethics*, 20.

28. Green, *Prolegomena to Ethics*, 37.

29. Green, *Prolegomena to Ethics*, 37.

30. For a helpful account of Green on experience, see Peter Hylton, *Russell, Idealism, and the Emergence of Analytic Philosophy* (Oxford: Clarendon Press, 1990), 21–43.

31. Mander, *British Idealism: A History*, 112.

32. F. H. Bradley, *Appearance and Reality: A Metaphysical Essay* (Oxford: Oxford University Press, 1978), 147. For a helpful account of Bradley on experience, see Mander, *British Idealism: A History*, 104–20.

33. Hilary Putnam, "Introduction," in *The Correspondence of William James*, vol. 10 (Charlottesville: University of Virginia Press, 2002), xxix.

34. The literature on Hodgson is not extensive. See W. J. Mander, "The Philosophy of Shadworth Hodgson," in *The Oxford Handbook of British Philosophy in the Nineteenth Century*, ed. W. J. Mander (Oxford: Oxford University Press, 2014), 173–88. See Jay, *Songs of Experience*, 278. On Hodgson's relationship to epiphenomenalism, see Adela Pinch, *Thinking About Other People in Nineteenth-Century British Writing* (Cambridge: Cambridge University Press, 2010), 65–72. See Holly K. Andersen, "The Hodgsonian Account of Temporal Experience," in *The Routledge Handbook of Philosophy of Temporal Experience*, ed. Ian Phillips (New York: Routledge, 2017), 69–81. On Hodgson's approach to time and his influence on Husserl, see Holly K. Andersen and Rick Grush, "A Brief History of Time-Consciousness: Historical Precursors to James and Husserl," *Journal of the History of Philosophy* 47, no. 2 (2009): 277–307.

35. William James, *The Correspondence of William James*, vol. 9, ed. Ignas K. Skrupskelis and Elizabeth M. Berkeley (Charlottesville: University of Virginia Press, 1992), 226.

36. William James, *The Correspondence of William James*, vol. 5, ed. Ignas K. Skrupskelis and Elizabeth M. Berkeley (Charlottesville: University of Virginia Press, 1992), 589.

37. Shadworth Hollway Hodgson, *The Metaphysic of Experience*, vol. 1 (London: Longmans, Green, 1898), 11.

38. Shadworth Hollway Hodgson, *Philosophy and Experience: An Address Delivered Before The Aristotelian Society October 26, 1885* (London and Edinburgh: Williams and Norgate, 1885), 122.

39. Hodgson, *Philosophy and Experience*, 88.

40. Hodgson, *Philosophy and Experience*, 89.

41. Shadworth Hodgson to William James, June 7, 1898, ALS: MH bMS Am 1092.9 [211]. Houghton Library, Harvard University.

42. Hodgson, *The Metaphysic of Experience*, 1:16, 34.

43. Hodgson, *The Metaphysic of Experience*, 1:64.

44. Hodgson, *The Metaphysic of Experience*, 1:64–65.
45. Hodgson, *The Metaphysic of Experience*, 1:35.
46. Mander, "The Philosophy of Shadworth Hodgson," 177.
47. Hodgson, *The Metaphysic of Experience*, 1:38.
48. William James's hilariously ambivalent description of *The Metaphysic of Experience*: "Dry, but *clean* in the extreme, like a beautifully prepared museum skeleton, with all the soft tissues got rid of & nothing but white ivory left." James, *The Correspondence of William James*, 1992, 9:225. An examination of the copy of the book that Hodgson presented to James, housed in the Houghton Library, Harvard University, reveals that James seems never to have finished reading it: the pages of volume 4 remain uncut.
49. Mary Ellen Waithe, ed., *A History of Women Philosophers* (Dordrecht: Kluwer, 1989), xl.
50. Alexis Easley, "The 1916 Centenary: Charlotte Brontë and First-Wave Feminism," in *Time, Space, and Place in Charlotte Brontë*, ed. Diane Long Hoeveler and Deborah Denenholz Morse (London: Routledge, 2017), 49.
51. Accounts of the explosion of Brontë-related writing by women in the later nineteenth century include Easley, "The 1916 Centenary"; Philippa Martindale, "The 'Genius of Enfranchised Womanhood': Suffrage and *The Three Brontës*," in *May Sinclair: Moving Toward the Modern*, ed. Andrew J. Kunka and Michele K. Troy (Aldershot: Ashgate, 2006), 161–77; Lucasta Miller, *The Brontë Myth* (London: Jonathan Cape, 2001); Beth Sutton-Ramspeck, "The Personal Is Poetical: Feminist Criticism and Mary Ward's Readings of The Brontës," *Victorian Studies* 34, no. 1 (1990): 55–75; Jane Silvey, "May Sinclair and the Brontës: 'Virgin Priestesses of Art,'" in *May Sinclair: Moving Toward the Modern*, ed. Andrew J. Kunka and Michele K. Troy (Aldershot: Ashgate, 2006), 161–77; Suzanne Raitt, "Literary History as Exorcism: May Sinclair Meets the Brontës," in *Women and Literary History: "For There She Was,"* ed. K. Binhammer and J. Wood (Newark: University of Delaware Press, 2003), 187–200.
52. Miriam Allot, ed., *The Brontës: The Critical Heritage* (London: Routledge, 1974), 84.
53. For a related discussion of Victorian "fact" versus "fiction," see Allison, "Narrative Form and Facts, Facts, Facts," 103.
54. Charlotte Brontë, "Biographical Notice of Ellis and Acton Bell," 'Editor's Preface to the New Edition of *Wuthering Heights*,' "Extract from the Prefatory Notes to 'Selections from Poems by Ellis Bell [1805]," in *Wuthering Heights*, ed. Helen Small (Oxford: Oxford World's Classics, 2009), 367–69.
55. John Churton Collins, review of *The Collected Works of Byron*, *Quarterly Review, 1905*, in Andrew Rutherford, *Byron: The Critical Heritage* (London: Routledge and Kegan Paul, 1970), 487.
56. Unsigned review in *The British Critic*, 1818, in B. C. Southam, *Jane Austen: The Critical Heritage* (London: Routledge and Kegan Paul, 1968), 80.
57. May Sinclair, *The Three Brontës* (London: Hutchinson, 1912), 3, 92, 96, 98, 126.
58. Gaskell, *The Life of Charlotte Brontë*, 173.
59. Thomas Wemyss Reid, *Charlotte Brontë: A Monograph* (New York: Scribner, Armstrong & Co, 1877), 59.

60. Laura C. Holloway, *An Hour with Charlotte Brontë; or, Flowers from a Yorkshire Moor* (Philadelphia: J. W. Bradley, 1882), 21.

61. Holloway, *An Hour with Charlotte Brontë*, 35.

62. Frederika Macdonald, *The Secret of Charlotte Brontë: Followed by Some Reminiscences of the Real Monsieur and Madame Héger* (London and Edinburgh: T. C. & E. C. Jack, 1914), 5–6. Allison sheds further light on Gaskell's suppression of the Heger letters. Allison, "Narrative Form and Facts, Facts, Facts," 102.

63. Gaskell, *The Life of Charlotte Brontë*, 173–74.

64. Robinson, *Emily Brontë*, 105–6.

65. Sylvia Townsend Warner, *Lolly Willowes: Or the Loving Huntsman* [1926] (New York: NYRB Classics, 1999), 84.

66. Robinson, *Emily Brontë*, 47.

67. Robinson, *Emily Brontë*, 2.

68. Robinson, *Emily Brontë*, 156.

69. Robinson, *Emily Brontë*, 219.

70. Margaret Oliphant, "The Sisters Brontë," in *Women Novelists of Queen Victoria's Reign* (London: Hunt and Blackett, 1897), 45.

71. Lucasta Miller also connects Sinclair's anti-Brontë experience stance with her idealism, but unsympathetically sees Sinclair's conscription of Emily Brontë for the idealist cause as an uninformed projection. Miller, *The Brontë Myth*, 119–23. Further scholarship on Sinclair's relation to the Brontës, manifest not only in her writings about them, but also in her novel *The Three Sisters* and her short story "The Intercessors," includes Raitt "Literary History"; Morse; Silvey. See Raitt, "Literary History," 187–200; Easley, "The 1916 Centenary"; Silvey, "May Sinclair and the Brontës."

72. For an excellent treatment of Sinclair's philosophical work, focusing in particular on her treatment of time and space in her second philosophy book *A New Idealism* (1922), see Emily Thomas, "The Idealism and Pantheism of May Sinclair," *Journal of American Philosophical Association* 5, no. 2 (2019): 137–57.

73. Yopie Prins, *Ladies' Greek: Victorian Translations of Tragedy* (Princeton, NJ: Princeton University Press, 2017), 16, 158.

74. On Hilda Oakeley, see Emily Thomas, "Hilda Oakeley on Idealism, History, and the Real Past," *British Journal for the History of Philosophy* 23, no. 5 (2015): 933–53. Oakeley's own attempt to grapple with "the true nature of our actual experience" (292) can be found in her essay "The World as Memory and as History": "It seems evident that that which . . . would enter into mind-experience as something for perception, knowledge, and scene for action, would be but a very fragmentary, unsystematic extract from the reality. It would be the footsteps, as it were, of a being which brushes over or past us, or rudely shocks us at points here and there, stimulating that unique sense of present experience or existence which is for us immediacy, actuality. Hence the chaotic character often attending on our experience of actuality." (H. D. Oakeley, "The World as Memory and as History," *Proceedings of The Aristotelian Society*, 1927, 307). While the image of the footsteps imprinting contact with the world on the mind derives from Plato, Oakeley's fleshing out of a whole body, a rude personage who "brushes over or past us," renders contact with experience like contact with a highly tactile being. On twentieth-century women philosophers' continued resistance to the attack on idealism, see Clare Mac

Cumhaill and Rachael Wiseman, *Metaphysical Animals: How Four Women Brought Philosophy Back to Life* (New York: Doubleday, 2022), 41–44, 892–99, 160–61, 176–78.

75. May Sinclair, *A Defence of Idealism: Some Questions and Conclusions* (London: Macmillan, 1917), 263.

76. Sinclair, *A Defence of Idealism*, v.

77. May Sinclair, "The Ethical and Religious Import of Idealism," *The New World: A Quarterly Review of Religion, Ethics and Theology* 2, no. 8 (1893): 698.

78. Philip Davis, *Memory and Writing* (Liverpool: Liverpool University Press, 1983), 7.

79. Sinclair, *A Defence of Idealism*, viii.

80. M. W. Robieson, "Review of May Sinclair, *A Defence of Idealism*," *International Journal of Ethics* 28, no. 4 (1918): 563.

81. Raitt, *May Sinclair: A Modern Victorian*; Philippa Martindale, "'Against All Hushing Up and Stamping Down': The Medico-Psychological Clinic of London and the Novelist May Sinclair," *Psychoanalysis and History* 6, no. 2 (2004): 177–200.

82. Sinclair, *A Defence of Idealism*, 375.

83. Sinclair, *A Defence of Idealism*, 78.

84. Sinclair, *The Three Brontës*, 1912, 142.

85. Sinclair, *The Three Brontës*, 106.

86. Sinclair, *The Three Brontës*, 133.

87. Sinclair, *The Three Brontës*, 145.

88. Sinclair, *The Three Brontës*, 170.

89. May Sinclair, "Letter to the Editor," *the Times*, August 1, 1913.

90. May Sinclair, *The Three Brontës*, 2nd ed. (Boston: Houghton Mifflin, 1914), xxiv–xxviii.

91. Sinclair, *The Three Brontës*, 1912, 140.

92. Sinclair, *The Three Brontës*, 144.

93. Sinclair, *The Three Brontës*, 200.

94. Sinclair, *The Three Brontës*, 197.

95. Sinclair, *The Three Brontës*, xv.

96. May Sinclair, *The New Idealism* (London: Macmillan, 1922), x.

97. Among recent biographers, Davies and Hewish make the strongest case for evidence that Emily Brontë was influenced by German philosophy—either directly or via the accounts of Coleridge, De Quincey, and others in *Blackwood's Magazine*. Steve Davies, *Emily Brontë: Heretic* (London: Women's Press, 1994), 48–51; John Hewish, *Emily Brontë: A Critical and Biographical Study* (London: Macmillan; St. Martin's Press, 1969), 126.

98. Sinclair, *The Three Brontës*, 1912, 114.

99. Sinclair, *The Three Brontës*, 205, 195.

100. Sinclair, *The Three Brontës*, 145.

101. Maude Goldring, *Charlotte Brontë, the Woman: A Study* (London: E. Matthews, 1915), 77.

102. Goldring, *Charlotte Brontë, the Woman*, 13.

103. Goldring, *Charlotte Brontë, the Woman*, 15.

104. Oliphant, "The Sisters Brontë," 9. Sinclair remarked condescendingly that Oliphant "had a heart tender for prodigal sons." May Sinclair, "Introduction," in *The Life of Charlotte Brontë*, by Elizabeth Gaskell (London: J. Dent, 1908), x.

105. Mary Augusta Ward, "Introduction," in *The Tenant of Wildfell Hall*, by Anne Brontë (London: Smith and Elder, 1900), xii.

106. Robinson, *Emily Brontë*, 161–62.

107. Sinclair, "Introduction," x.

108. Hodgson, *The Metaphysic of Experience*, 1:113.

109. Robinson, *Emily Brontë*, 162.

110. Sinclair, *The Three Brontës*, 1912, 133.

111. Juliet Barker, *The Brontës, Wild Genius of the Moors: The Story of a Literary Family*, 2nd ed. (New York: Pegasus, 2010), 104–14; Miller, *The Brontë Myth*, 28.

112. Sinclair, *The Three Brontës*, 1912, 3.

113. Warner, *Lolly Willowes*, 166.

114. Bessie Parkes, "Letter to Elizabeth Gaskell, October 1850," in *Early Visitors to Haworth: From Ellen Nussey to Virginia Woolf*, ed. Charles Lemon (Haworth: The Brontë Society, 1996), 16.

115. Gaskell, *The Life of Charlotte Brontë*, 11.

116. Gaskell, *The Life of Charlotte Brontë*, 11. See also Lemon, *Early Visitors to Haworth*, 73–74, 92.

117. Lemon, *Early Visitors to Haworth*, 42, 54, 91, 101, 93.

118. Sinclair, *The Three Brontës*, 276.

119. Virginia Woolf, "Haworth, November 1904," in Lemon, *Early Visitors to Haworth*, 126.

120. Sinclair, "Introduction," 13.

121. On rectangles within rectangles in Brontë-land: Deborah Lutz opens *The Brontë Cabinet* by recalling the rectangles within rectangles in the primal scene of reading in *Wuthering Heights*, where the house contains the room, which contains the oak box bed, which contains the books that Catherine writes in, and Lockwood reads. Deborah Lutz, *The Brontë Cabinet: Three Lives in Nine Objects* (New York: W.W. Norton, 2015), xix–xxi.

122. Alice Meynell, "Charlotte and Emily Brontë," in *Hearts of Controversy* (New York: Scribner, 1922), 80.

123. Sinclair, "Introduction," xiv.

124. Sinclair, *The Three Brontës*, 1912, 277.

125. Raitt opens her biographical study of Sinclair by describing this early scene of reading, which she dates to the early 1870s, when Sinclair was under ten years old. Raitt, *May Sinclair: A Modern Victorian*, 15.

126. Sinclair, *The Three Brontës*, 1912, 277.

127. Elizabeth Bishop, *Geography III* (New York: Farrar, Straus and Giroux, 1976), 4.

128. Bishop, *Geography III*, 4.

129. Barker, *The Brontës, Wild Genius of the Moors*, 938. While I speculate that the photograph seen in Figure 2 is one of the ones taken by Stewart, it is in fact undated and unsigned; the evidence of the relationship between Linton's engraving and this photograph is probable but not conclusive.

130. Jonathan Bishop, "Wordsworth and the 'Spots of Time,'" *ELH* 26, no. 1 (1959): 56–57; Thomas Weiskel, *The Romantic Sublime: Studies in the Structure and Psychology of Transcendence* (Baltimore. MD: Johns Hopkins University Press, 1976), 176–80.

131. William Wordsworth, *The Prelude, 1799, 1805, 1850: Authoritative Texts, Context and*

Reception, Recent Critical Essays, ed. Jonathan Wordsworth, M. H. Abrams, and Stephen Gill (New York: W.W. Norton, 1979), IX. 298–316.

132. James Merrill, *Collected Poems* (New York: Alfred A. Knopf, 2001), 4.

133. Sinclair, *The Three Brontës*, 1912, 276.

134. Sinclair, *The Three Brontës*, 277.

135. Sinclair, *The Three Brontës*, 278.

136. Sinclair, *The Three Brontës*, 277.

137. Sinclair, *The Three Brontës*, 279.

138. Meynell, "Charlotte and Emily Brontë," 90, 93.

139. Meynell, "Charlotte and Emily Brontë," 93.

140. Meynell, "Charlotte and Emily Brontë," 79.

141. Meynell, "Charlotte and Emily Brontë," 89.

142. Thomas G. Pavel, *Fictional Worlds* (Cambridge, MA: Harvard University Press, 1986), 12.

143. M. M. Bakhtin, *The Dialogic Imagination: Four Essays* (Austin: University of Texas Press, 1981), 253.

144. On the scale of the Brontë children's books, see Lutz, *The Brontë Cabinet*, 11; Barker, *The Brontës, Wild Genius of the Moors*, 177; Laura Forsberg, "The Miniature World of Charlotte Brontë's Glass Town," in *Charlotte Brontë from the Beginnings: New Essays from the Juvenilia to the Major Works*, ed. Judith E. Pike and Lucy Morrison (London: Routledge, 2017), 44–45. Other scholarship on the juvenilia that I have relied on includes Christine Alexander, "Autobiography and Juvenilia: The Fractured Self in Charlotte Brontë's Early Manuscripts," in *The Child Writer from Austen to Woolf*, ed. Juliet McMaster and Alexander McMaster (Cambridge: Cambridge University Press, 2005), 154–72; Heather Glen, "Configuring a World: Some Childhood Writings of Charlotte Brontë," in *Opening the Nursery Door: Reading, Writing, and Childhood 1600–1900*, ed. Mary Hilton, Morag Styles, and Victor Watson (London and New York: Routledge, 1997); Zak Sitter, "On Early Style: The Emergence of Realism in Charlotte Brontë's Juvenilia," in *Charlotte Brontë from the Beginnings: New Essays from the Juvenilia to the Major Works*, 30–43; Valerie Sanders and Emma Butcher, "'Mortal Hostility': Masculinity and Fatherly Conflict in the Glasstown and Angria Sagas," in *Charlotte Brontë from the Beginnings: New Essays from the Juvenilia to the Major Works*, 59–71; Laurie Langbauer, *The Juvenile Tradition: Young Writers and Prolepsis, 1750–1835* (Oxford: Oxford University Press, 2016).

145. Charlotte Brontë, *An Edition of the Early Writings of Charlotte Brontë: Volume I: The Glass Town Saga, 1826–1832*, ed. Christine Alexander (Oxford: Basil Blackwell, 1987), 12.

146. Brontë, *An Edition of the Early Writings of Charlotte Brontë*, xv.

147. Brontë, *An Edition of the Early Writings of Charlotte Brontë*, 29, 40.

148. Brontë, *An Edition of the Early Writings of Charlotte Brontë*, 24.

149. Brontë, *An Edition of the Early Writings of Charlotte Brontë*, 25.

150. Brontë, *An Edition of the Early Writings of Charlotte Brontë*, 25.

151. Branwell Brontë, *The Works of Patrick Branwell Brontë: An Edition*, vol. 1, ed. Victor A. Neufeldt (New York: Garland, 1997), 250.

152. Forsberg, "The Miniature World of Charlotte Brontë's Glass Town," 52.

153. Forsberg, "The Miniature World of Charlotte Brontë's Glass Town," 55. Another of the Brontë children's many magazines features a glowing art review of a painting—by a portrait painter of Glass Town, one Edward de Lisle, called "The Chief Genii in Council." It is a "glorious picture" of "gigantic dimensions" depicting the four Brontë children as the Genii, seated on thrones of gold in an immense, glittering hall (114–115). The reviewer describes the painting as astonishing in its reality effects: "in the centre hangs a sun-like lamp and you can hardly bring yourself to believe that it is not a reality" (114). They also imagine the fictional beings pondering their own ontological status and dependency. In "Strange Events," Charles Wellesley dimly becomes aware that he and his world are but an insubstantial and shadowy realm with an inscrutable copy-relation to some other world:

> It seemed as if I was a non-existent shadow, that I neither spoke, eat, imagine or lived of myself, but I was the mere idea of some other creature's brain. The Glass Town seemed so likewise. My father, Arthur and everyone with whom I am acquainted, passed into a state of annihilation; but suddenly I thought again that I and my relatives did exists, and yet not us but our minds and bodies without ourselves. Then this supposition—the oddest of any—followed the former quickly, namely, that WE without US were shadows; also, but at the end of a long vista, as it were, appeared dimly and indistinctly, beings that really lived in a tangible shape, that were called by our names and were US from whom WE had been copied by something—I could not tell what (257).

154. Lucy LaFarge, "The Imaginer and the Imagined," *Psychoanalytic Quarterly* 73, no. 3 (2004): 592–93.

155. LaFarge, "The Imaginer and the Imagined," 591–92.

156. Glen, "Configuring a World," 128, 223, 228; Forsberg, "The Miniature World of Charlotte Brontë's Glass Town," 56.

157. Glen, "Configuring a World," 220, 222; Sitter, "On Early Style," 42.

158. Juliet Barker, "Introduction," in *Charlotte Brontë: Juvenilia 1829–1835* (London: Penguin, 1996), xiii.

159. Charlotte Brontë, *The Letters of Charlotte Brontë: With a Selection of Letters by Family and Friends*, vol. I, ed. Margaret Smith (Oxford: Oxford University Press, 1995), 317.

160. Alfred Lord Tennyson, *The Poems of Tennyson*, ed. Christopher Ricks (London: Longman, 1969), 11.66–68.

161. Oliphant, "The Sisters Brontë," 56.

162. Oliphant, "The Sisters Brontë," 58.

163. Oliphant, "The Sisters Brontë," 58.

164. Oliphant, "The Sisters Brontë," 58.

2. The Story of O: Margaret Oliphant and Anti-metalepsis

1. For helpful, thorough overviews of the scholarly literature on metalepsis see John Pier, "Metalepsis," in *The Living Handbook of Narratology*, ed. Peter Hühn (Hamburg University, n.d.), http://lhn.sub.uni-hamburg.de/index.php/Metalepsis.html#:~:text =In%20its%20narratological%20sense%2C%20metalepsis,%2C%20etc.)%2C%20or %20othe. Also see Karin Kukkonen and Sonja Klimek, *Metalepsis in Popular Culture*

(New York: De Gruyter, 2011). A useful history of the term can be found in Ruurd Nauta, "The Concept of Metalepsis: From Rhetoric to the Theory of Allusion and to Narratology," in *Über Die Grenze: Metalepse in Text- Und Bildmedien Des Altertums*, ed. U. E. Eisen and Peter von Möllendorff (Berlin: De Gruyter, 2013), 469–82. For representative treatments that focus on the postmodern, anti-mimetic possibilities of metalepsis, see Brian McHale, *Postmodernist Fiction* (London: Routledge, 1987); Debra Malina, *Breaking the Frame: Metalepsis and the Construction of the Subject* (Columbus: Ohio State University Press, 2002).

2. Quoted in Monika Fludernik, "Eliot and Narrative," in *A Companion to George Eliot*, ed. Amanda S. Anderson and Harry E. Shaw (Oxford: Blackwell, 2013), 22.

3. Fludernik, "Eliot and Narrative," 22–23.

4. Elaine Freedgood, "Fictional Settlements: Footnotes, Metalepsis, the Colonial Effect," *New Literary History* 41, no. 2 (2010): 398.

5. Elaine Freedgood, "Hetero-ontologicality, or Against Realism," *English Studies in Africa* 57, no. 1 (2014): 93.

6. Gerard Genette, *Narrative Discourse: An Essay in Method*, trans. Jane E. Lewin (Ithaca, NY: Cornell University Press, 1980), 234; Bertrand Daunay, "La Métalepse Du Lecteur Ou La Porosité Du Métatexte," *Cahiers de Narratologie* 32 (2017), https://doi-org/10.4000/narratologie.7855.

7. Denis Diderot, "Elegy of Richardson," in *Selected Writings*, ed. Lester G. Crocker, trans. Derek Coltman (New York: Macmillan, 1966), 109.

8. Alice Bell and Jan Alber, "Ontological Metalepsis and Unnatural Narratology," *Journal of Narrative Theory* 42, no. 2 (2012): 167–68.

9. Marie-Laure Ryan, "Metaleptic Machines," in *Avatars of Story* (Minneapolis: University of Minnesota Press, 2006), 206–7.

10. Bell and Alber, "Ontological Metalepsis and Unnatural Narratology," 171.

11. Freedgood, "Fictional Settlements," 399.

12. Richard Walsh, "Person, Level, Voice: A Rhetorical Reconsideration," in *Postclassical Narratology: Approaches and Analyses*, ed. Monika Fludernik (Columbus: Ohio State University Press, 2010), 48.

13. For example, see Malina, *Breaking the Frame*.

14. Genette, *Narrative Discourse*, 4. Genette later walked back a bit from his commitment to the transgressive nature of metalepsis; see Gerard Genette, *Métalepse: de la figure à la fiction* (Paris: Editions du Seuil, 2004).

15. Here are two eloquent, critical voices on love and desire, particularly forbidden desire, and metalepsis: 1) Brian McHale: "Love ... makes fiction go round [and] love as a principle of fiction is, in at least two senses, metaleptic. If authors love their characters, and if texts seduce their readers, then these relations involve violations of ontological boundaries." McHale, *Postmodernist Fiction*, 222; and 2) Michael Lucey: "Queer textual practices in Proust have precisely to do ... with queer desire ... exhibiting such intensity that it fails to respect distinctions between the real world and literary characters, producing borrowing and sharings among characters as well as between real persons and characters, causing practical failures in the straw-figure of rigorous aesthetic attention that Proust has elaborated for us." Michael Lucey, "Proust's Queer Metalepsis," *MLN* 116, no. 4 (2001): 810.

16. Margaret Oliphant, *The Autobiography of Margaret Oliphant*, ed. Elisabeth Jay (Peterborough: Broadview, 2002), 43. Critical tradition has canonized Oliphant as "novelist of experience." George Levine: "She writes with a commitment to the direct and faithful confrontation with ordinary experience." George Levine, "Taking Oliphant Seriously: A Country Gentleman and His Family," *ELH* 83, no. 1 (2016): 233.

17. Elisabeth Jay, *Mrs. Oliphant: "A Fiction to Herself"* (Oxford: Clarendon Press, 1995), 2.

18. Oliphant, *The Autobiography of Margaret Oliphant*, 50. For a discussion of Oliphant's responses to Eliot, see Elsie Michie, "Envious Reading: Margaret Oliphant on George Eliot," *Nineteenth-Century Literature* 74, no. 1 (2019): 87–111.

19. Oliphant, *The Autobiography of Margaret Oliphant*, 48.

20. Anthony Trollope, *An Autobiography*, ed. Michael Sadleir and Frederick Page (Oxford: Oxford World's Classics, 1998), 319.

21. Oliphant, *The Autobiography of Margaret Oliphant*, 164.

22. Similarly, Elizabeth Gaskell: "When I had *little* children I do not think I could have written stories, because I should have become too much absorbed in my fictitious people to attend to my *real* ones." Elizabeth Gaskell, *The Letters of Mrs. Gaskell*, ed. Arthur Pollard and J. A. V. Chapple (Manchester: Manchester University Press, 1966), 394–95.

23. The compositional and publication history of Oliphant's *Autobiography* is complicated. For an excellent table of the history of its composition in relation to the memories it recounts, see Gail Twersky Reimer, "Revision of Labor in Margaret Oliphant's Autobiography," in *Life/Lines: Theorizing Women's Autobiography*, ed. Bella Brodzki and Celeste Schenck (Ithaca, NY: Cornell University Press, 1988), 215. It was first published two years after her death, heavily edited by her niece; a complete manuscript version edited by Elisabeth Jay was published by Oxford in 1990, and in a 2002 Broadview edition. Unless otherwise noted, all quotations in this study are from the Broadview edition. The scholarly literature on Oliphant's *Autobiography*, in addition to Reimer and Jay, includes Mary Jean Corbett, *Representing Femininity: Middle-Class Subjectivity in Victorian and Edwardian Women's Autobiographies* (New York: Oxford University Press, 1992); Deirdre D'Albertis, "The Domestic Drone: Margaret Oliphant and a Political History of the Novel," *Studies in English Literature, 1500–1900* 37, no. 4 (1997): 805–29; Philip Davis, *Memory and Writing* (Liverpool: Liverpool University Press, 1983); Laura Green, "'Long, Long Disappointment': Maternal Failure and Masculine Exhaustion in Margaret Oliphant's Autobiography," in *Other Mothers: Beyond the Maternal Ideal*, ed. Ellen Bayuk Rosenman and Claudia C. Klaver (Columbus: Ohio State University Press, 2008), 36–54; Laurie Langbauer, "Absolute Commonplaces: Oliphant's Theory of Autobiography," in *Margaret Oliphant: Critical Essays on a Gentle Subversive*, ed. D. J. Trela (Selinsgrove, PA: Susquehanna University Press, 1995), 124–34; Linda Peterson, *Traditions of Victorian Women's Autobiography: The Poetics and Politics of Life Writing* (Charlottesville: University of Virginia Press, 1999).

24. Oliphant, *The Autobiography of Margaret Oliphant*, 121.

25. Oliphant, *The Autobiography of Margaret Oliphant*, 182.

26. Oliphant, *The Autobiography of Margaret Oliphant*, 123.

27. Oliphant, *The Autobiography of Margaret Oliphant*, 96.

28. Margaret Oliphant, *The Autobiography and Letters of Mrs. M. O. W. Oliphant*, ed. Mrs. Harry Coghill (New York: Dodd, Mead, 1899), 427. Discussed in Elisabeth Jay, "A Bed of One's Own: Margaret Oliphant," in *Authors at Work: The Creative Environment*, ed. Ceri Sullivan and Graeme Harper (Woodbridge: Brewer, 2009), 49–67.

29. Oliphant, *The Autobiography of Margaret Oliphant*, 78.

30. Oliphant, *The Autobiography of Margaret Oliphant*, 125.

31. Oliphant, *The Autobiography of Margaret Oliphant*, 51.

32. Oliphant, *The Autobiography of Margaret Oliphant*, 122.

33. Oliphant, *The Autobiography of Margaret Oliphant*, 163.

34. Oliphant, *The Autobiography of Margaret Oliphant*, 125.

35. Oliphant, *The Autobiography of Margaret Oliphant*, 88.

36. Jay, *Mrs. Oliphant: "A Fiction to Herself*,*"* 30.

37. Margaret Oliphant, *The Railway Man and His Children*, vol. 2 (London: Macmillan, 1891), 16.

38. Brief critical discussions of "The Fancies of a Believer" can be found in Langbauer, "Absolute Commonplaces," 129–30; Susan E. Colon, *Victorian Parables* (London: Continuum, 2012), 66.

39. Margaret Oliphant, "The Fancies of a Believer," *Blackwood's Edinburgh Magazine*, 1895, 238.

40. Oliphant, "The Fancies of a Believer," 239.

41. Oliphant, "The Fancies of a Believer," 241.

42. Oliphant, "The Fancies of a Believer," 243.

43. Oliphant, "The Fancies of a Believer," 244.

44. Oliphant, *The Autobiography of Margaret Oliphant*, 46.

45. Margaret Oliphant, *The Marriage of Elinor*, vol. 2 (London: Macmillan, 1892), 25.

46. Oliphant, "The Fancies of a Believer," 244.

47. Oliphant, "The Fancies of a Believer," 250.

48. Oliphant, "The Fancies of a Believer," 244.

49. Oliphant, "The Fancies of a Believer," 247.

50. Oliphant, "The Fancies of a Believer," 246.

51. Oliphant, "The Fancies of a Believer," 247.

52. Oliphant, *The Autobiography of Margaret Oliphant*, 48.

53. Victorian Anglican thinkers often idealized the ancient Stoic philosophers as models for a restrained (and often explicitly anti-Catholic) acceptance of earthly suffering and faith in the afterlife. The Reverend William Wolfe Capes, for example wrote that the Stoics "were not there … to shrive the penitent and offer absolution, like the priest-confessors of a later age, but to strengthen to the tones of manly resignation, and whisper hopes of life beyond the grave." William Wolfe Capes, *Stoicism* (London: Society for the Promotion of Christian Knowledge, 1880), 111. On the complexities of Victorian Christian Stoicism, see Lee Behlman, "The Victorian Marcus Aurelius: Mill, Arnold, and the Appeal of the Quasi-Christian," *Journal of Victorian Culture* 16, no. 1 (2011): 1–24.

54. Talia Schaffer, *Communities of Care: The Social Ethics of Victorian Fiction* (Princeton. NJ: Princeton University Press, 2021), 22, 123, 147, 192.

55. Margaret Oliphant, "Miss Austen and Miss Mitford," *Blackwood's Edinburgh Magazine*, 1870, 295.

56. Oliphant, "Miss Austen and Miss Mitford," 295.

57. Andrew H. Miller, "Perfectly Helpless," in *The Burdens of Perfection: On Ethics and Reading in Nineteenth-Century British Literature* (Ithaca, NY: Cornell University Press, 2008), 128.

58. Miller, "Perfectly Helpless," 128.

59. Miller, "Perfectly Helpless," 128, 131.

60. Miller, "Perfectly Helpless," 124. Miller's account of readerly helplessness in Austen derives its contours from Stanley Cavell, "The Avoidance of Love: A Reading of *King Lear*," in *Must We Mean What We Say? A Book of Essays* (New York: Scribner, 1969), 267–79. Kurnick also links it to Lionel Trilling's writing on *Emma*: "Our heart goes out to hold her back and set her straight, but it cannot reach her." Quoted in David Kurnick, "Jane Austen, Secret Celebrity and Mass Eroticism," *New Literary History* 52, no. 1 (2021): 63.

61. Miller, "Perfectly Helpless," 129–30.

62. Feminist scholarship on Oliphant from the 1980s to the 2000s—particularly scholarship that focuses on the *Autobiography*—tends to focus on the tensions between Oliphant's life as a mother and her life as a writer, either lamenting the ways in which the latter gets subordinated to the former in the *Autobiography*—see for example, Dorothy Mermin, *Godiva's Ride: Women of Letters in England, 1830–1880* (Bloomington: Indiana University Press, 1993); Corbett, *Representing Femininity*; Peterson, *Traditions of Victorian Women's Autobiography*—or arguing for Oliphant's self-fashioning as a professional writer—see for example, D'Albertis, "The Domestic Drone."

63. William Flesch, "Narrative and Noncausal Bargaining," *NOVEL: A Forum on Fiction* 45, no. 1 (2012): 7.

64. Margaret Oliphant, *Kirsteen* (London: Dent, 1984), 216. I concede that Oliphant did occasionally use metaleptic language rhetorically, as when, for example, in a review of *The Last Chronicle of Barsetshire,* she protested against Trollope's removal of Mrs. Proudie from the series: "To kill Mrs. Proudie was murder, or manslaughter at the least." Margaret Oliphant, "Novels," *Blackwood's Edinburgh Magazine* 102, no. 623 (1867): 277. Thank you to Jacob Romanow for pointing this out to me.

65. Margaret Oliphant, *The Doctor's Family and Other Stories*, ed. Merryn Williams (Oxford: Oxford World's Classics, 1986), 68.

66. In a related approach to metalepsis in Oliphant, Romanow argues that Oliphant uses metalepsis "as a guerrilla tactic for the construction of privacy." Jacob Romanow, "The Novel of Exteriority: Form, Privacy, and Nation in Nineteenth-Century Britain" (PhD Dissertation, Rutgers University, 2022), 123.

67. John Kucich, "Genre Fusion and the Origins of the Female Political Bildungsroman," *NOVEL: A Forum on Fiction* 54, no. 2 (2021): 170.

68. Erik Gray, "Miss Marjoribanks's Pronouns; or, the Gender, the Particular, and the Novel," *Nineteenth-Century Literature* 76, no. 2 (2021): 226.

69. Margaret Oliphant, *Hester: A Story of Contemporary Life*, ed. Philip Davis (Oxford: Oxford World's Classics, 2009), 261.

70. John Plotz, *Semi-Detached: The Aesthetics of Virtual Experience Since Dickens* (Princeton, NJ: Princeton University Press, 2018), 266.

71. Oliphant, *The Marriage of Elinor*, vol. 1, p. 43.

72. Oliphant, *The Doctor's Family and Other Stories*, 70, 100, 108–9. Subsequent references in parentheses.

73. Oliphant tends to emphasize the physical strength of her meddler/interferer characters. Her short story "A Hidden Treasure" centers on the bizarre, crazy-heroic lengths a "manoeuvring mother" will go to, to protect her daughter from an unwanted suitor. The emphasis is on the mother's physical suffering and endurance, as she energetically toils up a steep flight of stairs, "half-fainting," under the hot French sun, to redirect the suitor away from the daughter. The contours of Oliphant's imagination concerning the extreme physical costs of maternal endurance is revealed in her comparison of Mrs. Mildmay to an African American enslaved woman heroically enduring physical feats to protect her child from slavery: "she did it as the slave-woman crossed the ice, that her child might not be taken away from her. Sir Harry Preston's good-looking young face was as terrible to her as if he had been a hideous planter who would have whipped Nora and made her pick cotton." Margaret Oliphant, "A Hidden Treasure," *The Argosy*, January 1866, 149, 153.

74. Margaret Oliphant, "The Open Door," in *Stories of the Seen and Unseen* (Edinburgh: Blackwood, 1902), 41; see also 13, 17, 26, 42. Subsequent references will be in parentheses.

75. "Inower," in *Dictionaries of the Scots Language*, n.d., https://dsl.ac.uk/.

76. Margaret Oliphant, "The Land of Suspense," *Blackwood's Edinburgh Magazine*, 1897, 137–38.

77. Isobel Armstrong, *Victorian Glassworlds: Glass Culture and the Imagination 1830–1880* (Oxford: Oxford University Press, 2008), 7.

78. Francis Oliphant, *A Plea for Painted Glass: Being an Inquiry into Its Nature, Character, Objects, and Its Claims as an Art* (Oxford: Henry Parker, 1855), 19. A contemporary scholar of Victorian stained glass calls Francis Oliphant "among the best" of mid-century stained-glass artists. A. Charles Sewter, *The Stained Glass of William Morris and His Circle* (New Haven, CT: Yale University Press, 1974), 12.

79. Lewis Carroll, *Through the Looking-Glass, and What Alice Found There* (New York: T.Y. Crowell, 1893), 23.

80. Emily Brontë, *Wuthering Heights*, ed. Helen Small (Oxford: Oxford World's Classics, 2009), 27. Dorothy Van Ghent's "The Window Figure and the Two Children Figure in *Wuthering Heights*" is the classic account of what she calls a "breakthrough from one mode of being into the other." Dorothy Van Ghent, "The Window Figure and the Two Children Figure in *Wuthering Heights*," *Nineteenth-Century Fiction* 7, no. 3 (1952): 189.

81. For a discussion of quantitative methods and the reading of Victorian Fiction, see Jesse Rosenthal and Adam Grener, eds., "Narrative against Data in the Victorian Novel," *Genre* 50, no. 1 (2017).

82. Jonathan Culler, "Apostrophe," in *The Pursuit of Signs: Semiotics, Literature, and Deconstruction* (Ithaca, NY: Cornell University Press, 1981), 146.

83. Culler, "Apostrophe," 152.

84. On the distinction between O as apostrophe and as exclamation, see Gabe

Rivin, "What Happened to O?," *The Paris Review*, August 27, 2015; Barbara Johnson, "Apostrophe, Animation, Abortion," in *A World of Difference* (Baltimore, MD: Johns Hopkins University Press, 1987), 187. For a sociolinguistic analysis of the usage of "Oh" in real-life dialogue which argues for its cognitive (as opposed to purely emotive) content, see Deborah Schiffrin, "Oh: Marker of Information Management," in *Discourse Markers* (Cambridge: Cambridge University Press, 1987), 73–101.

85. Margaret Oliphant, *The Railway Man and His Children*, vol. 3 (London: Macmillan, 1891), 224.

86. Margaret Oliphant, *The Curate in Charge* (London: Macmillan, 1894), 196.

87. Margaret Oliphant, *Old Lady Mary: A Story of the Seen and the Unseen* (Boston: Roberts Brothers, 1884), 109.

88. Oliphant, *Old Lady Mary*, 124.

89. Oliphant, *Old Lady Mary*, 129.

90. Elizabeth Bishop, *Geography III* (New York: Farrar, Straus and Giroux, 1976), ll 33–35, 43–49.

91. Margaret Oliphant, *The Railway Man and His Children*, vol. 1 (London: Macmillan, 1891), 88.

92. Thomas Carlyle, "Sir Walter Scott," in *Selections from Carlyle*, ed. A. H. R. Ball (Cambridge: Cambridge University Press, 1929), 38.

93. In *Auden's O*, Andrew W. Hass traces the intellectual, theological, and literary history of O—including Giotto, and including *The Story of O*—from a figure for earthly and heavenly plenitude and perfection, to a cipher or zero. Andrew H. Hass, *Auden's O: The Loss of One's Sovereignty in the Making of Nothing* (Albany: SUNY Press, 2013).

94. Hass, *Auden's O*, 160–65, 191.

95. Oliphant to John Blackwood on November 8, 1855; quoted in D'Albertis, "The Domestic Drone," 828. See also Jay, *Mrs. Oliphant: "A Fiction to Herself,"* 242, 244.

96. In Paul De Man's formulation, autobiography is less a genre than a mode of writing in which there is an endless "whirligig" of substitution between the "I" who writes and the "I" that is written. Paul De Man, "Autobiography as De-Facement," in *The Rhetoric of Romanticism* (New York: Columbia University Press, 1984), 70.

97. Oliphant, *The Autobiography of Margaret Oliphant*, 36.

98. Oliphant, *The Autobiography of Margaret Oliphant*, 35.

99. Dorrit Cohn asserts categorically the nonexistence of metalepsis in homodiegetic narration, but it happens all the time. See Dorrit Cohn, "Metalepsis and Mise en Abyme," *Narrative* 20, no. 1 (2012): 106.

100. The psychology that I have extracted from Oliphant here, in which constraint, inability to act, and helplessness function—counterintuitively—not as purely negative but as affirmations of a vivid feeling of living, bears a family resemblance to philosopher Harry Frankfurt's account of the relationship between volitional necessity and caring. In his influential essay "The Importance of What We Care About," Frankfurt opens up a space for a third area of inquiry in between epistemology and ethics by focusing on affect, caring, and love. He delineates this third space by detailing the ways in which the experience of being subject to "volitional necessity"—a sense of constraint on action—attends the experience of love. He argues that the experience of volitional necessity is

"liberating rather than coercive," and leads, paradoxically, to "especially valuable experiences or states of fulfillment and of freedom" by reinforming our commitment and attachment to what we care about. Frankfurt, "The Importance of What We Care About," in *The Importance of What We Care About: Philosophical Essays* (Cambridge: Cambridge University Press, 1988), 88, 89.

101. Nathaniel Hawthorne, *House of Seven Gables*, ed. Milton R. Stern (New York: Penguin American Classics, 1981), 30.

102. Henry James, *The Art of the Novel: Critical Prefaces* (Chicago: University of Chicago Press, 2011), 24. Subsequent references will be in parentheses.

103. Yi-Ping Ong, *The Art of Being: Poetics of the Novel and Existentialist Philosophy* (Cambridge, MA: Harvard University Press, 2018), 90.

104. W. R. Bion, *Attention and Interpretation* (Lanham, MD: Rowman & Littlefield, 2004), 118. Helpful discussions of Bion's use of "O" and experience include Thomas H. Ogden, "Reading Bion," in *This Art of Psychoanalysis: Dreaming Undreamt Dreams and Interrupted Cries* (London: Routledge, 2005), 82–85; Mary Jacobus, *The Poetics of Psychoanalysis: In the Wake of Klein* (Oxford: Oxford University Press, 2005), 226–50; Alicia Christoff, *Novel Relations: Victorian Fiction and British Psychoanalysis* (Princeton, NJ: Princeton University Press, 2019), 1, 76, 85.

105. W. R. Bion, *Transformations* (London: Karnac, 1984), 15; Jacobus, *The Poetics of Psychoanalysis*, 251.

106. Seamus Heaney, "Alphabets," in *The Haw Lantern* (London: Faber and Faber, 1987), 1–3. I am indebted to Chakraborty for bringing this poem to my attention. Sumita Chakraborty, "Of New Calligraphy: Seamus Heaney, Planetarity, and Lyric's Uncanny Space-Walk," *Cultural Critique*, no. 104 (2019): 122–23.

107. Ryan, "Metaleptic Machines," 230.

108. On the fantasy of touching fictional characters, see Kurnick, "Jane Austen, Secret Celebrity and Mass Eroticism," 54, 65.

109. Oliphant, "The Fancies of a Believer," 239.

110. On phenomenologies of weightiness and gravity as components of the lexicon of our experience of fictional worlds, see David Kurnick, *The Savage Detective, Reread* (New York: Columbia University Press, 2022), 14; Samuel R. Delany, *The American Shore* (Middletown, CT: Wesleyan University Press, 2014), xvi, 33, 159–61.

3. George Eliot and Prolepsis: Prediction, Prevention, Protection

1. Margaret Oliphant, *The Autobiography of Margaret Oliphant*, ed. Elizabeth Jay (Peterborough: Broadview, 2002), 49–50.

2. Gerard Genette, *Narrative Discourse: An Essay in Method*, trans. Jane E. Lewin (Ithaca, NY: Cornell University Press, 1980), 40.

3. For a discussion of the ontological status of fictional futures, see Currie and especially Hack, who argues that the practice of foreshadowing implicates literary texts' most basic ontological claims. Mark Currie, *About Time: Narrative, Fiction, and the Philosophy of Time* (Edinburgh: Edinburgh University Press, 2007), 21; Daniel Hack, "Reading for the Foreshadowing," *Representations* 165, no. 1: 37–63.

4. Currie, *About Time*, 39–40.

5. Currie, *About Time*, 50.

6. Monika Fludernik, *An Introduction to Narratology*, trans. Patricia Hausler-Greenfield and Monika Fludernik (London; New York: Routledge, 2009), 34; Caroline Levine, "The Prophetic Fallacy: Realism, Foreshadowing and Narrative Knowledge in *Romola*," in *From Author to Text: Re-Reading George Eliot's Romola*, ed. Caroline Levine and Mark W. Turner (Aldershot: Ashgate, 1998), 139.

7. Genette, *Narrative Discourse*, 73.

8. George Eliot in this instance demonstrates self-consciousness about this proleptic gesture. The next sentence reads, "What elegant historian would neglect a striking opportunity for pointing out that his heroes did not foresee the history of the world, or even their own actions?" George Eliot, *Middlemarch*, ed. David Carroll (Oxford: Oxford World's Classics, 1996), 61.

9. George Eliot, *The Mill on the Floss*, ed. A.S. Byatt (Harmondsworth: Penguin, 1979), 94.

10. Genette, *Narrative Discourse*, 75.

11. Genette, *Narrative Discourse*, 75.

12. Genette, *Narrative Discourse*, 76.

13. Genette, *Narrative Discourse*, 67.

14. Gary Saul Morson, *Narrative and Freedom: The Shadows of Time* (New Haven, CT: Yale University Press, 1994), 42. For a sophisticated defense of prolepsis in Eliot—specifically in *The Mill on the Floss*—very different from mine, see Nathan K. Hensley, "Database and the Future Anterior: Reading *The Mill on the Floss* Backwards," *Genre* 50, no. 1 (2017): 131.

15. According to Hack's research on the history of foreshadowing and secondary education, "foreshadowing" was not generally used to designate the literary technique until the late nineteenth century, when it began to appear in pedagogical manuals. My understanding of the history and theory of foreshadowing is deeply indebted to Hack, "Reading for the Foreshadowing."

16. Bruce Robbins, "Many Years Later: Prolepsis in Deep Time," *The Henry James Review* 33, no. 3 (2012): 192.

17. Morson, *Narrative and Freedom*, 51.

18. Yi-Ping Ong, *The Art of Being: Poetics of the Novel and Existentialist Philosophy* (Cambridge, MA: Harvard University Press, 2018), 67.

19. Genette, *Narrative Discourse*, 205.

20. Michael Andre Bernstein, *Foregone Conclusions: Against Apocalyptic History* (Los Angeles: University of California Press, 1994), 82.

21. Morson, *Narrative and Freedom*, 50.

22. Eliot, *The Mill on the Floss*, 215.

23. Susan Fraiman, *Unbecoming Women: British Women Writers and the Novel of Development* (New York: Columbia University Press, 1993); Joshua Esty, "Nationhood, Adulthood, and the Ruptures of Bildung: Arresting Development in *The Mill on the Floss*," *Narrative* 4, no. 2 (1996): 144–59; Alicia Christoff, "Metaleptic Mourning," *Victorian Literature and Culture* 47, no. 3 (2019): 631–36.

24. Vanessa Smith, "Toy Stories," *NOVEL: A Forum on Fiction* 50, no. 1 (2017): 37. See

also *Toy Stories: Analyzing the Child in Nineteenth-Century Literature* (New York: Fordham University Press, 2023), 125–35.

25. Alicia Christoff, *Novel Relations: Victorian Fiction and British Psychoanalysis* (Princeton, NJ: Princeton University Press, 2019), 85.

26. Bion, *Experiences in Groups* 86, 89 quoted by Christoff, *Novel Relations*, 86.

27. Thomas H. Ogden, "On Holding and Containing, Being and Dreaming," in *This Art of Psychoanalysis: Dreaming Undreamt Dreams and Interrupted Cries* (London: Routledge, 2005), 82, and *Reclaiming Unlived Life: Experiences in Psychoanalysis: Dreaming Undreamt Dreams and Interrupted Cries* (New York: Routledge, 2016), 95–96.

28. Ludwig Wittgenstein and G. H. von Wright, *On Certainty*, ed. G. E. M. Anscombe (New York: Harper, 1969), 130.

29. L. S. Vygotsky, *Mind in Society: The Development of Higher Psychological Processes*, ed. Michael Cole et al. (Cambridge, MA: Harvard University Press, 1978), 56. See also Michael Cole, "Culture and Development," in *Between Culture and Biology: Perspectives on Ontogenetic Development*, ed. Heidi Keller, Ype H. Poortinga, and Alex Scholmerich (Cambridge: Cambridge University Press, 2002), 182–87.

30. Boris G. Meshcheryakov, "Terminology in L. S. Vygotsky's Writing," in *The Cambridge Companion to Vygotsky*, ed. Harry Daniels, Michael Cole, and James V. Wertsch (Cambridge: Cambridge University Press, 2007), 166.

31. Vygotsky, *Mind in Society*, 85–86.

32. Lisina quoted by Meshcheryakov, "Terminology in L. S. Vygotsky's Writing," 167.

33. Kay Long, "Thinking Developmentally: Perspectives Following Loewald and Klein," *Journal of Infant, Child, and Adolescent Psychotherapy* 17, no. 2 (2018): 97.

34. H. W. Loewald, "On the Therapeutic Action of Psycho-Analysis," *International Journal of Psychoanalysis* 41 (1960): 20.

35. Vygotsky, *Mind in Society*, 56–57.

36. Robbins, "Many Years Later," 194.

37. James Merrill, *The Book of Ephraim* (New York: Alfred A. Knopf, 2018), 25.

38. Quoted by Sue Zemka, *Time and the Moment in Victorian Literature and Society* (Cambridge: Cambridge University Press, 2011), 125.

39. Debra Gettelman, "Reading Ahead in George Eliot," *NOVEL: A Forum on Fiction* 39, no. 1 (2005): 30.

40. George Eliot, *The Journals of George Eliot*, ed. Margaret Harris and Judith Johnston (Cambridge: Cambridge University Press, 2000), 76.

41. Eliot, *The Journals of George Eliot*, 77.

42. Rosemarie Bodenheimer, *The Real Life of Mary Ann Evans* (Ithaca, NY: Cornell University Press, 1994), 134; Rosemary Ashton, *George Eliot: A Life* (London: Penguin, 1996), 220; Ruby Redinger, *George Eliot: The Emergent Self* (New York: Knopf, 1975), 405.

43. Charles Swann, "Deja vu: Deja Lu: 'The Lifted Veil' as an Experiment in Art," *Literature and History* 5, no. 1 (1979): 40–57; Neil Hertz, *George Eliot's Pulse* (Stanford, CA: Stanford University Press, 2003).

44. Gillian Beer, *George Eliot* (Brighton: Harvester, 1986); Sandra Gilbert and Susan Gubar, *The Madwoman in the Attic* (New Haven, CT: Yale University Press, 1979); Mary Jacobus, "Men of Maxims and *The Mill on the Floss*," in *Reading Woman: Essays in Feminist Criticism* (New York: Columbia University Press, 1986), 62–82.

45. Thomas Albrecht, "Sympathy and Telepathy: The Problem of Ethics in George Eliot's 'The Lifted Veil,'" *ELH* 73, no. 2 (2006): 437–63; Rae Greiner, "Sympathy Time: Adam Smith, George Eliot, and the Realist Novel," *Narrative* 17, no. 3 (2009): 291–311.
46. George Eliot, *The Lifted Veil and Brother Jacob*, ed. Helen Small (Oxford: Oxford University Press, 1999), 3.
47. Eliot, *The Mill on the Floss*, 649.
48. George Eliot, *The George Eliot Letters*, vol. 3, ed. Gordon Sherman Haight (New Haven, CT: Yale University Press, 1954), 170.
49. Jill Galvan, "The Narrator as Medium in George Eliot's 'The Lifted Veil,'" *Victorian Studies* 48, no. 2 (2006): 240–48; Kate Flint, "Blood, Bodies, and The Lifted Veil," *Nineteenth Century Literature* 51, no. 4 (1997): 455–73; Jules Law, "Perilous Reversals: Fluid Exchange in George Eliot's Early Works," in *The Social Life of Fluids: Blood, Milk, and Water in the Victorian Novel* (Ithaca, NY: Cornell University Press, 2010), 71–97; Richard Menke, "Fiction as Vivisection: G. H. Lewes and George Eliot," *ELH* 67, no. 2 (2000): 617–53; Sally Shuttleworth, *George Eliot and Nineteenth-Century Science: The Make-Believe of a Beginning* (Cambridge: Cambridge University Press, 1987).
50. Eliot, *The George Eliot Letters*, 3:111.
51. Eliot, *The Lifted Veil and Brother Jacob*, 13.
52. Eliot, *The Lifted Veil and Brother Jacob*, 13.
53. Albrecht, "Sympathy and Telepathy: The Problem of Ethics in George Eliot's 'The Lifted Veil.'"
54. Suzy Anger, *Victorian Interpretation* (Ithaca, NY: Cornell University Press, 2006); Greiner, "Sympathy Time: Adam Smith, George Eliot, and the Realist Novel."
55. Eliot, *The Lifted Veil and Brother Jacob*, 8–9, 23.
56. Eliot, *The Lifted Veil and Brother Jacob*, 11–12.
57. Eliot, *The Lifted Veil and Brother Jacob*, 13.
58. Exceptions include Swann, "Deja vu: Deja Lu"; Shuttleworth, *George Eliot and Nineteenth-Century Science*; Hertz, *George Eliot's Pulse*.
59. Uri Margolin, "Of What Is Past, Is Passing, or to Come: Temporality, Aspectuality, Modality, and the Nature of Literary Narrative," in *Narratologies: New Perspectives on Narrative Analysis*, ed. David Herman (Columbus: Ohio State University Press, 1999), 142–66.
60. Eliot, *The Lifted Veil and Brother Jacob*, 3.
61. Eliot, *The Lifted Veil and Brother Jacob*, 3.
62. Eliot, *The Lifted Veil and Brother Jacob*, 43.
63. Swann, "Deja vu: Deja Lu," 53.
64. Eliot, *The Lifted Veil and Brother Jacob*, 21.
65. Eliot, *The Lifted Veil and Brother Jacob*, 21.
66. Eliot, *The Mill on the Floss*, 429.
67. Charles Bray, *The Philosophy of Necessity*, vol. 1 (London: Longmans, 1841), 166.
68. Eliot, *The Journals of George Eliot*, 81.
69. Auguste Comte, *The Catechism of Positive Religion*, trans. Richard Congreve (London: John Chapman, 1858), 104.
70. Ludwig Feuerbach, *The Essence of Christianity*, trans. Marian Evans (London: John Chapman, 1854), 237.
71. Hertz, *George Eliot's Pulse*, 57.

72. David Carroll, *George Eliot: The Critical Heritage* (London: Routledge and Kegan Paul, 1971), 121–22; Felicia Bonaparte, *Will and Destiny: Morality and Tragedy in George Eliot's Novels* (New York: NYU Press, 1975); U. C. Knoepflmacher, *George Eliot's Early Novels: The Limits of Realism* (Berkeley: University of California Press, 1968); Gerhard Joseph, "The Antigone as Cultural Touchstone: Matthew Arnold, Hegel, George Eliot, Virginia Woolf, and Margaret Drabble," *PMLA* 96, no. 1 (1981): 22–35.

73. Esty, "Nationhood, Adulthood, and the Ruptures of Bildung"; Fraiman, *Unbecoming Women*.

74. For a provocative discussion of the pull of the ending of *The Mill on the Floss*, see Hensley, "Database and the Future Anterior: Reading *The Mill on the Floss* Backwards."

75. Carroll, *George Eliot*, 139.

76. Carroll, *George Eliot*, 121–22.

77. Garrett Stewart, "Of Time as a River: The Mill of Desire," in *Novel Violence: A Narratography of Victorian Fiction* (Chicago: University of Chicago Press, 2009), 130.

78. Nancy K. Miller, "Emphasis Added: Plots and Plausibilities in Women's Fiction," *PMLA* 96, no. 1 (1981): 47.

79. Beer, *George Eliot*, 101–3.

80. Jacobus, "Men of Maxims and *The Mill on the Floss*," 252.

81. Eliot, *The George Eliot Letters*, 3:374.

82. Eliot, *The Journals of George Eliot*, 76.

83. Eliot, *The Mill on the Floss*, 61.

84. Eliot, *The Mill on the Floss*, 166.

85. Eliot, *The Mill on the Floss*, 90, 629.

86. Genette, *Narrative Discourse*, 67–71.

87. Genette, *Narrative Discourse*, 71.

88. D. A. Miller, *Narrative and Its Discontents: Problems of Closure in the Traditional Novel* (Princeton, NJ: Princeton University Press, 1981), 220.

89. Miller, *Narrative and Its Discontents*, 221; Roland Barthes, *S/Z*, trans. Richard Miller (New York: Hill and Wang, 1974), 112, 85–86.

90. Carroll, *George Eliot*, 143.

91. My treatment of *The Mill on the Floss* might be put in dialogue with David James's discussions in *Discrepant Solace*, of a genre of contemporary fiction he calls "fictions of approaching loss" (115) which feature a "fraught coexistence of solace and apprehension" (176). Particularly relevant are his discussions of Kazuo Ishiguro's *Never Let Me Go*, which he sees as a meditation on "the actions and thoughts we assume would occupy us when expecting an end we can do nothing to prevent" (183), and David Grossman's tragic enactment of parental dread and "magical thinking" (203) in *To the End of the Land*, a novel that cruelly prefigured the death of Grossman's own son. David James, *Discrepant Solace: Contemporary Literature and the Work of Consolation* (Oxford: Oxford University Press, 2019).

92. Adela Pinch, *Thinking About Other People in Nineteenth-Century British Writing* (Cambridge: Cambridge University Press, 2010), 162–69.

93. Eliot, *The Mill on the Floss*, 380.

94. Gettelman, "Reading Ahead in George Eliot," 29.

95. Eliot, *The Mill on the Floss*, 166.

96. Eliot, *The Mill on the Floss*, 145.
97. Elizabeth Gaskell, *'My Diary': The Early Years of My Daughter Marianne* (London: Clement Shorter, 1923), 11. See also 13, 17, 22, 27–28.
98. Carolyn Steedman, *Strange Dislocations: Childhood and the Idea of Human Interiority, 1780–1930* (Cambridge, MA: Harvard University Press, 1998), 64.
99. Eliot, *The George Eliot Letters*, 3:335, 117.
100. Bodenheimer, *The Real Life of Mary Ann Evans*, 192–99.
101. Eliot, *The George Eliot Letters*, 3:232.
102. Margaret Homans, *Bearing the Word: Language and Female Experience in Nineteenth-Century Women's Writing* (Chicago: University of Chicago Press, 1986); Stewart, "Of Time as a River."
103. Christoff also emphasizes the ways in which *The Mill on the Floss* is "future oriented." Christoff, *Novel Relations: Victorian Fiction and British Psychoanalysis*, 57.
104. Eliot, *The Mill on the Floss*, 641.
105. Andrew H. Miller, "Perfectly Helpless," in *The Burdens of Perfection: On Ethics and Reading in Nineteenth-Century British Literature* (Ithaca, NY: Cornell University Press, 2008), 123–36.
106. Eliot, *The Mill on the Floss*, 122.
107. Eliot, *The Mill on the Floss*, 357.
108. Carroll, *George Eliot*, 15.
109. Bodenheimer, *The Real Life of Mary Ann Evans*; Gilbert and Gubar, *The Madwoman in the Attic*; Jacobus, "Men of Maxims and *The Mill on the Floss*."
110. George Levine, "Determinism and Responsibility in the Works of George Eliot," *PMLA* 77, no. 3 (1962): 262–79; Alan Rauch, "Destiny as an Unmapped River: George Eliot's *The Mill on the Floss*," in *Useful Knowledge: The Victorians, Morality, and the March of the Intellect* (Durham, NC: Duke University Press, 2001), 190–206; William Myers, *The Teachings of George Eliot* (Leicester: Leicester University Press, 1984).
111. Eliot, *The Mill on the Floss*, 588.
112. Eliot, *The Mill on the Floss*, 606.
113. Eliot, *The Mill on the Floss*, 602.
114. Eliot, *The Mill on the Floss*, 601–2.
115. Bodenheimer, *The Real Life of Mary Ann Evans*, 103, 109.
116. Eliot, *The Mill on the Floss*, 628.
117. Eliot, *The Mill on the Floss*, 628.
118. Bodenheimer, *The Real Life of Mary Ann Evans*, 103.
119. Carroll, *George Eliot*, 111–12.
120. Eliot, *The Mill on the Floss*, 597.
121. Eliot, *The Mill on the Floss*, 451.
122. Eliot, *The Mill on the Floss*, 492.
123. Eliot, *The Mill on the Floss*, 515.
124. Eliot, *The Mill on the Floss*, 82.
125. Eliot, *The Mill on the Floss*, 82.
126. Eliot, 515. On modalities of mental functioning in *The Mill on the Floss* see Christoff, *Novel Relations: Victorian Fiction and British Psychoanalysis*, 58–62.
127. Eliot, *The Mill on the Floss*, 55.

128. Eliot, *The Mill on the Floss*, 53–54.
129. Eliot, *The Mill on the Floss*, 650.
130. Patricia Lockwood, *No One Is Talking About This* (New York: Riverhead, 2021), 132.
131. Lucy LaFarge, "The Imaginer and the Imagined," *Psychoanalytic Quarterly* 73, no. 3 (2004): 591–625.
132. Shuttleworth, *George Eliot and Nineteenth-Century Science*, 53.
133. Carolyn Steedman, *Strange Dislocations: Childhood and the Idea of Human Interiority, 1780–1930* (Cambridge, MA: Harvard University Press, 1998), x.
134. Homans, *Bearing the Word*; Jacobus, "Men of Maxims and *The Mill on the Floss*."
135. Eliot, *The Mill on the Floss*, 384.
136. Eliot, *The Mill on the Floss*, 382–83.
137. Eliot, *The Mill on the Floss*, 384.
138. Currie, *About Time*, 31–32; Laurie Langbauer, *The Juvenile Tradition: Young Writers and Prolepsis, 1750–1835* (Oxford: Oxford University Press, 2016); Teresa Bridgeman, "Thinking Ahead: A Cognitive Approach to Prolepsis," *Narrative* 13, no. 2 (May 2005): 125–59; Andrew Bennett, *Romantic Poets and the Culture of Posterity* (Cambridge: Cambridge University Press, 1999).
139. Eliot, *The Mill on the Floss*, 401, 432.
140. Eliot, *The Lifted Veil and Brother Jacob*, 56.
141. For an excellent discussion of De Beauvoir and Eliot, see Laura Green, "'I Recognized Myself in Her': Identifying with the Reader in George Eliot's 'The Mill on the Floss' and Simone de Beauvoir's 'Memoirs of a Dutiful Daughter,'" *Tulsa Studies in Women's Literature* 24, no. 1 (2005): 57–79. *The Mill on the Floss* was also Margaret Oliphant's favorite. See Elise Michie, "Envious Reading: Margaret Oliphant on George Eliot," *Nineteenth-Century Literature* 74, no. 1 (2019): 92. To the list of feminist writers with strong attachments to *The Mill on the Floss* must be added Sara Ahmed, *Living a Feminist Life* (Durham, NC: Duke University Press, 2017), 140.
142. Deidre Bair, *Simone de Beauvoir: A Biography* (New York: Simon & Schuster, 1990), 71.
143. Simone De Beauvoir, *Memoirs of a Dutiful Daughter*, trans. James Kirkup (Cleveland, OH: World Publishing, 1959), 148.
144. For reproduction of the original title page with epigraph, see George Eliot, *Silas Marner, the Weaver of Raveloe*, ed. David Carroll (New York: Penguin, 1996), 1.
145. Eliot, *The George Eliot Letters*, 3:382.
146. Eliot, *The Mill on the Floss*, 641.
147. Eliot, *Silas Marner*, 15–16.
148. Eliot, *Silas Marner*, 111.
149. Eliot, *Silas Marner*, 122.
150. Lee Edelman, *No Future: Queer Theory and the Death Drive* (Durham, NC: Duke University Press, 2004), 58. See also Jeff Nunokawa, "The Miser's Two Bodies: 'Silas Marner' and the Sexual Possibilities of the Commodity," *Victorian Studies* 36, no. 3 (1993): 273. For a reading of the novel that emphasizes the queerness of reproductivity, see also Devin Griffiths, "*Silas Marner* and the Ecology of Form," *Victorian Literature and Culture* 48, no. 1 (2020): 312–16.

151. Eliot, *Silas Marner*, 165. See also 146.
152. Eliot, *Silas Marner*, 119.
153. Eliot, *Silas Marner*, 162.
154. The phrase is Bakhtin's, cited by Morson, *Narrative and Freedom*, 44–45.
155. Kate E. Brown, "Loss, Revelry, and the Temporal Measures of *Silas Marner*: Performance, Regret, Recollection," *NOVEL: A Forum on Fiction* 32, no. 2 (1999): 245.
156. Eliot, *Silas Marner*, 110.
157. Brown, "Loss, Revelry, and the Temporal Measures of *Silas Marner*," 245.
158. For representative discussions, see Nunokawa, "The Miser's Two Bodies: 'Silas Marner' and the Sexual Possibilities of the Commodity," 288–89; Hertz, *George Eliot's Pulse*, 69–71; Courtney Berger, "When Bad Things Happen to Bad People: Liability and Individual Consciousness in *Adam Bede* and *Silas Marner*," *NOVEL: A Forum on Fiction* 33, no. 3 (2000): 320; Ilana M. Blumberg, "Stealing the 'Parson's Surplice' / the Person's Surplus: Narratives of Abstraction and Exchange in *Silas Marner*," *Nineteenth-Century Literature* 67, no. 4 (2013): 506–10.
159. Eliot, *The George Eliot Letters*, 3:382.
160. R. Jay Wallace, *The View from Here: On Affirmation, Attachment, and the Limits of Regret* (Oxford: Oxford University Press, 2013), 16, 24. For an approach to regret in Eliot that explores ways in which regret can be both retrospective and forward looking, see Supritha Rajan, "Regret Without Limit: The Ends of Agency and Genre in George Eliot's Middlemarch," *Victorian Literature and Culture* 49, no. 2 (2021): 261.
161. Edelman, *No Future: Queer Theory and the Death Drive*, 57.
162. Brown, "Loss, Revelry, and the Temporal Measures of *Silas Marner*."
163. Brown, "Loss, Revelry, and the Temporal Measures of *Silas Marner*," 247.
164. Eliot, *The Mill on the Floss*, 82.
165. Hertz, *George Eliot's Pulse*, 95.
166. Gaskell, *'My Diary': The Early Years of My Daughter Marianne*, 9–10.
167. Gaskell, *'My Diary': The Early Years of My Daughter Marianne*, 11.
168. Gaskell, *'My Diary': The Early Years of My Daughter Marianne*, 5.

4. Regret, Remorse, and Realism in Elizabeth Gaskell

1. Jessica F. Roberts, "The Little Coffin: Anthologies, Convention, and Dead Children," in *Representations of Death in Nineteenth-Century U.S. Writing and Culture*, ed. Lucy E. Frank (New York: Routledge, 2007), 141–54.
2. Strong explanations of the cultural, literary, and political meanings of nineteenth-century dead baby poetry include Kerry Larson, *Imagining Equality in Nineteenth-Century American Literature* (Cambridge: Cambridge University Press, 2008), 86–87; Roberts, "The Little Coffin."
3. Elizabeth Gaskell, *The Works of Elizabeth Gaskell: Volume 1: Journalism, Early Fiction*, ed. Joanne Shattock (London: Pickering and Chatto, 2005), 29.
4. Jenny Uglow, *Elizabeth Gaskell: A Habit of Stories* (London: Faber and Faber, 1993), 92.
5. Elizabeth Gaskell, *The Letters of Mrs. Gaskell*, ed. Arthur Pollard and J. A. V. Chapple (Manchester: Manchester University Press, 1966), 74–75.

6. Gaskell, *The Letters of Mrs. Gaskell*, 45.

7. Essential reading on this topic is Jan-Melissa Schramm's *Atonement and Self-Sacrifice in Nineteenth Century Narrative*, which expertly provides the contexts of Victorian debates about the efficacy of substitutive schemes in both theological and legal contexts. Particularly relevant for the Unitarian Gaskell is Schramm's discussion of ambivalence about sacrificial logics in Unitarian thought. Jan-Melissa Schramm, *Atonement and Self-Sacrifice in Nineteenth-Century Narrative* (Cambridge: Cambridge University Press, 2012), 3–5, 56–57, 141.

8. In a related article, Womack argues that themes of regret and desire for atonement toward the end of *North and South* channeled some of the drama surrounding Gaskell's stressful completion of the serialized sections of the novel for Charles Dickens's *Household Words*, demonstrating the ways in which Gaskell treated real persons, literary characters, and the text itself as "porous" versions of each other, and her books as alive, yet vulnerable. Elizabeth Womack, "Anticipated Ends, Atonement, and the Serialization of Gaskell's *North and South*," *Dickens Studies Annual* 48, no. 1 (2017): 240.

9. Gaskell, *The Letters of Mrs. Gaskell*, 347.

10. Elizabeth Gaskell, *The Life of Charlotte Brontë*, ed. Elizabeth Jay (Harmondsworth: Penguin Classics, 1998), 447.

11. Gaskell, *The Letters of Mrs. Gaskell*, 453.

12. Gaskell, *The Letters of Mrs. Gaskell*, 463.

13. For example, see Gaskell, *The Letters of Mrs. Gaskell*, 563.

14. Gaskell, *The Letters of Mrs. Gaskell*, 455, 458. I am necessarily only touching on the emotional register of Gaskell's experience surrounding the writing and reception of *The Life of Charlotte Brontë*. For fuller accounts of the persons who felt harmed by the book, the legal remedies, and the changes that Gaskell made between the first and third editions, see Uglow, *Elizabeth Gaskell*, 424–35; Linda Peterson, Introduction to *The Life of Charlotte Brontë* (London: Routledge, 2016), 1–4. Allison expertly treats the controversies surrounding *The Life of Charlotte Brontë* in the context of the shifting relations between fictionality and facticity. Sarah Allison, "Narrative Form and Facts, Facts, Facts: Elizabeth Gaskell's *Life of Charlotte Brontë*," *Genre* 50, no. 1 (2017): 97–116.

15. Allison, "Narrative Form and Facts, Facts, Facts"; Linda K. Hughes and Michael Lund, *Victorian Publishing and Mrs. Gaskell's Work* (Charlottesville: University of Virginia Press, 1999), 124–56.

16. Alice Meynell, "Charlotte and Emily Brontë," in *Hearts of Controversy* (New York: Scribner, 1922), 80.

17. May Sinclair, *The Three Brontës* (London: Hutchinson, 1912), 277.

18. The great tradition of writing about Gaskell's social realism extends from Raymond Williams, *Culture and Society* (1958) and Catherine Gallagher's *The Industrial Reformation of the English Novel* (1985). See Raymond Williams, *Culture and Society, 1780–1950*, 2nd ed. (New York: Columbia University Press, 1983); Catherine Gallagher, *The Industrial Reformation of English Fiction: Social Discourse and Narrative from 1832–1867* (Chicago: University of Chicago Press, 1985). Feminist criticism of Gaskell has, of course, treated questions of motherhood. See Margaret Homans, *Bearing the Word: Language and Female Experience in Nineteenth-Century Women's Writing* (Chicago: University

of Chicago Press, 1986). Homans begins her two chapters on Gaskell with a reading of the sonnet to the stillborn child, but her reading is quite different from mine. On questions of detail, Patsy Stoneman makes a connection in Gaskell between "maternal thinking" characterized by "intense, detail-oriented attention" that is "rooted in care" and Gaskell's realist mode. See Patsy Stoneman, *Elizabeth Gaskell*, 2nd ed. (Manchester: Manchester University Press, 2006), 24, 117. For a narratological treatment of Gaskell's fiction, whose focus on Gaskell's management of crossings between and separations of the real world and storyworld chimes with some of my interests, see Robyn Warhol, *Gendered Interventions: Narrative Discourse in the Victorian Novel* (New Brunswick, NJ: Rutgers University Press, 1989), 47–71.

19. On the distinction between regret and remorse, see Bernard Williams, *Moral Luck* (Cambridge: Cambridge University Press, 1982); Gabriele Taylor, *Shame, Pride, and Guilt: Emotions of Self-Assessment* (Oxford: Oxford University Press, 1987); Janet Landman, *Regret: The Persistence of the Possible* (New York: Oxford University Press, 1993); R. Jay Wallace, *The View from Here: On Affirmation, Attachment, and the Limits of Regret* (Oxford: Oxford University Press, 2013), 34–35.

20. A. H. Miller explores the ways in which, in Eliot, Dickens, and James, realist fiction's mode of setting the particularities of an individual life in relation to a world of possibilities activates our sense of our own lives' relation—often experienced as regret—of other, foreclosed possible paths. Andrew H. Miller, "Lives Unled in Realist Fiction," *Representations* 98, no. 1 (2007): 118–34, "'A Case of Metaphysics': Counterfactuals, Realism, 'Great Expectations,'" *ELH* 79, no. 3 (2012): 773–96, and *On Not Being Someone Else: Tales of Our Unled Lives* (Cambridge, MA: Harvard University Press, 2020). He writes, "To the extent that realism proposes to give us stories about how things really were, a space naturally opens up within that mode to tell us how things might have been, but were not. . . . In regularly shadowing forth lives for our characters that we do not see, realism reminds us of the singularity of those lives that we *do* see: it is this life, lived thus, and not other possible lives, formed by other choices, other changes, that the author has decided to represent." See Miller, "Lives Unled in Realist Fiction," 122. In a related essay, Rajan focuses on the philosophical underpinnings of regret in George Eliot's *Middlemarch*. Following Williams, she sees regret as a response to problems of agency, individual responsibility, sovereignty, and freedom. Supritha Rajan, "Regret Without Limit: The Ends of Agency and Genre in George Eliot's *Middlemarch*," *Victorian Literature and Culture* 49, no. 2 (2021): 259–300.

21. Elizabeth Gaskell, *Cousin Phillis and Other Stories*, ed. Heather Glen (Oxford: Oxford World's Classics, 2010), 232. My emphasis on fears of harm and accidental harm in relation to novelistic worldmaking bears a relationship to discussions of unintentional harm and responsibility in the eighteenth-century novel by Kramnick and Macpherson. "Injury," in Macpherson's account, "produces relationship" (182). Jonathan Kramnick, *Actions and Objects from Hobbes to Richardson* (Stanford, CA: Stanford University Press, 2010); Sandra Macpherson, *Harm's Way: Tragic Responsibility and the Novel Form* (Baltimore, MD: Johns Hopkins University Press, 2010).

22. Frederick Greenwood, "Postscript," in *Wives and Daughters*, by Elizabeth Gaskell (Oxford: Oxford World's Classics, 1987), 685.

23. Greenwood, "Postscript," 685. Greenwood's use of "real" here dates from rela-

tively early in discourses of "realism" in the arts. Daniel Brown dates the earliest usages of "realist" and realism" in discussions of aesthetic objects to Ruskin's *Modern Painters* (1856) and George Eliot's review of it in *Westminster Review* (Brown 4, 5); and G. H. Lewes's "Realism in Art" (1858). Pam Morris cites an 1851 *Frazer's Magazine* reference to Thackeray as "chief of the Realist School" (85). Freedgood's account of the "invention" of the Victorian novel as the embodiment of "realism" in twentieth-century literary criticism is salutary yet does not acknowledge the ways in which the evocation of real worlds was, in fact, a value in nineteenth-century writing about fiction. See Daniel Brown, *Representing Realism in Victorian Literature and Criticism* (Cham: Palgrave Macmillan, 2016); Pam Morris, *Realism* (London: Routledge, 2003); Elaine Freedgood, *Worlds Enough: The Invention of Realism in the Victorian Novel* (Princeton, NJ: Princeton University Press, 2019).

24. The opposition between narration and description in accounts of realist fiction starts, of course, with Lukacs's essay "Narrate or Describe?" Georg Lukacs, "Narrate or Describe?," in *Writer and Critic, and Other Essays*, trans. Arthur D. Kahn (New York: Grosset and Dunlap, 1971), 110–48. Lukacs's answer to his own question was, emphatically, "narrate"—in his view narration is necessary to capturing reality in its dynamic unfolding. Freedgood sees the emphasis on narration in not only Lukacs but also Genette as instrumental to the "invention" of the Victorian realist novel as a coherent genre. Freedgood, *Worlds Enough*, 22–23. Attempts to rehabilitate description and detail include Schor, and more recently, some of the authors in the 2016 special issue of the journal *Representations*, "Description Across the Disciplines." See Naomi Schor, *Reading in Detail: Aesthetics and the Feminine* (New York: Methuen, 1987); Sharon Marcus, Heather Love, and Stephen Best, eds., "Description Across the Disciplines," *Special Issue of Representations* 135, no. 1 (2016). For accounts of the consequences of seeing an opposition between narration and description, see David James, *Discrepant Solace: Contemporary Literature and the Work of Consolation* (Oxford: Oxford University Press, 2019), 70; Ruth Ronen, "Description, Narrative and Representation," *Narrative* 5, no. 3 (1997): 274–83. In spite of the general swing of the pendulum in the direction of description, strong accounts of the priority of narration over description can still be found in recent novel criticism and theory. For example, in *Good Form: The Ethical Experience of the Victorian Novel*, Rosenthal argues that the ethical meaning of Victorian realist novels—including Gaskell's *Mary Barton*—lies in the unfolding of story, not in what he terms "static representation." See Jesse Rosenthal, *Good Form: The Ethical Experience of the Victorian Novel* (Princeton, NJ: Princeton University Press, 2016), 16. My debts to, and engagements with, other theories of realism will be recorded in subsequent notes.

25. Virginia Woolf, *To the Lighthouse* (New York: Harcourt, Brace, and World, 1955), 48; Erich Auerbach, *Mimesis: The Representation of Reality in Western Literature*, trans. Willard R. Trask (Princeton, NJ: Princeton University Press, 2003), 548.

26. Woolf, *To the Lighthouse*, 43; Auerbach, *Mimesis*, 540.

27. Auerbach, *Mimesis*, 538, 546, 536.

28. Auerbach, *Mimesis*, 547.

29. Auerbach, *Mimesis*, 552.

30. Auerbach, *Mimesis*, 552.

31. Auerbach, *Mimesis*, 556.

32. On Auerbach and modernism see Herbert Lindenberger, "On the Reception of Mimesis," in *Literary History and the Challenge of Philology*, ed. Seth Lerer (Stanford, CA: Stanford University Press, 1996), 195–213; Bruce Robbins, *The Servant's Hand: English Fiction from Below* (New York: Columbia University Press, 1986), 48. For a counterinterpretation of *Mimesis* that claims that Auerbach did not value the "random," see Harry E. Shaw, *Narrating Reality: Austen, Scott, Eliot* (Ithaca, NY: Cornell University Press, 1999), 120.

33. David Carroll, "Mimesis Reconsidered: Literature • History • Ideology," *Diacritics* 5, no. 2 (1975): 7; Robbins, *The Servant's Hand*, 26.

34. "Emotionally charged": Helen Small, "Feminist Theory and the Return of the Real: 'What We Really Want out of Realism . . . ,'" in *Adventures in Realism*, ed. Matthew Beaumont (Oxford: Blackwell, 2007), 224. Recent scholarship on the affective dimension of *Mimesis* also includes Seth Lerer, *Error and the Academic Self* (New York: Columbia University Press, 2002), 226–31; Aamir R. Mufti, "Auerbach in Istanbul: Edward Said, Secular Criticism, and the Question of Minority Culture," *Critical Inquiry* 25, no. 1 (1998): 95–125. Scholarship on the cultural contexts in which *Mimesis* was written includes David Damrosch, "Auerbach in Exile," *Comparative Literature*, th, 47, no. 2 (1995): 97–117; James I. Porter, "Erich Auerbach and the Judaizing of Philology," *Critical Inquiry* 35, no. 1 (2008): 115–47; Kader Konuk, *East West Mimesis: Auerbach in Turkey* (Stanford, CA: Stanford University Press, 2010).

35. Woolf, *To the Lighthouse*, 45–46.

36. Auerbach, *Mimesis*, 117.

37. John Lucas, *The Literature of Change: Studies in the Nineteenth-Century Provincial Novel* (Sussex: Harvester, 1977), 26–27. Lucas's Lukacsian treatment of *Cousin Phillis*, which focuses on its representation of glacial social change, remains one of the best.

38. Gaskell, *Cousin Phillis and Other Stories*, 177.

39. Fredric Jameson, *Antinomies of Realism* (London: Verso, 2013), 11, 33.

40. Gaskell, *Cousin Phillis and Other Stories*, 177; Gaskell, *The Life of Charlotte Brontë*, 110.

41. William Empson, *Some Versions of Pastoral* (New York: New Directions, 1974), 114–15. For the view of *Cousin Phillis* as unadulterated pastoral, see for example Stoneman: "for once, Elizabeth Gaskell has avoided the mixed forms of fiction . . . and written in the clearly defined genre of pastoral." Stoneman, *Elizabeth Gaskell*, 105.

42. Gaskell, *The Life of Charlotte Brontë*, 447.

43. On the thematization of lines and threads in narrative, see J. Hillis Miller, *Ariadne's Thread*: "To follow the motif of the line will not be to simplify the knotted problems of narrative form but to retrace the whole tangle from the starting place of a certain point of entry." J. Hillis Miller, *Ariadne's Thread: Story Lines* (New Haven, CT: Yale University Press, 1992), 4. Miller returns to threads and lines, with particular reference to Gaskell's *Cranford*, in *Reading Narrative* (Norman: University of Oklahoma Press, 1998), 178–226.

44. Gaskell, *Cousin Phillis and Other Stories*, 156.

45. Gaskell, *Cousin Phillis and Other Stories*, 199.

46. Heather Glen, "Introduction," in *Cousin Phillis and Other Stories*, by Elizabeth Gaskell (Oxford: Oxford World's Classics, 2010), xxxiv.

47. Gaskell, *Cousin Phillis and Other Stories*, 177.

48. Gaskell, *Cousin Phillis and Other Stories*, 225–26.

49. Gaskell, *Cousin Phillis and Other Stories*, 219.

50. Gaskell, *Cousin Phillis and Other Stories*, 171.
51. Gaskell, *Cousin Phillis and Other Stories*, 217.
52. Gaskell, *Cousin Phillis and Other Stories*, 56.
53. Gaskell, *Cousin Phillis and Other Stories*, 156.
54. Gaskell, *Cousin Phillis and Other Stories*, 157.
55. Gaskell, *Cousin Phillis and Other Stories*, 170.
56. Gaskell, *Cousin Phillis and Other Stories*, 172.
57. M. M. Bakhtin, *The Dialogic Imagination: Four Essays* (Austin: University of Texas Press, 1981).
58. Gaston Bachelard, *The Poetics of Space*, trans. Maria Jolas (Boston: Beacon Press, 1994), 136–37.
59. On fiction as taking off housetops, see Peter Brooks, *Realist Vision* (New Haven, CT: Yale University Press, 2005), 3; Deanna K. Kreisel, "The Discreet Charm of Abstraction: Hyperspace Worlds and Victorian Geometry," *Victorian Studies* 56, no. 3 (2014): 400.
60. Fredric Jameson, "The Realist Floor-Plan," in *On Signs*, ed. Marshall Blonsky (Baltimore, MD: Johns Hopkins University Press, 1985), 376.
61. Jameson, "The Realist Floor-Plan," 374.
62. Anna Kornbluh, *The Order of Forms: Realism, Formalism, and Social Space* (Chicago: University of Chicago Press, 2019), 54.
63. Kornbluh, *The Order of Forms*, 54.
64. Elaine Auyoung, "The Sense of Something More in Art and Experience," *Style*, a, 44, no. 4 (2010): 547, 549. A classic account of fictional incompleteness is Ruth Ronen, "Completing the Incompleteness of Fictional Entities," *Poetics Today* 9, no. 3 (1988): 497–514.
65. Bruno Latour, *An Inquiry into Modes of Existence: An Anthropology of the Moderns*, trans. Catherine Porter (Cambridge, MA: Harvard University Press, 2014), 242.
66. The conceptual place of triangles in nineteenth-century fiction was elaborated by Rene Girard as an underlying dynamic structure of erotic plotting: "The triangle is no *Gestalt*. The real structures are intersubjective. They cannot be localized anywhere: the triangle has no reality whatever; it is a systematic metaphor, systematically pursued." Rene Girard, *Deceit, Desire, and the Novel: Self and Other in Literary Structure* (Baltimore, MD: Johns Hopkins University Press, 1961), 242.
67. Gaskell, *Cousin Phillis and Other Stories*, 177.
68. Gaskell, *Cousin Phillis and Other Stories*, 159. In its anatomization of the world into every imaginable kind of line, including the woolly and the straight, the fictional world of *Cousin Phillis* can seem like an embodiment of the "world as lines" phenomenology of anthropologist Tim Ingold, *The Life of Lines* (London: Routledge, 2015), and *Lines: A Brief History* (London: Routledge, 2016).
69. Glen, "Introduction," xxxii; Anna Unsworth, "Ruskin and 'Cousin Phillis,'" *The Gaskell Society Journal* 10 (1996): 77–82; Josie Billington, *Faithful Realism: Elizabeth Gaskell and Leo Tolstoy, a Comparative Study* (Lewisburg, PA: Bucknell University Press, 2002), 106.
70. Elizabeth Gaskell, *Wives and Daughters*, ed. Angus Easson, Oxford World's Classics (Oxford: Oxford University Press, 2009), 686.

71. Sylvia Townsend Warner, "Elizabeth Gaskell," *Our Time* 4, no. 7 (1945): 47.

72. Gaskell, *Cousin Phillis and Other Stories*, 201.

73. Mid-century engineering and surveying manuals that explain the use of the theodolite include J. Butler Williams, *Practical Geodesy: Comprising Chain Surveying, and the Use of Surveying Instruments; Levelling, and Tracing of Contours* (London: J.W. Parker, 1855), 42–55; Henry Merrett, *A Practical Treatise on the Science of Land and Engineering Surveying, Levelling, Estimating Quantities &c.* (London: E. & F. N. Spon, 1863), 3. On the challenges of trigonometric surveying with a theodolite in the nineteenth century, particularly in the move from the British isles to imperial territories, see D. Graham Burnett, *Masters of All They Surveyed: Exploration, Geography, and a British El Dorado* (Chicago: University of Chicago Press, 2000), 87–91.

74. Gaskell, *Cousin Phillis and Other Stories*, 159.

75. E.V. Gardner, *An Easy Introduction to Railway Mensuration* (London: J. Weale, 1847), 55.

76. George Eliot, "The Natural History of German Life," in *Selected Essays, Poems, and Other Writings*, ed. A.S. Byatt (London; New York: Penguin, 1990), 107.

77. Gaskell, *The Life of Charlotte Brontë*, 441.

78. In her study of geometry in Victorian England, Richards charts the emergence, in mid-century, of non-Euclidean, nondescriptive geometries—first called "imaginary geometry." Joan V. Richards, *Mathematical Visions: The Pursuit of Geometry in Victorian England* (San Diego, CA: Academic Press, 1988), 72. Henderson elaborates on the implication of this shift in geometry for understanding the role of the imagination and its impact on fiction: "nineteenth-century artists would profit from this new account of knowledge, for under its auspices even fictional representations, like the new 'imaginary geometries,' could be conceived as knowledge." Andrea K. Henderson, *Algebraic Art: Mathematical Formalism and Victorian Culture* (New York: Oxford University Press, 2018), 12.

79. Elaine Scarry, *Dreaming by the Book* (New York: Farrar, Straus and Giroux, 1999), 14.

80. Auerbach, *Mimesis*, 552.

81. Charles Taylor, "Irreducibly Social Goods," in *Philosophical Arguments* (Cambridge, MA: Harvard University Press, 1995), 127.

82. Gaskell, *Cousin Phillis and Other Stories*, 221.

83. On the centrality of lies to Gaskell's fiction, see John Kucich, *The Power of Lies: Transgression in Victorian Fiction* (Ithaca, NY: Cornell University Press, 1994), 121–57; Dorothy McGavran, "The Danger of Dying in One's Own Language: Lying and the Literacy of the Heart in Elizabeth Gaskell's *Sylvia's Lovers* and *Cousin Phillis*," ed. Anita Rose (Newcastle upon Tyne: Cambridge Scholars Publishing, 2008), 124–40.

84. Gaskell, *Cousin Phillis and Other Stories*, 219.

85. William Galperin, "'Describing What Never Happened': Jane Austen and the History of Missed Opportunities," *ELH* 73, no. 2 (2006): 377.

86. Gaskell, *Cousin Phillis and Other Stories*, 225.

87. Gaskell, *Cousin Phillis and Other Stories*, 227.

88. Gaskell, *Cousin Phillis and Other Stories*, 226.

89. Galperin, "'Describing What Never Happened,'" 363.

90. Joseph Davidson, *The Works of Virgil Literally Translated into English Prose as Near the Original as the Different Idioms of the Latin and English Language Will Allow* (London: William Allan, 1859), vi. For a review of beliefs about Virgil's relation to the land confiscations and reparations after the battle of Phillipi in 42 BC, see Nicholas M. Horsfall, "Virgil: His Life and Times," in *A Companion to the Study of Virgil*, ed. Nicholas M. Horsfall (Leiden: Brill, 1995), 12–13.

91. Dorothy W. Collin, "Strategies of Retrospection and Narrative Silence in *Cranford* and *Cousin Phillis*," *The Gaskell Society Journal* 11 (1997): 25–42; Jenny Curtis, "'Manning the World': The Role of the Male Narrator in Elizabeth Gaskell's *Cousin Phillis*," *Victorian Review* 21, no. 2 (1995): 129–44; Anna Koustinoudi, *The Split Subject of Narration in Elizabeth Gaskell's First-Person Fiction* (Lanham, MD: Lexington Books, 2011).

92. Gaskell, *Cousin Phillis and Other Stories*, 200.

93. Gaskell, *Cousin Phillis and Other Stories*, 222.

94. Gaskell, *Cousin Phillis and Other Stories*, 232.

95. On remorse in *Mary Barton* see Schramm, *Atonement and Self-Sacrifice*, 6–7, 133–39.

96. Gaskell, *Wives and Daughters*, 598.

97. Williams, *Moral Luck*, 29.

98. Wallace, *The View from Here*, 24.

99. Kucich, *The Power of Lies*, 121–57; Rosemarie Bodenheimer, "Secret-Keeping," *London Review of Books* 29, no. 16 (August 16, 2007); McGavran, "The Danger of Dying in One's Own Language."

100. Elizabeth Gaskell, *Sylvia's Lovers*, ed. Francis O'Gorman, Oxford World's Classics (Oxford: Oxford University Press, 2013), 230.

101. Gaskell, *Sylvia's Lovers*, 166.

102. Gaskell, *Sylvia's Lovers*, 369.

103. Gaskell, *Sylvia's Lovers*, 387.

104. Gaskell, *Sylvia's Lovers*, 368.

105. Gaskell, *Sylvia's Lovers*, 250.

106. Gaskell, *Sylvia's Lovers*, 224, 250.

107. Gaskell, *Sylvia's Lovers*, 251.

108. Gaskell, *Sylvia's Lovers*, 251.

109. For a discussion of interpretations of the Ring of Gyges, see Terence Irwin, "Republic 2: Questions about Justice," in *Plato 2: Ethics, Politics, Religion and the Soul*, ed. Gail Fine (Oxford: Oxford University Press, 2000), 164–84.

110. For a useful overview and original take on "how the novel form participated in the 'probabilistic revolution' that transformed the way nature and society were understood from the nineteenth century onward," see Adam Grener, *Improbability, Chance, and the Nineteenth-Century Realist Novel* (Columbus: Ohio State University Press, 2020), 4.

111. Gaskell, *Wives and Daughters*, 578.

112. Uglow, *Elizabeth Gaskell*, 489–90, 510–11.

113. Gaskell, *Cousin Phillis and Other Stories*, 223, 232.

114. Gaskell, *Cousin Phillis and Other Stories*, 215.

115. See also Amelie Rorty, "Agent Regret," in *Explaining Emotions* (Berkeley: University of California Press, 1980), 489–506.

116. "In scenarios of cruel optimism we are forced to suspend ordinary notions of repair and flourishing to ask whether the survival scenarios we attach to those affects were the problem in the first place." Lauren Berlant, *Cruel Optimism* (Durham, NC: Duke University Press, 2011), 47.

117. Gaskell, *Cousin Phillis and Other Stories*, 222, 232.

118. Landman, *Regret*, 133.

119. Galperin, "'Describing What Never Happened,'" 377.

120. For a related account of fictional description as "redress," see James, *Discrepant Solace*, 65–87.

121. Elizabeth Gaskell, *Further Letters of Elizabeth Gaskell*, ed. J.A.V. Chapple and Alan Shelston (Manchester: Manchester University Press, 2000), 260.

122. Talia Schaffer, *Novel Craft: Victorian Domestic Handicraft and Nineteenth-Century Fiction* (Oxford: Oxford University Press, 2011), 21.

123. Gaskell, *The Letters of Mrs. Gaskell*, 694.

124. In her study of care in Victorian literature, Schaffer stresses that the action of care always contains within it the prospect of failure, that no act of caring is ever complete, that the difference between caring and failed care is a thin line. See Talia Schaffer, *Communities of Care: The Social Ethics of Victorian Fiction* (Princeton, NJ: Princeton University Press, 2021), 22, 123, 147, 192.

Coda

1. Dorothy J. Hale, "The Place of the Novel in Reparative Reading," *Studies in the Novel* 51, no. 1 (2019): 105.

2. Hale, "The Place of the Novel in Reparative Reading," 105.

3. Lauren Berlant, *Cruel Optimism* (Durham, NC: Duke University Press, 2011), 139.

4. Berlant, *Cruel Optimism*, 157. To align Berlant's comments on the utopianism of the novel as a genre with Hale's account of Sedgwick is not at all to discount Berlant's cautions about Sedgwick's "reparative reading" elsewhere in *Cruel Optimism*; see pages 122–26. The cautionary and critical literature on Sedgwick's "reparative reading" includes Amanda Anderson, "Therapeutic Criticism," *NOVEL: A Forum on Fiction* 50, no. 3 (2017): 321–28; Alicia Christoff, *Novel Relations: Victorian Fiction and British Psychoanalysis* (Princeton, NJ: Princeton University Press, 2019), 37–38; Heather Love, "Truth and Consequences: On Paranoid Reading and Reparative Reading," *Criticism* 52, no. 20 (2010): 235–41; David Kurnick, "A Few Lies: Queer Theory and Our Method Melodramas," *ELH* 87, no. 2 (2020): 349–74. For a study of the novel that bravely asks us to scrutinize our resistance to thinking of fiction as consolation and offers a nuanced account of solace/consolation in and of literature as always partial, see David James, *Discrepant Solace: Contemporary Literature and the Work of Consolation* (Oxford: Oxford University Press, 2019).

5. Scholars of the eighteenth- and nineteenth-century novel have been, with good reason, fascinated by McEwan's *Atonement*. For two strong, but different accounts, see Sandra Macpherson, *Harm's Way: Tragic Responsibility and the Novel Form* (Baltimore, MD: Johns Hopkins University Press, 2010), 193–94; Andrew H. Miller, *On Not Being Someone Else: Tales of Our Unled Lives* (Cambridge, MA: Harvard University Press, 2020),

144–60. Related to MacPherson's rigorous stance on the novel—"responsibility is not atonement" (194)—is Blumberg's essay "Can Novels Make Amends?" in which Blumberg's answer—which begins with George Eliot's indictment of Arthur Donnithorne's belief that his social privilege will enable him to make things better for the ruined Hetty Sorrel in *Adam Bede*—is emphatically "no." Ilana Blumberg, "Can Novels Make Amends?," *Public Books*, March 15, 2021, https://www.publicbooks.org/can-novels-make-amends/.

6. Elizabeth Gaskell, *Cousin Phillis and Other Stories*, ed. Heather Glen (Oxford: Oxford World's Classics, 2010), 222, 232.

7. Georg Lukacs, *The Theory of the Novel*, trans. Anna Bostock (Cambridge, MA: MIT Press, 1971), 126.

8. Bernard Williams, *Moral Luck* (Cambridge: Cambridge University Press, 1982), 27; R. Jay Wallace, *The View from Here: On Affirmation, Attachment, and the Limits of Regret* (Oxford: Oxford University Press, 2013), 44.

9. Jan-Melissa Schramm's *Atonement and Self-Sacrifice in Nineteenth-Century Narrative* is devoted to demonstrating the ways in which Gaskell and other Victorian writers conceived of the reading of narrative fiction as a vicarious experience that served to substitute for, atone for, harms elsewhere, as fiction was folded into a vigorous debate about the logics, ethics, and theological nature of substitution, sacrifice, and atonement. Jan-Melissa Schramm, *Atonement and Self-Sacrifice in Nineteenth-Century Narrative* (Cambridge: Cambridge University Press, 2012), 36–37, 214–15.

10. George Eliot, *Middlemarch*, ed. David Carroll (Oxford: Oxford World's Classics, 1996), 785.

11. Daniel Wright, *The Grounds of the Novel* (Stanford, CA: Stanford University Press, 2024); Kent Puckett, *Narrative Theory: A Critical Introduction* (Cambridge: Cambridge University Press, 2016).

12. Puckett, *Narrative Theory*, 229 but passim.

13. Shadworth Hollway Hodgson, *Philosophy and Experience: An Address Delivered Before The Aristotelian Society October 26, 1885* (London and Edinburgh: Williams and Norgate, 1885), 89.

14. Jami Bartlett, *Object Lessons: The Novel as a Theory of Reference* (Chicago: University of Chicago Press, 2016); Jesse Rosenthal, *Good Form: The Ethical Experience of the Victorian Novel* (Princeton, NJ: Princeton University Press, 2016).

15. For Raymond Williams's account of the relationship between "experience past" and "experience present," see Raymond Williams, *Keywords: A Vocabulary of Culture and Society*, Revised (New York: Oxford University Press, 1985), 83–85. In his discussion of Walter Benjamin's account of *Erlebnis* and *Erfahrung*, Leo Bersani argues that the difference Benjamin stipulates depends on the ways in which Benjamin conceives of totality. Definitions of "experience" are not simply different ways of dividing up the pie but depend on what kind of pie you have. Leo Bersani, *The Culture of Redemption* (Cambridge, MA: Harvard University Press, 1990), 49–50.

16. Toril Moi, "Don't Look Back," *London Review of Books* 45, no. 8 (April 13, 2023): 21.

17. The usage of "lived experience" in theory of the novel goes back at least to Lukacs, who viewed the production of "lived experience" as the work of the writer. It is

the center of how an event is turned into art, into "a limpid, generously flowing, all-embracing message only when the event, in its epic objectivation, becomes the vehicle and symbol of unbounded feeling; when a soul is the hero and that soul's longing is the story . . . ; when the object, the event that is given form, remains isolated as indeed it should, but when the lived experience that absorbs the event and radiates it out also carries within it the ultimate meaning of life, the artist's sense-giving, life-conquering power." The "form-giving intention" of the novelist takes the elements of the novel—nostalgia for utopian perfection, the present existence of social structures and the distance between these elements and "renders it sensuous as the lived experience of the novel's characters." Lukacs, *The Theory of the Novel*, 52, 71.

18. A Twitter user named ZUBY lists "lived experience" along with "emotional labor" and "micro-aggression" as left-leaning platitudes to be avoided: "The word 'lived' is totally redundant here. If it's an experience, then it is automatically implied that you lived through it." ZUBY, "If You Use the Terms 'emotional Labour' and 'Micro-Aggression' Non-Ironically, Then I Will Struggle to Take You Seriously . . . ," *Twitter* (blog), March 3, 2020, https://twitter.com/ZubyMusic/status/1234858211787800578. A Reddit user named braidcuck starts a thread, "what does lived experience even mean." An anonymous user responds, "the phrase 'lived experience' doesn't exist to provide any more meaning, it exists to signify which social bracket you're part of." braidcuck, "What Does Lived Experience Even Mean," *Reddit* (blog), August 29, 2022, https://www.reddit.com/r/redscarepod/comments/xoukeq/what_does_lived_experience_even_mean/?utm_source=share&utm_medium=web3x&utm_name=web3xcss&utm_term=1&utm_content=share_button. For a more considered discussion see Patricia O'Conner and Stewart Kellerman, "The Life of a Lived Experience," *Grammarphobia* (blog), December 10, 2021, https://www.grammarphobia.com/blog/2021/12/lived-experience.html; Sam Leith, "Living with 'Lived Experience,'" *Prospect*, no. 248 (November 2016): 82.

Bibliography

Ahmed, Sara. *Living a Feminist Life*. Durham, NC: Duke University Press, 2017.
Albrecht, Thomas. "Sympathy and Telepathy: The Problem of Ethics in George Eliot's 'The Lifted Veil.'" *ELH* 73, no. 2 (2006): 437–63.
Alcoff, Linda Martín. "Phenomenology, Post-Structuralism, and Feminist Theory on the Concept of Experience." In *Feminist Phenomenology*, edited by Linda Fisher and Lester Embree, 39–56. Dordrecht: Kluwer, 2000.
Alexander, Christine. "Autobiography and Juvenilia: The Fractured Self in Charlotte Brontë's Early Manuscripts." In *The Child Writer from Austen to Woolf*, edited by Juliet McMaster and Alexander McMaster, 154–72. Cambridge: Cambridge University Press, 2005.
———. "Playing the Author: Children's Creative Writing, Paracosms, and the Construction of Family Magazines." In *Children, Childhood and Cultural Heritage*, edited by Kate Darian-Smith and Carla Pascoe, 85–103. Abingdon: Routledge, 2013.
Allison, Sarah. "Narrative Form and Facts, Facts, Facts: Elizabeth Gaskell's *Life of Charlotte Brontë*." *Genre* 50, no. 1 (2017): 97–116.
Allot, Miriam, ed. *The Brontës: The Critical Heritage*. London: Routledge, 1974.
Andersen, Holly K. "The Hodgsonian Account of Temporal Experience." In *The Routledge Handbook of Philosophy of Temporal Experience*, edited by Ian Phillips, 69–81. New York: Routledge, 2017.
Andersen, Holly K., and Rick Grush. "A Brief History of Time-Consciousness: Historical Precursors to James and Husserl." *Journal of the History of Philosophy* 47, no. 2 (2009): 277–307.
Anderson, Amanda. "Therapeutic Criticism." *NOVEL: A Forum on Fiction* 50, no. 3 (2017): 321–28.
Anderson, Amanda, and Joseph Valente, eds. *Disciplinarity at the Fin de Siècle*. Princeton, NJ: Princeton University Press, 2002.
Anger, Suzy. *Victorian Interpretation*. Ithaca, NY: Cornell University Press, 2006.
Anthony, Laurence. "AntConc: Design and Development of a Freeware Corpus Analysis Toolkit for the Technical Writing Classroom." In *IEEE International Professional Communication Conference Proceedings* (2005), 729–37.
Armstrong, Isobel. *Victorian Glassworlds: Glass Culture and the Imagination 1830–1880*. Oxford: Oxford University Press, 2008.
Arnold, Matthew. *Poetry and Prose*. Edited by John Bryson. Cambridge, MA: Harvard University Press, 1960.
Ashton, Rosemary. *George Eliot: A Life*. London: Penguin, 1996.
Auerbach, Erich. *Mimesis: The Representation of Reality in Western Literature*. Translated by Willard R. Trask. Princeton, NJ: Princeton University Press, 2003.

Auyoung, Elaine. "The Sense of Something More in Art and Experience." *Style* 44, no. 4 (2010): 547–65.
———. *When Fiction Feels Real: Representation and the Reading Mind*. New York: Oxford University Press, 2018.
Bachelard, Gaston. *The Poetics of Space*. Translated by Maria Jolas. Boston: Beacon Press, 1994.
Baillie, J. B. *An Outline of the Idealistic Construction of Experience*. London: Macmillan, 1906.
Bair, Deidre. *Simone de Beauvoir: A Biography*. New York: Simon & Schuster, 1990.
Bakhtin, M. M. *The Dialogic Imagination: Four Essays*. Austin: University of Texas Press, 1981.
Barker, Juliet. "Introduction." In *Charlotte Brontë: Juvenilia 1829–1835*, vii–xx. London: Penguin, 1996.
———. *The Brontës, Wild Genius of the Moors: The Story of a Literary Family*. 2nd ed. New York: Pegasus, 2010.
Barthes, Roland. *S/Z*. Translated by Richard Miller. New York: Hill and Wang, 1974.
Bartlett, Jami. *Object Lessons: The Novel as a Theory of Reference*. Chicago: University of Chicago Press, 2016.
Beer, Gillian. *George Eliot*. Brighton: Harvester, 1986.
Behlman, Lee. "The Victorian Marcus Aurelius: Mill, Arnold, and the Appeal of the Quasi-Christian." *Journal of Victorian Culture* 16, no. 1 (2011): 1–24.
Bell, Alice, and Jan Alber. "Ontological Metalepsis and Unnatural Narratology." *Journal of Narrative Theory* 42, no. 2 (2012): 166–92.
Bennett, Andrew. *Romantic Poets and the Culture of Posterity*. Cambridge: Cambridge University Press, 1999.
Berger, Courtney. "When Bad Things Happen to Bad People: Liability and Individual Consciousness in *Adam Bede* and *Silas Marner*." *NOVEL: A Forum on Fiction* 33, no. 3 (2000): 307–27.
Berlant, Lauren. *Cruel Optimism*. Durham, NC: Duke University Press, 2011.
Bernstein, Michael Andre. *Foregone Conclusions: Against Apocalyptic History*. Los Angeles: University of California Press, 1994.
Bersani, Leo. *The Culture of Redemption*. Cambridge, MA: Harvard University Press, 1990.
Billington, Josie. *Faithful Realism: Elizabeth Gaskell and Leo Tolstoy, a Comparative Study*. Lewisburg, PA: Bucknell University Press, 2002.
Bion, W. R. *Attention and Interpretation*. Lanham, MD: Rowman & Littlefield, 2004.
———. *Learning From Experience*. London: Karnac, 1984.
———. *Transformations*. London: Karnac, 1984.
Bishop, Elizabeth. *Geography III*. New York: Farrar, Straus and Giroux, 1976.
Bishop, Jonathan. "Wordsworth and the 'Spots of Time.'" *ELH* 26, no. 1 (1959): 45–65.
Black, Helen C. *Notable Women Authors of the Day*. Glasgow: David Black, 1893.
Blumberg, Ilana. "Can Novels Make Amends?" *Public Books*, March 15, 2021. https://www.publicbooks.org/can-novels-make-amends/.
———. "Stealing the 'Parson's Surplice' / the Person's Surplus: Narratives of Abstraction and Exchange in *Silas Marner*." *Nineteenth-Century Literature* 67, no. 4 (2013): 490–519.

Bodenheimer, Rosemarie. "Secret-Keeping." *London Review of Books* 29, no. 16 (August 16, 2007).

———. *The Real Life of Mary Ann Evans*. Ithaca, NY: Cornell University Press, 1994.

Bollas, Christopher. "The Transformational Object." In *The Shadow of the Object: Psychoanalysis of the Unthought Known*. New York: Columbia University Press, 1989.

Bonaparte, Felicia. *Will and Destiny: Morality and Tragedy in George Eliot's Novels*. New York: NYU Press, 1975.

Boucher, David, and Andrew Vincent. *British Idealism: A Guide for the Perplexed*. London: Continuum, 2012.

Bradley, F. H. *Appearance and Reality: A Metaphysical Essay*. Oxford: Oxford University Press, 1978.

braidcuck. "What Does Lived Experience Even Mean." *Reddit* (blog), August 29, 2022. https://www.reddit.com/r/redscarepod/comments/x0ukeq/what_does_lived_experience_even_mean/?utm_source=share&utm_medium=web3x&utm_name=web3xcss&utm_term=1&utm_content=share_button.

Bray, Charles. *The Philosophy of Necessity*. Vol. 1. London: Longmans, 1841.

———. *The Philosophy of Necessity*. Vol. 2. London: Longmans, 1841.

Bridgeman, Teresa. "Thinking Ahead: A Cognitive Approach to Prolepsis." *Narrative* 13, no. 2 (May 2005): 125–59.

Brontë, Branwell. *The Works of Patrick Branwell Brontë: An Edition*. Vol. 1. Edited by Victor A. Neufeldt. New York: Garland, 1997.

Brontë, Charlotte. *An Edition of the Early Writings of Charlotte Brontë: Volume I: The Glass Town Saga, 1826–1832*. Edited by Christine Alexander. Oxford: Basil Blackwell, 1987.

———. "Biographical Notice of Ellis and Acton Bell," "Editor's Preface to the New Edition of *Wuthering Heights*," "Extract from the Prefatory Notes to 'Selections from Poems by Ellis Bell' [1805]." In *Wuthering Heights*, edited by Helen Small, 361–72. Oxford World's Classics. Oxford: Oxford University Press, 2009.

———. *Jane Eyre*. Edited by Margaret Smith. Oxford World's Classics. Oxford: Oxford University Press, 2008.

———. *The Letters of Charlotte Brontë: With a Selection of Letters by Family and Friends*. Vol. 1. Edited by Margaret Smith. Oxford: Oxford University Press, 1995.

———. *Villette*. Edited by Margaret Smith. Oxford World's Classics. Oxford: Oxford University Press, 2008.

Brontë, Emily. *Wuthering Heights*. Edited by Helen Small. Oxford World's Classics. Oxford: Oxford University Press, 2009.

Brooks, Peter. *Realist Vision*. New Haven, CT: Yale University Press, 2005.

Brown, Daniel. *Representing Realism in Victorian Literature and Criticism*. Cham: Palgrave Macmillan, 2016.

Brown, Kate E. "Loss, Revelry, and the Temporal Measures of *Silas Marner*: Performance, Regret, Recollection." *NOVEL: A Forum on Fiction* 32, no. 2 (1999): 222–49.

Burnett, D. Graham. *Masters of All They Surveyed: Exploration, Geography, and a British El Dorado*. Chicago: University of Chicago Press, 2000.

Capes, William Wolfe. *Stoicism*. London: Society for the Promotion of Christian Knowledge, 1880.

Carlyle, Thomas. "Sir Walter Scott." In *Selections from Carlyle*, edited by A. H. R. Ball, 37–44. Cambridge: Cambridge University Press, 1929.

Carroll, David. *George Eliot: The Critical Heritage*. London: Routledge and Kegan Paul, 1971.

———. "Mimesis Reconsidered: Literature • History • Ideology." *Diacritics* 5, no. 2 (1975): 5–12.

Carroll, Lewis. *Through the Looking-Glass, and What Alice Found There*. New York: T.Y. Crowell, 1893.

Carson, Anne. "The Glass Essay." In *Glass, Irony, and God*. New York: New Directions, 1995.

Caruth, Cathy. *Unclaimed Experience: Trauma, Narrative, and History*. Baltimore, MD: Johns Hopkins University Press, 1996.

Cavell, Stanley. "The Avoidance of Love: A Reading of *King Lear*." In *Must We Mean What We Say? A Book of Essays*. New York: Scribner, 1969.

Chadwick, Esther Alice. *In the Footsteps of the Brontës*. London: Isaac Pitman, 1914.

Chakraborty, Sumita. "Of New Calligraphy: Seamus Heaney, Planetarity, and Lyric's Uncanny Space-Walk." *Cultural Critique* 104 (2019): 101–34.

Christoff, Alicia. "Alone with 'Tess.'" *NOVEL: A Forum on Fiction* 48, no. 1 (2015): 18–44.

———. "Metaleptic Mourning." *Victorian Literature and Culture* 47, no. 3 (2019): 631–36.

———. *Novel Relations: Victorian Fiction and British Psychoanalysis*. Princeton, NJ: Princeton University Press, 2019.

Cohen, William A. "Envy and Victorian Fiction." *NOVEL: A Forum on Fiction* 42, no. 2 (2009): 297–303.

Cohn, Dorrit. "Discordant Narration." *Style* 34, no. 2 (2000): 307–16.

———. "Fictional versus Historical Lives: Borderlines and Borderline Cases." *The Journal of Narrative Technique* 19, no. 1 (1989): 3–24.

———. "Metalepsis and Mise en Abyme." *Narrative* 20, no. 1 (2012): 105–14.

———. *The Distinction of Fiction*. Baltimore, MD: Johns Hopkins University Press, 1999.

Cohn, Elisha. *Still Life: Suspended Development in the Victorian Novel*. New York: Oxford University Press, 2015.

Cole, Michael. *Cultural Psychology: A Once and Future Discipline*. Cambridge, MA: Harvard University Press, 1996.

———. "Culture and Development." In *Between Culture and Biology: Perspectives on Ontogenetic Development*, edited by Heidi Keller, Ype H. Poortinga, and Alex Scholmerich, 303–19. Cambridge: Cambridge University Press, 2002.

Collin, Dorothy W. "Strategies of Retrospection and Narrative Silence in *Cranford* and *Cousin Phillis*." *The Gaskell Society Journal* 11 (1997): 25–42.

Colon, Susan E. *Victorian Parables*. London: Continuum, 2012.

Comte, Auguste. *The Catechism of Positive Religion*. Translated by Richard Congreve. London: John Chapman, 1858.

Corbett, Mary Jean. *Representing Femininity: Middle-Class Subjectivity in Victorian and Edwardian Women's Autobiographies*. New York: Oxford University Press, 1992.

Culler, Jonathan. "Apostrophe." In *The Pursuit of Signs: Semiotics, Literature, and Deconstruction*. Ithaca, NY: Cornell University Press, 1981.

———. "Story and Discourse in the Analysis of Narrative." In *The Pursuit of Signs: Semiotics, Literature, Deconstruction.* Ithaca, NY: Cornell University Press, 1981.
Currie, Mark. *About Time: Narrative, Fiction, and the Philosophy of Time.* Edinburgh: Edinburgh University Press, 2007.
Curtis, Jenny. "'Manning the World': The Role of the Male Narrator in Elizabeth Gaskell's *Cousin Phillis*." *Victorian Review* 21, no. 2 (1995): 129–44.
D'Albertis, Deirdre. "The Domestic Drone: Margaret Oliphant and a Political History of the Novel." *Studies in English Literature, 1500–1900* 37, no. 4 (1997): 805–29.
Damrosch, David. "Auerbach in Exile." *Comparative Literature*, th, 47, no. 2 (1995): 97–117.
Daunay, Bertrand. "La Métalepse Du Lecteur Ou La Porosité Du Métatexte." *Cahiers de Narratologie* 32 (2017). https://doi-org/10.4000/narratologie.7855.
Davidson, Joseph. *The Works of Virgil Literally Translated into English Prose as Near the Original as the Different Idioms of the Latin and English Language Will Allow.* London: William Allan, 1859.
Davies, Steve. *Emily Brontë: Heretic.* London: Women's Press, 1994.
Davis, Philip. *Memory and Writing.* Liverpool: Liverpool University Press, 1983.
———. *The Transferred Life of George Eliot.* Oxford: Oxford University Press, 2018.
Davis, Theo. *Formalism, Experience, and the Making of American Literature in the Nineteenth Century.* Cambridge: Cambridge University Press, 2007.
De Beauvoir, Simone. *Memoirs of a Dutiful Daughter.* Translated by James Kirkup. Cleveland, OH: World Publishing, 1959.
De Man, Paul. "Autobiography as De-Facement." In *The Rhetoric of Romanticism.* New York: Columbia University Press, 1984.
De Roo, Neal. *The Political Logic of Experience.* New York: Fordham University Press, 2022.
Delany, Samuel R. *The American Shore.* Middletown, CT: Wesleyan University Press, 2014.
Den Otter, Sandra M. *British Idealism and Social Explanation: A Study in Late Victorian Thought.* Oxford: Oxford University Press, 1996.
Diderot, Denis. "Elegy of Richardson." In *Selected Writings*, edited by Lester G. Crocker, translated by Derek Coltman, 108–12. New York: Macmillan, 1966.
D'Oyly, Charles. *Eight Months' Experience of the Sepoy Revolt, in 1857.* Blandford: H. Shipp, 1891.
Dukes, Hunter. "Beckett's Vessels and the Animation of Containers." *Journal of Modern Literature* 40, no. 4 (2017): 75–89.
Easley, Alexis. "The 1916 Centenary: Charlotte Brontë and First-Wave Feminism." In *Time, Space, and Place in Charlotte Brontë*, edited by Diane Long Hoeveler and Deborah Denenholz Morse, 49–65. London: Routledge, 2017.
Edelman, Lee. *No Future: Queer Theory and the Death Drive.* Durham, NC: Duke University Press, 2004.
Eliot, George. *Adam Bede.* Edited by Carol A. Martin. Oxford World's Classics. Oxford: Oxford University Press, 2001.
———. *Middlemarch.* Edited by David Carroll. Oxford World's Classics. Oxford: Oxford University Press, 1996.

———. *Silas Marner: The Weaver of Raveloe*. Edited by David Carroll. New York: Penguin, 1996.

———. *The George Eliot Letters*. Edited by Gordon Sherman Haight. 9 vols. New Haven, CT: Yale University Press, 1954.

———. *The Journals of George Eliot*. Edited by Margaret Harris and Judith Johnston. Cambridge: Cambridge University Press, 2000.

———. *The Lifted Veil and Brother Jacob*. Edited by Helen Small. Oxford: Oxford University Press, 1999.

———. *The Mill on the Floss*. Edited by A.S. Byatt. Harmondsworth: Penguin, 1979.

———. "The Natural History of German Life." In *Selected Essays, Poems, and Other Writings*, edited by A.S. Byatt, 107–39. London; New York: Penguin, 1990.

Empson, William. *Some Versions of Pastoral*. New York: New Directions, 1974.

Esty, Joshua. "Nationhood, Adulthood, and the Ruptures of Bildung: Arresting Development in *The Mill on the Floss*." *Narrative* 4, no. 2 (1996): 144–59.

Felski, Rita. *The Limits of Critique*. Chicago: University of Chicago Press, 2015.

———. *Uses of Literature*. Oxford: Wiley-Blackwell, 2008.

Feuerbach, Ludwig. *The Essence of Christianity*. Translated by Marian Evans. London: John Chapman, 1854.

Flesch, William. *Comeuppance: Costly Signaling, Altruistic Punishment, and Other Biological Components of Fiction*. Cambridge, MA: Harvard University Press, 2007.

———. "Narrative and Noncausal Bargaining." *NOVEL: A Forum on Fiction* 45, no. 1 (2012): 6–9.

Flint, Kate. "Blood, Bodies, and The Lifted Veil." *Nineteenth Century Literature* 51, no. 4 (1997): 455–73.

Fludernik, Monika. *An Introduction to Narratology*. Translated by Patricia Hausler-Greenfield and Monika Fludernik. London; New York: Routledge, 2009.

———. "Eliot and Narrative." In *A Companion to George Eliot*, edited by Amanda S. Anderson and Harry E. Shaw, 21–34. Oxford: Blackwell, 2013.

———. "Scene Shift, Metalepsis, and the Metaleptic Mode." *Style* 37, no. 4 (2003): 382–400.

Forsberg, Laura. "The Miniature World of Charlotte Brontë's Glass Town." In *Charlotte Brontë from the Beginnings: New Essays from the Juvenilia to the Major Works*, edited by Judith E. Pike and Lucy Morrison, 44–58. London: Routledge, 2017.

Fraiman, Susan. *Unbecoming Women: British Women Writers and the Novel of Development*. New York: Columbia University Press, 1993.

François, Anne-Lise. *Open Secrets: The Literature of Uncounted Experience*. Stanford, CA: Stanford University Press, 2007.

Frankfurt, Harry G. *The Importance of What We Care About: Philosophical Essays*. Cambridge: Cambridge University Press, 1988.

Freedgood, Elaine. "Fictional Settlements: Footnotes, Metalepsis, the Colonial Effect." *New Literary History* 41, no. 2 (2010): 393–411.

———. "Hetero-ontologicality, or Against Realism." *English Studies in Africa* 57, no. 1 (2014): 92–100.

———. *Worlds Enough: The Invention of Realism in the Victorian Novel*. Princeton, NJ: Princeton University Press, 2019.

Gallagher, Catherine. *The Industrial Reformation of English Fiction: Social Discourse and Narrative from 1832–1867*. Chicago: University of Chicago Press, 1985.

———. "The Rise of Fictionality." In *The Novel: Volume I: History, Geography, and Culture*, edited by Franco Moretti, 336–63. Princeton, NJ: Princeton University Press, 2006.

Galperin, William. "'Describing What Never Happened': Jane Austen and the History of Missed Opportunities." *ELH* 73, no. 2 (2006): 355–82.

———. *The History of Missed Opportunities: British Romanticism and the Emergence of the Everyday*. Stanford, CA: Stanford University Press, 2017.

Galvan, Jill. "The Narrator as Medium in George Eliot's 'The Lifted Veil.'" *Victorian Studies* 48, no. 2 (2006): 240–48.

Gardner, Edward V. *An Easy Introduction to Railway Mensuration*. London: J. Weale, 1847.

Gaskell, Elizabeth. *Cousin Phillis and Other Stories*. Edited by Heather Glen. Oxford World's Classics. Oxford: Oxford University Press, 2010.

———. *Further Letters of Elizabeth Gaskell*. Edited by John A.V. Chapple and Alan Shelston. Manchester: Manchester University Press, 2000.

———. *'My Diary': The Early Years of My Daughter Marianne*. London: Clement Shorter, 1923.

———. *Sylvia's Lovers*. Edited by Francis O'Gorman. Oxford World's Classics. Oxford: Oxford University Press, 2013.

———. *The Letters of Mrs. Gaskell*. Edited by Arthur Pollard and John A.V. Chapple. Manchester: Manchester University Press, 1966.

———. *The Life of Charlotte Brontë*. Edited by Elizabeth Jay. Harmondsworth: Penguin Classics, 1998.

———. *The Works of Elizabeth Gaskell: Volume 1: Journalism, Early Fiction*. Edited by Joanne Shattock. London: Pickering and Chatto, 2005.

———. *Wives and Daughters*. Edited by Angus Easson. Oxford World's Classics. Oxford: Oxford University Press, 2009.

Genette, Gerard. *Métalepse: de la figure à la fiction*. Paris: Editions du Seuil, 2004.

———. *Narrative Discourse: An Essay in Method*. Translated by Jane E. Lewin. Ithaca, NY: Cornell University Press, 1980.

Gettelman, Debra. "Reading Ahead in George Eliot." *NOVEL: A Forum on Fiction* 39, no. 1 (2005): 25–47.

Gilbert, Sandra, and Susan Gubar. *The Madwoman in the Attic*. New Haven, CT: Yale University Press, 1979.

Girard, Rene. *Deceit, Desire, and the Novel: Self and Other in Literary Structure*. Baltimore, MD: Johns Hopkins University Press, 1961.

Glen, Heather. "Configuring a World: Some Childhood Writings of Charlotte Brontë." In *Opening the Nursery Door: Reading, Writing, and Childhood 1600–1900*. Edited by Mary Hilton, Morag Styles, and Victor Watson. London and New York: Routledge, 1997.

———. "Introduction." In *Cousin Phillis and Other Stories*, by Elizabeth Gaskell, vii–xxxv. Oxford World's Classics. Oxford: Oxford University Press, 2010.

Glynn, Dylan, and Mette Sjolin. "Cognitive Linguistic Methods for Literature: A Usage-Based Approach to Metanarration and Metalepsis." In *Texts and Minds: Papers*

in *Cognitive Poetics and Rhetoric*, edited by Alina Kwiatkowska, 85–102. Frankfurt am Main: Peter Lang, 2012.

Goldring, Maude. *Charlotte Brontë, the Woman: A Study*. London: E. Matthews, 1915.

Goodlad, Lauren M. E. *The Victorian Geopolitical Aesthetic: Realism, Sovereignty, and Transnational Experience*. Oxford: Oxford University Press, 2015.

Green, Laura. "'I Recognized Myself in Her': Identifying with the Reader in George Eliot's 'The Mill on the Floss' and Simone de Beauvoir's 'Memoirs of a Dutiful Daughter.'" *Tulsa Studies in Women's Literature* 24, no. 1 (2005): 57–79.

———. *Literary Identification from Charlotte Brontë to Tsitsi Dangarembga*. Columbus: Ohio State University Press, 2012.

———. "'Long, Long Disappointment': Maternal Failure and Masculine Exhaustion in Margaret Oliphant's Autobiography." In *Other Mothers: Beyond the Maternal Ideal*, edited by Ellen Bayuk Rosenman and Claudia C. Klaver, 36–54. Columbus: Ohio State University Press, 2008.

———. "Wishing to Be Fictional." *Victorians Institute Journal* 35 (2007): 217–28.

Green, T. H. *Prolegomena to Ethics [1883]*. Edited by David O. Brink. Oxford: Oxford University Press, 2003.

Greenwood, Frederick. "Postscript." In *Wives and Daughters*, by Elizabeth Gaskell. Oxford World's Classics. Oxford: Oxford University Press, 1987.

Greiner, Rae. "Sympathy Time: Adam Smith, George Eliot, and the Realist Novel." *Narrative* 17, no. 3 (2009): 291–311.

Grener, Adam. *Improbability, Chance, and the Nineteenth-Century Realist Novel*. Columbus: Ohio State University Press, 2020.

Griffiths, Devin. "*Silas Marner* and the Ecology of Form." *Victorian Literature and Culture* 48, no. 1 (2020): 299–326.

Hack, Daniel. "In Literature as in Life?" manuscript, North American Victorian Studies Association Conference, 2017.

———. "Reading for the Foreshadowing." *Representations* 165, no. 1 (2024): 37–62.

Hale, Dorothy J. "The Place of the Novel in Reparative Reading." *Studies in the Novel* 51, no. 1 (2019): 104–9.

Hartman, Saidiya V. *Scenes of Subjection: Terror, Slavery, and Self-Making in Nineteenth-Century America*. New York: Oxford University Press, 1997.

Hass, Andrew H. *Auden's O: The Loss of One's Sovereignty in the Making of Nothing*. Albany: SUNY Press, 2013.

Hawthorne, Nathaniel. *House of Seven Gables*. Edited by Milton R. Stern. New York: Penguin American Classics, 1981.

Hayot, Eric. *On Literary Worlds*. Oxford: Oxford University Press, 2012.

Heaney, Seamus. "Alphabets." In *The Haw Lantern*. London: Faber and Faber, 1987.

Henderson, Andrea K. *Algebraic Art: Mathematical Formalism and Victorian Culture*. New York: Oxford University Press, 2018.

Hensley, Nathan K. "Database and the Future Anterior: Reading *The Mill on the Floss* Backwards." *Genre* 50, no. 1 (2017): 117–37.

Hershinow, Stephanie Insley. *Born Yesterday: Inexperience and the Early Realist Novel*. Baltimore, MD: Johns Hopkins University Press, 2019.

Hertz, Neil. *George Eliot's Pulse*. Stanford, CA: Stanford University Press, 2003.

Hewish, John. *Emily Brontë: A Critical and Biographical Study*. London: Macmillan; St. Martin's Press, 1969.
Heyes, Cressida J. *Anaesthetics of Existence: Essays on Experience at the Edge*. Durham, NC: Duke University Press, 2020.
Hodgson, Shadworth Hollway. *Philosophy and Experience: An Address Delivered Before The Aristotelian Society October 26, 1885*. London and Edinburgh: Williams and Norgate, 1885.
———. *The Metaphysic of Experience*. 4 vols. London: Longmans, Green, 1898.
Holloway, Laura C. *An Hour with Charlotte Brontë; or, Flowers from a Yorkshire Moor*. Philadelphia: J. W. Bradley, 1882.
Homans, Margaret. *Bearing the Word: Language and Female Experience in Nineteenth-Century Women's Writing*. Chicago: University of Chicago Press, 1986.
Horsfall, Nicholas M. "Virgil: His Life and Times." In *A Companion to the Study of Virgil*, edited by Nicholas M. Horsfall, 1–25. Leiden: Brill, 1995.
Hughes, Linda K., and Michael Lund. *Victorian Publishing and Mrs. Gaskell's Work*. Charlottesville: University of Virginia Press, 1999.
Hylton, Peter. *Russell, Idealism, and the Emergence of Analytic Philosophy*. Oxford: Clarendon Press, 1990.
Ingold, Tim. *Lines: A Brief History*. London: Routledge, 2016.
———. *The Life of Lines*. London: Routledge, 2015.
"Inower." In *Dictionaries of the Scots Language*, n.d. https://dsl.ac.uk/.
Irwin, Terence. "Republic 2: Questions about Justice." In *Plato 2: Ethics, Politics, Religion and the Soul*, edited by Gail Fine, 164–84. Oxford: Oxford University Press, 2000.
Jacobus, Mary. "Men of Maxims and *The Mill on the Floss*." In *Reading Woman: Essays in Feminist Criticism*. New York: Columbia University Press, 1986.
———. *Psychoanalysis and the Scene of Reading*. Oxford: Oxford University Press, 1999.
———. *The Poetics of Psychoanalysis: In the Wake of Klein*. Oxford: Oxford University Press, 2005.
Jaffe, Audrey. *The Victorian Novel Dreams of the Real: Conventions and Ideology*. New York: Oxford University Press, 2016.
James, David. *Discrepant Solace: Contemporary Literature and the Work of Consolation*. Oxford: Oxford University Press, 2019.
James, Henry. *The Art of Fiction, And Other Essays*. New York: Oxford University Press, 1948.
———. *The Art of the Novel: Critical Prefaces*. Chicago: University of Chicago Press, 2011.
James, William. "A World of Pure Experience." In *Essays in Radical Empiricism and a Pluralistic Universe*, edited by Ralph Perry, 39–91. New York: Longmans, Green, 1947.
———. *Principles of Psychology*. 2 vols. New York: Henry Holt, 1890.
———. *The Correspondence of William James*. 12 vols. Edited by Ignas K. Skrupskelis and Elizabeth M. Berkeley. Charlottesville: University of Virginia Press, 1992.
———. *The Varieties of Religious Experience: A Study in Human Nature*. New York: Longmans, Green, 1902.
Jameson, Fredric. *Antinomies of Realism*. London: Verso, 2013.
———. "The Realist Floor-Plan." In *On Signs*, edited by Marshall Blonsky, 373–83. Baltimore, MD: Johns Hopkins University Press, 1985.

Jay, Elisabeth. "A Bed of One's Own: Margaret Oliphant." In *Authors at Work: The Creative Environment*, edited by Ceri Sullivan and Graeme Harper, 49–67. Woodbridge: Brewer, 2009.

———. *Mrs. Oliphant: "A Fiction to Herself."* Oxford: Clarendon Press, 1995.

Jay, Martin. *Songs of Experience: Modern American and European Variations on a Universal Theme*. Los Angeles: University of California Press, 2006.

Johnson, Barbara. "Apostrophe, Animation, Abortion." In *A World of Difference*. Baltimore, MD: Johns Hopkins University Press, 1987.

Joseph, Betty. "Transference: The Total Situation." *International Journal of Psychoanalysis* 66, no. 4 (1985): 447–54.

Joseph, Gerhard. "The Antigone as Cultural Touchstone: Matthew Arnold, Hegel, George Eliot, Virginia Woolf, and Margaret Drabble." *PMLA* 96, no. 1 (1981): 22–35.

Kant, Immanuel. *Critique of Pure Reason*. Edited and translated by Norman Kemp Smith. London: Macmillan, 1929.

Kirby, Georgiana Bruce. *Years of Experience: An Autobiographical Narrative*. New York: G. P. B. Putnam's Sons, 1887.

Knoepflmacher, U. C. *George Eliot's Early Novels: The Limits of Realism*. Berkeley: University of California Press, 1968.

Konuk, Kader. *East West Mimesis: Auerbach in Turkey*. Stanford, CA: Stanford University Press, 2010.

Kornbluh, Anna. *The Order of Forms: Realism, Formalism, and Social Space*. Chicago: University of Chicago Press, 2019.

Koustinoudi, Anna. *The Split Subject of Narration in Elizabeth Gaskell's First-Person Fiction*. Lanham, MD: Lexington Books, 2011.

Kramnick, Jonathan. *Actions and Objects from Hobbes to Richardson*. Stanford, CA: Stanford University Press, 2010.

Kreisel, Deanna K. "The Discreet Charm of Abstraction: Hyperspace Worlds and Victorian Geometry." *Victorian Studies* 56, no. 3 (2014): 398–410.

Kruks, Sonia. *Retrieving Experience: Subjectivity and Recognition in Feminist Politics*. Ithaca, NY: Cornell University Press, 2001.

Kucich, John. "Genre Fusion and the Origins of the Female Political Bildungsroman." *NOVEL: A Forum on Fiction* 54, no. 2 (2021): 163–88.

Kucich, John. *The Power of Lies: Transgression in Victorian Fiction*. Ithaca, NY: Cornell University Press, 1994.

Kukkonen, Karin, and Sonja Klimek. *Metalepsis in Popular Culture*. New York: De Gruyter, 2011.

Kurnick, David. "A Few Lies: Queer Theory and Our Method Melodramas." *ELH* 87, no. 2 (2020): 349–74.

———. "Jane Austen, Secret Celebrity and Mass Eroticism." *New Literary History* 52, no. 1 (2021): 53–75.

———. *The Savage Detective, Reread*. New York: Columbia University Press, 2022.

LaFarge, Lucy. "Interpretation and Containment." *International Journal of Psychoanalysis* 81, no. 1 (2000): 67–84.

———. "The Imaginer and the Imagined." *Psychoanalytic Quarterly* 73, no. 3 (2004): 591–625.

Landman, Janet. *Regret: The Persistence of the Possible*. New York: Oxford University Press, 1993.

Langbauer, Laurie. "Absolute Commonplaces: Oliphant's Theory of Autobiography." In *Margaret Oliphant: Critical Essays on a Gentle Subversive*, edited by D. J. Trela, 124–34. Selinsgrove, PA: Susquehanna University Press, 1995.

———. *The Juvenile Tradition: Young Writers and Prolepsis, 1750–1835*. Oxford: Oxford University Press, 2016.

Lanser, Susan. "The 'I' of the Beholder: Equivocal Attachments and the Limits of Structuralist Narratology." In *A Companion to Narrative Theory*, edited by James Phelan and Peter J. Rabinowitz, 206–19. Oxford: Blackwell, 2008.

Larson, Kerry. *Imagining Equality in Nineteenth-Century American Literature*. Cambridge: Cambridge University Press, 2008.

Latour, Bruno. *An Inquiry into Modes of Existence: An Anthropology of the Moderns*. Translated by Catherine Porter. Cambridge, MA: Harvard University Press, 2014.

Law, Jules. "Perilous Reversals: Fluid Exchange in George Eliot's Early Works." In *The Social Life of Fluids: Blood, Milk, and Water in the Victorian Novel*. Ithaca, NY: Cornell University Press, 2010.

Lawrence, D. H. *Women in Love*. Oxford World's Classics. Oxford: Oxford University Press, 1998.

Leith, Sam. "Living with 'Lived Experience.'" *Prospect*, no. 248 (November 2016): 82.

Lemon, Charles, ed. *Early Visitors to Haworth: From Ellen Nussey to Virginia Woolf*. Haworth: The Brontë Society, 1996.

Lerer, Seth. *Error and the Academic Self*. New York: Columbia University Press, 2002.

Levine, Caroline. "The Prophetic Fallacy: Realism, Foreshadowing and Narrative Knowledge in *Romola*." In *From Author to Text: Re-Reading George Eliot's Romola*, edited by Caroline Levine and Mark W. Turner, 135–63. Aldershot: Ashgate, 1998.

Levine, George. "Determinism and Responsibility in the Works of George Eliot." *PMLA* 77, no. 3 (1962): 262–79.

———. "Taking Oliphant Seriously: A Country Gentleman and His Family." *ELH* 83, no. 1 (2016): 233–58.

Lindenberger, Herbert. "On the Reception of Mimesis." In *Literary History and the Challenge of Philology*, edited by Seth Lerer, 195–213. Stanford, CA: Stanford University Press, 1996.

Lockwood, Patricia. *No One Is Talking About This*. New York: Riverhead, 2021.

Loewald, H. W. "On the Therapeutic Action of Psycho-Analysis." *International Journal of Psychoanalysis* 41 (1960): 16–33.

Long, Kay. "Thinking Developmentally: Perspectives Following Loewald and Klein." *Journal of Infant, Child, and Adolescent Psychotherapy* 17, no. 2 (2018): 96–100.

"The Lost Letters of Charlotte Brontë." the *Times*, July 29, 1913.

Love, Heather. "Truth and Consequences: On Paranoid Reading and Reparative Reading." *Criticism* 52, no. 20 (2010): 235–41.

Lucas, John. *The Literature of Change: Studies in the Nineteenth-Century Provincial Novel*. Sussex: Harvester, 1977.

Lucey, Michael. "Proust's Queer Metalepsis." *MLN* 116, no. 4 (2001): 795–815.

Lukacs, Georg. "Narrate or Describe?" In *Writer and Critic, and Other Essays*, edited and translated by Arthur D. Kahn, 110–48. New York: Grosset and Dunlap, 1971.
———. *The Theory of the Novel*. Translated by Anna Bostock. Cambridge, MA: MIT Press, 1971.
Lutz, Deborah. *The Brontë Cabinet: Three Lives in Nine Objects*. New York: W.W. Norton, 2015.
Mac Cumhaill, Clare, and Rachael Wiseman. *Metaphysical Animals: How Four Women Brought Philosophy Back to Life*. New York: Doubleday, 2022.
Macdonald, Frederika. *The Secret of Charlotte Brontë: Followed by Some Reminiscences of the Real Monsieur and Madame Héger*. London and Edinburgh: T. C. & E. C. Jack, 1914.
Macpherson, Sandra. *Harm's Way: Tragic Responsibility and the Novel Form*. Baltimore, MD: Johns Hopkins University Press, 2010.
Malina, Debra. *Breaking the Frame: Metalepsis and the Construction of the Subject*. Columbus: Ohio State University Press, 2002.
Mander, W. J. *British Idealism: A History*. Oxford: Oxford University Press, 2011.
———. "The Philosophy of Shadworth Hodgson." In *The Oxford Handbook of British Philosophy in the Nineteenth Century*, edited by W. J. Mander, 173–88. Oxford: Oxford University Press, 2014.
Marcus, Sharon, Heather Love, and Stephen Best, eds. "Description Across the Disciplines." *Special Issue of Representations* 135, no. 1 (2016).
Margolin, Uri. "Of What Is Past, Is Passing, or to Come: Temporality, Aspectuality, Modality, and the Nature of Literary Narrative." In *Narratologies: New Perspectives on Narrative Analysis*, edited by David Herman, 142–66. Columbus: Ohio State University Press, 1999.
Martindale, Philippa. "'Against All Hushing Up and Stamping Down': The Medico-Psychological Clinic of London and the Novelist May Sinclair." *Psychoanalysis and History* 6, no. 2 (2004): 177–200.
———. "The 'Genius of Enfranchised Womanhood': Suffrage and The Three Brontës." In *May Sinclair: Moving Toward the Modern*, edited by Andrew J. Kunka and Michele K. Troy, 161–77. Aldershot: Ashgate, 2006.
McGavran, Dorothy. "The Danger of Dying in One's Own Language: Lying and the Literacy of the Heart in Elizabeth Gaskell's *Sylvia's Lovers* and *Cousin Phillis*," in *Gender and Victorian Reform*, edited by Anita Rose, 124–40. Newcastle upon Tyne: Cambridge Scholars Publishing, 2008.
McGill, Meredith L., ed. "*Taking Liberties with the Author: Selected Essays from the English Institute*." Cambridge, MA: American Council of Learned Societies, 2013. https://hdl.handle.net/2027/heb90058.0001.001.
McHale, Brian. *Postmodernist Fiction*. London: Routledge, 1987.
Menke, Richard. "Fiction as Vivisection: G. H. Lewes and George Eliot." *ELH* 67, no. 2 (2000): 617–53.
Mermin, Dorothy. *Godiva's Ride: Women of Letters in England, 1830–1880*. Bloomington: Indiana University Press, 1993.
Merrett, Henry. *A Practical Treatise on the Science of Land and Engineering Surveying, Levelling, Estimating Quantities &c*. London: E. & F. N. Spon, 1863.
Merrill, James. *Collected Poems*. New York: Alfred A. Knopf, 2001.

———. *The Book of Ephraim*. New York: Alfred A. Knopf, 2018.
Meshcheryakov, Boris G. "Terminology in L. S. Vygotsky's Writing." In *The Cambridge Companion to Vygotsky*, edited by Harry Daniels, Michael Cole, and James V. Wertsch, 155–77. Cambridge: Cambridge University Press, 2007.
Mew, Charlotte. "The Poems of Emily Brontë." *Temple Bar* 130, no. 525 (1904): 153–67.
Meynell, Alice. "Charlotte and Emily Brontë." In *Hearts of Controversy*. New York: Scribner, 1922.
———. "Review of Clement Shorter." *Charlotte Brontë and Her Circle*. *The Bookman* 4, no. 5 (1897): 454–56.
Michie, Elsie. "Envious Reading: Margaret Oliphant on George Eliot." *Nineteenth-Century Literature* 74, no. 1 (2019): 87–111.
Miller, Andrew H. "'A Case of Metaphysics': Counterfactuals, Realism, 'Great Expectations.'" *ELH* 79, no. 3 (2012): 773–96.
———. "Lives Unled in Realist Fiction." *Representations* 98, no. 1 (2007): 118–34.
———. *On Not Being Someone Else: Tales of Our Unled Lives*. Cambridge, MA: Harvard University Press, 2020.
———. "Perfectly Helpless." In *The Burdens of Perfection: On Ethics and Reading in Nineteenth-Century British Literature*. Ithaca, NY: Cornell University Press, 2008.
Miller, D. A. *Narrative and Its Discontents: Problems of Closure in the Traditional Novel*. Princeton, NJ: Princeton University Press, 1981.
Miller, J. Hillis. *Ariadne's Thread: Story Lines*. New Haven, CT: Yale University Press, 1992.
———. *Reading Narrative*. Norman: University of Oklahoma Press, 1998.
Miller, Lucasta. *The Brontë Myth*. London: Jonathan Cape, 2001.
Miller, Nancy K. "Emphasis Added: Plots and Plausibilities in Women's Fiction." *PMLA* 96, no. 1 (1981): 36–48.
Milne, A. J. M. *The Social Philosophy of English Idealism*. London: Allen & Unwin, 1962.
Milner, Marion. *A Life of One's Own*. London: Routledge, 2011.
Moers, Ellen. *Literary Women*. New York: Doubleday, 1976.
Moi, Toril. "Don't Look Back." *The London Review of Books* 45, no. 8 (April 2023): 21–24.
———. *Revolution of the Ordinary: Literary Studies after Wittgenstein, Austin, and Cavell*. Chicago: University of Chicago Press, 2017.
———. *Sexual/Textual Politics*. London: Routledge, 2002.
Montgomery, Edmund. "Actual Experience." *The Monist* 9, no. 3 (1899): 359–81.
———. *The Revelation of Present Experience*. Boston: Sherman, French, 1910.
Moon, Michael. "No Coward Souls: Poetic Engagements between Emily Brontë and Emily Dickinson." In *The Traffic in Poems: Nineteenth-Century Poetry and Transatlantic Exchange*, edited by Meredith L. McGill, 231–49. New Brunswick, NJ: Rutgers University Press, 2008.
Moore, Grace, and Susan Pyke. "Haunting Passions: Revising and Revisiting *Wuthering Heights*." *Victorians Institute Journal* 34 (2007): 239–49.
Moran, Richard. *Authority and Estrangement: An Essay on Self Knowledge*. Princeton, NJ: Princeton University Press, 2001.
Morris, Pam. *Realism*. London: Routledge, 2003.

Morson, Gary Saul. *Narrative and Freedom: The Shadows of Time*. New Haven, CT: Yale University Press, 1994.
Mufti, Aamir R. "Auerbach in Istanbul: Edward Said, Secular Criticism, and the Question of Minority Culture." *Critical Inquiry* 25, no. 1 (1998): 95–125.
Myers, William. *The Teachings of George Eliot*. Leicester: Leicester University Press, 1984.
Nauta, Ruurd. "The Concept of Metalepsis: From Rhetoric to the Theory of Allusion and to Narratology." In *Über Die Grenze: Metalepse in Text- Und Bildmedien Des Altertums*, edited by Ute E. Eisen and Peter von Möllendorff, 469–82. Berlin: De Gruyter, 2013.
Newbolt, W. C. E. *The Gospel of Experience, or The Witness of Human Life to the Truth of Revelation*. London: Longmans, Green, 1896.
Nunokawa, Jeff. "The Miser's Two Bodies: 'Silas Marner' and the Sexual Possibilities of the Commodity." *Victorian Studies* 36, no. 3 (1993): 273–92.
Oakeley, H. D. "The World as Memory and as History." *Proceedings of The Aristotelian Society*, 1927.
O'Conner, Patricia, and Stewart Kellerman. "The Life of a Lived Experience." *Grammarphobia* (blog), December 10, 2021. https://www.grammarphobia.com/blog/2021/12/lived-experience.html.
Ogden, Thomas H. "On Holding and Containing, Being and Dreaming." In *This Art of Psychoanalysis: Dreaming Undreamt Dreams and Interrupted Cries*. London: Routledge, 2005.
———. "Reading Bion." In *This Art of Psychoanalysis: Dreaming Undreamt Dreams and Interrupted Cries*. London: Routledge, 2005.
———. *Reclaiming Unlived Life: Experiences in Psychoanalysis*. New York: Routledge, 2016.
———. *This Art of Psychoanalysis: Dreaming Undreamt Dreams and Interrupted Cries*. London: Routledge, 2005.
Oksala, Johana. *Feminist Experiences: Foucauldian and Phenomenological Investigations*. Evanston, IL: Northwestern University Press, 2016.
Oliphant, Francis. *A Plea for Painted Glass: Being an Inquiry into Its Nature, Character, Objects, and Its Claims as an Art*. Oxford: Henry Parker, 1855.
Oliphant, Margaret. "A Hidden Treasure." *The Argosy*, January 1866.
———. *Hester: A Story of Contemporary Life*. Edited by Philip Davis. Oxford World's Classics. Oxford: Oxford University Press, 2009.
———. *Kirsteen*. London: Dent, 1984.
———. "Miss Austen and Miss Mitford." *Blackwood's Edinburgh Magazine*, 1870.
———. "Novels." *Blackwood's Edinburgh Magazine* 102, no. 623 (1867): 257–80.
———. *Old Lady Mary: A Story of the Seen and the Unseen*. Boston: Roberts Brothers, 1884.
———. *Stories of the Seen and Unseen*. Edinburgh: Blackwood 1902, n.d.
———. *The Autobiography and Letters of Mrs. M. O. W. Oliphant*. Edited by Mrs. Harry Coghill. New York: Dodd, Mead, 1899.
———. *The Autobiography of Margaret Oliphant*. Edited by Elisabeth Jay. Peterborough: Broadview, 2002.
———. *The Curate in Charge*. London: Macmillan, 1894.

---. *The Doctor's Family and Other Stories*. Edited by Merryn Williams. Oxford World's Classics. Oxford: Oxford University Press, 1986.
---. "The Fancies of a Believer." *Blackwood's Edinburgh Magazine*, 1895.
---. "The Land of Suspense." *Blackwood's Edinburgh Magazine*, 1897.
---. *The Marriage of Elinor*. 3 vols. London: Macmillan, 1892.
---. *The Railway Man and His Children*. 3 vols. London: Macmillan, 1891.
---. "The Sisters Brontë." In *Women Novelists of Queen Victoria's Reign*. London: Hunt and Blackett, 1897.
Ong, Yi-Ping. *The Art of Being: Poetics of the Novel and Existentialist Philosophy*. Cambridge, MA: Harvard University Press, 2018.
Orel, Harold, ed. *The Brontës: Interviews and Recollections*. Iowa City: University of Iowa Press, 1997.
Otto, Peter. *Multiplying Worlds: Romanticism, Modernity, and the Emergence of Virtual Reality*. Oxford: Oxford University Press, 2011.
Parkes, Bessie. "Letter to Elizabeth Gaskell, October 1850." In *Early Visitors to Haworth: From Ellen Nussey to Virginia Woolf*, edited by Charles Lemon, 15–18. Haworth: The Brontë Society, 1996.
Pavel, Thomas G. *Fictional Worlds*. Cambridge, MA: Harvard University Press, 1986.
Peterson, Linda. Introduction to *The Life of Charlotte Brontë*. London: Routledge, 2016.
---. *Traditions of Victorian Women's Autobiography: The Poetics and Politics of Life Writing*. Charlottesville: University of Virginia Press, 1999.
Phipps, Alison. "Whose Personal Is More Political? Experience in Contemporary Feminist Politics." *Feminist Theory* 17, no. 3 (2016): 303–21.
Pier, John. "Metalepsis." In *The Living Handbook of Narratology*. Edited by Peter Hühn. Hamburg University, n.d. http://lhn.sub.uni-hamburg.de/index.php/Metalepsis.html#:~:text=In%20its%20narratological%20sense%2C%20metalepsis,%2C%20etc.)%2C%20or%20the.
Pinch, Adela. *Thinking About Other People in Nineteenth-Century British Writing*. Cambridge: Cambridge University Press, 2010.
Plotz, John. *Semi-Detached: The Aesthetics of Virtual Experience Since Dickens*. Princeton, NJ: Princeton University Press, 2018.
Porter, James I. "Erich Auerbach and the Judaizing of Philology." *Critical Inquiry* 35, no. 1 (2008): 115–47.
Prins, Yopie. *Ladies' Greek: Victorian Translations of Tragedy*. Princeton, NJ: Princeton University Press, 2017.
Puckett, Kent. *Narrative Theory: A Critical Introduction*. Cambridge: Cambridge University Press, 2016.
Putnam, Hilary. "Introduction." In *The Correspondence of William James*, 10: xxv–xlvii. Charlottesville: University of Virginia Press, 2002.
Raitt, Suzanne. "Literary History as Exorcism: May Sinclair Meets the Brontës." In *Women and Literary History: "For There She Was,"* edited by Katherine Binhammer and Jeanne Wood, 187–200. Newark: University of Delaware Press, 2003.
---. *May Sinclair: A Modern Victorian*. Oxford: Oxford University Press, 2000.
Rajan, Supritha. "Regret Without Limit: The Ends of Agency and Genre in George Eliot's *Middlemarch*." *Victorian Literature and Culture* 49, no. 2 (2021): 259–300.

Rauch, Alan. "Destiny as an Unmapped River: George Eliot's *The Mill on the Floss*." In *Useful Knowledge: The Victorians, Morality, and the March of the Intellect*. Durham, NC: Duke University Press, 2001.
Redgrove, H. Stanley. *The Magic of Experience: A Contribution to the Theory of Knowledge*. London: J. M. Dent & Sons Ltd., E. P. Dutton & Co, 1915.
Redinger, Ruby. *George Eliot: The Emergent Self*. New York: Knopf, 1975.
Reid, Thomas Wemyss. *Charlotte Brontë: A Monograph*. New York: Scribner, Armstrong & Co, 1877.
Reimer, Gail Twersky. "Revision of Labor in Margaret Oliphant's Autobiography." In *Life/Lines: Theorizing Women's Autobiography*, edited by Bella Brodzki and Celeste Schenck, 203–20. Ithaca, NY: Cornell University Press, 1988.
Richards, Joan V. *Mathematical Visions: The Pursuit of Geometry in Victorian England*. San Diego, CA: Academic Press, 1988.
Richmond, Wilfrid John. *Experience: A Chapter of Prolegomena*. London: S. Sonnenschein, 1896.
Rivin, Gabe. "What Happened to O?" *The Paris Review*, August 27, 2015.
Robbins, Bruce. "Many Years Later: Prolepsis in Deep Time." *The Henry James Review* 33, no. 3 (2012): 191–204.
———. *The Servant's Hand: English Fiction from Below*. New York: Columbia University Press, 1986.
Roberts, Jessica F. "The Little Coffin: Anthologies, Convention, and Dead Children." In *Representations of Death in Nineteenth-Century U.S. Writing and Culture*, edited by Lucy E. Frank, 141–54. New York: Routledge, 2007.
Robieson, M.W. "Review of May Sinclair, A Defence of Idealism." *International Journal of Ethics* 28, no. 4 (1918): 563–67.
Robinson, A. Mary F. *Emily Brontë*. London: W. H. Allen, 1883.
Romanow, Jacob. "The Novel of Exteriority: Form, Privacy, and Nation in Nineteenth-Century Britain." PhD Dissertation, Rutgers University, 2022.
Ronen, Ruth. "Completing the Incompleteness of Fictional Entities." *Poetics Today* 9, no. 3 (1988): 497–514.
———. "Description, Narrative and Representation." *Narrative* 5, no. 3 (1997): 274–86.
———. *Possible Worlds in Literary Theory*. Cambridge: Cambridge University Press, 1994.
Rorty, Amélie. "Agent Regret." In *Explaining Emotions*, edited by Amélie Rorty, 489–506. Berkeley: University of California Press, 1980.
Rosenthal, Jesse. *Good Form: The Ethical Experience of the Victorian Novel*. Princeton, NJ: Princeton University Press, 2016.
Rosenthal, Jesse, and Adam Grener, eds. "Narrative Against Data in the Victorian Novel." *Special Issue of Genre* 50, no. 1 (2017).
Rowlinson, Matthew. "Mourning and Metaphor: On the Literality of Tennyson's 'Ulysses.'" *Boundary 2* 20, no. 2 (1993): 230–65.
Rutherford, Andrew. *Byron: The Critical Heritage*. London: Routledge and Kegan Paul, 1970.
Ryan, Marie-Laure. "Metaleptic Machines." In *Avatars of Story*, edited by Marie-Laure Ryan, 204–30. Minneapolis: University of Minnesota Press, 2006.

---. *Possible Worlds, Artificial Intelligence, And Narrative Theory*. Bloomington: Indiana University Press, 1991.
Sanders, Valerie, and Emma Butcher. "'Mortal Hostility': Masculinity and Fatherly Conflict in the Glasstown and Angria Sagas." In *Charlotte Brontë from the Beginnings: New Essays from the Juvenilia to the Major Works*, edited by Judith E. Pike and Lucy Morrison, 59–71. New York: Routledge, 2017.
Scarry, Elaine. *Dreaming by the Book*. New York: Farrar, Straus and Giroux, 1999.
Schaffer, Talia. *Communities of Care: The Social Ethics of Victorian Fiction*. Princeton, NJ: Princeton University Press, 2021.
---. *Novel Craft: Victorian Domestic Handicraft and Nineteenth-Century Fiction*. Oxford: Oxford University Press, 2011.
Schiffrin, Deborah. "Oh: Marker of Information Management." In *Discourse Markers*. Cambridge: Cambridge University Press, 1987.
Schor, Naomi. *Reading in Detail: Aesthetics and the Feminine*. New York: Methuen, 1987.
Schramm, Jan-Melissa. *Atonement and Self-Sacrifice in Nineteenth-Century Narrative*. Cambridge: Cambridge University Press, 2012.
Schwab, Gabrielle. "Words and Moods: The Transference of Literary Knowledge." *SubStance* 26, no. 3 (1997): 107–27.
Scott, Joan W. "The Evidence of Experience." *Critical Inquiry* 17, no. 4 (1991): 773–97.
Sedgwick, Eve Kosofsky. "Paranoid Reading and Reparative Reading; or, You're So Paranoid, You Probably Think This Introduction Is About You." In *Novel Gazing: Queer Readings in Fiction*, edited by Eve Kosofsky Sedgwick, 1–37. Durham, NC: Duke University Press, 1997.
Sewter, A. Charles. *The Stained Glass of William Morris and His Circle*. 2 vols. New Haven, CT: Yale University Press, 1974.
Shattock, Joanne. "The Feminisation of Literary Culture." In *The History of British Women's Writing, 1830–1880*, 6:23–38. Edited by Lucy Hartley. London: Palgrave Macmillan, 2018.
Shaw, Harry E. *Narrating Reality: Austen, Scott, Eliot*. Ithaca, NY: Cornell University Press, 1999.
Showalter, Elaine. *A Literature of Their Own: British Women Novelists from Brontë to Lessing*. Princeton, NJ: Princeton University Press, 1977.
---. "Twenty Years On: A Literature of Their Own Revisited." *NOVEL: A Forum on Fiction* 31, no. 3 (1998): 399–413.
Shuttleworth, Sally. *George Eliot and Nineteenth-Century Science: The Make-Believe of a Beginning*. Cambridge: Cambridge University Press, 1987.
---. "Introduction." In *The Lifted Veil and Brother Jacob*, by George Eliot. New York: Penguin, 2001.
Silvey, Jane. "May Sinclair and the Brontës: 'Virgin Priestesses of Art.'" In *May Sinclair: Moving Toward the Modern*, edited by Andrew J. Kunka and Michele K. Troy, 161–77. Aldershot: Ashgate, 2006.
Sinclair, May. *A Defence of Idealism: Some Questions and Conclusions*. London: Macmillan, 1917.
---. "Guyon: A Philosophical Dialogue." In *Essays in Verse*. London: Kegan Paul, 1891.

———. "Introduction." In *The Life of Charlotte Brontë*, by Elizabeth Gaskell. London: J. Dent, 1908.
———. "Letter to the Editor." the *Times*, August 1, 1913.
———. "The Ethical and Religious Import of Idealism." *The New World: A Quarterly Review of Religion, Ethics and Theology* 2, no. 8 (1893): 694–708.
———. *The New Idealism*. London: Macmillan, 1922.
———. *The Three Brontës*. London: Hutchinson, 1912.
———. *The Three Brontës*. 2nd ed. Boston: Houghton Mifflin, 1914.
Sitter, Zak. "On Early Style: The Emergence of Realism in Charlotte Brontë's Juvenilia." In *Charlotte Brontë from the Beginnings: New Essays from the Juvenilia to the Major Works*, edited by Judith E. Pike and Lucy Morrison, 30–43. London: Routledge, 2017.
Small, Helen. "Feminist Theory and the Return of the Real: 'What We Really Want out of Realism . . .'" In *Adventures in Realism*, edited by Matthew Beaumont, 224–40. Oxford: Blackwell, 2007.
Smith, Vanessa. "Toy Stories." *NOVEL: A Forum on Fiction* 50, no. 1 (2017): 35–55.
———. *Toy Stories: Analyzing the Child in Nineteenth-Century Literature*. New York: Fordham University Press, 2023.
Southam, B. C. *Jane Austen: The Critical Heritage*. London: Routledge and Kegan Paul, 1968.
Spacks, Patricia Ann Meyer. *The Female Imagination*. New York: Knopf, 1975.
Star, Summer J. "Feeling Real in 'Middlemarch.'" *ELH* 80, no. 3 (2013): 839–69.
Steedman, Carolyn. *Master and Servant: Love and Labour in the English Industrial Age*. Cambridge: Cambridge University Press, 2007.
———. *Strange Dislocations: Childhood and the Idea of Human Interiority, 1780–1930*. Cambridge, MA: Harvard University Press, 1998.
Stewart, Garrett. "Of Time as a River: The Mill of Desire." In *Novel Violence: A Narratography of Victorian Fiction*. Chicago: University of Chicago Press, 2009.
Stockton, Kathryn Bond. *The Queer Child: Or Growing Sideways in the Twentieth Century*. Durham, NC: Duke University Press, 2009.
Stoneman, Patsy. *Elizabeth Gaskell*. 2nd ed. Manchester: Manchester University Press, 2006.
Sutton-Ramspeck, Beth. "The Personal Is Poetical: Feminist Criticism and Mary Ward's Readings of The Brontës." *Victorian Studies* 34, no. 1 (1990): 55–75.
Swann, Charles. "Deja vu: Deja Lu: 'The Lifted Veil' as an Experiment in Art." *Literature and History* 5, no. 1 (1979): 40–57.
Taylor, Charles. "Irreducibly Social Goods." In *Philosophical Arguments*. Cambridge, MA: Harvard University Press, 1995.
Taylor, Gabriele. *Shame, Pride, and Guilt: Emotions of Self-Assessment*. Oxford: Oxford University Press, 1987.
Tennyson, Alfred Lord. *The Poems of Tennyson*. Edited by Christopher Ricks. London: Longman, 1969.
Thomas, Emily. "Hilda Oakeley on Idealism, History, and the Real Past." *British Journal for the History of Philosophy* 23, no. 5 (2015): 933–53.

———. "The Idealism and Pantheism of May Sinclair." *Journal of American Philosophical Association* 5, no. 2 (2019): 137–57.
Trollope, Anthony. *An Autobiography*. Edited by Michael Sadleir and Frederick Page. Oxford World's Classics. Oxford: Oxford University Press, 1998.
———. *Framley Parsonage*. London: Folio Society, 1996.
Uglow, Jenny. *Elizabeth Gaskell: A Habit of Stories*. London: Faber and Faber, 1993.
Unsworth, Anna. "Ruskin and 'Cousin Phillis.'" *The Gaskell Society Journal* 10 (1996): 77–82.
Van Ghent, Dorothy. "The Window Figure and the Two Children Figure in *Wuthering Heights*." *Nineteenth-Century Fiction* 7, no. 3 (1952): 189–97.
Vermeule, Blakey. *Why Do We Care About Literary Character?* Baltimore, MD: Johns Hopkins University Press, 2010.
Vygotsky, L. S. *Mind in Society: The Development of Higher Psychological Processes*. Edited by Michael Cole, Vera John-Steiner, Sylvia Scribner, and Ellen Souberman. Cambridge, MA: Harvard University Press, 1978.
Waithe, Mary Ellen, ed. *A History of Women Philosophers*. 4 vols. Dordrecht: Kluwer, 1989.
Walker, Bettina. *My Musical Experiences*. London: Richard Bentley and Son, 1892.
Wallace, R. Jay. *The View from Here: On Affirmation, Attachment, and the Limits of Regret*. Oxford: Oxford University Press, 2013.
Waller, Philip. *Writers, Readers, and Reputations: Literary Life in Britain, 1870–1918*. Oxford: Oxford University Press, 2006.
Walsh, Richard. "Person, Level, Voice: A Rhetorical Reconsideration." In *Postclassical Narratology: Approaches and Analyses*, edited by Monika Fludernik, 35–57. Columbus: Ohio State University Press, 2010.
Ward, Mary Augusta. "Introduction." In *The Tenant of Wildfell Hall*, by Anne Brontë, ix–xxi. London: Smith and Elder, 1900.
Warhol, Robyn. *Gendered Interventions: Narrative Discourse in the Victorian Novel*. New Brunswick, NJ: Rutgers University Press, 1989.
Warner, Sylvia Townsend. "Elizabeth Gaskell." *Our Time* 4, no. 7 (1945): 45–52.
———. *Lolly Willowes: Or the Loving Huntsman* [1926]. New York: NYRB Classics, 1999.
Weiskel, Thomas. *The Romantic Sublime: Studies In the Structure and Psychology of Transcendence*. Baltimore, MD: Johns Hopkins University Press, 1976.
Williams, Bernard. *Moral Luck*. Cambridge: Cambridge University Press, 1982.
Williams, J. Butler. *Practical Geodesy: Comprising Chain Surveying, and the Use of Surveying Instruments; Levelling, and Tracing of Contours*. London: J.W. Parker, 1855.
Williams, Raymond. *Culture and Society, 1780–1950*. 2nd ed. New York: Columbia University Press, 1983.
———. *Keywords: A Vocabulary of Culture and Society*. Revised. New York: Oxford University Press, 1985.
Winnicott, D.W. *Playing and Reality*. London: Routledge, 1971.
Wittgenstein, Ludwig. *On Certainty*. Edited by G. E. M. Anscombe and G. H. von Wright. New York: Harper, 1969.
Womack, Elizabeth. "Anticipated Ends, Atonement, and the Serialization of Gaskell's *North and South*." *Dickens Studies Annual* 48, no. 1 (2017): 231–51.

Woolf, Virginia. "Haworth, November 1904." In *Early Visitors to Haworth: From Ellen Nussey to Virginia Woolf*, edited by Charles Lemon, 124–27. Haworth: The Brontë Society, 1996.

———. *To the Lighthouse*. New York: Harcourt, Brace, and World, 1955.

Wordsworth, William. *The Prelude, 1799, 1805, 1850: Authoritative Texts, Context and Reception, Recent Critical Essays*. Edited by Jonathan Wordsworth, M. H. Abrams, and Stephen Gill. New York: W.W. Norton, 1979.

Wright, Daniel. *The Grounds of the Novel*. Stanford, CA: Stanford University Press, 2024.

Zemka, Sue. *Time and the Moment in Victorian Literature and Society*. Cambridge: Cambridge University Press, 2011.

ZUBY. "If You Use the Terms 'Emotional Labour' and 'Micro-Aggression' Non-Ironically, Then I Will Struggle to Take You Seriously . . ." *Twitter* (blog), March 3, 2020. https://twitter.com/ZubyMusic/status/1234858211787800578.

Index

Alcoff, Linda Martín, 14
Allison, Sarah, 21
Armstrong, Isobel, 75
Arnold, Matthew, 3
Auerbach, Erich, 123–24, 132
Austen, Jane, 31, 66–67, 69, 87, 104
Auyoung, Elaine, 128

Bachelard, Gaston, 127
Bakhtin, M. M., 8
Barker, Juliet, 40
Barthes, Roland, 100
Beauvoir, Simone de, 110, 149
Beckett, Samuel, 7
Behlman, Lee, 166n53
Bell, Alice, and Jan Alber, 59
Berlant, Lauren, 141, 145, 185n4
Bishop, Elizabeth 44–45, 79–80
Bion, W. R., 5–7, 53–55, 83, 90
Blumberg, Ilana, 186n5
Bodenheimer, Rosemarie, 105
borders and boundaries: between fiction and life, 5, 7–10, 51, 55–56, 82–83, 85, 127, 147; between inner and outer reality, 4–6, 51–55, 59; as doors, walls, windows, 74–75, 80, 85, 127, 168n80; and lines,126–27; separating people, 69, 78–79, 81, 104, 127
Bradley, F. H., 24, 25–26
Brontë family: juvenile writings by, 50–55; late Victorian writing about, 30–33, 37–40, 48–50; transfers of experience within,18, 37–40
Brontë, Branwell, 38–40

Brontë, Charlotte, 7, 21, 31–32, 36–40, 48, 54–55; *Jane Eyre*, 31, 39 42, 44, 48–49, 50; *Villette*, 7, 21–22, 37, 49
Brontë, Emily, 20, 33, 37, 48–49, 125; *Wuthering Heights*, 18–19, 38–39, 50, 75
Brown, Kate 113–15
Bulwer-Lytton, Edward, 99
Byron, George Gordon, Lord, 31

care, 66, 93, 102–3, 107–8, 169n100. *See also* protection
Carson, Anne, 19–21
Christoff, Alicia, 6, 90, 170n104, 175n103, 175n126
Cohn, Dorrit, 88
Culler, Jonathan, 76
Currie, Mark, 86

Davidson, Joseph, 135–36
Davis, Theo, 13
Diderot, Denis, 58, 59
diegesis, intra- vs. extra-, 7, 9, 59, 86. *See also* story vs. discourse
discourse vs. story: *See* story vs. discourse

Eliot, George, 6, 12, 60, 132; *Adam Bede*, 57, 68–69, 93, 115; "Brother Jacob," 110; *Daniel Deronda*, 100, 101, 115; "The Lifted Veil," 93–98; *Middlemarch*, 13, 87, 101, 146–47, 171n8; *The Mill on the Floss*, 9–10, 87, 89, 99–110, 140; *Romola*, 142; *Silas Marner*, 111–14, 118

empiricism, 24, 27
Empson, William, 125, 134
experience: defined, 2–3, 22–23, 81,148–49; biographical vs. phenomenological, 22; in contemporary feminist debates, 13–15, 154n51; *Erfahrung* vs. *Erlebnis*, 22; and helplessness, 81; "learning from," 7, 25, 89–90; "lived experience," 88, 146, 148–50, 187n18; May Sinclair on, 33–37; and metalepsis, 57–59; and prolepsis, 90–91; texture of, 3, 32, 33–41, 46–48, 102, 127; transferable nature of, 1–6, 9, 10, 18–22, 37, 40, 54, 79, 83, 102, 122, 146–47; in Victorian philosophy, 22–30; vicarious and virtual, 6, 121,131–32, 147, 149, 150

family relations: between parents and children, 11, 13, 78–79, 101–3, 103, 112, 113–14, 115–16, 117–19; between siblings, 37–40, 50–54, 103
Fanon, Frantz, 149
Frankfurt, Harry, 169n100
free will vs. determinism, 67, 88–89, 97–98, 103–7
feminist criticism and theory, 12–15
Flesch, William, 6, 68,155n2
Fothergill, Jesse, 20
Fludernik, Monika, 57, 58
Freedgood, Elaine, 8, 57–59
future: in George Eliot's fiction, 11, 86–110; and care, 93, 101–3; and children, 89–91,111; in metalepsis, 86; in ordinary thinking, 97–98, 107; in magical thinking, 100–103; and reading, 92, 109–10

Galperin, William, 134–35, 141
Gardner, E.V., 131–32
Gaskell, Elizabeth, 55, 101, 102, 115–16, 117–43, 145–47; *Cousin Phillis,* 122, 124–37, 141–43, 145–47; *Cranford,* 137; *A Dark Night's Work,* 137; *The Life of Charlotte Brontë,* 21–22, 40–48, 50; 119–21; 125; "Lizzie Leigh," 137; "Lois the Witch," 137; *Mary Barton,* 118, 134, 137; *North and South,* 121, 134, 137–38; "The Poor Clare," 137; *Ruth,* 121; *Sylvia's Lovers,*122, 127, 134, 138–41; *Wives and Daughters,* 122, 137, 140
Genette, Gerard, 57–59, 83, 85, 87–89, 147–48
geometry, 126–31; imaginary, 131–32, 183n78
Gettelman, Debra, 92
Goldring, Maude, 38
Goodlad, Lauren M. E., 153n25
Gray, Erik, 69
Green, T. H., 24–25, 34–35

Hack, Daniel, 13, 87, 170n3, 171n15
Hale, Dorothy, 144–46
Hartman, Saidiya, 155n51
Haworth (parsonage and village), 30, 40–48, 125
Hawthorne, Nathaniel, 82
Hayot, Eric, 153n29
Heaney, Seamus, 84
helplessness, 64–75, 78, 89,103–4; and experience, 81; and metalepsis, 66–68
Hershinow, Stephanie Insley, 89, 153n25, 156n21
Hertz, Neil, 98, 115
Hinton, James, 38
Hodgson, Shadworth Hollway, 2, 26–30, 38, 39, 47
Holloway, Laura C., 32

idealism, 24–26, 34–37

James, David, 274n91
James, Henry, 2, 12, 82–83

James, William, 24, 26, 27, 158n48
Jameson, Fredric, 124–25, 127–68

Kant, Immanuel, 151n6
Klein, Melanie, 114, 144
Kornbluh, Anna, 128
Kurnick, David, 153n31, 167n60, 170n108, 170n110, 185n4

LaFarge, Lucy, 53–54,
Landman, Janet, 141
Langbauer, Laurie, 89
Latour, Bruno, 128
Lewes, G. H., 12, 31, 42, 60, 93, 102, 180n23
Lockwood, Patricia, 107
Loewald, Hans, 91
Lucey, Michael, 164n15
Lukacs, Georg, 145, 146, 147, 180n24, 186n17
Lutz, Deborah, 161n121

Macdonald, Frederika, 32
Macpherson, Sandra, 154n37, 179n21
McHale, Brian, 164n15
Merrill, James, 47, 92
metalepsis, 11, 56, 68; defined, 7, 56–57; and anti-metalepsis, 67–69, 73, 79, 81–83; and helplessness, 66–68; and prolepsis, 85–88, 142
Mew, Charlotte, 20
Meynell, Alice, 20, 44, 48–50
Miller, Andrew H., 67–68, 104, 179n20
Miller, Lucasta, 40
Milner, Marion, 3
Moi, Toril, 14
Moon, Michael, 21
Morson, Gary Saul, 87–88, 104

narrative theory, 7, 57–60, 148. *See also*: diegesis; metalepsis; prolepsis; story vs. discourse

novel theory 144–45, 147. *See also*: realism; worlds

Oakeley, Hilda, 34
Oliphant, Francis
Oliphant, Margaret, 33–34, 38, 55, 59–84, 92–93, 121; *Autobiography*, 60–65, 81; *Chronicles of Carlingford*, 61, 73; *The Curate in Charge*, 77; *The Doctor's Family*, 69, 70–73, 80; "The Fancies of a Believer," 64–67; "A Hidden Treasure," 168; *Hester*, 69–70; *Kirsteen*, 68; *The Marriage of Elinor*, 65, 70; *Miss Marjoribanks*, 69–70; *The Railway Man and His Children*, 70, 80; supernatural tales, 73–75, 77–79
Ong, Yi-Ping, 8–9, 82–83, 88

Parkes, Bessie, 41
Pavel, Thomas, 8, 51
Plotz, John, 9–10, 70
prolepsis: 11, 85–93; defined, 7, 85–87, 100; and foreshadowing, 86; and magical thinking, 100–104, 174n91; and metalepsis, 85–88, 142
protection: and metalepsis, 59; 93; and prolepsis, 100–104. *See also* care
psychoanalysis, 3–7, 35–36, 53–54, 91, 144
Puckett, Kent, 57, 147

Rajan, Supritha, 177n160, 179n20
realism, 2, 11, 14, 58–59, 100, 123–32, 136, 140; 179–80n20, n23; 180n24, 181n34, 184n110; and remorse, 136–43
regret, 122, 179n20
Reid, T. Wemyss, 32, 39
remorse, 63, 137–42; defined, 121–22; vs. regret, 121–22; 179n19
responsibility, 70–71, 115–16
Robinson, A. Mary. F., 20, 33, 39, 40
Robbins, Bruce, 88

Romanow, Jacob, 167n64, 167n66
Rosenthal, Jess, 148, 180n24
Ryan, Marie-Laure, 84

Sedgwick, Eve Kosofsky, 144, 185n4
Scarry, Elaine, 132
Schaffer, Talia, 6, 66, 142, 185n124
Schramm, Jan-Melissa, 152n16, 178n7, 186n9
Scott, Joan, 14
Showalter, Elaine, 14
Sinclair, May, 20, 29–30, 33–38, 40–48
Smith, Vanessa, 6, 90
Steedman, Carolyn Kay, 90, 101
Stockton, Kathryn, 89
stoicism, 66, 266n53
story vs. discourse, 7, 87, 97, 102, 104, 107 144, 145, 146–48. *See also* diegesis

Taylor, Charles, 133
Tennyson, Alfred Lord, 2–3, 54
Trollope, Anthony, 6–7, 12, 60–61, 68

Uglow, Jenny, 118

Virgil, *Georgics*, 134–36
Vygotsky, L. S., 90–91

Wallace, R. Jay, 114, 138, 141, 146, 179n19
Walsh, Richard, 59
Warner, Sylvia Townsend, 41, 129
Wheelwright, Laetitia, 21
Williams, Bernard, 121, 138, 146, 179n19
Williams, Raymond, 22, 149
Winnicott, D. W., 3–4,
Wittgenstein, Ludwig, 90
Woolf, Virginia, 42–43, 123–24, 132, 143
Wordsworth, William, 5, 46–47, 111–12, 126, 134
worldmaking as recompense, 142, 179n21
worlds: fictional, 51–55; possible, 8–9, 59; storyworlds, 9–10; world stack, 84

Zemka, Sue, 92

Adela Pinch is Professor of English at the University of Michigan. She is the author of *Strange Fits of Passion: Epistemologies of Emotion, Hume to Austen* (1996), and *Thinking about Other People in Nineteenth-Century British Writing* (2010).

Sara Guyer and Brian McGrath, series editors

Sara Guyer, *Reading with John Clare: Biopoetics, Sovereignty, Romanticism.*

Philippe Lacoue-Labarthe, *Ending and Unending Agony: On Maurice Blanchot.* Translated by Hannes Opelz.

Emily Rohrbach, *Modernity's Mist: British Romanticism and the Poetics of Anticipation.*

Marc Redfield, *Theory at Yale: The Strange Case of Deconstruction in America.*

Jacques Khalip and Forest Pyle (eds.), *Constellations of a Contemporary Romanticism.*

Geoffrey Bennington, *Kant on the Frontier: Philosophy, Politics, and the Ends of the Earth.*

Frédéric Neyrat, *Atopias: Manifesto for a Radical Existentialism.* Translated by Walt Hunter and Lindsay Turner, Foreword by Steven Shaviro.

Jacques Khalip, *Last Things: Disastrous Form from Kant to Hujar.*

Jacques Lezra, *On the Nature of Marx's Things: Translation as Necrophilology.* Foreword by Vittorio Morfino.

Jean-Luc Nancy, *Portrait.* Translated by Sarah Clift and Simon Sparks, Foreword by Jeffrey S. Librett.

Karen Swann, *Lives of the Dead Poets: Keats, Shelley, Coleridge.*

Erin Graff Zivin, *Anarchaeologies: Reading as Misreading.*

Ramsey McGlazer, *Old Schools: Modernism, Education, and the Critique of Progress.*

Zachary Sng, *Middling Romanticism: Reading in the Gaps, from Kant to Ashbery.*

Marc Redfield, *Shibboleth: Judges, Derrida, Celan.*

Emily Sun, *On the Horizon of World Literature: Forms of Modernity in Romantic England and Republican China.*

Robert Mitchell, *Infectious Liberty: Biopolotics between Romanticism and Liberalism.*

Orrin N. C. Wang, *Techno-Magism: Media, Mediation, and the Cut of Romanticism.*

Brian McGrath, *Look Round for Poetry: Untimely Romanticisms.*

Christopher Rovee, *New Critical Nostalgia: Romantic Lyric and the Crisis of Academic Life.*

www.ingramcontent.com/pod-product-compliance
Lightning Source LLC
Chambersburg PA
CBHW020408080526
44584CB00014B/1222